German Drawings and Watercolors

The Collections of the Detroit Institute of Arts

German Drawings and Watercolors

Including Austrian and Swiss Works

Horst Uhr

Hudson Hills Press, New York

In Association with the Founders Society
Detroit Institute of Arts

First Edition

© 1987 by the Founders Society Detroit Institute of Arts

Distributed in the United States, its territories and
possessions, Mexico, and Central and South America
by Rizzoli International Publications, Inc.
Distributed in Canada by Irwin Publishing, Inc.
Distributed in the United Kingdom, Eire, Europe,
Israel, and the Middle East by Phaidon Press Limited.
Distributed in Australia by Bookwise International.
Distributed in Japan by Yohan (Western Publications
Distribution Agency).

For Hudson Hills Press
Editor and Publisher: Paul Anbinder

For the Founders Society Detroit Institute of Arts
Director of Publications: Julia Henshaw
Assistant Editor: Cynthia Jo Fogliatti

Designer: Michael Glass Design
Composition: AnzoGraphics Computer Typographers
Manufactured in Japan by Toppan Printing Company

Support for this publication was provided by the
National Endowment for the Arts, the Ford Founda-
tion, and Founders Society Detroit Institute of Arts

Library of Congress Cataloguing-in-Publication Data

Detroit Institute of Arts.
 German drawings and watercolors, including Aus-
trian and Swiss works.

 (The Collections of the Detroit Institute of Arts)
 Bibliography: p. 278
 Includes index.
 1. Drawing, German—Catalogues. 2. Drawing—
Michigan—Detroit—Catalogues. 3. Watercolor
painting, German—Catalogues. 4. Watercolor
painting—Michigan—Detroit—Catalogues.
5. Detroit Institute of Arts—Catalogues. I. Uhr,
Horst, 1934– II. Founders Society. III. Title.
IV. Series: Detroit Institute of Arts. Collections of the
Detroit Institute of Arts.
NC249.D38 1987 741.943′074′017434 87-3000

ISBN 0-933920-83-0 (alk. paper)

Table of Contents

List of Color Plates

Foreword

The Detroit Institute of Arts has recently concluded its centennial celebration – 100 years of growth, characterized by the generosity and support of many, that has resulted in a permanent collection of quality and variety. The most appropriate method of acknowledging such an achievement is to publish a series of detailed catalogues of the permanent collection. The first of these catalogues, *Flemish and German Paintings of the 17th Century* by Julius S. Held, was published in 1982, and highlights of the complete collection were most recently featured in *100 Masterworks from the Detroit Institute of Arts* in 1985. The present volume, which gives complete documentation for each German, Austrian, and Swiss drawing or watercolor, is the first of several planned to examine the museum's graphic arts collection.

Of those who contributed to the realization of this catalogue, we are most indebted to Dr. Horst Uhr, Professor of Art History at Wayne State University. He began the painstaking and thorough research for this catalogue in 1982 and has added considerable information and documentation to enrich our knowledge and understanding of these works. The resulting analysis of more than 150 drawings and watercolors is concise yet conveys a special interest and eloquent enthusiasm for each subject, using the tools of the art historian to make the works come alive. Thanks also are due to Dr. Peter Guenther, Professor of Art History at the University of Houston, who served as reader of the initial manuscript.

Many current and former staff members of the Detroit Institute of Arts assisted with various aspects of this catalogue. Deserving special recognition are Ellen Sharp, Curator of Graphic Arts, and her staff: Christine Swenson, Associate Curator; Kathleen Erwin, Assistant Curator; Douglas Bulka, Senior Preparator; Diana Bulka, Preparator; Thomas Salas, Assistant to the Preparators; and Dianne Johnston, Secretary; as well as Marilyn F. Symmes, former Associate Curator; and Michael Jackson, former Assistant to the Preparators. The very important examination and conservation of each work included in this catalogue was accomplished by Barbara Heller, Chief Conservator; Valerie Baas, Paper Conservator; Nancy Harris, former Paper Conservator; and Jerri R. Nelson, former Andrew Mellon Foundation Fellow.

The initial editing of the manuscript was performed by Sheila Schwartz. Final editing of the manuscript and production coordination with the publisher were supervised by Julia Henshaw, Director of Publications, who was aided by Cynthia Jo Fogliatti, Assistant Editor, A. D. Miller, Editorial Assistant, and Opal D. Suddeth-Hodge, Secretary. Photography of the works was deftly handled by Dirk Bakker, Director of Photography, who was assisted by Robert Hensleigh, Associate Director, Timothy Thayer and Marianne Letasi, Assistant Photographers, David Krieger, Darkroom Technician, and Gloria Parker, Photo Services Assistant.

Through the efforts of Donald Jones, Assistant Director of Development, Mary Piper, Grants Coordinator, and Janet McDougal, former Development Coordinator, the museum was fortunate to receive substantial grants for the research and publication of this and future permanent collections catalogues. We are greatly indebted to the National Endowment for the Arts and to the Ford Foundation, for without their encouragement and generous support, this catalogue would not have been possible.

Great appreciation is due also to Michael Glass and the staff of Michael Glass Design, Chicago, for the elegance and beauty of this catalogue. We are also grateful to Paul Anbinder, President of Hudson Hills Press, Inc., New York, for his commitment to this project.

Samuel Sachs II
Director
The Detroit Institute of Arts

Introduction

In 1885, the first two acquisitions for the newly founded Detroit Museum of Art were two old master drawings, each related to the Sistine chapel, presented by James E. Scripps (1835–1906), founder and publisher of the *Detroit Evening News*.[1] *The Sacrifice at Lystra* (1885.1) pertains to Raphael's design for the chapel's tapestry series and *Study of a Seated Man* (1885.2) was attributed to Michelangelo due to its resemblance to the prophet Isaiah on the Sistine ceiling. Neither drawing's attribution has withstood scrutiny by twentieth-century scholars, as our knowledge of sixteenth-century draftsmanship has widened and defined more artistic personalities. Whereas collectors of earlier centuries, with what seems like undue optimism, attributed many drawings to the greatest masters of the High Renaissance, today we are more circumspect.[2]

Scripps, like many drawing collectors of his era, was not a connoisseur in distinguishing artists' hands. He understood the importance of the graphic arts, however, and his gift reflected his conviction that in any great museum, such as the one he envisioned for the city of Detroit, there should be a substantial collection of prints and drawings. In 1894 he gave to the museum an additional 23 drawings, and in 1909, three years after his death, his widow gave 1200 prints and 123 drawings, a major portion of his remaining collection.[3] Thus, the Scripps collection became the foundation of the museum's current graphic arts collection as his paintings were for the European art collection.

For nearly a decade after Mrs. Scripps's generous gift, there were few acquisitions in the area of drawings. However, in 1926 Detroit was fortunate to acquire a major drawing by Michelangelo, a sheet of studies for the Sistine ceiling.[4] This purchase, an impressive coup, was yet another in a great series of acquisitions being made in many different areas by Wilhelm R. Valentiner (1880-1958), who had been appointed director of the Institute in 1924 after serving as consultant to the Detroit museum since 1921.

In 1905-07, as a young art historian working in Amsterdam and Berlin with such renowned scholars as Cornelis Hofstede de Groot and Wilhelm von Bode, Valentiner devoted most of his time to the study and cataloguing of Dutch and Flemish painting of the seventeenth century. In 1908, Valentiner went to New York, where he was appointed Curator of Decorative Arts at the Metropolitan Museum of Art. With the outbreak of war in 1914 and his enlistment in the German army, Valentiner became acquainted with contemporary art in Germany through Franz Marc, with whom he served in officers' training school.[5]

After the war, when Valentiner joined the Council for Intellectual Workers, he was brought into contact with many other of the leading avant-garde artists in Germany. Among the painters who belonged to the Council were the *Die Brücke* artists Erich Heckel, Emil Nolde, Otto Mueller, Max Pechstein, and Karl Schmidt-Rottluff, as well as graphic artists Ludwig Meidner and Käthe Kollwitz and the sculptors Georg Kolbe, Richard Scheibe, Gerhard Marcks, and Wilhelm Lehmbruck. Valentiner began to write about these artists, developed several lasting friendships among them, and acquired their work for his own collection.

Upon his return to the United States in 1921, Valentiner was appointed art advisor to the Detroit Institute of Arts. He was also asked, by the Anderson Galleries of New York, to organize an exhibition of modern German art, which opened in October of 1923, and served to introduce the work of the German Expressionists to American viewers. After he became director of the Detroit museum in 1924, Valentiner presented over a dozen exhibitions of modern German painting, sculpture, drawing, and watercolor by artists such as Christian Rohlfs, Paul Klee, Lovis Corinth, Ernst Ludwig Kirchner, Lyonel Feininger, Carl Hofer, and Gerhard Marcks.

In the summer of 1934, with letters of credit totaling $4,000, Valentiner traveled to Europe and purchased 69 drawings ranging from the sixteenth to the nineteenth centuries, many by the most celebrated artists of the Italian, French, Dutch, and Flemish schools.[6] However significant these

additions were to the drawing collection, it was not through actual purchase for the museum that Valentiner was to make his greatest contribution. Valentiner often bought works for his own collection from the exhibitions of contemporary German art he organized. More importantly, he encouraged local collectors to do the same or to donate works to the museum. Drawings by sculptors Kolbe (nos. 61–63), Scheibe (nos. 129, 130), and Marcks (nos. 79–96) now in the Detroit collection were gifts from the Friends of Modern Art in 1935. The museum also was fortunate to acquire four watercolors by Rohlfs (nos. 121, 123, 124, 125) given by Lillian Henkel Haass and Walter F. Haass and another given by C. Edmund Delbos (no.122). A fifth watercolor by this artist (no. 127) was donated by John S. Newberry in 1959 in memory of Valentiner, while the sixth (no. 126) was purchased by Robert H. Tannahill and came to the museum as part of his 1970 bequest.

The interest of such local collectors as Mrs. Allan Shelden, Dr. and Mrs. George Kamperman, Ralph Harman Booth, Robert H. Tannahill, and his friend John S. Newberry in the work of the German Expressionists was due entirely to the influence of Wilhelm R. Valentiner. Ultimately it was Tannahill and Newberry who, through their bequests containing over 100 superb examples of twentieth-century German drawings and watercolors, became the two donors most responsible for the handsome and important group of works that today are the strength of the Detroit collection.

A member of the Arts Commission from 1932 to 1962 (and its president in 1962), Robert H. Tannahill was Honorary Curator of American Art from 1929 until his death in 1970. In the early years of Valentiner's directorship the two men formed an enduring friendship and often traveled to Europe together to buy works for the museum and for Tannahill's collection. Tannahill once said that in the decade of the 1930s, other collectors in Detroit often accompanied Valentiner to Germany and purchased drawings and watercolors there, especially from the Galerie Günther Franke in Munich. Sources in this country for their acquisitions, also recommended by Valentiner, were the Buchholz Gallery (Curt Valentin Gallery) and J. B. Neumann in New York.

Tannahill was also the originator and guiding force behind the exhibition program in the gallery of the Society of Arts and Crafts in Detroit. In the 1930s and 1940s, he arranged exhibitions of modern German art to coincide with and complement those being held at the Detroit Institute of Arts. For example, in 1935 the Society presented an exhibition of contemporary European sculpture, including works by Barlach, Lehmbruck, Marcks, and Scheibe, which was held in the same month as the museum's exhibition of drawings by those artists. In 1936 the Society held an exhibition of paintings and watercolors by Schmidt-Rottluff, in 1937 an exhibition of contemporary German paintings from Detroit collections. Another 1937 exhibition, inspired by the "Degenerate Art" exhibition held in Munich earlier that year and seen by Tannahill and Valentiner, gave the "public in Detroit the chance to judge whether or not these artists [were] representative of the truly modern spirit" or were indeed degenerate.[7] Tannahill lent Schmidt-Rottluff's *Blossoming Trees* (no. 131) to the exhibition, and works such as Kirchner's *Mountain Lake* (no. 59), Mueller's *Two Bathers* (no. 97), Nolde's *Reflections* (no. 108), and Rohlfs's *Sunflowers* (no. 126) were probably also on loan from the Tannahill and Newberry collections. In 1940 Tannahill purchased *Open-Air Sport* (no. 146) from an exhibition of paintings and watercolors by Paul Klee.

John S. Newberry served under Valentiner as Honorary Curator of Graphic Arts and Curator of Alger House (formerly a branch museum of the Detroit Institute of Arts located in Grosse Pointe) from 1938 to 1941, when he resigned to enlist in the Armed Forces. After the war, in 1946, during the directorship of Edgar Richardson, he was appointed Curator of Graphic Arts and remained in that capacity until he moved to NewYork in 1957. He died unexpectedly in Paris in 1964.

The Tannahill and Newberry collections complemented each other in many ways. Both included works by Schmidt-Rottluff, such as *Quinces* (no. 133) and *Water Lilies* (no. 135), as well as self-portraits and other watercolors by Nolde. Tannahill anticipated this and, not long before his death, mentioned to this author how resplendent the Detroit collection would be when his Noldes were added to those in the Newberry bequest. However, these and other works acquired in the Valentiner era were largely from the 1930s, the mature years of the German Expressionist artists. In recent years the Department of Graphic Arts has been able to purchase a few significant drawings to fill gaps in the collection, including *The Art Student (Herbert Schönbohm)* (no. 42) by Corinth and *Smoker and Dancer* (no. 55) by Kirchner. The latter drawing is one of a few works in the collection from the *Die Brücke* period (1905-13). The acquisition of Max Kaus's watercolor *Portrait of the Artist's Wife* (no. 54) and Max Klinger's *Standing Female Nude* (no. 60) added works by artists not previously represented in the collection. Two interesting drawings by artists of the Vienna Secession, *Sleeping Boy* (no. 139) by Gustav Klimt and *Dancer III* (no. 140) by Kolomon Moser, were the first of this important twentieth-century art movement to enter our collection. The rococo drawing *Saint Bernard of Clairvaux* (no. 9) by Johann Wolfgang Baumgartner was a significant and handsome addition, as was the nineteenth-century *Portrait of a Man* (no. 18) by Adolf Menzel. We hope with future acquisitions to strengthen the collection in such areas as works by members of *Der Blaue Reiter*, particularly Franz Marc and Wassily Kandinsky, and the early works of *Die Brücke* artists.

The first publication on the Detroit drawing collection was a catalogue by Ernst Scheyer (1900-1985) in 1936, *Drawings and Miniatures from the XII. to the XX. Century,*[8] which was issued in connection with an exhibition that Valentiner planned as a showcase for the drawings acquired during his European trip in 1934. Scheyer had worked at the Art Academy in Breslau, which he left in 1933 due to the political atmosphere in Europe, and subsequently worked for a few years in Amsterdam. In 1936, Valentiner brought him to the Detroit Institute of Arts as a Research Fellow. He was soon asked to join the faculty of Wayne State University, where he taught one of the first art history courses in the United States on the subject of twentieth-century German art. In 1950, the museum was able to acquire from his collection a rare portrait study by the nineteenth-century artist Carl Philipp Fohr (no. 15).

The university courses that Scheyer initiated have been continued in the last two decades by one of his former students, Horst Uhr. Dr. Uhr, presently Professor of Art History at Wayne State University, has taken a keen interest in the graphic arts collection. Uhr, a versatile scholar who has already published *Masterpieces of German Expressionism at the Detroit Institute of Arts,*[9] is admirably suited to the task of cataloguing drawings that range from the sixteenth through the twentieth centuries. For this catalogue he has evaluated the opinions of other scholars as well as provided many useful new insights and has come to sound conclusions about the authorship, style, dating, iconography, and technique for both well-known and more obscure works.

We are very pleased to publish such thorough art historical research in *German Drawings and Watercolors Including Austrian and Swiss Works*, the first in a series of volumes that will fully document our collection of European and American drawings and watercolors.

Ellen Sharp
Curator of Graphic Arts
The Detroit Institute of Arts

Notes

1.
See Lugt Suppl. 2357a for information regarding the Scripps collector's mark.

2.
For a future volume including sixteenth-century Italian drawings in the collection, Graham Smith, Professor of Art History at the University of Michigan, has catalogued *Sacrifice at Lystra* as a copy after Raphael and *Study of a Seated Man* as in the circle of Bartolommeo Passarotti.

3.
Scripps must have purchased the drawings given in 1885 and 1894 with the museum's collection in mind, as they were presented in the same years that he acquired them at the August Grahl sale at Sotheby, Wilkinson and Hodge, London, April 27 and 28, 1885, and at the J. J. Peoli sale, American Art Galleries, New York, May 8-12, 1894 (see Lugt 1199 and 2020). Scripps acquired the majority of the drawings in his collection from the Peoli sale.

4.
The Michelangelo drawing (1927.2) was acquired from the sale of drawings from the collection of Emile Wauters (see Lugt Suppl. 911) at Frederik Muller and Co., Amsterdam, June 15-16, 1926.

5.
Valentiner wrote in his diary:

> During the officers' training course I became friends with a painter who already occupied an important place in the world of modern art movements, although I did not know it. He was the Munich artist Franz Marc, a leader of German Expressionism, who, unfortunately was killed only a few weeks after we finished our officers' training. I found a chance to ask about these artistic endeavors in Germany, the subject of an impassioned conflict for sometime before the war. Because of my professional activity in America in the years preceding the war, I had had almost no contact with German artists. Thus I had never seen any paintings by Marc or by his friend August Macke, whose death at the beginning of the war had deeply distressed Marc (Margaret Sterne, *The Passionate Eye: The Life of William R. Valentiner* [Detroit: Wayne State University Press, 1980], p. 115).

6.
Ibid., pp. 249-250. A list of the drawings and the price paid for each is given. Many of the drawings have since been reattributed to other hands. There were, however, remarkable acquisitions in this group.

7.
Arts and Crafts in Detroit, 1906-1976: The Movement, the Society, the School (Detroit: The Detroit Institute of Arts, 1976–77), p. 168. The exhibition was held at the Detroit Institute of Arts from November 26, 1976, to January 16, 1977.

8.
A copy of this catalogue is on file in the Department of Graphic Arts and is annotated with Scheyer's later reattributions.

9.
New York: Hudson Hills Press, 1982.

Author's Acknowledgments

Of the individuals who supported me in the preparation of this catalogue, my thanks are due, above all, to the members of the Detroit Institute of Arts' Department of Graphic Arts. My gratitude goes foremost to Ellen Sharp, Curator, for asking me to undertake the project, but also to Christine Swenson, Associate Curator, Kathleen Erwin, Assistant Curator, and former Associate Curator Marilyn Symmes, who provided a pleasant ambiance in which to work and willing assistance when needed. Many colleagues at various institutions took time in answering my questions. They include Fedja Anzelewsky, Staatliche Museen, Berlin; Heinrich Fuchs, Städtische Kunsthalle, Mannheim; Dieter Gleisberg, Museum der bildenden Künste, Leipzig; Gode Krämer, Kunstsammlungen, Augsburg; John Rowlands, The British Museum; Martina Rudloff, Gerhard Marcks-Stiftung, Bremen; Rainer Schoch, Germanisches Nationalmuseum, Nuremberg; Alice Strobl, Albertina; and Paul Vogt, Museum Folkswang. I also extend my appreciation to the staff of the Research Library of the Detroit Institute of Arts and to the staff of the library of the Kunsthistorisches Institut, Munich. Sheila Schwartz, of the Whitney Museum of American Art, New York, and Julia Henshaw and Cynthia Jo Fogliatti, Director and Assistant Editor of Publications at the Detroit Institute of Arts, made useful editorial suggestions and carefully checked the galleys and the bibliography. I fondly remember Ernst Scheyer, who took a keen interest in this catalogue and in an unfailingly gracious manner responded to my inquiries. To Edwin Hall, whose sound counsel and constructive criticism sustained me throughout my work, I owe a very special debt of gratitude.

Horst Uhr
Detroit, January 1987

Notes to the Catalogue

SEQUENCE

Within the categories of German, Austrian, and Swiss works, the catalogue entries are arranged chronologically by century and then alphabetically by the artist's surname. When two or more works by the same artist are listed, they are given in chronological order.

ATTRIBUTION

Works either signed or considered to be autograph are designated by the artist's name. If a reasonable doubt exists concerning the authorship of a work, the term "attributed to" has been used. The following terms are defined to clarify an artist's contribution to works not believed to be autograph:

"Circle of": the drawing is the work of an unidentified artist who is stylistically related to the master, possibly trained or directly influenced by him, and proximate in time and place.

"Copy after": the drawing is a copy by an unidentified artist of a known or suspected original by the master but not produced in his studio; a copy may range in date from a work contemporary with the original to a modern version.

MEDIUM AND CONDITION

Although most terms used in the description of media and condition are self-explanatory, a few require clarification. The terms *graphite* and *graphite pencil* are used in this catalogue to distinguish methods and techniques of application rather than elemental differences. Graphite refers to the use of the material in lump or stick form, producing lines of variable thickness. Graphite pencils are fabricated by mixing powdered graphite with clay, and occasionally other materials, forming the mixture into rods, and mounting the rods in hollow wooden sheaths. Graphite pencils produce a thinner, more consistent line than graphite in its pure form. The medium of graphite, whether natural or synthetic, in stick or pencil form, is a grayish black, semi-crystalline, flaky, and greasy material that, when applied to paper, has a characteristic metallic sheen.

The term *lightstruck* has been used specifically when changes in color are the result of exposure to light as opposed to discoloration from acidic materials such as a window mat.

White lead discoloration or blackening is a chemical change that occurs when the medium (basic lead carbonate) is exposed to sulphuretted hydrogen gas present in the atmosphere and is converted to black sulphide. The chemical process generally may be reversed with simple treatment.

DIMENSIONS

Maximum sheet dimensions have been given for all works, height preceding width. Measurements were taken at the time each drawing or watercolor was examined by Detroit Institute of Arts conservators.

CONSERVATION

Condition reports were prepared by Valerie Baas, Paper Conservator, with the exception of Johann Heinrich Roos's *Italian Landscape with Cattle* (no. 7) by Nancy Harris, former Paper Conservator, and Kolomon Moser's *Dancer III* (no. 140) by Jerri R. Nelson, former Andrew Mellon Foundation Fellow.

PROVENANCE

The history of each work has been traced as completely as possible. Dealers have been so designated to distinguish them from collectors, although in some cases the two categories overlap and it was not possible to determine whether a work was in a dealer's private collection. References to collector's marks, estate stamps, etc., in Lugt (see bibliography) are given as L. or L. Suppl. In the case of sales, the owner's name, if known, precedes the place and date of the sale.

EXHIBITIONS AND REFERENCES

All known exhibition and bibliographical information has been included, with the exception of references to illustrations that convey no information about a work (such as in annual reports, picture books, etc., published by the Detroit Institute of Arts and others).

Within the entries, exhibition and bibliographical references are indicated by a short form consisting of the city and date of exhibition for the former and the author's name and date of publication for the latter. Complete citations may be found in the bibliography.

ACCESSION NUMBERS

In this catalogue the full year of acquisition is given in each accession number even though the first two digits of the year of acquisition were not used in accession numbers prior to 1983, when it became necessary to distinguish between works acquired beginning in 1883 and those acquired in 1983 and later years. For this reason acquisitions made before 1983 are listed in the Curatorial Files and in the DARIS program with the first two digits of the year omitted, e.g., 1970.319 is listed as 70.319.

15th-, 16th-, and 17th-century German Drawings

Hans Baldung Grien

1484/85 Schwäbisch-Gmünd – Strasbourg 1545

1.

Christ on the Cross (recto)
Studies of Heads and a Standing Figure
(verso), ca. 1505–07

Pen and brown ink (recto), pen and brown and black ink (verso), on cream laid paper; 289 x 203 mm

ANNOTATION: Indecipherable fragment of name or word in pen and brown ink on recto at left near Christ's side

CONDITION: Surface grime; uneven staining; upper corners and sections of right and left edges replaced; repaired tear at top

PROVENANCE: P & D Colnaghi & Co., Ltd.

EXHIBITION: London 1950

REFERENCES: London 1950, no. 1, frontispiece (as Hans Baldung Grien); Newberry 1950–51, pp. 59–60, ill. (as Hans Baldung Grien)

Founders Society Purchase, Charles L. Freer Fund (1950.73)

When this drawing was exhibited at Colnaghi's in 1950, it was attributed to Hans Baldung Grien on the basis of what were perceived to be stylistic affinities to Baldung's drawing *Man of Sorrows Worshipped by Christoph Scheurl* (ca. 1505, Museum of Fine Arts, Budapest; Koch 1941, no. 5). Newberry saw further similarities in both technique and pose between the drawing and a sketch with four studies of *Christ on the Cross* in the Louvre, attributed to Baldung by Paul Wescher (1936, p. 70, pl. 69) and tentatively dated ca. 1508–09. Neither comparison is convincing. The Detroit work lacks the complex system of hatchings and crosshatchings of the drawings Baldung executed in Nuremberg during 1504 and 1505 while he was a member of Dürer's workshop. Nor does it share the energy of the markedly elongated forms of the Louvre sketch. The parallel curved hatchings are more closely related to the formal language of Baldung's early woodcuts, recalling in particular some of his contributions to the cycles *Der Beschlossen Gart des Rosenkranz Mariae* and *Speculum passionis domini nostri Ihesu christi* (Bartsch 34.26 and 34.2; there attributed to Hans Schäufelein), collaborative projects undertaken in Dürer's shop and published by Ulrich Pinder in Nuremberg in 1505 and 1507, respectively. In a general way reminiscent of the linear conventions of these works, the modeling of the Detroit *Christ on the Cross* falls short, however, of the expressive vigor that is possibly the most characteristic feature of Baldung's draftsmanship. This lack of graphic animation is partly due to the ink that has been used to reinforce lighter lines throughout the drawing. In areas of denser modeling, details such as the windswept end of Christ's loincloth and the position of the left leg have been rendered inarticulate or spatially obscure. While these reinforcements may be later additions, the original lines themselves convey little of Baldung's usual emotive force. Indeed, in view of the lack of linear energy throughout the drawing, the attribution to this artist is difficult to defend. Rather, the Detroit work seems to be a copy of a lost drawing by Baldung, done—as the random trial hatchings on both the recto and the verso suggest—with the aim of emulating his modeling technique. The lost prototype may have been related to Baldung's woodcuts from the years 1505 to 1507, or possibly it was inspired by Dürer's 1505 pen-and-brush drawing *Christ on the Cross* in the Albertina (Strauss 1974, no. 1505/12), formerly attributed to Baldung (Tietze and Tietze-Conrat 1928–36, T. A176). In fact, the drawing in Detroit and the one in the Albertina share not only compositional format but also pose and general conception, further suggesting that the original source may be sought among the drawings made in Nuremberg between 1505 and 1507.

Except for similar, possibly later, reinforcements, the studies on the verso seem to be contemporary with *Christ on the Cross*. They, too, point to a connection with Dürer's shop. The head of the obese man in the lower right, for instance, recalls a familiar Dürer type and appears to have been copied from his woodcut *Christ before the People* (Bartsch 9), datable to the years between 1497 and 1500 although not published as part of the *Large Passion* until 1511. The modeling of the turbaned head and fragmentary image of the bearded male face follows once again Baldung's method of defining form by means of rhythmically animated parallel lines. However, in comparison to such drawings as the Baldung study sheet dated ca. 1505–07 in the Louvre, which features a head of Christ (recto) and five physiognomic studies (verso; Koch 1941, nos. 16–17), this example seems labored and fails to achieve Baldung's level of expression.

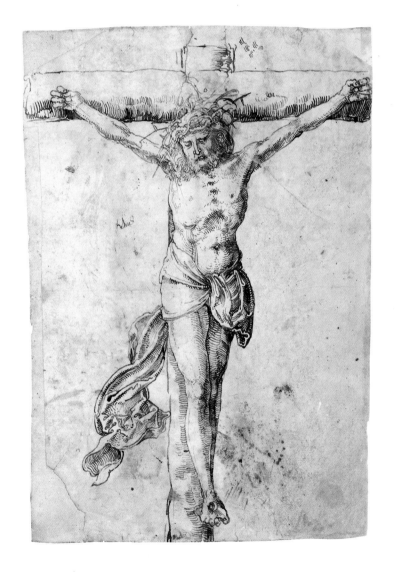

Albrecht Dürer

1471 Nuremberg 1528

2.

Recumbent Lion, ca. 1494/95

Plate I

Brush and brown ink over faint black chalk with touches of pink watercolor and blue black pigment on discolored laid paper; 124 x 174 mm

CONDITION: Abrasion; repaired tear at top edge

PROVENANCE: E. and A. Silberman, New York

EXHIBITION: Detroit 1960a (as Lorenzo Costa [?])

REFERENCES: Wescher 1950, pp. 156–160, fig. 1; Panofsky 1955, p. 299; Winkler 1957, p. 47, fig. 15; Detroit 1960a, p. 15, no. 19 (as Lorenzo Costa [?]); Winkler 1965, p. 80, fig. 31; Anzelewsky 1971, p. 122; Strauss 1974, no. 1494/18 (as *Lion in Repose, Facing Left*)

Gift of A. Silberman (1934.158)

Originally thought to be a work by Lorenzo Costa, the drawing was attributed to Dürer by Wescher, who believed that it was executed during the artist's first stay in Venice, between the autumn of 1494 and the spring of 1495. Calling attention to the animal's expressive, elongated head, Wescher pointed to similar formal conventions in the lion heads of Dürer's *Rape of Europa* (Strauss 1974, no. 1494/16), the well-known composition study from Venice in the Albertina, and in the lion of the small gouache of 1494 in the Kunsthalle Hamburg (Strauss 1974, no. 1494/17). Panofsky, questioning the attribution, considered the drawing to be a free copy of the lion in Dürer's engraving *Saint Jerome Penitent in the Wilderness* (ca. 1496; Bartsch 61), to which the Detroit lion indeed bears a most striking resemblance in both posture and expression. Wescher's attribution and date have been accepted by Winkler, Anzelewsky, and Strauss. Winkler, in addition, suggested that the head of the lion was subsequently used for the beast with the lamb's horns in Dürer's woodcut (Bartsch 74) from the *Apocalypse*, published in 1498, and pointed to the similarity between the drawing and an anonymous early sixteenth-century Italian engraving, tentatively identified as a copy after Dürer (Hind 1938–48, 7: pl. 885, 2). Winkler also saw a relationship between the Detroit drawing and the lion in Dürer's engraving *Sol Justitiae* (ca. 1499; Bartsch 79), as well as the preliminary drawing for this print in the Kupferstichkabinett, Dresden (Strauss 1974, no. 1498/4).

Taking note of the marked discrepancy between the observed and imagined features of Dürer's lions, scholarly opinion has differed as to whether the animals were drawn from life or copied from sculpture, such as the Leoncini near Saint Mark's in Venice. Wescher believed that the Detroit example was done from lions kept in captivity, and he attributed the animal's forced physiognomic expression to a tradition, traceable in classical and medieval sources, by which analogies were drawn between the physiognomy and behavior of certain animal types and human character and virtues. Arguing that Dürer was heir to this tradition, Wescher saw a parallel between the expressive face of the Detroit lion (now somewhat exaggerated by touches of ink added in a different hand to reinforce the pupils) and Dürer's efforts to chart human character in his contemporary portraits. Anzelewsky, too, assumed that the Detroit lion was done from life and that the same model was used for the Albertina and Hamburg drawings, as well as for the lion in the small painting of a *Penitent Saint Jerome* (ca. 1497–98) in the collection of Sir Edmund Bacon, Norwich, Norfolk (on loan to the Fitzwilliam Museum, Cambridge; Anzelewsky 1971, pp. 14–15, no. 14, figs. 12, 13).

It is uncertain to what extent live lions were available in Venice; whatever firsthand knowledge Dürer had of the rare animal seems, at the time, to have been rather minimal. Its treatment in the Detroit drawing and in the other works cited is fundamentally heraldic in approach and differs sharply from the verisimilitude of such contemporary, meticulously rendered animal studies as the drawings of heads of deer in the Bibliothèque Nationale, Paris (Strauss 1974, no. 1495/45), and in the Musée Bonnat, Bayonne (Strauss 1974, no. 1495/47), or of the lobster in the Kupferstichkabinett, Berlin (Strauss 1974, no. 1495/21). Considering Dürer's curiosity about nature, which during these years also gave rise to remarkably detailed plant studies and to his earliest topographical landscapes, the lion in the Detroit drawing seems indebted more to another work of art rather than to life. Indeed, Dürer may have had no occasion to study lions in captivity until 1520, when he first visited Brussels. Remaining in that city from August 27 to September 2, he noted in his diary that he had seen the royal zoological garden there (Rupprich 1956–69, 1:155). During a return visit between July 3 and 11 of the following year, he apparently went to the zoological garden a second time, making several silverpoint sketches of a reclining lion (Kupferstichkabinett, Berlin: Strauss 1974, no. 1521/11–12; and Albertina: Strauss 1974 no. 1521/13) that capture convincingly both the appearance and the character of the animal.

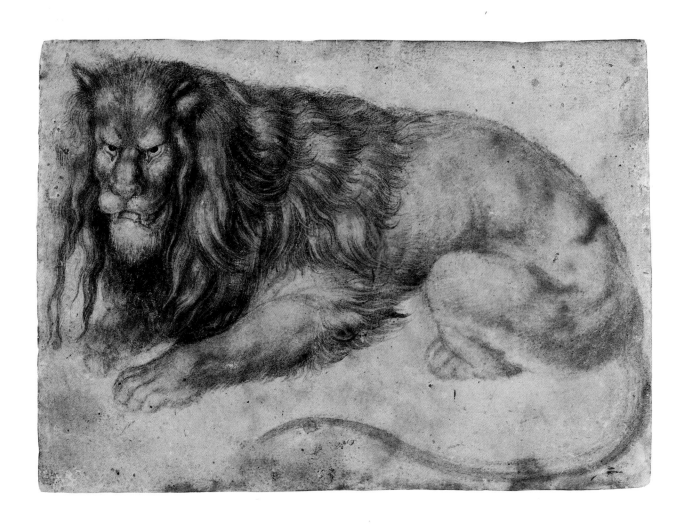

Copy after
Albrecht Dürer
1471 Nuremberg 1528

3.

Draftsman with the Lute, after 1525

Pen and brown ink on discolored laid paper;
149 x 190 mm

ANNOTATIONS: Dürer's monogram in pen and black ink on recto at lower center; on recto in upper left corner, *82*; red stamp on verso at lower center, *W.K. & Co.*; on paper support at bottom edge, *W.O.Ko.*, annotated in pen and black ink to the right, *1261*

CONDITION: Corrosive ink has caused the sheet to break into fragments along the lines of the design. Numerous losses; lined with another sheet

PROVENANCE: John P. Heseltine, London (black collector's mark [L. 1507] on verso at lower left); A. S. Drey, New York

EXHIBITION: According to the original bill from A. S. Drey, dated February 19, 1928 (Curatorial Files), the drawing was exhibited at Colnaghi's Art Gallery, London, and the Fogg Art Museum, Harvard University, Cambridge. Neither institution was able to confirm this information from existing records.

REFERENCES: Weadock 1928, p. 85, ill.; Scheyer 1936, no. 23, ill.; Panofsky 1948, 2: 159, no. 1709

Founders Society Purchase, William C. Yawkey Fund (1928.41)

The drawing was first published by Weadock as a preliminary study for Dürer's woodcut (Bartsch 147) from the fourth book of his treatise on measurement, *Underweysung der Messung mit dem Zirckel und Richtscheyt* (A Course in the Art of Measurement with Compass and Ruler, Nuremberg, 1525). The attribution has since been questioned by Panofsky, Strauss (letter, July 14, 1979; Curatorial Files), and Anzelewsky (letter to the author, March 27, 1981; Curatorial Files), all of whom consider the drawing to be a copy by an anonymous hand after the woodcut. Although the watermark is fragmentary and barely visible, the paper seems to be contemporary with Dürer's treatise. In order to have served as a study for the woodcut, the drawing would have to be reversed, as are other preparatory drawings for Dürer's prints. A notable exception is a sheet in the Sächsische Landesbibliothek, Dresden (Strauss 1974, no. 1525/11), showing two sketches of a draftsman drawing a vase with the help of a modified version of the perspective apparatus illustrated in the Detroit drawing. The more finished of these sketches served as a model for the woodcut (Bartsch 148) added in the second edition of Dürer's *Underweysung*, published in 1538. It is possible that the publisher, intending to enhance the authority of the posthumous edition, may have striven on purpose for an exceptional approximation of the illustration to Dürer's original drawing.

A drawing closely related to the one in Detroit is in the Kupferstichkabinett, Berlin (Bock 1921, p. 34, no. 68). Like the Detroit drawing, it is not a reversed image of the woodcut. It is slightly smaller (132 x 182 mm) and differs in a number of details. Except for the modeling of the two figures, the Berlin drawing bears no trace of any hatching or crosshatching, and the spatial dimensions of the workshop interior, the work table, and the perspective apparatus are indicated in clean lines drawn with a ruler. In a conspicuous departure from the woodcut, the dotted perspective image of the lute has been replaced by an empty frame traversed by two seemingly useless vertical lines. Although the authenticity of the Berlin drawing has long been questioned, Anzelewsky, in his forthcoming catalogue of the Dürer drawings in Berlin, attributes it to Dürer. His argument rests above all on the substitution of the empty frame for the dotted perspective image of the lute, a change he considers to be contrary to the practice of a mere copyist. By this departure, however, the Berlin drawing falls short of Dürer's goals in the very feature that forms the basis of the fourth book of his treatise on measurement and that the woodcut was intended to illustrate: the correct representation of objects in space through the application of the laws of perspective. Not only is the relationship of the standing figure to the spatial setting awkwardly rendered in the Berlin drawing, but the absence of the dotted foreshortened image of the lute makes the workings of the perspective mechanism virtually unintelligible. Given Dürer's habitual care and methodical approach, it is unlikely that he would have omitted such an essential detail.

Dürer had acquired his knowledge of the laws of perspective during his second trip to Italy (1505–07) and devoted the last years of his life to the task of imparting to his fellow artists in the North the theoretical foundation which he considered an indispensable underpinning for the artist's craft. As described in the *Underweysung*, Dürer's perspective system is much indebted to Italian theorists. It is based, fundamentally, on the Euclidean notion that objects are perceived by straight visual rays, converging on the eye as in the apex of a pyramid with

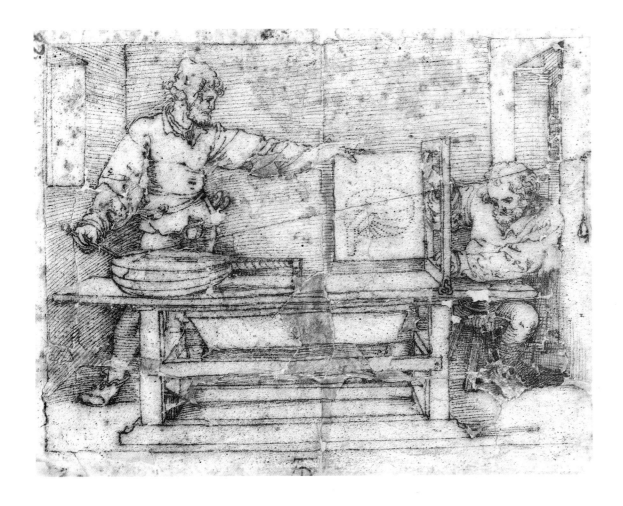

the object forming the base. In the fifteenth century this principle was seemingly first applied to the problem of graphic representation by Filippo Brunelleschi, who conceived of the Euclidean pyramid as being intersected by a plane between the object and the eye, thus projecting the image of the object on a flat surface. The first written description of this concept is found in Piero della Francesca's treatise *De prospectiva pingendi* (1484–87), where it is accompanied by instructions on how to draw a perspective image utilizing the geometric method of parallel projection.

Dürer's *Underweysung* was not intended as a treatise on mathematics, but as a book for practical use, and the composition in the Detroit drawing illustrates a device with which to achieve correct perspective rendering by mechanical means. Here a nail or hook or some similar object driven into a wall serves as the eye at the apex of the Euclidean pyramid, while a string, with a weight attached to one end and a stylus to the other, substitutes for straight visual rays. Between the eye of the hook and the object to be drawn is placed a frame within which two movable threads cross each other at right angles. As the string is placed on a certain point of the object, in this case the lute, the place where the string passes through the frame determines the location of the corresponding point on the future image. This point is fixed by adjusting the two movable threads in the frame and is then transferred to a piece of paper hinged to the frame. By repeating this process, the foreshortened image of the subject is gradually transmitted to the paper.

Albrecht Dürer
1471 Nuremberg 1528

4a.
Group of Soldiers, 1519 (?)

Pen and brown ink on cream laid paper;
197 x 149 mm

INSCRIPTION: Dated with pen and brown ink on
recto at lower left, *1519*

CONDITION: Solidly mounted to heavy paper; in-
scribed date altered from 1619 to 1519; examination
under ultraviolet light indicates lines of drawing
may have been reinforced; surface grime; discolora-
tion; some losses due to corrosive ink

PROVENANCE: John J. Peoli, New York (purple
collector's mark [L. 2020] on verso of paper support
at upper right); sale, American Art Galleries,
New York, 1894, no. 189; James E. Scripps, Detroit

REFERENCE: New York 1894, no. 189

Gift of Mrs. James E. Scripps (1909.1 S-Dr. 105.1)

4b.
The Betrayal of Christ, 1519 (?)

Pen and brown ink on cream laid paper;
190 x 150 mm

INSCRIPTION: Dated with pen and brown ink on
recto at lower left margin, *1519*

CONDITION: Solidly mounted to heavy paper; in-
scribed date altered from 1619 to 1519; examination
under ultraviolet light indicates lines of drawing
may have been reinforced; surface grime and stain-
ing in lower third of composition; some losses due to
corrosive ink

PROVENANCE: John J. Peoli, New York (purple
collector's mark [L. 2020] on verso of paper support
at lower right); sale, American Art Galleries,
New York, 1894, no. 189; James E. Scripps, Detroit

REFERENCE: New York 1894, no. 189

Gift of Mrs. James E. Scripps (1909.1 S-Dr. 105.2)

These drawings are detailed copies of two of a group
of five woodcuts executed by Dürer in 1510. The first
and third drawings depict the left- and right-hand
groups of soldiers guarding Christ's tomb in Dürer's
The Resurrection of Christ (Bartsch 15), while the
second drawing is a copy of *The Betrayal of Christ*
(Bartsch 7). The original five woodcuts, together with
seven earlier prints, form the cycle of the *Large Pas-
sion* published in Nuremberg in 1511. Stylistically,
the woodcuts of 1510 represent a high point in Dü-
rer's development following his second trip to Italy
in 1505–07. They are distinguished from his earlier
woodcuts by an unprecedented range of value con-
trasts, extending from bright highlights to deep
shadows. An intermediate tonal value is achieved in
these works through uniform parallel hatchings that
are applied even for the modeling of curved or irreg-
ular surfaces seen in half-light; these surfaces thus
share the value of the middle tone. Highlights result

from the blank areas of the paper, while deeper shad-
ows are obtained by hatchings of varying density
and by cross-hatchings.

The Detroit drawings seem to have been done
with the purpose of emulating and mastering
Dürer's innovative chiaroscuro woodcut technique.
For rather than copying each entire scene, the artist
has concentrated his efforts on those parts of the
compositions that display the widest possible value
contrasts. Ranging from the illuminated face of
Christ to Judas's hand clutching the bag of silver in
the shadow of his garment in *The Betrayal of Christ*,
the individual tonal values are obtained through a
careful imitation of Dürer's system of hatching.

It seems that the date of 1519 inscribed on the
drawings is an alteration from the original 1619. It is
impossible to confirm the accuracy of either date
without further information.

4c.
Group of Soldiers, 1519 (?)

Pen and brown ink on cream laid paper;
197 x 148 mm

INSCRIPTION: Dated with pen and brown ink on
recto near bottom center, *1519*

CONDITION: Solidly mounted to heavy paper; in-
scribed date altered from 1619 to 1519; examination
under ultraviolet light indicates lines of drawing
may have been reinforced; surface grime; some
losses due to corrosive ink

PROVENANCE: John J. Peoli, New York (purple
collector's mark [L. 2020] on verso of paper support
at lower right); sale, American Art Galleries,
New York, 1894, no. 187; James E. Scripps, Detroit

REFERENCE: New York 1894, no. 187

Gift of Mrs. James E. Scripps (1909.1 S-Dr. 105.3)

 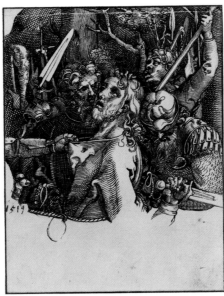 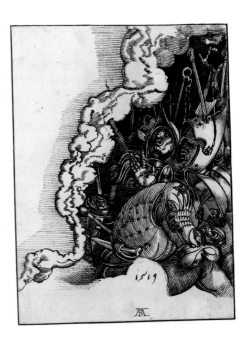

Melchior Feselen (Feselein)

ca. 1495 Nördlingen(?) – Ingolstadt 1538

5.
A Battle Scene, ca. 1529–33

Pen and brush and black ink on discolored laid paper; 313 x 308 mm

ANNOTATIONS: With dark brown ink on verso at upper left, combined initials *T* and *G* crossed by what may be a recumbent *Z*, with two smaller letters *X* suspended from the stem of the *T*. (This may be an old owner's identification of the same type as the unidentified collector's mark in L. Suppl. 2451b.)

WATERMARK: Possibly a high crown as in Briquet 5035 (1542)

CONDITION: Sheet joined at center; repaired tears upper edge; fold lines

PROVENANCE: F. A. C. Prestel, Frankfort (black collector's mark [L. 2730] on verso at lower left and upper right); Albertina, Vienna; Henry Oppenheimer, London; sale, Christie's, London, July 10, 13–14, 1936, no. 374; R. Langton Douglas, London

EXHIBITION: Montreal 1953

REFERENCES: Baldass in Thieme and Becker 11: 502; Meder 1922, p. 10, pl. 29 (as *The War before Venice*); Bock 1929, 1: 220; Montreal 1953, no. 105, ill.; Sutton 1979, pp. 35, 38, no. 2

Founders Society Purchase, William H. Murphy Fund (1940.54)

The attribution of this drawing rests upon stylistic similarities to Feselen's painting *The Siege of Alesia by Julius Caesar* of 1533 (Alte Pinakothek, Munich; Munich 1963, pp. 213–214, ill. p. 288), one of possibly three works he contributed to a series of biblical and ancient histories commissioned by Duke Wilhelm IV of Bavaria from a number of South German artists, including Albrecht Altdorfer, Jörg Breu the Elder, Hans Burgkmair, and several others. The drawing shares with the painting Feselen's toylike figures, as well as the compositional format and dual perspective—the cuirassiers and lansquenets in the foreground have been observed head on, while the distant battlefield is seen from an elevated position.

Iconographically, the drawing has only a typological connection with the Munich painting. It illustrates neither a biblical subject nor an episode from ancient history, but an early sixteenth-century event. Exactly which battle is shown cannot be determined, since the setting is entirely imaginary and offers no information as to a specific geographic location. What is certain, on the other hand, is that the drawing depicts an encounter between German Imperial forces and Venetian troops. The Venetians, who are seen in the process of being routed, are identified by flags bearing the lion of Saint Mark; the Germans display the various insignia of the Emperor Maximilian I. Emblazoned upon the foremost flags is the cross of Saint Andrew, patron saint of Burgundy, surrounded by the flints and steels from the collar of the Burgundian Order of the Golden Fleece, signifying the motto *Ante ferit quam micat* ("First strike, then shine"). The striped flags represent the colors of Hungary and Burgundy; the escutcheon of Austria adorns the roof of the small tent on the right. Considering Maximilian's ultimately ill-fated campaign against Venice, Feselen's drawing can logically illustrate only one of a number of encounters that took place between June 1 and 5, 1509. During this brief span of time, the emperor, as a member of the League of Cambrai, conquered in rapid succession several Venetian strongholds in northern Italy, including the cities of Verona and Padua, with the aim of ending Venetian power on the mainland.

Prototypes for Feselen's drawing are found among the many battle scenes of *Der Weisskunig*. This romanticized account of Maximilian's childhood, youth, and military exploits to the year 1513 had been dictated by the emperor to his private secretary, Marx Treitzsaurwein, and illustrated between 1514 and 1516 with 251 woodcuts by Hans Burgkmair, Leonhard Beck, and Hans Schäufelein, among others. The first complete edition of the biography was published in Augsburg in 1526. Feselen, who is generally believed to have been a pupil of Schäufelein, was most likely familiar with this work and may have been drawn to the subject of Maximilian's battles when, along with Burgkmair, he found himself in the service of Duke Wilhelm IV, painting historical scenes of a military nature. The densely packed throng of clashing armies in Feselen's drawing, moreover, suggests familiarity with the most famous of the histories painted for the duke, Albrecht Altdorfer's *Battle of Alexander* of 1529, now in Munich (Munich 1963, pp. 205–206, ill. p. 289). A reasonable date for the Detroit battle scene, therefore, seems to be the period between 1529, when Feselen finished his earliest surviving painting for the duke (*Porsenna Frees Cloelia and Other Women during the Siege of Rome*, Munich; Munich 1963, pp. 212–213, ill. p. 298), and the completion four years later of *The Siege of Alesia*.

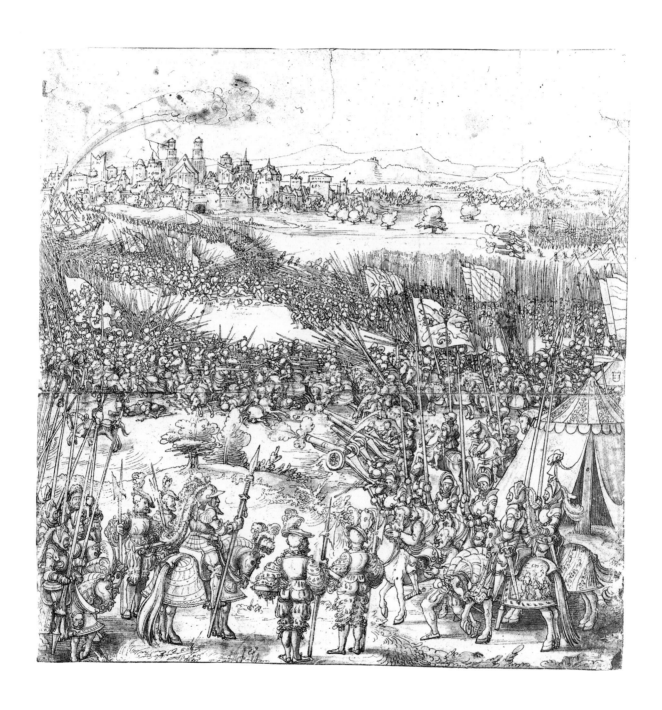

Circle of
Adam Elsheimer
1578 Frankfort on the Main – Rome 1610

6.
Diana and Callisto, ca. 1606–08

White lead gouache and black wash on laid paper; 186 x 178mm

CONDITION: White lead discoloration; small loss bottom edge; edges abraded

PROVENANCE: John J. Peoli, New York (purple collector's mark [L. 2020] on verso of paper support at lower left); sale, American Art Galleries, New York, 1894, no. 225; James E. Scripps, Detroit

REFERENCE: New York 1894, no. 225

Gift of Mrs. James E. Scripps (1909.1 S-Dr. 109)

The original attribution of this drawing to Adam Elsheimer is presumably based on stylistic similarities to other gouaches by him, in particular to his characteristic method of giving definition to the individual form by applying white pigment over a bluish black ground. In the Detroit drawing, layers of white have been superimposed upon shades of blue and black so that whatever is touched by light seems to become itself luminescent. This effect is reminiscent of that in Elsheimer's famous nocturnal subjects in oil. Both the individual figures and the terrain in *Diana and Callisto* acquire palpability as they emerge from the dark ground. In gouaches that have been attributed to Elsheimer with some assurance, the white pigments are applied over the underlying dark colors with a rather dry brush. Here, however, especially in the three female nudes in the foreground, they have been applied somewhat more heavily, with the result that the drawing falls short of Elsheimer's sensitive modeling and rich atmospheric effects. Gode Krämer recently doubted Elsheimer's authorship and suggested that the drawing might have been done at a date considerably further into the seventeenth century (letter to the author, October 8, 1981). The possibility, however, that the drawing originated in Elsheimer's workshop or that the white pigments were strengthened by a later hand cannot be excluded.

The drawing can be related to other Elsheimer works of female nudes in a landscape setting, such as *Venus and Cupid*, formerly in the F. Koenigs collection in Haarlem (Möhle 1966, no. 34), and *Bathsheba*, in Berlin (Möhle 1966, no. 35), both dated to around 1605. But in the Detroit sheet, the relationship of the figures to their surroundings is far less intimate, and the landscape itself is less poetic in mood. Iconographically, the drawing is related to such Ovidian subjects as *Apollo and Coronis* at Corsham Court, Corsham, Wiltshire, England, and the well-known *Mocking of Ceres* in the Prado, a painting on copper believed to have been executed by Elsheimer during the period from about 1606 to 1608 (Andrews 1977, nos. 21, 23, pls. 76, 82). The story is taken from Ovid's *Metamorphoses* (2: 457–465), a copy of which was listed among Elsheimer's possessions at the time of his death. Callisto, having been seduced by Jupiter, is fearful of joining Diana and her companions in a bath lest her unchastity be revealed. She is involuntarily disrobed by two attendants of the virgin goddess and her advanced stage of pregnancy disclosed. Diana, seated on the left and accompanied by several other attendants, banishes the unfortunate nymph from her presence.

The lack of integration of the figure group with the landscape behind may be partly explained by the fact that the friezelike arrangement of the principal characters has been taken from Titian's painting of the same subject of 1556 to 1569 (National Gallery of Scotland, Edinburgh; Wethey 1969–75, 3: no. 10, pl. 143), although the orientation of the composition has been reversed. The direct inspiration of the drawing was most likely Cornelis Cort's engraving of about 1566 after the contemporary workshop version of Titian's painting (Kunsthistorisches Museum, Vienna: Wethey 1969–75, 3: no. 11, pls. 154, 216). That the theme enjoyed a certain measure of popularity in Elsheimer's shop is evident from the existence of at least four drawings of the subject, all of which have been variously attributed to Elsheimer himself or to the Dutch engraver Hendrik Goudt (1573–1648), who from 1604 to 1610 may have been both Elsheimer's pupil and patron in Rome. They include two brush drawings in the Städelsches Kunstinstitut, Frankfort (Schilling and Schwarzweller 1973, nos. 240, 310), a pen-and-ink drawing in the British Museum (inv. 1897–4–10–11), and one at Christ Church, Oxford (Möhle 1966, G.73). Only one of the brush drawings in the Städelsches Kunstinstitut, Frankfort (Schilling and Schwarzweller 1973, no. 240), a free variation of the Detroit composition, is still considered to be by Elsheimer's own hand.

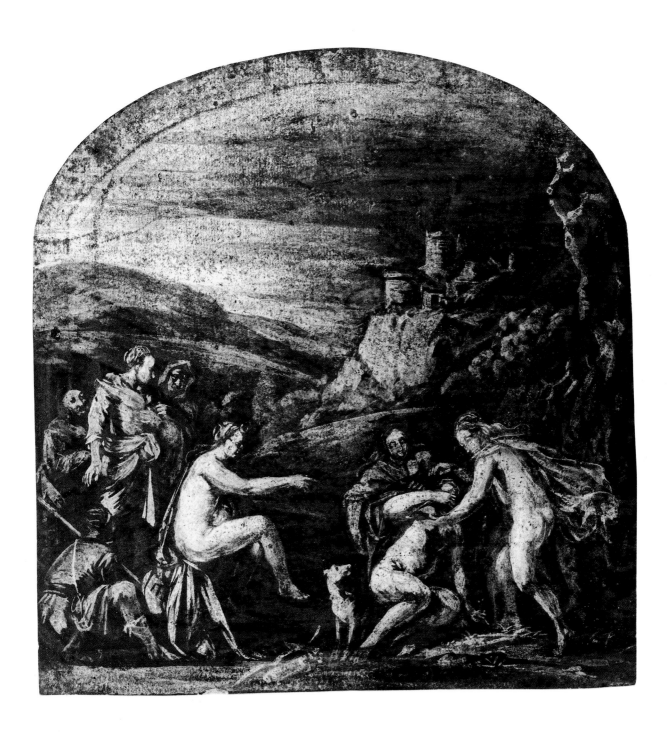

Johann Heinrich Roos

1631 Reipoltskirchen/Palatinate – Frankfort on the Main 1685

7.

Italian Landscape with Cattle,
ca. 1672–75

Pen and brown ink and gray wash over preliminary drawing in graphite on buff laid paper; 395 x 321 mm

ANNOTATION: In pencil on verso at upper right, *BeRCHeM*

WATERMARK: Grape cluster similar to Heawood 2101 and 2106 and to Briquet 13073

CONDITION: Foxing; repaired tears

EXHIBITION: Princeton et al. 1982

REFERENCES: *BDIA* 20 (1940): 47 (as Philipp Roos); Princeton 1982 et al., pp. 210–211, no. 83, ill.

Gift of David Garfinkel (1940.136)

The former attribution of this drawing to Philipp Roos (1657–1706) is presumably the result of mistaken identity. For although there is a thematic analogy to Philipp Roos's landscapes of the Roman Campagna, usually inhabited by shepherds and cattle, the Detroit sheet shows none of the artist's typically impetuous and far more simplified draftsmanship. Rather, it shares fully in both the sensitive observation of nature and meticulous execution that distinguish the drawing of Philipp Roos's father, the landscape and animal painter Johann Heinrich Roos.

The parallel pen strokes reinforcing the wash in the shaded areas of the landscape and the short curved lines employed in the modeling of the animals are typical of Roos's earliest pen-and-wash drawings of 1663, but the composition itself points to a somewhat later date. In a group of etchings begun in 1668, the problem of unifying the pictorial space has been solved in a similar way (Jedding 1955, nos. 16–27): animals, seen from up close, occupy the width of the foreground plane, while hills, brooks, paths, or architectural elements, usually laid out along the diagonal axis and enlivened with smaller figures, lead the eye into the far distance. The drawing is especially close to two pen-and-wash drawings now in the Albertina (Vienna 1926–41, 4 and 5: nos. 911, 912, ill.). They have been dated to the period ca. 1672–75 and, although somewhat smaller and done in a horizontal rather than vertical format, are akin to the Detroit drawing in general conception. The animals and human figures are relatively few in number, and the nostalgic mood of the landscape is reinforced by the presence of ancient ruins. The Albertina drawings evidently never served as preliminary studies for either paintings or prints, but were produced as entirely independent works of art. The self-contained composition suggests that the Detroit drawing was similarly conceived.

Roos's Italianate landscapes, many of which appear to have been inspired by the terrain of the Campagna, show the ruins of such Roman monuments as the Temple of Vespasian, Hadrian's Tomb, and the Ponte Molle. This has led to the assumption that Roos may have spent some time in Italy, possibly between 1651 and 1654. There is, however, no documentary evidence that such a journey ever took place. On the other hand, Roos is known to have studied in Amsterdam from 1647 to 1650, and it has been suggested that he may very well have adopted these Roman motifs from Dutch Italianate landscape painters, in whose works ancient ruins and other Roman monuments were fairly common features by 1650. It is believed that in addition to a possible contact with Karel Dujardin (1622–1678), Roos also knew Dujardin's reputed teacher, the Haarlem painter Nicolaes Berchem (1620–1683), or that he was at least familiar with Berchem's works. The annotation on the verso of the drawing was evidently made in recognition of thematic and formal analogies to Berchem's sunlit landscapes, in which ruins, animals, and human figures in the foreground plane are similarly contrasted with the open view of the distant countryside.

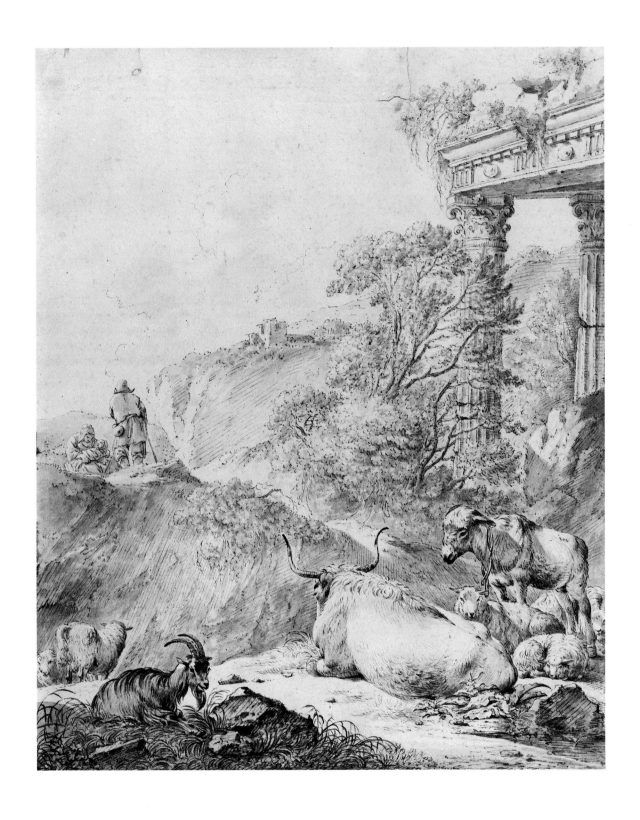

Copy after
Martin Schongauer
ca. 1450 Colmar – Breisach 1491

8.

Flight into Egypt

Pen and brown ink on discolored laid paper coated on verso with charcoal or black chalk;
257 x 182 mm

WATERMARK: Indecipherable

CONDITION: Small losses; horizontal crease. Impressed lines visible on both sides of the drawing do not coincide with the ink lines, indicating that the sheet was used in a transfer process. Fractures along the lines of the design indicate corrosive ink.

PROVENANCE: Sotheby's, March 1889; James E. Scripps, Detroit

Gift of Mrs. James E. Scripps (1901.1 S-Dr. 259)

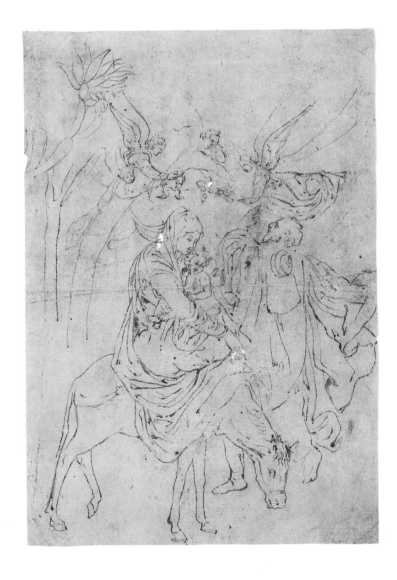

This drawing is a copy of Schongauer's engraving of ca. 1470–75 (Bartsch 7), illustrating the journey of the Holy Family to Egypt (Matthew 2:13–15; amplified in various New Testament apocryphal texts). Tracing marks on both the recto and the verso, not always coinciding with the strokes of the pen, may indicate that the image was achieved by some process of duplication, although the size of the central group is larger than in Schongauer's original print. The draftsmanship itself has none of the characteristics of drawings of the fifteenth and sixteenth centuries, but seems to be of a later, possibly seventeenth-century, date.

18th-century German Drawings

Johann Wolfgang Baumgartner

1712 Kufstein/Tyrol – Augsburg 1761

9.

Saint Bernard of Clairvaux, 1760

Plate II

Pen and black ink, brush and black ink, and gray wash heightened with white gouache over graphite pencil on blue laid paper; 518 x 351 mm

ANNOTATION: With pen and brown ink on recto at lower left, *Jo. Wolffg. Baumgartner fec. 1760.*

WATERMARK: Coat of arms similar to Heawood 572–574

CONDITION: Light staining; foxing; paper residue on reverse from previous mount

PROVENANCE: Prince of Liechtenstein, Vaduz; Hans P. Kraus, New York; R. E. Lewis, Inc., San Rafael, California; Sven H. A. Bruntjen, Woodside, California

Founders Society Purchase, Joseph H. Boyer Memorial Fund, General Endowment Fund (F1980.173)

The meticulous execution of this drawing suggests that it served as a preliminary study for an engraving. Possibly done as part of a series, it belongs to the same general type as the drawing of *Saint Euphemia* (Städelsches Kunstinstitut, Frankfort; Schilling and Schwarzweller 1973, no. 606), where the virgin martyr, surrounded by her principal attributes, is shown standing beneath the arch of a graceful rococo ornament. A more elaborate conception of the Detroit subject is found in Baumgartner's drawing in the Nationalmuseum, Stockholm (Bjurström 1972, no. 491). There Saint Bernard, accompanied by putti carrying several of his attributes, appears in half-length, borne aloft on a cloud, with the Abbey of Clairvaux visible in the landscape below. The rococo frame surrounding the central image contains no fewer than seven scenes from the saint's life, each lavishly decorated with its own set of emblems. In the simpler composition of the Detroit drawing, Baumgartner achieved a far more ingenious union of naturalistic detail and abstract form. The oval frame seems to grow organically from the predella-like picture below, while the saint's attributes have been made an integral part of the decorative elements of the frame.

By clothing Bernard in a black rather than a white habit, Baumgartner departed from the more traditional representation of the saint. This may be explained by the fact that the image, whatever its ultimate purpose, either in the form of a book or calendar illustration or as an independent devotional print, was probably intended for a Benedictine, rather than a Cistercian house. There is, on the other hand, no question as to the identity of the saint. The narrative scene set into the cartouche shows Bernard healing a lame and blind man, a miracle illustrated in earlier cycles of scenes from his life. Moreover, arranged around the upper part of the oval frame are the instruments of Christ's Passion, which at the time of the Counter Reformation became Bernard's most frequent set of attributes (Dijon 1953, p. 57, nos. 145–148, p. 61, no. 161). The choice of these attributes rests on Bernard's commentaries and sermons on the Passion of Christ, in which he stressed that man, in order truly to earn his redemption, must not only remember the Passion, but must contemplate it so intensely as to re-experience each stage of Christ's suffering vividly in both a physical and a spiritual sense (see Berliner 1955, p. 41). It is further evident from Bernard's writings that he recognized in the concrete visualization of the individual instruments of Christ's Passion a useful stimulus to human co-suffering.

While in most representations of Saint Bernard the instruments of the Passion are limited to the cross, lance, crown of thorns, and a reed surmounted by a sponge, in Baumgartner's drawing they have been expanded into a more comprehensive set of references to Christ's suffering and death. In addition to the conventional instruments, there are the lantern, club, and sword, which refer to the arrest of Christ in the garden of Gethsemane; Pilate's ewer and basin; the column and scourges of the Flagellation; and the seamless coat as well as the dice that were cast to win possession of it. The instruments have been distributed along the perimeter of the oval frame not in chronological sequence but for the purpose of achieving the greatest possible formal balance. Specific emphasis has been given to Bernard's vision of the crucifix, a motif that serves to relate the seated saint to the imagery of the frame. This motif is derived from the so-called "amplexus," a theme that was especially popular in Northern European art of the fourteenth and fifteenth centuries. In its most frequent form, Bernard is shown kneeling in prayer before the crucifix, while Christ, having detached his arms from the cross, embraces him (see, for example, the painting by Johann Koerbecke in the Alte Pinakotek, Munich; Stange 1934–61, 6: pl. 29). In the Detroit drawing, this mystical union is only suggested, as Bernard gazes in rapture upon Christ who extends one arm in his direction.

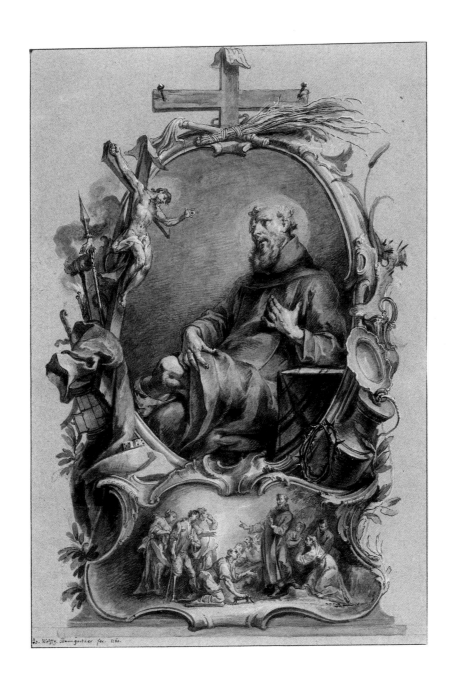

Johann Elias Ridinger
1698 Ulm – Augsburg 1767

10.
Wild Boar

Red crayon or chalk on tan laid paper; 176 x 245 mm

INSCRIPTION: Signed with red chalk on recto at lower right, *J.E.R.*

WATERMARK: ICT with scrollwork surmounted by a crown

CONDITION: Surface grime; thin spots at corners

PROVENANCE: Bangs & Co., New York; James E. Scripps, Detroit

Gift of Mrs. James E. Scripps (1909.1.S-Dr. 218)

This drawing is a quick sketch, probably done from life as a preliminary study for one of the numerous depictions of wild boars and boar hunts found among Ridinger's engravings (see following entry).

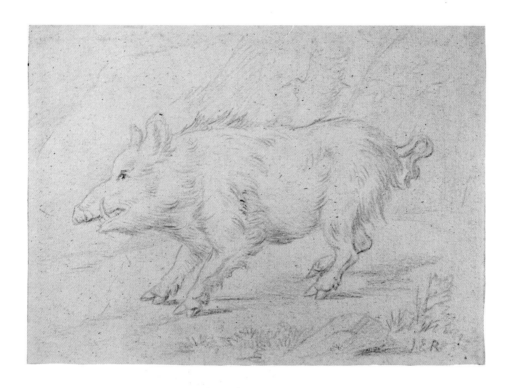

11.
Two Bison, ca. 1738–40

Pen and sanguine ink on dark yellow laid paper coated on both sides with a transparent substance of undetermined composition; 313 x 277 mm

ANNOTATION: With pen and black ink on verso at lower right, *J. E. Ridinger (Hamburg-Weigel)*

CONDITION: Mottled staining; horizontal crease at center

PROVENANCE: E. Parsons & Sons, London

Founders Society Purchase, Octavia W. Bates Fund (1934.136)

Although the composition is not listed among those described in Thienemann's 1856 catalogue, this drawing may have been done in conjunction with a group of animal prints published in Augsburg between 1738 and 1740 (Thienemann 1856, pp. 91–101, nos. 391–480; p. 276, portfolio IV). In these engrav-

ings Ridinger departed from his usual hunting scenes and depicted several species of animals with the purpose of rendering their characteristic appearance and behavior. According to Thienemann (p. 92), the preliminary drawings for this cycle formed part of the collection acquired in 1830 by J. A. G. Weigel, Leipzig, from Ridinger's heirs. The annotation on the verso may refer to this collection. In contrast to other known preparatory studies for Ridinger's prints, the drawing lacks the colored wash that would have enhanced the modeling of the animals and lent depth, light, and atmosphere to the landscape.

The animals portrayed are the European bison (*Bos bonasus*), sometimes called aurochs by conflation with the species extinct since the seventeenth century, *Bos taurus primigenius*.

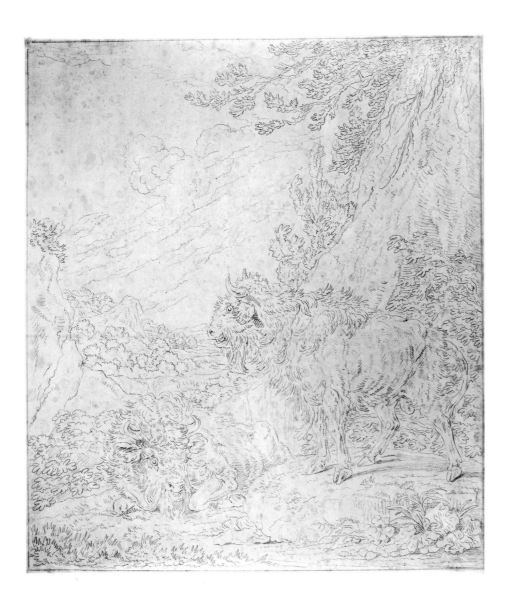

Gottlieb Welté

ca. 1745 Mainz – Reval, Estonia, ca. 1790

12.
Figures in Interior

Pen and black ink and gray wash on discolored laid paper; 115 x 138 mm

ANNOTATIONS: With pencil on verso, upper left, *Welte*; lower right, *4511/E. J A [?]*

CONDITION: Creases; abrasions

PROVENANCE: Charles E. Feinberg, Detroit

Gift of Charles E. Feinberg in memory of Sarah Lambert Brown Niremberg (F1977.66)

This drawing may have served as a preliminary sketch for one of Welté's tavern scenes. It appears to be close in spirit to the two etchings of men and women gathered around a table at an inn as described by Nagler (1835–52, 24: 113, nos. 7–8).

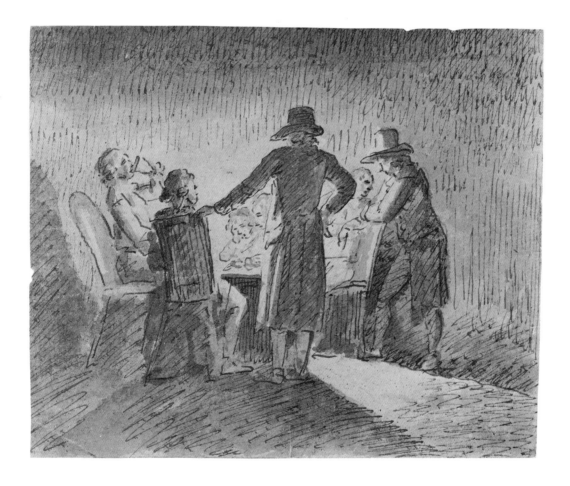

19th-century German Drawings and Watercolors

German or Austrian artist

Active first half of the 19th century

13.
Woman Sewing

Graphite pencil on cream wove paper; 184 x 121 mm

CONDITION: Good

PROVENANCE: Sotheby's, London; R. Langton
Douglas, London

REFERENCE: Scheyer 1936, no. 11 (as Ingres)

Founders Society Purchase, Laura H. Murphy Fund
(1934.129)

This drawing was originally acquired as a work by
Ingres. The attribution was evidently based on such
stylistic features as the artist's emphasis on con-
tours and the distinction between the elaborate
treatment of the model's head and the less detailed
description of the figure.

Even a cursory examination reveals that the
drawing contains weaknesses inconsistent with an
artist of Ingres's stature. Indicative of the artist's in-
competence is the careless depiction of the chair.
The stretchers do not match, and the incorrect per-
spective renders the entire construction of the chair
implausible. In addition, the model lacks precise an-
atomical articulation. This is evident not only in the
exaggerated length of the thighs, but also in the
clumsy depiction of the left hand, whose gesture is
made yet more ambiguous by the omission of the
other hand. As a result, the woman seems to be gaz-
ing at her work, rather than sewing.

Shortcomings such as these presumably led the
museum to reattribute the drawing to an anony-
mous French artist of the first half of the nineteenth
century. Ernst Scheyer, who accepted the original
attribution to Ingres when he first published the
drawing in 1936, has recently suggested (verbally)
that the drawing is not French, but German. Indeed,
in terms of its subject matter and the artist's con-
ception, the drawing epitomizes the bourgeois vir-
tues dominating both German and Austrian domes-
tic culture between 1815 and 1848, the period most
commonly known as Biedermeier. It seems per-
missible, therefore, to ascribe the sheet to a German
or Austrian artist working in the first half of the
nineteenth century.

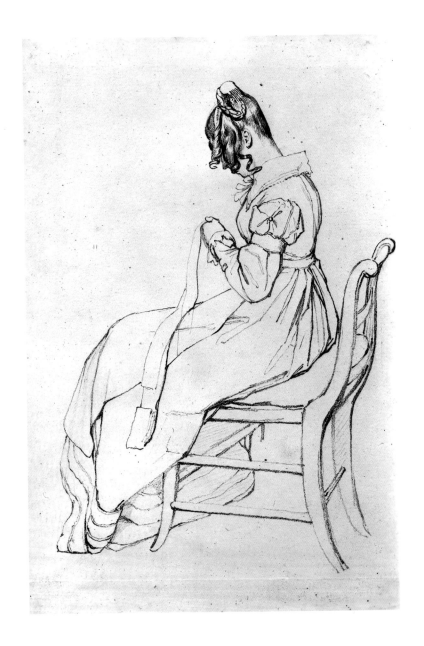

Anselm Feuerbach

1829 Speyer – Venice 1880

14.

*Kneeling Female Figure with a Mandolin
and Crowned with a Laurel Wreath,*
ca. 1857–59

Plate III

Black crayon with stumping and white gouache on
tan wove paper; 453 x 330 mm

ANNOTATION: With pencil on recto at lower right,
A. Feuerbach.

CONDITION: Yellow stain around figure from
fixative; slight cockling overall

PROVENANCE: Brobinskoy collection, Moscow;
C. G. Boerner, Düsseldorf

REFERENCE: Arndt 1968, p. 232, no. 47

Founders Society Purchase, Charles L. Freer Fund
(1964.200)

According to Arndt this drawing was done in Rome
sometime between 1857 and 1859. Her dating is
based on stylistic grounds, in particular on Feuer-
bach's use of both black crayon and white gouache
for the modeling, a technique that is first evident in
his drawings of around 1857 to 1858. Utilizing the
tone of the colored paper as a middle value, Feuer-
bach modeled the figure with long parallel strokes,
applying the gouache with the pen in the hatching
and adding the fluid highlights with a smooth brush.
This modeling technique, especially in the fastidi-
ous manner in which it has been employed here, is
reminiscent of Venetian chiaroscuro drawings of the
fifteenth and sixteenth centuries and may indeed
have been a legacy of Feuerbach's sojourn in Venice
from June 1855 to May 1856.

Although thematically reminiscent of Feuer-
bach's allegory entitled *Musikalische Poesie,* a
painting done in Venice and now in Karlsruhe (Karls-
ruhe 1971, p. 99, fig. 550), it is doubtful that the De-
troit drawing was ever intended to signify an alle-
gory. If the figure had been conceived as an allegory,
Feuerbach would surely not have represented her

from the back. In the painting in Karlsruhe, as well
as in a preliminary drawing dated 1855 (Staatliche
Graphische Sammlung, Munich, inv. 35 749; Karls-
ruhe 1976, p. 197, no. Z 11, ill. p. 282), the model,
prominently displaying a violin and a bow, is ren-
dered in a profile posture and gazes directly at the
viewer. In the Detroit drawing, on the other hand, the
position of the model, combined with the relatively
finished state of the execution, suggests that the
sheet was probably produced as a detail study for a
large, as yet unidentified, multifigured composition.
Feuerbach did use the drawing several years later as a
study for one of the kneeling women in his impor-
tant *Pietà,* completed in 1863 (Bayerische
Staatsgemäldesammlungen, Munich; Munich 1969,
pp. 111-115, no. 11 518, pl. 161). In the painting the
figure has been adapted to the religious context. The
fashionable costume has been slightly altered in
order to give it a more timeless, ideal appearance, the
musical instrument and laurel wreath have been
omitted, and the model's hands are raised in a tradi-
tional gesture of prayer.

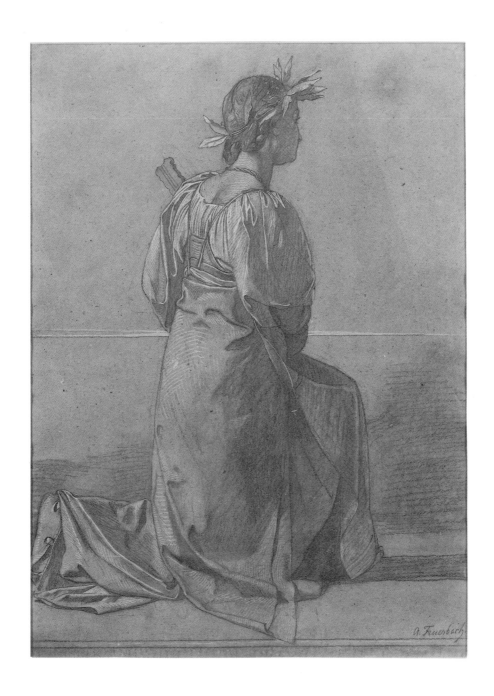

Anselm Feuerbach, *Kneeling Female Figure with a Mandolin* (cat. no. 14)

Carl Philipp Fohr

1795 Heidelberg – Rome 1818

15.
Portrait of Ludwig Simon, 1816

Pen and brush and black ink on discolored wove paper with gilt upper, right, and lower edges; 246 x 198 mm

ANNOTATION: With pen and brown ink on verso at bottom center, *Bildnis eines zu Heidelberg studierenden Spanischen Grafen, / Zeichnung meines lieben Freundes Carl Fohr. Er fand seinen Tod in den Tiefen der Tiber / bei Ponte Molle zu Rom am Tage St. Petri 1818.*; in faint pencil on verso at lower left, [406]?

CONDITION: Corners trimmed; small loss in upper left corner

PROVENANCE: Carl Herrmann, Rome and Breslau; Raphael Schall, Breslau; Adelbert Woelfl, Breslau; Eduard Feige, Breslau; Ernst Scheyer, Detroit

EXHIBITIONS: Detroit 1949a; Frankfort 1968

REFERENCES: Scheyer 1932, pp. 82–87, ill. following p. 82; Lohmeyer 1935, pp. 248–249, no. 145; Grote 1944, pp. 20–21, no. 9; Detroit 1949a, no. 18, fig. 1; Scheyer 1949, p. 235, fig. 1; Jensen 1961, p. 10, fig. 4; Frankfort 1968, p. 51, no. 110, pl. 37; Jensen 1968, pp. 36, 38, 40–44, 110, no. 46, pl. 41

Founders Society Purchase, Elizabeth P. Kirby Fund (1950.17)

According to Scheyer, who first published this drawing in 1932, Fohr's portrait of Ludwig Simon probably formed part of an album that originally also contained Fohr's self-portrait, now in the Kurpfälzisches Museum in Heidelberg (inv. Z 271), and at least seven other portrait drawings of students from the University of Heidelberg (Städelsches Kunstinstitut, Frankfort, inv. 243, 244, 245, 246; Hessisches Landesmuseum, Darmstadt, HZ 1248; Albertina, inv. 24.856; Staatsgalerie, Stuttgart, C. 51/343; reproduced in Frankfort 1968, nos. 102–108, 112, pls. 1, 34–36, and Jensen 1968, nos. 34, 35, pls. 26, 33. For a reconstruction of the entire album, see Frankfort 1968, no. 82).

Although only one of the portraits bears a date (July 18, 1816; Frankfort, inv. 244), the remaining ones were done sometime during the summer of 1816, between May 8, when Fohr, dissatisfied with his studies at the Munich Academy, returned to his native Heidelberg, and October 18, when he departed for Rome. Fohr took the album with him to Rome. After his untimely death by drowning in the Tiber on June 29, 1818, the individual pages were auctioned off separately. Today, they differ slightly from each other in size, possibly due to later cutting and to minor variations in the dimensions of the original sheets. The Detroit drawing still shows the original gilt edge on the uncut portions of the top, right, and bottom rims of the paper.

Scheyer identified the handwriting of the inscription on the verso as that of the Silesian painter Carl Herrmann (1791–1845), who lived in Rome between 1817 and 1820 and, like Fohr, was in close contact with the Nazarenes. Herrmann apparently acquired the drawing at the auction of Fohr's estate, at which time Fohr's drawings were eagerly bought by his many admirers among the then-thriving Ger-

man artists' community in Rome. A measure of Fohr's esteem among his peers is evident from the fact that until 1896 the Detroit drawing remained in artists' hands. From Herrmann's collection it found its way into that of the painter Raphael Schall (1814–1859), a native of Breslau and a follower of the Nazarenes; from there the drawing came into the collection of the painter Adelbert Woelfl (1824–1896), also active in Breslau.

Fohr's sitter, Ludwig Simon, was born in the Spanish town of Cadiz; he matriculated at the University of Heidelberg on April 21, 1814, to study political economy. About 1817 he moved to Berlin, where he seems to have taken up the study of theology. He eventually settled as a pastor on the island of Rügen, where his stepfather had preceded him in the same profession. As Scheyer suggested, contrary to the inscription on the verso, which refers to Simon as a "Spanish count," Simon was probably not of aristocratic birth. The designation may have been based on a misunderstanding or may have been fictitious, invented possibly in jest.

While at the University of Heidelberg, Ludwig Simon was a leading member of the fraternity "Teutonia," an offshoot of the "German Reading Society." A nationalist student association with affiliates at universities throughout the country, the society had been founded in 1814 in an effort to revive a distinctly German culture during the War of Liberation against Napoleon (1813–15). In Fohr's drawing, Simon is shown before the facade of the early seventeenth-century Friedrichsbau of Heidelberg Castle wearing a fur-trimmed velvet beret adorned with a jaunty array of ostrich feathers fastened to it with a cross. He is dressed in the so-called "old German coat" (*der altdeutsche Rock*), fitted with a wide collar upon which is embroidered a

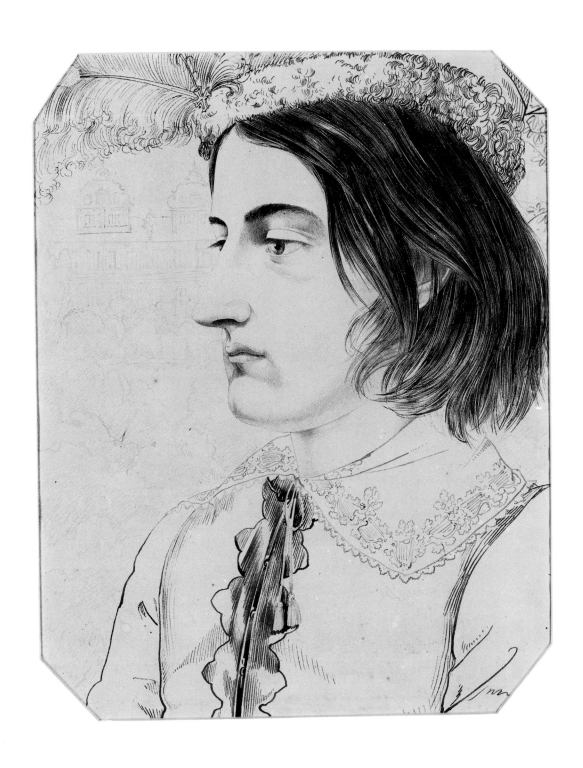

succession of harps and clusters of oak leaves. Derived from the black uniforms of the famous "free corps" of student volunteers and intellectuals which, under the command of Adolf von Lützow, played an important part in the campaign against Napoleon in 1813, the *altdeutsche Rock* was the patriotic garment par excellence. After 1814, in the wake of Ernst Moritz Arndt's call for a ban on all non-German manners in German culture and life, it became especially popular among the members of the newly founded nationalist student leagues (*Burschenschaften*), as well as among artists and intellectuals. Fohr, who during the summer of 1816 took an active part in the Heidelberg student movement, subsequently made the "old German coat" fashionable among the German artists in Rome.

On October 15, 1816, just three days prior to his departure for Rome, Fohr made a second, closely related bust-length portrait drawing of Ludwig Simon, now in Basel (inv. 1932–11; Jensen 1968, no. 47, fig. 52). This time Simon is shown in front of the bell tower of Heidelberg Castle, bare-headed, although dressed in the same *altdeutsche Rock*. The embroidery pattern on his collar is slightly altered; the clusters of oak leaves now alternate with lyres, rather than harps. It is believed that this drawing was not part of a album which Fohr took to Rome; nevertheless, along with the Detroit portrait and Fohr's self-portrait in Heidelberg, it forms part of a distinct group, illustrating both conceptually and stylistically a high point in Fohr's development as a draftsman. The Detroit drawing seems to have been the first of the three in which the exquisite modeling, achieved through the most delicate hatchings and crosshatchings, has been limited to only a few areas of the face: the shadows around the eyes, nose, mouth, and chin. In the Basel portrait and in Fohr's self-portrait, the modeling has been still further reduced, increasing the overall transparency of each drawing. Only the wash, superimposed as in the Detroit drawing over the delicate lines of the hair, provides an impression of texture and tangibility. All three portraits are pervaded by the same introspective mood, by an air of seriousness, indeed poignancy, that has come to be recognized as a quintessential feature of German Romanticism.

Fohr, who seems to have been especially close to Ludwig Simon, included him in two group portrait drawings. One of these is now preserved in Darmstadt (HZ 1250; Frankfort 1968, no. 98, pl. 32); the other, formerly in the collection of Theodor Stein, Darmstadt, was destroyed in World War II (Jensen 1968, no. 59, fig. 17). Another drawing in the Städtische Galerie, Frankfort (SG 957), may show both Fohr and Simon together in the room of one of the leaders of the Heidelberg student community, Adolf August Ludwig Follen (Jensen 1968, no. 54, fig. 36). A pencil drawing depicting Simon at full length was included as no. 1790 in the auction of the collection of Daniel Fohr in Munich on July 6, 1863 (Frankfort 1968, p. 51). Fohr subsequently used both the Detroit portrait and the self-portrait in Heidelberg for a drawing dedicated to Carl Gustav Jung, another student from Heidelberg (Jensen 1968, no. 60, fig. 48). This drawing, now in the collection of Franz Jung, Küsnacht, Switzerland, also includes the portraits of Jung and two other fellow students, Christian Sartorius and Karl Follen.

Hofmann de Waldenburg (G. W. Hofmann?)

Active late 18th/early 19th century

16.
Portrait of Hubert Simon, 1816

Gouache on discolored laid paper; 250 x 200 mm

WATERMARK: Upper portion of fleur-de-lis

CONDITION: Paper brittle; minor water damage; abrasions to image layer; flaking paint

PROVENANCE: Carl Julius Simon, Detroit; Lillie Simon, Ferndale, Michigan

Gift of Lillie Simon (1946.67)

The puzzling aspect of this portrait concerns the identity of the artist, who on the pendant *Portrait of Maria Sophia Rosenkranz Simon* (see no. 17) signed his name "Hofmann de Waldenburg." It is tempting to identify the artist with the painter who signed his name *Hoffmann pinxit ex Saxoni. De Waldenburg* on the miniature portrait of Emilie von Waldenburg, dated 1804 and sold in 1894 at Heberle's in Berlin from the estate of Emilie von Waldenburg at Potsdam (Thieme and Becker, 17: 255). But the association is by no means certain, since in that instance the name "De Waldenburg" may have been intended to apply to the sitter. On the other hand, the painter of the miniature could conceivably have hailed from the small Saxon town of Waldenburg, northeast of Chemnitz, which would locate him within the general proximity of Leipzig, where Hubert Simon lived and the two Detroit drawings were presumably made. The suggestion made in Thieme and Becker that the artist of the Waldenburg portrait may be identical with the eighteenth-century Berlin painter G. W. Hofmann (or Hoffmann) should not necessarily be dismissed, although the possibility would seem to be contradicted by the fact that the inscription explicitly refers to the painter as Saxon.

That the artist who painted Hubert Simon was an engaging portraitist is borne out by the sitter's animated face, which enlivens even the psychologically neutral profile view. The spirited countenance, suggestive of an easygoing, genial temperament, stands in sharp contrast, however, to the perfunctory treatment of the hair, which lacks both texture and luster. Equally lifeless are the details of the cravat and the lace-trimmed shirt.

According to information provided by the sitter's granddaughter, Miss Lillie Simon (Curatorial Files), who donated the portrait and its companion piece to the museum in 1946, Hubert Simon, a tailor by trade, served for a time as burgomaster of the city of Leipzig. Neither the dates of his term in office nor his own birth and death dates are known, although Simon does not appear to have been much older than his wife, who was about twenty-nine at the time the two portraits were painted. The portraits were apparently brought to America by the couple's son, Carl Julius Simon, who immigrated to the United States in 1852, settling in Detroit as a music teacher.

17.
Portrait of Maria Sophia Rosenkranz Simon, 1816

Gouache on discolored laid paper; 249 x 203 mm

INSCRIPTION: Signed and dated with pen and black ink at lower part of painted oval frame, *pinxit. Hofmann de Waldenburg, Anno. 1816*

CONDITION: Paper brittle; abrasions to image layer; losses at edges

PROVENANCE: Carl Julius Simon, Detroit; Lillie Simon, Ferndale, Michigan

Gift of Lillie Simon (1946.68)

The portrait of Maria Sophia Rosenkranz Simon was conceived as a pendant to the portrait of her husband, Hubert Simon (see no. 16). Shown in profile, facing toward her right, she occupies the sinistral side traditionally reserved for women in pendant and double portraits of engaged and married couples. In contrast to the bust-length portrait of Hubert Simon, she is depicted half-length, apparently to convey the difference between her small figure and her husband's larger frame. Her homely features bear a lively and appealing expression, but as in the pen-dant portrait, the physiognomic animation is not matched by a similarly subtle approach to details of texture. The schematic rendering of the hair and lace embroidery accounts for much of the portrait's naïve charm, but also accentuates its primitivizing stiffness. Maria Sophia Rosenkranz was about twenty-nine years old when this portrait was painted in 1816. According to a certificate issued by the Leipzig City Council, she died on November 18, 1817, at the age of thirty (Curatorial Files).

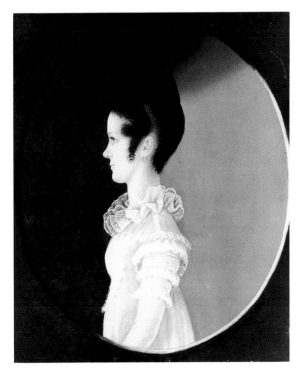

Adolf Menzel

1815 Breslau – Berlin 1905

18.
Portrait of a Man, 1894

Plate IV

Graphite and black chalk with stumping on
discolored wove paper; 307 x 226 mm

INSCRIPTION: Signed and dated with black chalk on
recto at lower left, <u>A. M.</u> over *94.*

ANNOTATION: With pencil on verso at lower left,
30/41 [1/2]?

CONDITION: Yellowing at edges; light foxing

PROVENANCE: Gustav Engelbrecht, Hamburg;
Amsler and Ruthardt, Berlin, 1924; David Daniels,
New York; Nathan Chaikan, Tolochenaz s/Morges
(Vaud), Switzerland

REFERENCES: Ebertshäuser 1976, 2: 1335;
Detroit 1979, p. 265, no. 216

Founders Society Purchase, Miscellaneous Gifts
Fund (1969.60)

Although many of Menzel's portrait drawings served
as preparatory studies for his paintings, this as-
tonishingly lifelike example appears to have been
done independently. The drawing is indicative of
that innate reserve which rarely allowed Menzel to
portray the sitter *en face,* but which already early in
his career led him to choose the psychologically less
revealing profile pose. As the drawing further illus-
trates, a profound awareness of the individual sitter's
personality remained nonetheless an essential fea-
ture of Menzel's conception.

Stylistically the drawing is typical of Menzel's
late work. The rich tonal gradations, achieved by
manipulating the chalk with a stump, are charac-
teristic of his portrait drawings from the early 1880s
on, while the close-up view, in which the model
tends to be observed either from above or below,
dominates his portrait drawings of the 1890s. Draw-
ings that are comparable in terms of both technique
and conception are found in the Staatliche Graph-
ische Sammlung, Munich (inv. 38633), and in the
Kunsthalle Hamburg (inv. 1937/18 and 1937/22; both
reproduced in Ebertshäuser 1976, 2: 1216, 1284,
1334).

Johann Heinrich Schilbach

1798 Barchfeld/Werra – Darmstadt 1851

19.
Temple of Venus and Roma, 1828

Graphite pencil on discolored wove paper; 416 x 540 mm

INSCRIPTIONS: With pencil on recto at lower center, *Tempio delle Venere Roma*; with pencil on recto at lower right, *Rom den 21ᵗ May 1828*; with pencil on recto at middle of left margin, *Garten*; with pencil on recto at middle of right margin [*Hang*]?; along upper margin, *10 20 30 40 50 60 70*; along lower margin, *1 2 3 4 5 6 7*; along right margin, *1 2 3 4 5*

ANNOTATIONS: With pencil at lower left, *5 Thlr.–*; with pencil on verso at lower left, *U3*; left of center,

Schillbach H. (Ger) / *Temple of Venus, Rome*; at upper right, [*J*]? or [*F*]?; with pen and brown ink in lower left corner, *Solo 1856*.

WATERMARK: A [indecipherable] M [indecipherable] FABRIANO 18 [3]

CONDITION: Surface grime, stains, foxing; creases, edge tears, and losses

PROVENANCE: Theodore Hoffman, Detroit

City of Detroit Purchase (1922.137)

Schilbach's view of the Temple of Venus and Roma, dated May 21, 1828, is a rare topographical document, for at the time the drawing was done the site was still in the process of being excavated. The first stage of the excavations had been conducted between 1810 and 1814; the second, begun in 1827, was not to be completed until 1829. The view is from the Colosseum toward the west, across the immense podium that carried the original Temple of Venus and Roma, consecrated by Hadrian in A.D. 136 or 137 to the patron goddess of the Julian family and to the spirit of Rome. Destroyed by the fire that seriously damaged the Forum in the reign of Carianus (A.D. 283–84), the temple was rebuilt by Maxentius in A.D. 307 on a smaller scale, and it is to this later structure that the coffered apses of the cella of Venus and Roma, erected back to back, belong. In Schilbach's drawing, the apse of the cella of Venus, facing the Colosseum, dominates the middle ground. Randomly scattered in front of the apse are remnants of the granite shafts that belonged to the colonnade which originally surrounded the temple. On the extreme left of the composition is seen the descending slope of the Farnese Gardens, laid out during the pontificate of Paul III (1534–50). Immediately to the right of the gardens stands the Arch of Titus, commemorating the victories of Vespasian and his son Titus over the Jews in A.D. 70 and dedicated to Titus by Domitian in A.D. 81. Having served throughout the Middle Ages as part of the family fortress of the Frangipani, the triumphal arch had been restored only in 1822 by Giuseppe Valadier (1762–1839). The cluster of buildings just beyond the apse of the cella of Venus, partly occupying the cella of Roma, belongs to the convent of Santa Francesca Romana and is surmounted by the church's Romanesque campanile. In the far distance rises the sixteenth-century bell tower of the Palazzo del Senatóre on the

Capitoline Hill. The colossal arches of the fourth-century Basilica of Maxentius are seen on the right.

The squaring marks along all four margins of the drawing suggest that Schilbach's view was to be transferred to canvas. Indeed, the drawing may have served as the preliminary study for the painting of the same subject listed by both Nagler and Boetticher as having been in the possession of the Berlin printer and publisher von Decker (Nagler 1835–52, 17: 199; Boetticher 1891–1901, 2, 2: 556). This painting, as well as its companion piece—a view of the Colosseum and the Arch of Constantine as seen from the Palatine Hill, also formerly in the von Decker collection—can no longer be traced.

Schilbach, who prior to his appointment to the position of court theater painter in Darmstadt resided in Rome from November 1823 to May 1828, established his reputation with *vedute* paintings of this type. His earliest known view of the Roman Forum, looking in the direction of the Capitoline Hill, was shown in 1825 at an exhibition of German artists in Rome, where it was acquired by the Danish Neoclassical sculptor Berthel Thorvaldsen (1768/70–1844). Thorvaldsen promptly commissioned Schilbach to paint a pendant view of the Forum as seen from the opposite direction. Both paintings are now in the Thorvaldsen Museum in Copenhagen (Bergsträsser 1959, p. 53, fig. 15; Copenhagen 1961, p. 70, no. 160). The preliminary pencil drawing for the earlier of the two views is preserved in the Hessisches Landesmuseum, Darmstadt (inv. 687); a pencil and watercolor of ca. 1826–27, apparently done in conjunction with Schilbach's second painting for Thorvaldsen, is in the Staatliche Graphische Sammlung, Munich (inv. no. 36923; Bergsträsser 1959, p. 54, fig. 16). The two views painted for Thorvaldsen are so far the only ones that can be said with assurance to have been

done in Rome. Schilbach's other views of the Forum were probably painted upon his return to Germany on the basis of his carefully rendered drawings.

The Schilbach drawing in Detroit must have been one of the last he made prior to his departure for Germany in 1828. Stylistically, it is closely related to the example in Munich, in which the lines defining the chief structural and decorative details of the buildings have also been partly executed with the aid of a ruler. In a general way, the delicate drafts-manship recalls drawings by members of the Nazarene brotherhood, with whose work Schilbach was doubtlessly familiar through Josef Anton Koch (1768–1839), whose circle he is known to have frequented during his years in Rome. In contrast to the fundamentally romantic outlook of the Nazarenes, however, Schilbach eschewed the picturesque in favor of meticulous attention to topographical detail, an approach that distinguishes him as a pioneer of realistic landscape painting.

Color Plates I-XII

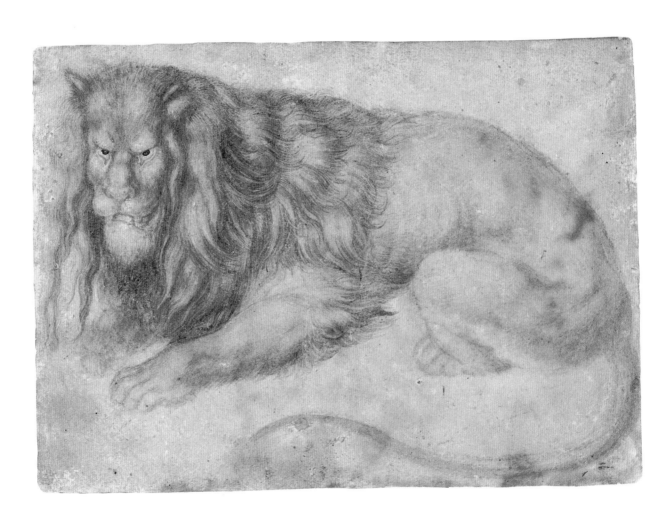

Plate I Albrecht Dürer, *Recumbent Lion* (cat. no. 2)

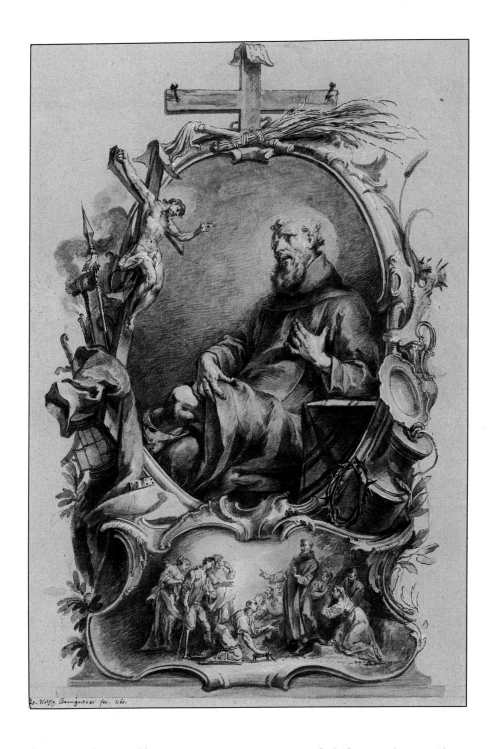

Plate II Johann Wolfgang Baumgartner, *Saint Bernard of Clairvaux* (cat. no. 9)

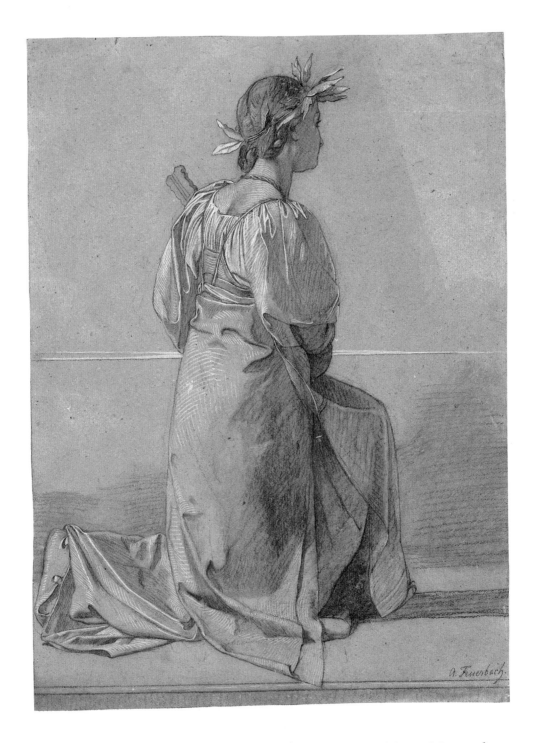

Plate III Anselm Feuerbach, *Kneeling Female Figure with a Mandolin and Crowned with a Laurel Wreath* (cat. no. 14)

Plate IV Adolf Menzel, *Portrait of a Man* (cat. no. 18)

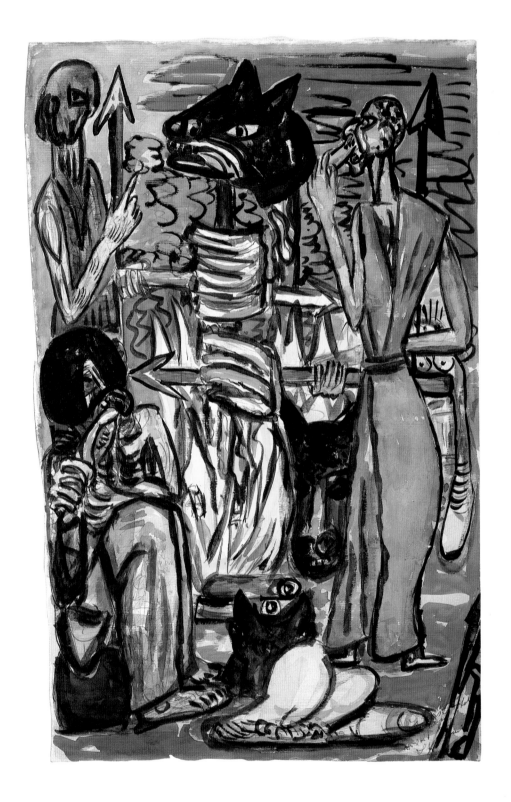

Plate V Max Beckmann, *Sacrificial Meal* (cat. no. 38)

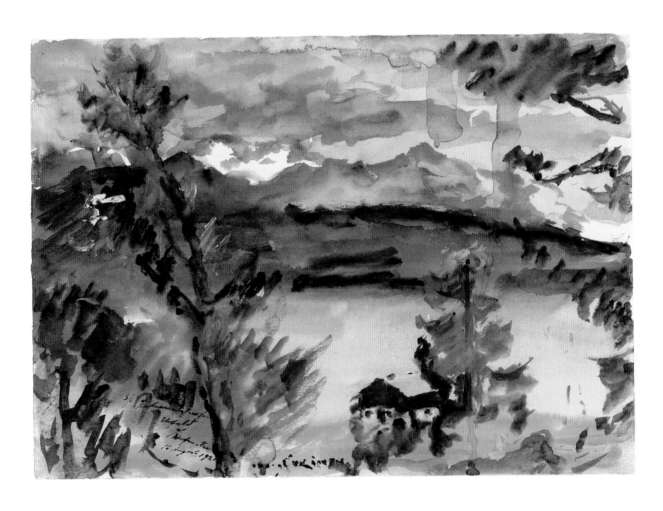

Plate VI Lovis Corinth, *Pink Clouds, Walchensee* (cat. no. 41)

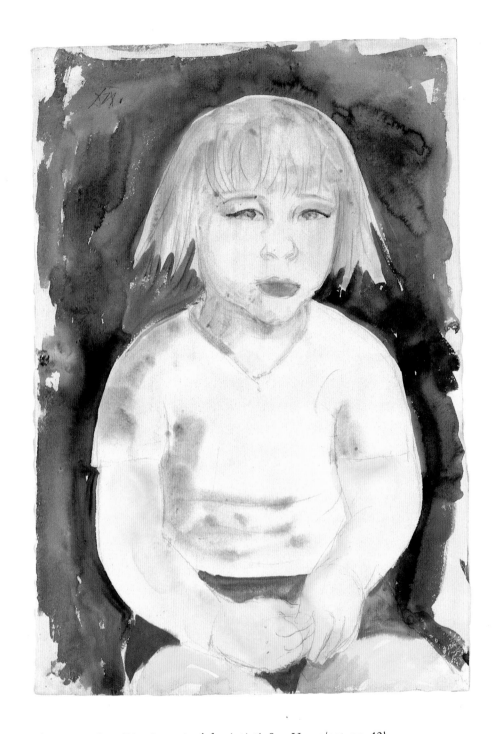

Plate VII Otto Dix, *Portrait of the Artist's Son Ursus* (cat. no. 43)

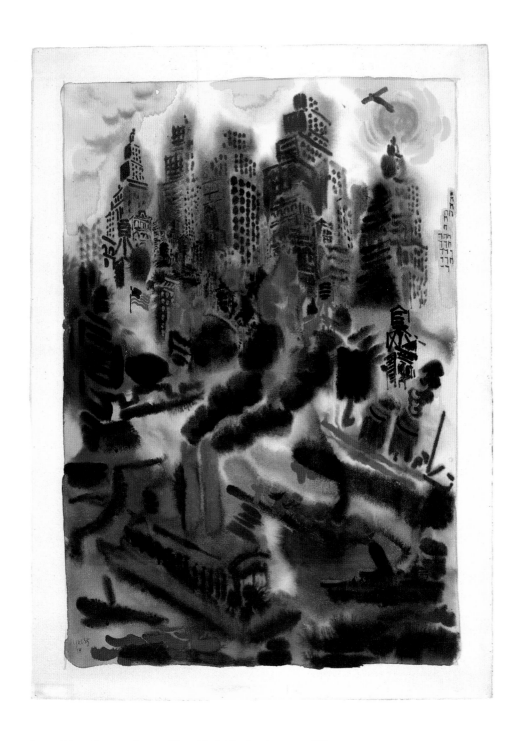

Plate VIII George Grosz, *New York Harbor* (cat. no. 49)

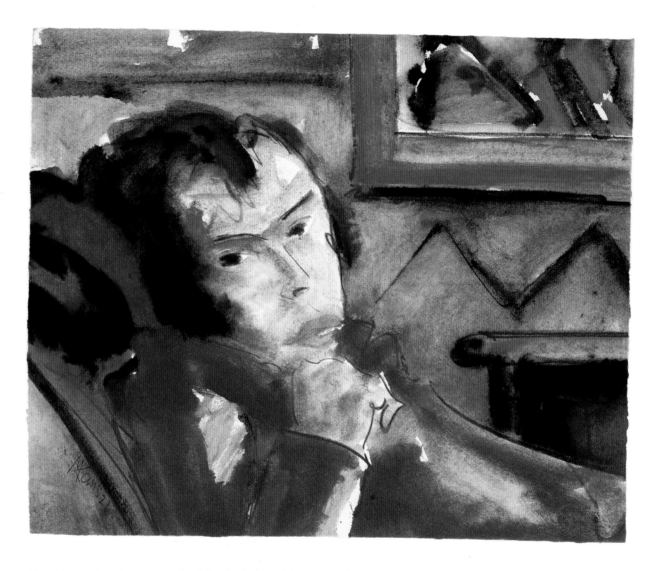

Plate IX Max Kaus, *Portrait of the Artist's Wife* (cat. no. 54)

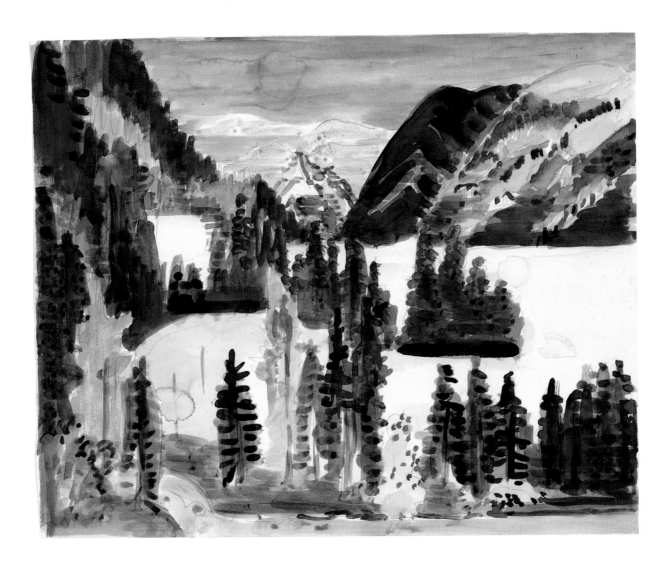

Plate X Ernst Ludwig Kirchner, *Landscape with Mountain Lake* (cat. no. 56)

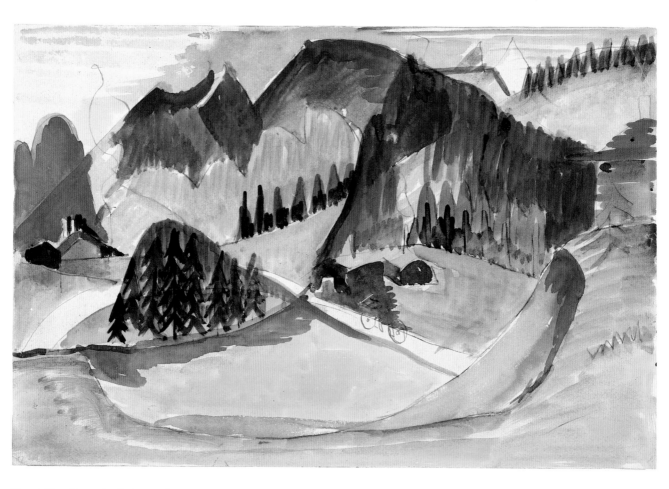

Plate XI Ernst Ludwig Kirchner, *Mountain Landscape* (cat. no. 57)

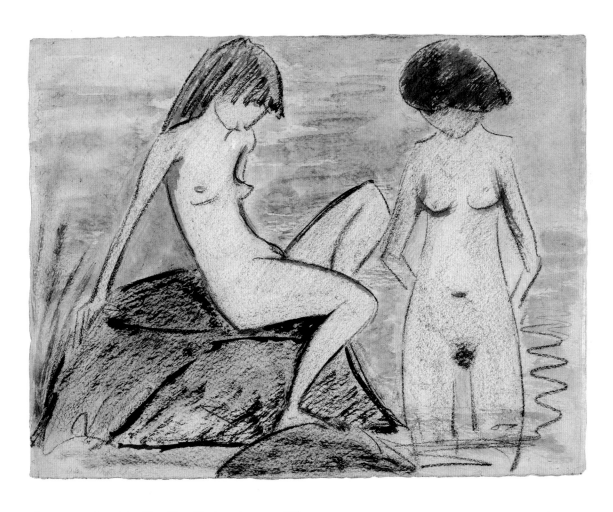

Plate XII Otto Mueller, *Two Bathers* (cat. no. 97)

Adolf Schreyer

1828 Frankfort on the Main – Kronberg/Taunus 1899

20.
Two Horses, 1898

Pen and brown ink over red crayon or chalk on discolored laid paper; 169 x 185 mm

ANNOTATION: With black pencil on recto at lower right, *A Schreyer 1898*

WATERMARK: Fragment of fleur-de-lis

CONDITION: Edges trimmed after drawing was executed; faint mat burn; solidly mounted to acidic cardboard

PROVENANCE: William E. Scripps, Detroit

Gift of Mrs. William E. Scripps (1956.285)

Combining careful observation and expressive freedom, Schreyer's drawing exemplifies the kind of life studies he relied upon for the few themes that dominate his paintings: Arab horsemen hunting or fighting in the African desert; horse-drawn wagons and sleds making their way across the gloomy steppes of Russia and Central Europe; and teams of horses, huddled together against the cold, waiting patiently outside a snow-covered inn. The drawing is a late work, although Schreyer often repeated this particular grouping of two horses. It is found, virtually unchanged, in an undated, more tightly executed drawing in the Städelsches Kunstinstitut, Frankfort (inv. 1875; property of the Städtische Galerie, Frankfort), and in such paintings as *Wallachian Post House*, 1867, in the Philadelphia Museum of Art, and the

undated *Wallachian Pack Train* at the Paine Art Center, Oshkosh, Wisconsin (Oshkosh 1972, pp. 45, 54).

With these subjects Schreyer established his reputation in Paris, where he lived throughout the 1860s until the outbreak of the Franco-Prussian War. His paintings were lavishly praised by Théophile Gautier (1811–1872) and continued to be popular for the remainder of Schreyer's career, especially among American collectors. It was largely with the income from his American sales that Schreyer financed his elegant lifestyle in Kronberg, where he settled upon his return from France. He soon became the center of a small provincial painters' colony; his guests occasionally included Queen Victoria's eldest daughter "Vicky," the German Empress Friedrich.

Franz August Schubert

1806 Dessau 1893

21.

The Archangel Michael, 1836

Watercolor over graphite pencil on cream wove
paper; 437 x 281 mm

ANNOTATIONS: With pencil on recto at lower left,
Lucas Singorelli. [sic].p.; in pencil on recto at lower
right, *copirt [sic] v. F. Schubert 1836 in Orvieto das
Original / ist jetzt in Leipzig*; with pencil on verso
at lower left, *Der Erzengel Michael den Satan
besiegend.*; with pencil on verso in lower left corner,
EP5/75 M.

CONDITION: Light foxing

PROVENANCE: Berk, Dessau (black collector's mark
below lower right corner of composition); Franz
Meyer, Dresden, 1889; James E. Scripps, Detroit

Gift of Mrs. James E. Scripps (1909.1 S-Dr. 263)

The watercolor is a copy of a fragment of fresco for-
merly in Leipzig (Leipzig 1891, no. 480; destroyed in
World War II). Attributed successively to Raphael,
Signorelli, Insegno, Eusebio, and Pinturicchio, the
fresco originally formed part of the decoration of the
Gualtieri family chapel (the Brizio Chapel) in the
Cathedral at Orvieto. It was subsequently removed
to the Casa Gualtieri, where Peter Cornelius
(1783–1867) rediscovered and restored the fragment
sometime in 1811. Schubert, who studied with Cor-
nelius and Julius Schnorr von Carolsfeld (1794–1872)
in Munich in the late 1820s, copied the fresco while
traveling in Italy between 1833 and 1839. Although
the date of 1836, inscribed at lower right, is evidently
not by Schubert's hand, there is no reason to doubt
that the watercolor was executed at that time.

The watercolor documents the reawakened in-
terest in the art of Dürer, Raphael, and their immedi-
ate predecessors, an interest which had already
given rise in the early nineteenth century to the
Brotherhood of Saint Luke, commonly known as the
Nazarenes. This group of German painters in Rome
included Cornelius and Schnorr in its ranks. Saint
Michael is depicted standing on the prostrate figure
of Satan, shown in the form of a mortally wounded,
fire-spitting dragon. With his meticulous draftsman-
ship, especially evident in the intricate details of the
armor, and his clear colors, Schubert captured the
decorative charm of Pinturicchio's original. Both the
graceful figure type and the limpid landscape, with
its gently sloping terrain and feathery trees, are a
legacy of the Perugino school, of which Pinturicchio
was the last important member.

Carl Spitzweg
1808 Munich 1885

22.
Gentleman with Two Ladies, ca. 1845

Graphite pencil on discolored wove paper;
208 x 176 mm

CONDITION: Lined with lightweight japanese paper;
mat burn

PROVENANCE: Carl Spitzweg Estate (black artist's
estate stamp [L. 2307, as Karl von Spitzweg] on verso
at lower right); Dr. Gabriel Steiner, Detroit

Gift of the Estate of Dr. Gabriel Steiner (F1968.23)

Although this drawing cannot be related specifically
to any of Spitzweg's known compositions, there is a
possibility that it was executed in conjunction with
his painting *English Tourists in the Campagna,* a
work datable on the basis of the costumes to about
1845 and now in the Nationalgalerie, Berlin (Roen-
nefahrt 1960, no. 621). The gentleman chaperone be-
neath the gigantic parasol is clad in a large-buttoned
coat that is similar to the one worn by the monocled
traveler in the Berlin picture, while the bearing of
the two fashionable ladies, one of whom carries a
large sketchbook, reinforces the thematic connec-
tion. Stylistically, too, the drawing is compatible
with Spitzweg's draftsmanship of the mid-1840s.
The sketchy lines contrast with his earlier, more
methodical approach; the doubling of the contours
endows the figures with potential movement and
creates the illusion of light and atmosphere.

Conceptually, the drawing is typical of that
mildly satirical observation for which Spitzweg is
best known. Despite his mock complacency, the
gentleman cannot hide the fact that he assumes his
social duties with no small measure of authority and
self-esteem. The demeanor of the two ladies has
been similarly intensified. While the one on the
right shares her male companion's imperious reserve
and dour mien, the one on the left is conspicuously
eloquent about her reaction to the world around her.
This tendency to look for the most characteristic
element in a given situation, and to accentuate the
eccentricities of human behavior, was encouraged by
Spitzweg's activity, from 1844 on, as an illustrator
for several newspapers and journals, among them
the Munich-based *Fliegende Blätter.*

A watercolor related to Spitzweg's painting in
Berlin was formerly in the Galerie Heinemann in
Munich (Roennefahrt 1960, no. 622). A related pen
drawing is in the Albertina (Berlin 1977,
pp. 388–390).

23.
Standing Figure, ca. 1855

Graphite pencil on off-white wove paper;
213 x 73 mm

CONDITION: Solidly mounted to thin cardboard

PROVENANCE: Carl Spitzweg Estate (blue artist's
estate stamp [L. 2307, as Karl von Spitzweg] on verso
at lower center); Dr. Gabriel Steiner, Detroit

Gift of the Estate of Dr. Gabriel Steiner (F1968.21)

This quick figure study cannot be related to any of
Spitzweg's known compositions, but appears to be-
long conceptually, as well as stylistically, to a group
of sketches from the mid-1850s illustrating some of
his favorite figure types (see no. 25).

24.
Standing Soldier Gazing into the Distance, ca. 1859

Graphite pencil on off-white wove paper;
186 x 168 mm

ANNOTATION: With pencil on verso at lower left,
[indecipherable] *2917*

CONDITION: Lined with lightweight japanese paper;
mat burn at edges

PROVENANCE: Carl Spitzweg Estate (black artist's
estate stamp [L. 2307, as Karl von Spitzweg] on verso
at lower right); Dr. Gabriel Steiner, Detroit

Gift of the Estate of Dr. Gabriel Steiner (F1968.22)

Spitzweg's drawing may have served as a prelimin-
ary study for his painting *Sentry* in the Frederick
Coester collection, Orange, New York (Roennefahrt
1960, no. 778). Although the precise date of the
painting is not known, the sale of the picture to the
Kunstverein in Prague is recorded in Spitzweg's sale
catalogue of 1859 (Roennefahrt 1960, p. 217). In the
painting the same aging sentinel, also seen from the
back, gazes from the walls of a bastion high above a
provincial town toward roofs and turrets in the far
distance. He does not shield his eyes and—as in the
Detroit drawing—he holds a piece of knitting in his
left hand.

Between the late 1840s and 1860s Spitzweg painted the figure of the sentry repeatedly in the activities of knitting, catching flies, or taking snuff, yawning, or sleeping soundly (Roennefahrt 1960, nos. 778–802), satirically highlighting the uselessness of what was by then an outmoded institution. During Spitzweg's lifetime there could still be seen many such sentries, relics from the period prior to 1848, when Germany had been divided into a vast number of autonomous states, ranging from monarchies such as Prussia to small principalities, from imperial cities to market towns, each protected by its own militia. At a time when security of the towns no longer depended on the watchman's vigilance, the sentry became for Spitzweg another paradigm of human eccentricity, an amiable representative of vanity and pride, of intellectual limitation and futility.

25.
Study of Three Comic Male Figures, ca. 1855

Graphite pencil on discolored wove paper; 210 x 337 mm

INSCRIPTION: With pencil on recto at lower left, *Das war/ein Schuss!/Nicht!*

ANNOTATIONS: With pencil on verso at lower right, 738; also at lower right, 81

CONDITION: Lightstruck, adhered to mount at upper edge

PROVENANCE: Carl Spitzweg Estate (blue artist's estate stamp [L. 2307, as Karl von Spitzweg] on recto near lower center); Dr. Gabriel Steiner, Detroit

Gift of the Estate of Dr. Gabriel Steiner (F1968.24)

Throughout his career Spitzweg made quick sketches to record the characteristic demeanor of the small-town eccentrics who subsequently found their way into his paintings. These drawings generally strike a balance between realistic observation and caricature and include an entire gallery of characters of whom Spitzweg was especially fond: officious customs inspectors, perennial suitors, diffident postmen, professors, clerks, and a host of others whom circumstances had forced to assume postures, if not roles, of importance and authority.

In the Detroit drawing, too, each of the three figures is conceived as an exaggerated example of a type, and their airs and pretensions are exposed with the gentle irony of the Biedermeier artist. The fact that the three figures seem anecdotally unrelated and juxtaposed randomly on the same sheet suggests that the drawing may belong to a group of pencil sketches from the mid-1850s, all of which have as their subject Spitzweg's favorite characters and appear to have been done by him in a spirit of whimsical self-quotation. As epitomized by the example in Erlangen (Munich 1968, no. 179, pl. 83), in most of these sketches the element of caricature tends to be far more emphasized than is the case with the figures in the Detroit drawing.

Otto Wagner

1803 Torgau – Dresden 1861

26.
A Prison Interior, 1820

Watercolor and pen and black ink on cream wove paper; 406 x 519 mm

INSCRIPTION: Dated and signed with pencil on verso near lower right margin, *31. Dezember 1820. OW.* (in monogram)

ANNOTATIONS: With pencil on verso in left corner, *N90*; on verso near lower left margin, (*Hofmaler Otto Wagner* [T] / *Das Gefängnis*)

CONDITION: Pinholes on verso coincide with the major lines of the drawing

PROVENANCE: Francis W. Robinson, Detroit

Gift of Francis W. Robinson (1955.192)

Although the costumes of the figures point to a sixteenth-century context, the subject of this watercolor has so far defied explanation. The view reveals the interior of a prison in which two guards, armed with halberds, are leading a bearded man in chains toward a cell that is being unlocked by a jailer at the lower right. A third guard follows the group at some distance, while a fourth, accompanied by a man wearing a broad-brimmed hat, observes the scene from an elevated walkway. The complex setting, a two-aisled, multistoried hall traversed by vaulted landings and flights of stairs, may have been inspired by Piranesi's *Carceri* which were first published in 1750. In contrast to Piranesi's puzzling architectural fantasies, however, the prison interior Otto Wagner depicted in this watercolor remains within the realm of structural plausibility.

The watercolor possesses the standard features of a stage design and was undoubtedly intended as such. Not only does the setting provide opportunity for access from the wings on several levels, includ-ing the upper and lower stages, but the painted interior also suggests a *trompe-l'oeil* conceived as adjoining a proscenium arch. The somber colors, shades of brown and gray, as well as the evocative use of light and shadow, reinforce the impression of a staged event.

The seventeen-year-old Wagner painted the watercolor in 1820 while he attended the Dresden Academy, studying perspective, principles of architecture, and ornament under the guidance of Johann Gottfried Jentzsch (1759–1826). He most likely executed the watercolor as an assignment for Jentzsch, who from 1797 on designed sets and decorations for the Dresden court theater and the stages of the summer theater at Linckesches Bad and the palace at Pillnitz. Although after Jentzsch's death in 1826 Wagner was allowed to take over some of his teacher's classes at the academy, his own activity for the Dresden court theater apparently did not begin until after 1831.

Heinrich Wilhelmi

ca. 1816 Xanten – Düsseldorf 1902

27.
Portrait of the Artist's Wife (Lina), 1848

Black, white, and cream chalks over graphite pencil on brown wove paper; 366 x 307 mm

INSCRIPTIONS: Partial inscription in white chalk on recto at upper left, *lmi/1848*; dated and signed with pencil on recto at lower left, *Xanten./11 Juni 1848./H. Wilhelmi*; with pencil on recto at lower right, *Lina*.

ANNOTATION: With pencil on recto at center of lower edge, *756* [indecipherable] *1* [indecipherable] *–150* [indecipherable]

CONDITION: Discolored from contact with wood, particulary verso; trimmed on all sides; edge tear at left center

PROVENANCE: Mrs. Hilda Elliott, Pleasant Ridge, Michigan

Gift of Mrs. Hilda Elliott (1950.152)

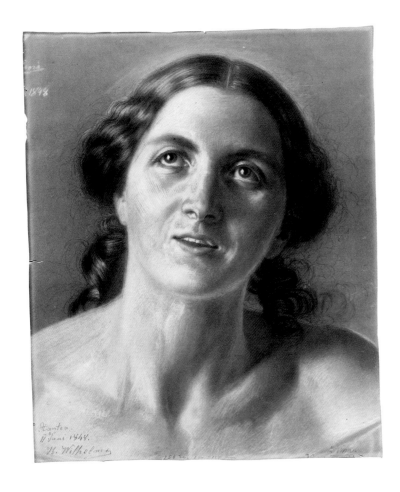

Inscribed with the name "Lina," this drawing was done in 1848 in Xanten, shortly after Wilhelmi's return from a six-year stay in Rome. The woman's features are carefully modeled and enlivened by bold contrasts of light and shade. The drawing has been cut at the left and lower margins, making the head appear somewhat large for the size of the sheet. When the drawing was acquired by the museum, a note in English was found on the backing of the frame ("Grandmother of Caroline Wilhelmi, drawn from life by Grandfather Wilhelmi in 1848") that identifies the sitter as the painter's wife.

20th-century German Drawings and Watercolors

Alo Altripp (Friedrich Schlüssel)

1906 Altripp/Rhine

28.
Abstract Drawing (G 206/58 XII), 1958

Black crayon on off-white wove paper;
440 x 627 mm

INSCRIPTION: Signed and dated with pencil on recto at lower right, *ALTRIPP 58*

ANNOTATIONS: Embossed stamp on recto in upper left corner, *SCHUTZMARKE SCHOELLERSHAMMER HAMMER 4G*; with pen and black ink on verso at lower center, *G 206/58 XII*; with pencil on verso in lower right corner, *XII*; with pencil on back of paper mount, *ALO ALTRIPP 1958/G 206/58 XII*

CONDITION: Good; slight cockling at upper edge

PROVENANCE: John S. Newberry, New York

Bequest of John S. Newberry (1967.38)

The drawing belongs to a series of abstractions done between 1954 and 1961, a period during which Altripp temporarily abandoned color in favor of black and white. Dominating Altripp's output from these years is the pictorial problem of defining pure form and pure light solely in terms of their mutual interdependence. In the Detroit drawing, tonal gradations ranging from transparent gray to opaque black emerge in rhythmic patterns from a white paper ground, achieving both their fullest and their least measure of saturation wherever form and light cease to interact. Throughout the drawing emphasis is on the evolution and growth of forms whose individual character is determined by the degree of reciprocity with which form and light penetrate one another. Developed from a triad of shapes in which positive and negative values of form and light maintain a subtle balance, the composition as a whole echoes the delicate chiaroscuro of its individual parts. With so much attention devoted to the process of formation, the creative act itself becomes the real content of the drawing.

Ernst Barlach

1870 Wedel/Holstein – Rostock 1938

29.
Walking Woman, 1922

Charcoal on discolored wove paper; 345 x 263 mm

INSCRIPTION: Signed and dated with charcoal on recto at lower left, *E Barlach / 23 3 22*

ANNOTATION: Blue customs stamp on verso in lower left corner, *Zollzweigstelle Bahnhof Friedrichstrasse Berlin*

CONDITION: Staining at center of sheet from discolored fixative; top and side edges perforated as if torn from a larger sheet

PROVENANCE: Lillian Henkel Haass, Detroit

EXHIBITION: Lincoln et al. 1955 (traveled to Seattle, Dayton, Cambridge, and Washington, D.C.)

REFERENCE: Lincoln et al. 1955, no. 61

Gift of Lillian Henkel Haass (1940.149)

Dated March 23, 1922, Barlach's drawing was done during a period of intense graphic production, in the course of which he increasingly turned his attention from the predominantly narrative subjects of his earlier drawings and prints to the human figure as the embodiment of archetypal states of human experience, a concept he had already explored in his sculptural work. The drawing also marks the culmination of Barlach's efforts to find an appropriate graphic means with which to unify content and form. In contrast to his earlier, loosely stroked manner, the sweeping lines employed here serve a descriptive as well as an expressive function. While the illusion of physical movement is achieved through the kinetic flow of the simplified folds of the robe, the gestural line of the attenuated body is as evocative as the figure's face.

The Detroit drawing, not included in Schult's 1971 catalogue, is closely related to a group of drawings executed in March 1922 and preserved as part of Barlach's estate in Güstrow. These drawings include—besides sketches of grotesque old hags and witches—figures illustrating such notions as "slander" and "curse" (Schult 1971, nos. 1512, 1536, 1560, 1563). Some of these drawings were done as independent explorations; others may have served as preliminary suggestions for Barlach's series of eight lithographs published by Paul Cassirer in 1922 under the title *Die Ausgestossenen* (Schult 1958, nos. 195–202).

The drawing was presented to the museum by the Friends of Modern Art in June of 1935, which suggests that it may have been acquired from the exhibition of drawings by modern German sculptors that the Detroit Institute of Arts had organized in March of the same year.

30.
Standing Woman, 1922

Charcoal on tan wove paper; 343 x 263 mm

INSCRIPTION: Signed and dated with charcoal on recto at lower left, *EBarlach / 24 3 22*

ANNOTATION: Blue customs stamp on verso in lower left corner, *Zollzweigstelle Bahnhof Friedrichstrasse Berlin*

CONDITION: Staining at center of sheet from discolored fixative; top and side edges perforated as if torn from a larger sheet

EXHIBITIONS: Detroit 1935; Chicago 1939; Lincoln et al. 1955 (traveled to Seattle, Dayton, Cambridge, and Washington, D.C.)

REFERENCES: Chicago 1939, no. 86; Lincoln et al. 1955, no. 60

Founders Society Purchase, Friends of Modern Art Fund (1935.60)

Like the preceding drawing, this sketch bearing the date March 24, 1922, is not included in Schult's 1971 catalogue, but belongs to the same group of drawings preserved as part of Barlach's estate in Güstrow that have as their subject simplified human figures that communicate a wide range of emotions through emphatic gestures, postures, and facial expressions. While the figure in the drawing of March 23 is the very epitome of physical and emotional frailty, energy and strength determine the gestural line of the figure here.

The evocation of earthy vigor in Barlach's drawing recalls works by Emil Nolde (see no. 106), who similarly rejected conventional notions of beauty and grace. Both artists looked for the primeval side of humanity and in their pursuit of the archaic and primitive frequently exploited the ugly and the grotesque.

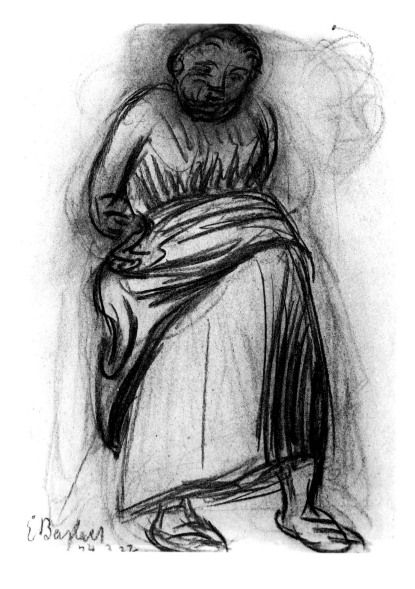

Eugen Batz

1905 Velbert/Rhineland

31.
Composition No. 26, 1956–59

Watercolor on wove paper; 148 x 208 mm

INSCRIPTIONS: Signed with pencil on recto at lower right, *ebatz*; with blue ball-point pen on recto in lower right corner, *26*; with blue ball-point pen on recto in lower left corner, *16 XII. 59 V.elt.*; with brush and black ink on recto in top left corner, *16 XII. 56* (inverted); with pencil on recto in upper left corner, *16* (inverted); with pencil on mount above upper right corner of sheet, *26* (inverted)

CONDITION: Solidly mounted to a larger sheet

PROVENANCE: John S. Newberry, New York

Bequest of John S. Newberry (1967.42)

In this watercolor shades of blue and dark red interlock with one another in a transparent fabric of color that covers the surface of the sheet without giving prominence to any particular part of the composition. Although the individual dabs of color vary in size and saturation, their combined effect is one of tonal and textural unity. It is as if the composition had developed of its own accord, like a living organism whose final structure is determined by the division and multiplication of individual cells.

The theoretical basis for Batz's work—allowing the composition to grow from pictorial elements prompted by visual experiences and memories stored in the artist's unconscious—is a legacy from Paul Klee (see nos. 141–150), with whom Batz studied at the Bauhaus in Dessau from 1929 to 1931 and at the academy in Düsseldorf from 1931 to 1933.

Curiously, the drawing has been dated twice, "*16 XII.59*" at the lower left, and "*16 XII.56*," written upside down, at the upper left. Since the two dates are in an inverted relationship to each other, it would seem that the artist not only reworked the composition at a later date, but in so doing also altered the axis of the composition by 180 degrees. Whether the fact that the interval between the two dates is exactly three years to the day resulted from coincidence or design is difficult to say.

32.
Composition No. 32, 1957

Watercolor on cream wove paper; 133 x 185 mm

INSCRIPTIONS: Dated with brush and brown ink on recto in lower left corner, *27.XII.57*; signed with pencil on recto at lower left, *e.batz*; with blue ballpoint pen on recto at lower left, *V.-elt.*; with brush and brown ink in lower right corner, *32*

CONDITION: Edged down to a larger sheet

PROVENANCE: John S. Newberry, New York

Bequest of John S. Newberry (1967.41)

Dated December 27, 1957, this composition bears a relationship to *Composition No. 26* (no. 31), illustrating a progression from comparatively static to dynamic relations of color. The top two-thirds of the sheet is dominated by shades of blue superimposed upon red and brown. The lower third is covered with dabs of yellow, orange, light blue, and gray. The progressive increase in the saturation of the colors, as well as the contrasts of both complementary and cold and warm hues, invest the composition with a heightened level of expressive energy.

33.
Composition No. 41, 1960

Watercolor on paper with laid texture; 387 x 251 mm

INSCRIPTIONS: Dated with black ball-point pen on recto in lower left corner, *B.-Baden 12. X. 1960*; with black ball-point pen on recto to right of lower center, *e batz*; with black ball-point pen on recto in lower right corner, *41*

CONDITION: Good; edged down to a larger sheet

PROVENANCE: John S. Newberry, New York

Bequest of John S. Newberry (1967.44)

Reconciliation of structured form and diffuse areas of color provide the dynamics of this composition. The rhythmic tapestry of color dominating the surrounding shades of gray, pink, and green results from the interaction of the three primaries red, yellow, and blue with random patches of black. There are no con- tours, the colors having been applied in transparent, overlapping washes and allowed to pass into one an- other. The ultimate impression is one of continuous change, transforming the composition into a pic- torial metaphor of growth.

34.
Composition No. 45 (Paracelsus House),
1960

Pen and black ink on cream laid paper;
186 x 332 mm

INSCRIPTIONS: Titled and dated with brush and
black ink on recto at lower left, *Paracelsus.haus VIII
60*; with blue ball-point pen on recto in lower left
corner, *12/Velt*; with brush and black ink on recto in
lower right corner, *45*; with brush and black ink on
recto at lower center, *ebatz*

WATERMARK: ROMA below indistinct figures

CONDITION: Mounted to a larger sheet with spots of
adhesive along the edges

PROVENANCE: John S. Newberry, New York

Bequest of John S. Newberry (1967.43)

Accepting movement as inherent in the dynamic character of the creative process, Batz developed this drawing from the simplest elements of form. Set in motion, the individual lines have been made to enter into multiple relationships with one another to form a polyphonic pictorial structure. Even the calligraphy of the artist's signature, appended at the lower center, has been incorporated into the design.

Transitions from lighter to darker tones give weight to certain parts of the composition, enhancing the image with a measure of mass. Having begun the pictorial process without any preconceived object or content in mind, Batz acknowledged the suggestive power of the figurative and architectonic elements of the finished drawing in the title *Paracelsus House.*

35.
Composition No. 48, 1960

Watercolor over silverpoint on heavy paper with prepared ground; 124 x 176 mm

INSCRIPTIONS: With blue ball-point pen on recto at lower left, *V.elt.*; dated with brush and black ink on recto at lower left, *6. I. 60*; signed with pencil on recto at right of lower center, *e.batz*; with brush and black ink on recto in lower right corner, *48*

CONDITION: Solidly mounted to a larger sheet

PROVENANCE: John S. Newberry, New York

Bequest of John S. Newberry (1967.40)

The structure and rhythm of this composition are determined by the interaction of graphic elements, contrasts of complementaries, and tonal gradations. While delicate lines, applied with the silverpoint to the white paper ground, form a lively pattern that reaffirms the two-dimensional plane, the third dimension is achieved through the juxtaposition of the colors and the progressive intensification of color energy. Over shades of pale green, gravitating toward yellow and gray, have been superimposed strokes of transparent red, each stroke culminating in a saturated dab of color. If the composition contains vague memories of natural forms, they are prompted by the orchestration of the pictorial means rather than by a specific prototype in nature.

36.
Composition No. 76 (P.-House), 1960

Pen and black ink on cream laid paper; 150 x 143 mm

INSCRIPTIONS: Dated with pen and black ink on recto at lower left, *12/P.-Haus IX.60/Velt*; signed with pen and blue ink on recto at lower center, *e batz*; with pen and blue ink on recto in lower right corner, *76*

CONDITION: Mounted to a larger sheet with spots of adhesive along the edges

PROVENANCE: John S. Newberry, New York

Bequest of John S. Newberry (1967.39)

Dated September of 1960, this drawing is a variation of the Detroit *Composition No. 45 (Paracelsus House)* (no. 34) done the preceding month. In both drawings movement becomes the basis of the pictorial process. Organized into a loosely connected calligraphic structure, the lines twist and turn back upon themselves, their energy intensified by repeated changes in tonal value. As in the earlier drawing, the figurative element of the composition is a direct expression of the labile balance of the formal means.

Willi Baumeister

1889 Stuttgart 1955

37.

Cheerful Movement on Pink IV, 1947

Gouache on off-white wove paper; 320 x 480 mm

INSCRIPTION: Signed with pencil on recto at lower right, *W Baumeister*

CONDITION: Good

PROVENANCE: Paul G. Lutzeier, Farmington, Michigan

REFERENCE: Grohmann 1965, pp. 102, 305, no. 945

Gift of Paul G. Lutzeier (1950.129)

According to Grohmann, this gouache dates from 1947 and is fourth in a set of six variations on a theme Baumeister painted between 1946 and 1948 (Grohmann 1965, p. 305, nos. 942–947). In the Detroit version, the color pink referred to in the title is limited to a few dabs of pigment superimposed upon an amorphous shape in red floating near the center of the composition. Elsewhere the ground is made up of delicate shades of blue interspersed with random touches of yellow, green, and slate gray. Silhouetted against the atmospheric ground are abstract forms painted in white and pale yellow. At the right and left of the composition these forms co-

alesce, giving rise to bizarre figures that are no longer entirely abstract, but belong to an intermediary realm where abstraction and representation meet. Vaguely human in appearance, they seem to belong to a primordial race of legendary beings engaged in a mysterious ritual. Whimsical in expression, their implied movement across the picture surface contributes to a mood of gaiety that is reinforced by the cheerful colors.

The gouache is one of more than forty compositions that make up the series *Figured Walls*, a theme to which Baumeister turned intermittently between 1942 and 1949 (Grohmann 1965, pp. 304–305, nos.

905–947). All the *Figured Walls* are inhabited by fantastic creatures composed of either pseudo-hieroglyphic signs or fragments of cyclopean forms reminiscent of Pre-Columbian reliefs. Although in some of the compositions this association is affirmed by such titles as *Mayan Wall* (Grohmann 1965, no. 910) and *Peruvian Wall* (Grohmann 1965, nos. 911–918), Baumeister's pictorial language is not dependent on any given prototype. It is a language of forms whose components he discovered accidentally in the course of the working process and explored for their associative value. This method, which Baumeister described in the third part of his book *Das Unbekannte in der Kunst* (1947, pp. 155–162), allies him closely with such artists as Paul Klee (see nos. 141–150).

Baumeister's *Figured Walls* are an outgrowth of his famous *Gilgamesh* series, on which he worked at the same time (Grohmann 1965, pp. 300–302, nos. 815–881 *passim*). Here, too, the forms are strongly archaic and resemble the imagery of a remote culture without having been copied from a specific source. Inspired by the ancient Sumerian and Babylonian epics, the forms originated in the depth of the artist's psyche, like a pictorial script activated by dim recollections on a subliminal level.

Max Beckmann

1884 Leipzig – New York 1950

38.
Sacrificial Meal, 1947

Plate V

Pen and black ink and watercolor on discolored laid paper; 502 x 320 mm

INSCRIPTIONS: Signed and dated with pen and black ink on recto in lower right corner, *Chase Hotel/ Beckmann/4.Okt 47/St. Louis*; with pen and blue ink on verso at upper right, *"Opfermahl" Sacrificial/ Meal/for Mr. Newberry/2. Nov. 47. St. Louis/pour souvenir./Max Beckmann*

ANNOTATIONS: With pencil on verso at upper left, *Newberry*; on verso at upper right, *"Am Spiess gebraten" 4. Okt. 47*

WATERMARK: Indecipherable

CONDITION: Left edge irregularly trimmed

PROVENANCE: John S. Newberry, New York

EXHIBITIONS: Cambridge 1948; New York 1948; St. Louis 1948; Ann Arbor, 1954; Detroit 1960; New York 1964; Frankfort and Hamburg 1965; London 1965

REFERENCES: Cambridge 1948, p. 21; New York 1948, no. 4; St. Louis 1948, p. 99, no. 89; Detroit 1960, no. 27; New York 1964, p. 152, no. 110; Elam 1965, pp. 68–69, ill.; Frankfort and Hamburg 1965, no. 104; London 1965, p. 33, no. 104; Göpel and Göpel 1976, 1: 450; Uhr 1982, pp. 46–47, color ill.

Bequest of John S. Newberry (1965.174)

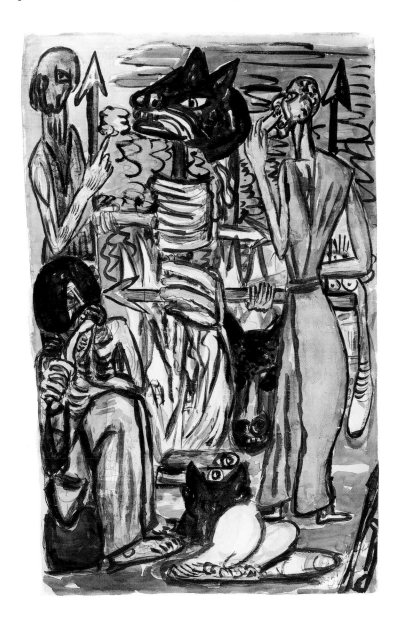

Beckmann's watercolor falls thematically within the context of the enigmatic parables of human existence into which he transposed his view of modern life and which found its most profound expression in the nine large triptychs he painted between 1932 and 1950. At first glance, the watercolor appears to illustrate little more than a sacrificial meal celebrated on a primeval cultural level, as two male figures in long robes prepare to roast large pieces of a dismembered carcass over a flaming fire, while a woman, seated in the left foreground, voraciously claws and feeds upon a chunk of meat. Three severed animal heads still dripping with blood, one impaled above the flames, the other two lying discarded on the ground, serve as grisly reminders of the slaughter that preceded. The deliberate calm with which the scene is enacted makes the event all the more terrifying, while the crude splendor of the colors—contrasting shades of red, yellow, and blue—reinforces the subject's violence. That the underlying meaning of the theme is

man's inhumanity toward his fellow man is borne out by the painting in the Stephan Lackner Collection, Santa Barbara, California (Göpel and Göpel 1976, 2: no. 750, pl. 273), for which the watercolor served as a preliminary study. In the painting, which was completed between October 9 and October 26, 1947, Beckmann translated the subject into one of overt cannibalism. The figure at the lower left was replaced by two bound naked women, while the two male figures drive their enormous spears through the gaping mouths of two severed human heads which they hold suspended above the flames of the open pit.

Dated October 4, 1947, the watercolor bears on the verso a dedicatory inscription to John S. Newberry, philanthropist and patron of the arts, and Curator of Graphic Arts at the Detroit Institute of Arts from 1946 to 1957. Beckmann, who painted Newberry's portrait in the fall of 1947, evidently presented the watercolor to him as a gift.

Julius Heinrich Bissier

1893 Freiburg/Breisgau – Ascona, Switzerland 1965

39.
18. Dez. 63, 1963

Gouache on cotton fabric; 165 x 231 mm

INSCRIPTIONS: Signed and dated with brush and brown paint on recto at lower left, *18. Dez. 63 / Jules Bissier*; with pencil on verso at lower left, *17 gr Perll. auf 1/2 LW + 1 Di / + wenig Kreide 2.12.63*

CONDITION: Good

PROVENANCE: Robert H. Tannahill, Grosse Pointe Farms, Michigan

EXHIBITION: Detroit 1970a

REFERENCE: Detroit 1970a, pp. 73, 96, ill.

Bequest of Robert H. Tannahill (1970.298)

Problems of technique were always of great interest to Bissier. In the summer of 1956 his experiments in this regard led him to the use of primed, unstretched canvases, cut into irregular shapes, and dry pigments in powdered form suspended in a homemade emulsion of egg and oil. Bissier called these works "miniatures." They are indeed small in size, typically measuring no more than eight inches square, although from 1959 on, somewhat larger dimensions are predominant in his work. Bissier also began using pieces of finely woven cotton, often referred to as batiste, during this time. Technically and conceptually, the Detroit work belongs to this later group of compositions on fabric.

In preparation for the Bissier retrospective held in Boston in 1964, Sue Thurmann observed the painter at work in his studio in Ascona (Boston 1964). Her description of his technical procedure is of great interest, for in Bissier's late works there is always a close relationship between execution and content. According to Thurmann's account, Bissier began by immersing in water the cloth upon which he was to paint, then wringing it out and pressing it with an iron until it was just barely damp. He then proceeded to cover the cloth with a mixture made of chalk and poppy seed oil over which he applied a coat or two of varnish. Always sensitive to problems of composition, he stopped the chalk-oil mixture just short of the edge of the cloth or allowed it to cover the cloth all the way, in which case he mounted the piece upon a backing mat for contrast. The dry pigments were blended with the egg-oil emulsion just

prior to application; sometimes Bissier accentuated the colors further by adding touches of watercolor or tusche.

Equally interesting is Thurmann's description of Bissier's work environment. His studio was of monkish simplicity, a cell measuring no more than seven feet in any direction with an uncommonly small door and window. Except for a stool and a tiny water basin that stood in one corner of the room, the floor space was claimed by a desk-size table upon which were laid out a few utensils: sable brushes, a porcelain mixing palette, a small sponge, and a book of gold leaf. All works of art were banished from the room except for the one lying on the table awaiting the master's hand, it's title – the day's date – already inscribed in a jerky calligraphy that eventually became an integral part of the composition. Not surprisingly, Bissier's introspective work habit has often been compared to that of medieval scribes and illuminators.

The Detroit work accords with the technical procedure described above, except that the pigments are said to be gouache (their actual composition may be more complex). The inscription on the verso, written sixteen days before the work itself was executed, is most likely contemporary with the ground and states the components and materials used. Painted in limpid hues, simplified jugs and funnels complemented by cruciform and pseudo-geometric shapes conjure up the impression of a still life. They are the logical products of the painter's meditative mind and convey an air of innocence and introspection that is the hallmark of Bissier's most mature works of this type.

Arno Breker

1900 Elberfeld

40.

Kneeling Female Nude (recto)
Figure (verso), 1930

Pen and black ink and sienna and black chalk (recto),
red chalk (verso), on cream laid paper; 480 x 317 mm

INSCRIPTION: Signed and dated with pencil on recto
at lower right, *A. Breker/30*

ANNOTATION: Blue customs stamp on verso in
lower left corner, *Zollzweigstelle Bahnhof
Friedrichstrasse Berlin*

WATERMARK: MBM

CONDITION: Good; slight yellowing at edges

EXHIBITION: Detroit 1935

Founders Society Purchase, Friends of Modern Art
Fund (1935.61)

Volume and plasticity are the dominant features of
Breker's drawings. In this example, delicate transi-
tions of light and shade, achieved through the use of
the stump and subsequent erasures, emphasize the
voluptuous forms of the full-bodied model, while
the double and triple contour lines, applied with pen
and black ink, endow the figure with a measure of
pliancy suggestive of vigorous movement. The en-
ergy manifested in the naked body is matched by the
alert expression of the model's face. Dated 1930, the
drawing recalls *Kneeling Woman*, a bronze Breker
executed in Paris in 1927 (Bodenstein 1974, p. 26, no.
17; an undated but closely related drawing showing
the same model in a nearly identical pose is
reproduced in Sommer 1942, no. 24). The verso of
the Detroit drawing bears a quick sketch in red
crayon partially outlining the body of a crouching
female nude.

Breker's drawing was probably included in the
exhibition of drawings by modern German sculptors
held at the Detroit Institute of Arts from March 5 to
March 31, 1935, and was most likely purchased by
the Friends of Modern Art for the museum's perma-
nent collection at that time.

Lovis Corinth

1858 Tapiau/East Prussia – Zandvoort, Holland 1925

41.
Pink Clouds, Walchensee, 1921

Plate VI

Watercolor and gouache on off-white wove paper;
362 x 510 mm

INSCRIPTIONS: With pen and black ink on recto at
lower left, *S/l Petermannchenchen/Urfeld/a/
Walchen-See/16 August 1921*; signed with brush
and black watercolor on recto near lower center,
LOVIS CORINTH

ANNOTATION: With pencil on verso at lower right, 7

CONDITION: Brown paper strips adhered to edges
on verso

PROVENANCE: Charlotte Berend-Corinth,
New York; B. Westermann Co., New York; Robert H.
Tannahill, Grosse Pointe Farms, Michigan

EXHIBITIONS: Detroit 1970a; Detroit 1976

REFERENCES: Detroit 1970a, pp. 75, 96, ill.; Detroit
1976, p. 192, no. 253, ill.; Uhr 1977, pp. 209–215,
fig. 1; Uhr 1982, pp. 58–59, color ill.

Bequest of Robert H. Tannahill (1970.299)

Like most of his Walchensee landscapes, Corinth's watercolor was painted in the immediate vicinity of his vacation home high above Urfeld, a secluded hamlet at the northern end of the lake, from which he enjoyed a superb view of the Karwendel and Wetterstein ranges beyond the far shore. Dated August 16, 1921, the watercolor is one of several views of the lake Corinth painted in the course of that summer and resembles most closely the oil painting in the Saarlandmuseum in Saarbrücken, *Walchensee, View of the Wetterstein* (Berend-Corinth 1958, p. 233, pl. XIII). In both landscapes, Corinth's empathic rendering of his perceptions resulted in an equilibrium of feeling and fact that not only places these works among his finest views of the Walchensee, but illustrates a particularly felicitous moment in both the evolution of his concept of landscape painting and the development of his late style.

In the Detroit watercolor, trees and branches frame a small mountain cottage, behind which the lake recedes into the distance. Wooded hills at the southeastern shore give way to the steep slopes of the Wetterstein massif. Having saturated the water-soaked paper with washes of yellow and pink, Corinth allowed small pools of burgundy red to collect around the peaks of the mountains, defining the details of the setting after the evocative ground had dried. Vigorous strokes of a rich, velvety black alternate with flashes of cool green and yellow in the trees and branches, retaining the relief texture and

glossy appearance of the watercolor paste wherever it was applied—like oil paint—directly from the tube. Strokes of black, modified now and then by admixtures of deep blue, slash across the hills in the distance and seep down from the sky in the upper right corner of the sheet.

Pink Clouds, Walchensee bears a dedication to Corinth's wife, the painter Charlotte Berend. The name "Petermannchenchen" in the inscription is the double diminutive of "Petermann," the term of endearment with which Corinth addressed his wife from the early days of their engagement, after she told him how she had once discouraged an unwanted suitor by inventing a story that she was an adopted child of gypsy descent, a daughter of the tribe Petermann (Berend-Corinth 1958a, pp. 117–120).

Herbert Bittner of the Westermann Gallery, New York, purchased the watercolor from Charlotte Berend-Corinth in 1937 and sold it to Robert H. Tannahill the following year. According to information provided by the donor, the watercolor was exhibited in the "Sixteenth International Watercolor Exhibition" at the Art Institute of Chicago in 1937 and at the Westermann Gallery in 1938. The catalogue of the 1937 Chicago exhibition, however, lists no works by Corinth, although a Walchensee watercolor by the artist was shown in the "Thirteenth International Watercolor Exhibition" there in 1934 (cat. no. 83). The information regarding the Westermann exhibition cannot be verified.

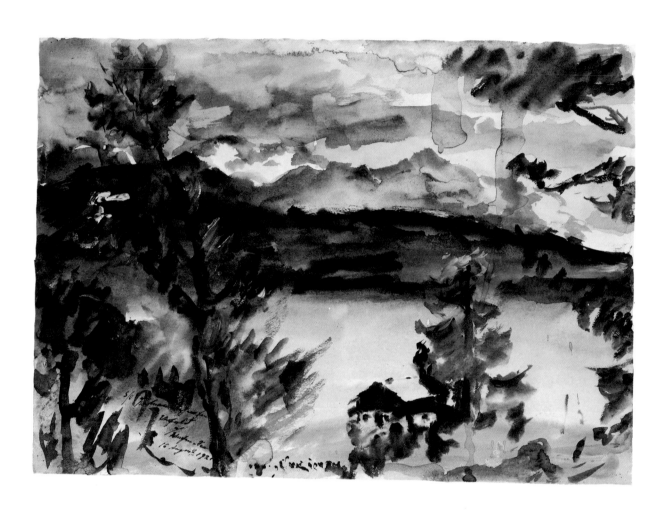

42.
The Art Student (Herbert Schönbohm), 1923

Graphite pencil on discolored wove paper with irregular left deckle edge; 457 x 337 mm

INSCRIPTIONS: With pencil in upper left corner, *Nro.1*; signed and dated with pencil to left of sitter's face, *Lovis Corinth/Nov. 1923.*

ANNOTATIONS: With pencil on recto in upper right corner, *9*; red customs stamp on verso in lower left corner, *H.Z.A.P. Berlin Abt. Niederlage No. 3*

CONDITION: Pencil slightly smudged

PROVENANCE: Allan Frumkin Gallery, New York and Chicago

EXHIBITION: Kansas City 1964

REFERENCES: Kansas City 1964, no. 32, ill.; Deecke 1973, pp. 103–104, 241, n. 281, 307, no. 192

Founders Society Purchase, Dr. and Mrs. George Kamperman Fund (1966.9)

Corinth's drawing, commonly known by the title *The Art Student*, typifies his late draftsmanship and epitomizes a conception that dominated his portraits from 1918 onward. These portraits do not necessarily capture the character of a given sitter, but rather tend to reflect the artist's own feelings. They are documents of self-expression insofar as Corinth projected upon his sitters something of his own increasingly frail existence—the effect of a stroke he had suffered on December 11, 1911.

Except for the nervous lines employed in the contours, the graphic pattern in the Detroit drawing follows a predominantly diagonal direction without any true commitment of modeling, anatomical plausibility, or spatial depth. As a result, the sitter, although depicted in an ostensibly quiet pose, acquires an air of instability, manifested in a peculiar elasticity that allows his figure to expand and contract simultaneously as if distorted in a curved mirror. These stylistic traits, shared by virtually all of Corinth's late paintings, drawings, and prints, were only partly physiological in origin. From the wide range of distortions found in his late works, it is also evident that Corinth intentionally explored the expressive potential of what had begun as an enforced

dissolution of form. This is especially well documented in the drawings he had made between 1912 and 1917. They not only illustrate the process that led from Corinth's initial attempt to regain physical control of the medium to his gradual acceptance of the inevitable dissolution of form, but suggest that the degree of departure from verisimilitude in any given work is a direct measure of the depth of his empathy with the subject. In 1923 Corinth translated the Detroit drawing into a drypoint which, while following the stylistic conventions of his late draftsmanship, is more impressionistically rendered and, as a result, conveys less of the sitter's ambivalent presence (Müller 1960, no. 696).

From information supplied by the artist's son Thomas, Deecke identified the individual in the Detroit drawing as Herbert Schönbohm, at one time Corinth's student. A more objective portrait of Schönbohm, done in crayon and dated 1923, is in the Kestner Museum, Hannover (Lübeck 1965, no. 98), erroneously identified as a portrait of Thomas Corinth. A third portrait drawing of Schönbohm, also done in crayon and dated—like the Detroit drawing—November of 1923, is in the Nationalgalerie, Staatliche Museen, Berlin.

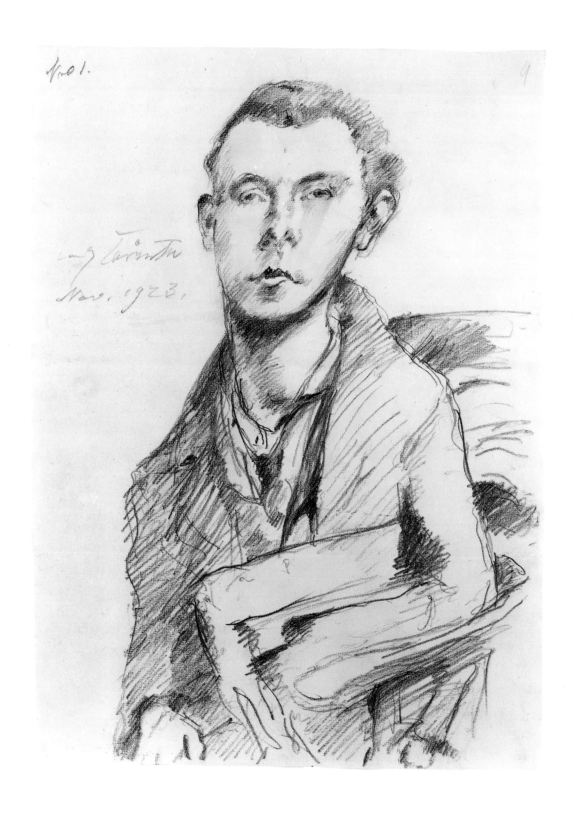

Lovis Corinth
Nov. 1923.

Otto Dix

1891 Untermhaus/Thuringia – Singen/Lake Constance 1969

43.
Portrait of the Artist's Son Ursus, 1931

Plate VII

Watercolor and graphite pencil on cream wove paper; 564 x 390 mm

INSCRIPTION: Signed with pencil on recto at upper left, *DIX.*

ANNOTATIONS: With pencil on verso near lower center, *Ursus*; with pencil on verso at center of lower margin, *Lg. 1823*

CONDITION: Good; vertical streaks through the face of the child may have occured at the time the portrait was executed

PROVENANCE: J. B. Neumann, New York; Robert H. Tannahill, Grosse Pointe Farms, Michigan

EXHIBITIONS: Cleveland 1934; Detroit 1936; Chicago 1937; Detroit 1970a

REFERENCES: Chicago 1937, no. 30; Detroit 1970a, pp. 75, 97, ill.

Bequest of Robert H. Tannahill (1970.300)

This watercolor is a study for Dix's portrait of his son Ursus, painted in 1931 (private collection, on loan to the Galerie der Stadt Stuttgart; Löffler 1981, no. 1931/4). The watercolor anticipates the painting in pose and composition, but shows greater freedom in the handling of color and form. There is less emphasis on detail, and the watercolor washes retain a robust freshness, reinforcing the simple and unaffected conception. The red of the boy's trousers, his blond hair, and the delicate pink of the flesh tones are set off by vigorously applied shades of blue, green, and brown in the background. A similarly relaxed draftsmanship is apparent elsewhere in Dix's graphic production of the years 1927–32, marking a departure from the incisive description of human folly and vice that dominated his penetrating character studies in the early and mid-1920s. By the end of the decade, Dix turned his attention to subjects of a more conciliatory nature, and a more dispassionate objectivity began to govern his style.

Born in Berlin on March 11, 1927, Ursus Dix was approximately four years old when the watercolor was painted. It is one in a series of portraits that documents the pride and joy Dix took in his eldest son. The birth of Ursus had moved Dix deeply. A painting recording his birth (Löffler 1981, no. 1927/12) was never completed, although the daring verisimilitude with which Dix conceived the scene survives in at least two preliminary studies for the work (Conzelmann 1969, nos. 92–93). In numerous subsequent drawings, watercolors, and paintings, Dix traced his son's development through the first year (Conzelmann 1969, nos. 88–91; Essen 1971, no. 140; Stuttgart 1981, no. 108; Löffler 1981, nos. 1927/5–8, 1928/5). Later paintings show Ursus at play, either alone (Löffler 1981, no. 1928/4) or with his older sister Nelly (ibid., no. 1929/2); Ursus is also included in a family portrait of 1927 (ibid., no. 1927/4) and appears for the last time with his younger brother Jan in Dix's self-portrait of 1934 (ibid., no. 1934/2).

Karl Doebel

1903 Kassel 1959

44.
Twilight, 1934

Watercolor on linen mounted on cardboard;
403 x 532 mm

INSCRIPTION: Signed and dated with pen and black
ink on recto at lower right, *Karl Doebel 34*

CONDITION: Good; lightstruck

PROVENANCE: Curt Valentin, Berlin

EXHIBITION: Detroit 1936

REFERENCE: Newberry 1936, pp. 37, 41

Founders Society Purchase, Friends of Modern Art
Fund (1936.45)

Ships by the seashore was Doebel's major theme. Surmounted by the sun, the moon, or the stars, they are shown singly and in groups, the many variations unified by a lyrical conception which in the course of Doebel's career became progressively more pronounced. Dated 1934, *Twilight* is one of these quintessential works. Flat washes of gray, light yellow, and blue give rise to a hushed and meditative mood, and only the sketchiest outlines allude to the material essence of the boats and the terrain.

George Grosz

1893 Berlin 1959

45.

Tangle of Lives, early 1920s

Pen and black ink on off-white discolored wove paper; 641 x 491 mm

INSCRIPTIONS: With pencil on recto at lower left, *18* (crossed out) *N⁰ 1 Knäuel*; with pencil on verso at lower right, *25 Cafe Terrasse*

ANNOTATIONS: With pencil on recto at lower center, *-19-*; with pencil on recto in lower right corner, [illegible traces of erased annotation] */323*; with pencil on verso at lower left, *Ulk reprod. 1930*; with pencil on verso in lower left corner, *B 12819*; with pencil on verso near center of sheet, *345* (in circle); with pencil on verso near upper center, *605* (in circle); with pencil on verso in upper left corner, *1902.*; label on verso at upper left, *NST*

WATERMARK: VIDACON-LES-ANNONAY B CRAYON ANC^{NF} MANU ^{FAC} CANSON & MONTGOLFIER

CONDITION: Surface grime; tears mended with pressure-sensitive tape

PROVENANCE: Unidentified collector (blue collector's mark on verso in lower left corner); The Mayor Gallery, Ltd., London (gallery label on verso at upper right near center, *#605*); Dr. and Mrs. Hanns Schaeffer, New York

Gift of Dr. and Mrs. Hanns Schaeffer (1946.278)

Grosz frequently turned to street and café scenes to vent his scorn at the petty and philistine world of the bourgeoisie, castigating those whose comforts depended on the exploitation of others. Less contemptuous in tone than the bitter indictments of German society Grosz made immediately after the First World War, this drawing is datable on the basis of style and conception to the early 1920s. Compositionally it is still indebted to Grosz's works from the preceding years: there is no unified perspective, and figures of a different scale have been piled up in the same vertical plane. The characterizations, on the other hand, are not as exaggerated as those in Grosz's earlier caricatures and are based less on invention than on observation made in a sidewalk café in Berlin. As a result, the drawing depicts most of the figures as both individuals and social types. In the lower right, there is the successful, well-dressed businessman or profiteer, sporting a walking cane and gloves. Three contrasting types share a table near the center of the composition. The man in the middle facing the viewer is the very image of bourgeois propriety, subservient to his two companions, one ruthless, the other calculating and shrewd in expression. Further contrasts are explored in the soulful features of the debonair dandy and the brutal physiognomy of the pimp and in the juxtaposition of two matrons and two prostitutes. One of the prostitutes is eyeing the gathering like a greedy bird of prey. The other's face, more skull than flesh, evokes the traditional *vanitas* symbol signifying the transitory nature of all earthly pleasures. The phallic image pointing obscenely in the direction of her lap has given way, in the lower left, to a more discreet reference to hidden desires, as the lines defining the seated man's lower leg cross into the anatomy of the woman.

George Grosz, *Tangle of Lives* (cat. no. 45)

46.
Conversation, ca. 1928

Pen and pale sienna ink and watercolor on cream wove paper; 780 x 573 mm

INSCRIPTION: Signed with pen and black ink on recto at lower right, *Grosz*

ANNOTATION: With pencil on recto at lower left margin, *9 nach dem Souper*

WATERMARK: P. M. FABRIANO

CONDITION: Edges creased where once folded; surface grime

PROVENANCE: Galerie Alfred Flechtheim, Berlin

EXHIBITION: Berlin 1962

REFERENCES: Berlin 1962, p. 95, no. 99; Uhr 1982, pp. 72–73, color ill.

City of Detroit Purchase (1930.380)

Conversation dates from about 1928 and was painted in conjunction with a group of watercolors and drawings, sixty of which were published in 1920 by Paul Cassirer in Berlin under the title *Über alles die Liebe* ("love above all"). Illustrating a variety of relationships among married and unmarried members of the middle class, the selection was intended as a satirical commentary on the hypocrisy of bourgeois morals.

In this scene a man and a woman, both elegantly dressed, gaze at each other with mock affability, their features a mixture of fawning and smug self-esteem. That their interest in each other is by no means confined to casual discourse is implied by the provocative position of the maid bending over a champagne cooler. The lecherous nature of human relationships, which Grosz usually suggested by means of large breasts and buttocks and lumpy genitalia pressing through the clothing of his figures, has been somewhat understated, although the woman's dress, clinging tightly to her body, has been rendered virtually transparent. The soft colors, dominated by pink, light brown, and blue, tend to diminish the satirical tone of the subject. Applied in delicate shades that are largely independent of the graphic elements of the composition, they differ from the heavier watercolor washes that Grosz used to reinforce the outlines of his figures in the early 1920s.

The Detroit watercolor was not included in Cassirer's publication, but was replaced by a more suggestive variation on the subject, entitled *After the Meal*. Omitting the woman, this watercolor depicts the maid in the same provocative position, with the man, whose pose is also repeated, observing her appreciatively from behind (Grosz 1930, no. 111).

47.
Vendor, 1930s

Graphite pencil, watercolor, and black crayon on off-white wove paper ruled with blue lines; 146 x 92 mm

INSCRIPTION: Signed with pen and black ink on mount at lower right of composition, *George Grosz*

CONDITION: Good

PROVENANCE: John S. Newberry, New York

Bequest of John S. Newberry (1968.177)

The objective portrayal of the street vendor suggests that this sketch was done during the 1930s, after Grosz had settled permanently in the United States. The draftsmanship is less incisive than in Grosz's cynical depictions of working-class types from the 1920s, and there is greater emphasis on conventional painterly values in the use of the colors. The absence of any didactic intent is indicative of the naïve optimism with which Grosz viewed life in America.

This sketch is glued as a frontispiece into a copy of George Grosz's book *Drawings,* published by H. Bittner and Co., New York, in 1944. Grosz added the following inscription to the front inside cover of the book: *No. 11 of a limited edition of 12 copies/George Grosz.* The page to which the drawing has been affixed bears the artist's full signature at the lower right.

48.
New York, 1934

Watercolor on cream wove paper; 665 x 482 mm

INSCRIPTION: Signed and dated with pen and brown ink on recto in lower right corner, *Grosz/34/N.Y*

WATERMARK: P. M. FABRIANO

CONDITION: Good

PROVENANCE: George Grosz, New York; Lillian Henkel Haass, Detroit

EXHIBITIONS: Berlin 1962; Detroit 1970

REFERENCES: Berlin 1962, p. 96, no. 112; Detroit 1970, pp. 30–31, ill.; Uhr 1982, pp. 74–75, color ill.

Gift of Lillian Henkel Haass (1934.162)

This watercolor is one of a large number of views of New York that Grosz painted during his early years in the United States. Most were produced between the time of his emigration in January 1933 and his move to Douglaston, Long Island, three years later. Some date from his first visit to New York in the summer of 1932, when he was a guest lecturer at the Art Students League. While in his New York street scenes and in his portrayals of American social types there is still a hint of Grosz's old satirical attitude, these watercolors differ markedly from his German works. They reflect a sympathetic curiosity about

America and the American way of life, rather than a desire to criticize or to judge. Grosz's panoramic views of New York are of special interest within the context of his development at this time, because they give the clearest indication of his efforts to redefine himself in America, not as a satirical draftsman, but as a painter in the traditional sense.

Dated 1934, this watercolor exemplifies not only Grosz's new attitude toward the pictorial qualities of his art, but the emotional detachment characteristic of his work of the mid-1930s. While in the past he had cared little for conventional aesthetics, the firmly controlled washes of considerable density, resulting in a glossy surface texture reminiscent of oil paint, and the individual hues—shades of red, blue,

brown, and black—have been carefully adjusted so as to achieve tonal unity. The scene itself is not an actual view, but a composite of different impressions assembled from sketches made in several places at different times. Elements of Grosz's former style are still evident in the futuristic simultaneity of the buildings depicted. In contrast to his earlier programmatic compositions, however, which were based on the satirist's pessimistic conception, the kaleidoscopic arrangement of billboards, corniced tenements, and a church steeple, dwarfed by skyscrapers of fantastic height, evokes a romanticized image of the American metropolis (see also *New York Harbor*, no. 49).

49.
New York Harbor, 1934

Plate VIII

Watercolor on off-white wove paper; 664 x 482 mm

INSCRIPTION: Signed and dated with pen and brown ink on recto in lower left corner, *Grosz/34*

WATERMARK: P. M. FABRIANO

CONDITION: Good

PROVENANCE: Robert H. Tannahill, Grosse Pointe Farms, Michigan

EXHIBITIONS: Detroit 1936; Detroit 1970a

REFERENCE: Detroit 1970a, pp. 75, 97, ill.

Bequest of Robert H. Tannahill (1970.301)

This view is not a description but an evocation of New York harbor, teeming with tenders and barges, a ferry, and a giant ocean liner docked in the shadow of the Manhattan skyline. As in the watercolor *New York* (no. 48), images of a different scale, and a variety of visual impressions, have been joined together to produce what is essentially a paean to the great seaport, replete with an airplane in the sky. Painted in 1934, the watercolor betrays the awestruck vision of the recently arrived immigrant. Everything has been transposed into the superlative—size, distance, and height. Already as a boy Grosz had yearned to see America, and as early as 1916 had anglicized his first name, changing it officially from Georg to George, to express his enthusiasm for the United States. As if to pay special homage to his new homeland, he prominently displayed the American flag at the left of the composition, far too large in relation to the setting and, as if miraculously hoisted, suspended without any visible support. The colors, a combination of shades of red, blue, brown, and gray, have been subdued in the interest of tonal harmony. The pigments have been applied rather heavily in part, endowing the surface of the watercolor with a rich, glossy texture. Closely related to the Detroit work, although somewhat more grandiose in conception, is the watercolor of New York harbor in the Metropolitan Museum of Art, which Grosz painted two years later (Hess 1974, p. 206, fig. 191).

John Gutmann

1905 Breslau

50.

Three Female Bathers on the Beach (recto)
Figure (verso), ca. 1936–37

Black ink, black chalk, and pastel (recto), black ink
(verso), on discolored wove paper; 652 x 502 mm

INSCRIPTION: Signed with pen and black ink on
recto at lower right, *J.G.*

CONDITION: Poor quality paper faded from original
purplish color to brownish tan; losses at corners;
repaired tears along upper and lower edges

PROVENANCE: John Gutmann, San Francisco (1937);
Dr. and Mrs. Ernst Scheyer, Detroit

EXHIBITIONS: Detroit 1937; Detroit 1938;
Detroit 1976

REFERENCE: Detroit 1976, p. 196, no. 258

Gift of Dr. and Mrs. Ernst Scheyer (F1976.112)

Though better known as a photographer, Gutmann
began his career as a painter. He studied with Otto
Mueller at the Breslau Academy and in 1927 con-
tinued his training at the Academy in Berlin. Even
after he turned to photography as a profession in
1933, he remained active as a painter and draftsman.
When he joined the faculty of San Francisco State
College in 1936, he introduced new studio classes
and a survey of modern art long before he developed
a similar program in creative photography.

According to Ernst Scheyer (verbally, December
31, 1982), the Detroit drawing was executed some-
time in 1936 or early 1937; he purchased it from
Gutmann on a visit to San Francisco in August 1937.
Even though Gutmann had left Mueller's studio a
decade earlier, the profound influence of Mueller,
who considered Gutmann one of his favorite pupils,
is seen not only in the thematic choice, but in the
simplified portrayal of the human figure (see no. 97).
Without emulating the introspective mood pro-
jected by Mueller's languid nudes, Gutmann, like his
teacher, conceived the composition in terms of the
rhythmic interrelationship of its individual parts.
The pictorial structure of the drawing is determined
by the poses and gestures of the bathers, whose an-
gular limbs are accentuated by heavy contours
painted in black wash. There is only a hint of model-
ing, and except for a few touches of pastel—specks of
yellow, red, brown, and white—the figures are un-
modified by color. The original effect of the drawing
must have been richer than it is today, since the
plum-colored paper has faded to a dull tan. An al-
most identical sketch of the tall bather in the center,
swiftly executed in black wash, is repeated on the
verso of the sheet.

Johann Hammann (Hammann-Bensheim)

Active in Bensheim/Bergstrasse

51.
Tree, 1922

Black crayon on tan wove paper; 219 x 281 mm

INSCRIPTIONS: Signed and dated with pencil on recto at lower right, *Hammann*; on paper support below right of composition, *Hammann-Bensheim 1922.*

ANNOTATION: Label on verso of mount in upper left corner, *Johann/Hammann-Bensheim/Bensheim[11]/[11] 17./[indecipherable]/[indecipherable]/ [indecipherable]/Hammann*

CONDITION: Surface grime; solidly mounted to thin cardboard

PROVENANCE: Mr. and Mrs. Bernhard Sterne, Detroit

Gift of Mr. and Mrs. Bernhard Sterne (F1974.63)

The label glued to the backing of this drawing identifies the artist as Johann Hammann, who also signed his name "Hammann-Bensheim," after Bensheim, a small town on the Bergstrasse, just south of Darmstadt. Both signatures are found on the label, while the drawing is simply inscribed *Hammann*. The expanded signature and date, *Hammann-Bensheim 1922*, appears on the paper support at the bottom right of the composition. Nothing seems to be known about Hammann's career, and the drawing itself allows little room for conjecture as to his possible artistic origins. The simplified design, based on the contrast between the black silhouette of the stylized tree and the undifferentiated tan of the paper ground, suggests an affinity with the decorative arts, while the conception is indicative of a romantic imagination. Indeed, the gnarled tree trunk and the exaggerated sweep of the barren branches are more likely to conjure up the evocative character of a stage property than the image of a tree observed in nature.

Hans Jaenisch

1907 Eilenstedt/Halberstadt

52.

Indian Chief in Battle Dress, ca. 1943–45

Watercolor and pen and black ink with additions of white gouache on discolored wove paper; 370 x 243 mm

INSCRIPTIONS: With pen and black ink on recto at upper left, *30/5 Indianer im Kriegsschmuck/im Camp*; with pencil on recto at upper right, *für meinen Freund/Pit Szluk/9-9-49*; signed with pen and black ink on recto at lower left, *Jae*

CONDITION: Mark from a cup or glass in upper right corner; repaired tears at lower right

PROVENANCE: Mr. and Mrs. Peter F. Szluk, Phoenix, Arizona

Gift of Mr. and Mrs. Peter F. Szluk (1973.241)

This watercolor was painted sometime between the autumn of 1943 and the end of 1945, while Jaenisch was a prisoner of war in the United States. Assigned to camps in Tonkawa, Oklahoma, and Roswell, New Mexico, he became fascinated by the exotic appearance of the native Indian and austere beauty of the American southwest and made numerous drawings and watercolors during these years. The pictorial world he discovered there reminded Jaenisch of North Africa, where he had spent the preceding four years as a member of the German Afrika Corps. Stylistically, too, his American works bear the mark of the decorative approach to color and form Jaenisch had first developed during his study of ancient African rock drawings and the ornamental idiom of Islamic art.

In this watercolor the image appears as if constructed from many individual color panes, held together by a network of lines that ties the composition firmly to the surface of the sheet. The figure of the Indian chief, although the main focus of the composition, is no more important pictorially than the environment he occupies. The colors of his battle dress—shades of red, orange, and ocher—have been extended to the setting, while the lines, which find a logical explanation in the decorative details of the costume, impose their abstract rhythm on much of the composition irrespective of any descriptive function. Jaenisch added the dedicatory inscription in the upper right corner of the sheet on September 9, 1949, when he presented the watercolor as a gift to his American friend Peter Szluk.

53.
Red Sun over Towers, early 1960s

Watercolor and black crayon on cotton fabric;
190 x 270 mm

INSCRIPTION: With brush and light brown water-
color on recto at upper right, *Jae*

CONDITION: Good

PROVENANCE: E. Weyhe, Inc., New York; Robert H.
Tannahill, Grosse Pointe Farms, Michigan

EXHIBITION: Detroit 1970a

REFERENCE: Detroit 1970a, pp. 75, 98, ill.

Bequest of Robert H. Tannahill (1970.302)

Red Sun over Towers dates from the early 1960s and belongs to a group of abstractions for which Jaenisch coined the term "Fuguettes" (New York 1963b). As in a musical composition, the pictorial elements are arranged so as to form contrasting and complementary motifs based on the fugal principles of repetition and variation. Vertical, horizontal, and diagonal strokes of watercolor intersect each other at fairly regular intervals at the left, yielding a spiky treelike structure. This distinct configuration is set off against the mellower forms of a series of brown vertical rectangles rising progressively in height and diminishing in saturation toward the top. Continuing the musical analogy, each of the two main motifs is, in turn, accompanied by its own basso continuo: a unified field of gray wash rises at the left; a horizontal band of green with a brown core stretches across the bottom. Additional washes of gray and blue border the top and sides of the composition; the frayed edges of the cotton ground are tinged with brown. Near the top of the spiky structure appears a red squarish shape that is echoed in modified form and hue in the inverted red triangle at the bottom of the gray field at the left. Throughout the composition the interaction of the colors with the fine cotton ground remains an integral part of the conception. As the washes are dissipated into the texture of the cloth, the pictorial elements gently fade away.

Despite the descriptive title, which may not be the artist's own, it would be futile to invest the pictorial elements with any specific representational significance. What Jaenisch aimed for in his "Fuguettes" was an artistic reality. Resemblances to anything seen or known are purely fortuitous. He continued to observe the forms of nature at this stage in his development, but did so in order to understand nature's laws of coordination and structure, which he then sought to translate into modulations of color and form.

Jaenisch's "Fuguettes" were painted on the island of Amrum, off the west coast of Denmark, where he kept a summer home. Amrum is an austere, wind-swept place of sand dunes and moss-covered cairns marking ancient graves, and thus utterly unlike the modern industrialized landscape of forms that the Detroit watercolor may conjure up for some viewers. He generally painted these small abstractions on pieces cut from old sails discarded by the local fishermen, utilizing the unique texture that resulted from the prolonged exposure of the cloth to the salty sea air and the sun. The ground in the Detroit work, however, is too delicate ever to have been put to such tough use, and the textural distinctions are solely the result of the painter's own manipulation of color.

Max Kaus

1891 Berlin 1977

54.
Portrait of the Artist's Wife, 1921

Plate IX

Gouache, watercolor, and graphite or pastel on
off-white wove paper; 422 x 520 mm

INSCRIPTION: Signed and dated with pencil on recto
at lower left, *MKaus 21*

CONDITION: Good

PROVENANCE: Rudolph M. Riefstahl, Perrysburg,
Ohio

EXHIBITION: New York 1937

Founders Society Purchase, Director's Discretionary
Fund (1967.132)

Kaus's portrait of his wife is typical of the introspective work he produced during the years immediately following the end of the First World War. Although the model is identifiable, Kaus was interested neither in the appearance nor in the feelings of a specific individual. In an effort to reveal the essence of things, he sought to render a universal state of human experience in a generalized and commensurably expressive form. Pressed into a shallow space, the woman embodies the epitome of loneliness. Despite her physical proximity to the viewer, her deceptively steady gaze remains inner-directed, while the glowing shades of red, green, and blue merely add a touch of lyricism to the drawing's reflective mood. Kaus shared this empathetic sense of the frailty of man with Erich Heckel (1883–1970), whom he had met while serving as a hospital orderly in Belgium between 1915 and 1918, and whose melancholy figures project a similar attitude of emotional withdrawal.

Ernst Ludwig Kirchner

1880 Aschaffenburg – Davos 1938

55.
Smoker and Dancer, 1912

Graphite and black crayon on cream wove paper;
559 x 365 mm

INSCRIPTIONS: Signed and dated with pencil on
recto at lower right, *E L Kirchner.*; with pencil on
verso at lower right, *Raucher und Tanzerin/1912*

ANNOTATIONS: With pencil on recto at lower left,
2680/2; with red crayon on verso at upper left, *34*;
with pencil on verso at lower left, *21d/2*

CONDITION: Corner and upper edge creased and
broken; graphite and crayon smudged

PROVENANCE: E. L. Kirchner Estate (blue artist's
estate stamp on verso in lower left corner [L. Suppl.
1570b] annotated with pen and black ink, *K BelBg 1*);
Kornfeld and Klipstein, Bern, 1967

REFERENCES: Bern 1967, cat. 123, p. 98, no. 660;
Uhr 1982, pp. 98–99, ill.

Founders Society Purchase, John S. Newberry Fund
(1967.270)

Smoker and Dancer illustrates Kirchner's ability to
report a sensation swiftly and to translate his im-
pressions into a pictorial equivalent. Slashing diago-
nals, their rhythms accelerating to a nervous flutter
in the dancer's hand, combine with sweeping curves
to convey the idea of vigorous motion. The spatial
thrust of the setting has been similarly energized by
the steep perspective and the tension engendered by
the contrast between the figure of the dancer and the
rapidly diminishing scale of the smoker reclining on
the couch in the background. At the same time, the
graphic elements remain tied to the picture surface,
having been carefully adjusted to the dimensions of
the paper so as to achieve an equilibrium of image
and ground and to transform the composition into a
linear abstraction that embodies as much as it de-
scribes the scene. Kirchner, commenting on his
drawings in 1920, called such abstractions "hiero-
glyphs" (Marsalle 1920, p. 217).

The Detroit drawing of 1912 belongs to a group of
works that announce Kirchner's mature and most

typically Expressionist style, a style that was to
reach its characteristic form in the pulsating and
hectic compositions of his Berlin street and cabaret
scenes of 1913–14. The spatial tension and surging
rhythms of angular and curvilinear forms are found
in the paintings he did in the summer of 1912 on the
island of Fehmarn. Among his graphic works, the
drawing has close affinities to a colored crayon
drawing in Bremen, *Bathing Girl by the Rocks*, also
done at Fehmarn (Bremen 1972, no. 27) and to a pen-
cil drawing of 1912, *Two Dancing Female Nudes*, in
the Staatliche Kunstsammlungen, Kassel (inv. MG
1964/48; Berlin 1979, pp. 204–205, no. 207).

Iconographically, the drawing reflects Kirchner's
lifelong interest in the naked human figure in move-
ment. It probably had its origin in the bohemian
atmosphere of the artist's studio in Berlin and recalls
such incidents as the one captured in photographs
taken by Kirchner in 1915, in which his friend Hugo
Biallowons is seen performing an impromptu dance
in the nude (Berlin 1979, pp. 72–73, figs. 75–76).

Ernst Ludwig Kirchner, *Smoker and Dancer* (cat. no. 55)

56.
Landscape with Mountain Lake,
ca. 1923–26

Plate X

Watercolor over graphite pencil on off-white wove paper; 363 x 448 mm

ANNOTATIONS: With pen and black ink on verso in lower left corner, *Figurenkomposition*; with pencil on verso in lower right corner, *10* (in circle) *2*

CONDITION: Good

PROVENANCE: E. L. Kirchner Estate (purple artist's estate stamp [L. Suppl. 1570b] on verso at lower left) annotated with pen and black ink, *ADa/Aa 84*

EXHIBITIONS: Raleigh 1958; Düsseldorf 1960; Detroit 1966; Detroit 1970a

REFERENCES: Raleigh 1958, pp. 60, 117, no. 61, ill.; Düsseldorf 1960, no. 120, ill.; *BDIA* 45, nos. 3–4 (1966): no. 31; Detroit 1970a, pp. 75, 99, ill.

Bequest of Robert H. Tannahill (1970.303)

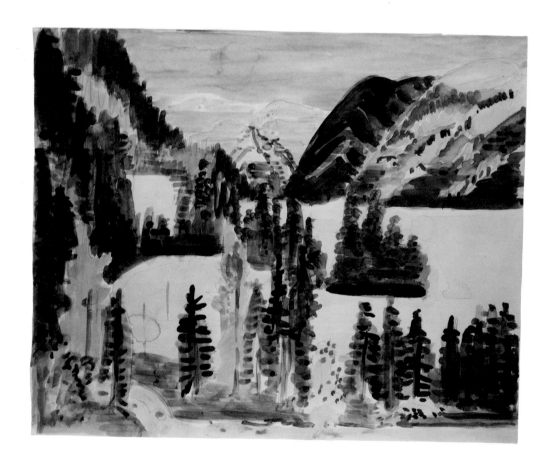

In the watercolor *Landscape with Mountain Lake* the spatial thrust of the setting is subordinated to the integrity of the two-dimensional picture plane, except that the predominantly flat rendering of the individual color areas has given way to a richly textured surface. While the mountains create an illusion of spatial depth, the trees and wooded islands have been flattened so as to assume the character of silhouettes, absorbed into the blank paper surface that substitutes for the expanse of the lake. The colors, ranging from orange and yellow to shades of blue and green, have been applied in short parallel brushstrokes. Alternating between a vertical and a horizontal direction, they strengthen the similarity between the picture surface and the woven texture of a tapestry. The technique is similar to the one Kirchner used in *Wildboden*, a watercolor of 1923 in the Städelsches Kunstinstitut, Frankfort (inv. SG 2930; Berlin 1979, pp. 276–277, no. 353). A reliance on repetitive vertical and horizontal patterns is also seen in several of Kirchner's paintings from 1924–25 (Gordon 1968, nos. 767, 793, 795-799).

57.
Mountain Landscape, ca. 1923–26

Plate XI

Watercolor over pen and gray ink on off-white wove paper; 286 x 425 mm

ANNOTATIONS: With pencil on verso at lower left, *12381*; on verso in lower right corner, *P G 2 1/4*; on verso near upper left, *16 x 22*

CONDITION: Slight yellowing

PROVENANCE: E. L. Kirchner Estate (purple artist's estate stamp [L. Suppl. 1570b] on verso in lower left corner annotated with pen and black ink, *ADa/Aa 106*); Buchholz Gallery, New York, 1951; John S. Newberry, New York

EXHIBITIONS: Cambridge 1950; Detroit 1960; Boston 1962; Detroit 1965; Detroit 1966; Lima 1968

REFERENCES: Cambridge 1950, p. 7; Detroit 1960, no. 11, ill.; Detroit 1965, p. 49, ill.; *BDIA* 45, nos. 3–4 (1966): 57, no. 29

Bequest of John S. Newberry (1965.224)

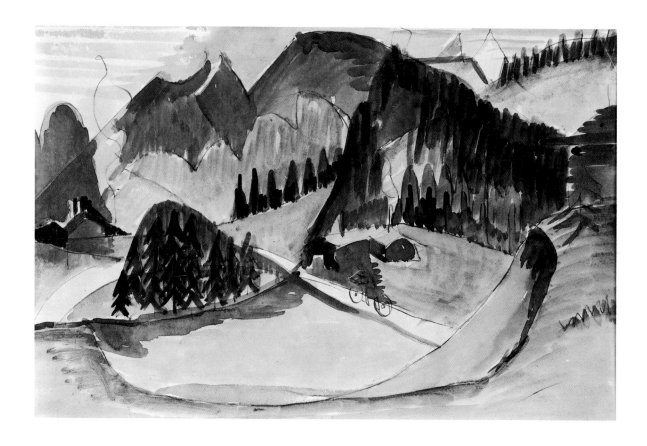

Kirchner's *Mountain Landscape* was probably painted in the vicinity of his house at Wildboden, near Davos-Frauenkirch, where he settled in October 1923. Although the site cannot be specifically identified, the crescent-shaped mountain top at the left and the narrow, winding path, animated by the whimsical figure of a bicyclist, suggest that the view may be toward the Sertig valley, a subject Kirchner painted a number of times following his move to Wildboden (Gordon 1968, nos. 757–758, 796, 799).

The watercolor belongs to the first phase of Kirchner's post-Expressionist development and is datable on stylistic grounds to the period from 1923 to 1926. These were the years during which Kirchner collaborated closely with the Swiss weaver Lise Gujer, whose hand-woven tapestries encouraged

him to place greater emphasis on purer and lighter colors and on the decorative unity of the picture surface. For all its apparent spontaneity, the composition of the watercolor is carefully constructed, unifying surface pattern and the illusion of space. Except for the curvilinear rhythm that is introduced by the winding path and the slope of the hill in the lower part of the composition, the landscape is made up of a series of modified triangular shapes describ-ing both the valley in the foreground and the mountains in the far distance. The cluster of pine trees, foreshortened houses, and winding path still serve a space-defining function. Yet the decorative logic of the design is affirmed by the brilliant hues of orange, green, purple, and blue. Applied in fairly unified washes within the graphic pattern of the design, they reinforce the architectonic structure of the composition.

58.
Vase of Flowers, 1929

Watercolor over pen and ink on off-white wove paper; 506 x 362 mm

INSCRIPTION: Signed and dated with pencil at lower right, *E L Kirchner 29*

ANNOTATION: With pencil on verso in lower right corner, *25*

CONDITION: Good

PROVENANCE: Unidentified collector (blue collector's mark on verso at lower left, *I* over *28* [in circle]); Robert H. Tannahill, Grosse Pointe Farms, Michigan

EXHIBITIONS: Raleigh 1958; Düsseldorf 1960; Detroit 1970a

REFERENCES: Raleigh 1958, pp. 60, 115, no. 59, ill.; Düsseldorf 1960, no. 119, ill.; Detroit 1970a, pp. 75, 98, ill.

Bequest of Robert H. Tannahill (1970.304)

Painted in 1929, Kirchner's watercolor *Vase of Flowers* illustrates that his development toward an increasingly abstract conception did not exclude an occasional digression into a more naturalistic style. The pink, purple, and pale blue flowers—set against broad washes of brown, blue, and green—have been carefully observed, with attention to their individual appearance and character and random placement in the bouquet. Even the shape of the vase, formed by the white paper ground, achieves sufficient volume through the judicious placement of a few shadow lines. In two flower still lifes of the same period, a colored crayon drawing of about 1928, *Field Flowers in a Vase* (Kirchner Estate; Campione 1964, p. 73), and a watercolor from 1928–30 (formerly collection of Ernesto Blohm, Caracas; Campione 1971, pp. 54–55, no. 27), the shapes of the flowers and the vase are considerably modified so as to produce a decorative surface pattern. This is also true of two slightly later flower still lifes in oil, *Meadow Flowers and Cat*, 1931/32, and *Umbrella Flowers with Newspaper and Sculpture*, 1930–32 (Gordon 1968, nos. 955–956). The stylistic disparity does not necessarily cast doubt on Kirchner's own dating of the Detroit watercolor, as has been assumed (Raleigh 1958, no. 59; Düsseldorf 1960, no. 119); even so, the composition anticipates the commitment to nature that manifested itself in his work after 1935. A similar divergence is to be seen between Kirchner's fairly naturalistic watercolor *Brandenburg Gate* (Berlin 1979, pp. 292–293, no. 380), executed in late June 1929, and the decorative painting of the subject he completed on the basis of the watercolor the same year (Gordon 1968, no. 936).

Ernst Ludwig Kirchner, *Vase of Flowers* (cat. no. 58)

59.
Mountain Lake, ca. 1930

Watercolor over graphite pencil on cream wove paper; 360 x 505 mm

INSCRIPTION: Signed with pencil on recto at lower left, *E L Kirchner*

ANNOTATIONS: Embossed stamp on verso in lower right corner, two concentric circles with the letters *SIHL* in the center, the word *DEPOSE* at the top between the circles, and the word *SUPERBUS* completing the outer circle at the bottom

CONDITION: Green and blue pigments have faded where exposed to light

PROVENANCE: Unidentified collector (blue collector's mark in lower right corner, *I* over *28* [in circle]); John S. Newberry, Grosse Pointe Farms, Michigan

EXHIBITIONS: Raleigh 1958; Detroit 1965; Detroit 1966; Boston et al. 1968 (circulated to Seattle and Pasadena); Detroit 1976

REFERENCES: Raleigh 1958, pp. 60, 111, no. 54, ill.; Detroit 1965, p. 49, ill.; *BDIA* 45, nos. 3–4 (1966): 57, no. 28, ill.; Boston et al. 1968, pp. 128–129, no. 101, ill.; Detroit 1976, p. 196, no. 259, ill.; Uhr 1982, pp. 106–107, color ill.

Gift of John S. Newberry (1945.458)

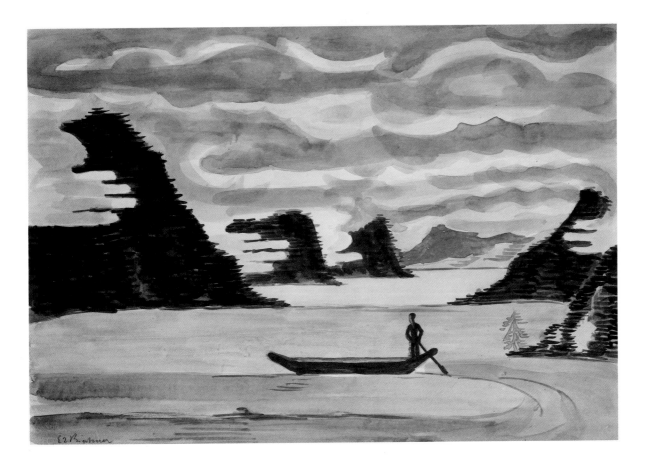

Kirchner's progressive emphasis on the decorative logic of his compositions was reinforced in 1925–26 by his exposure to synthetic Cubism and the later works of Wassily Kandinsky (1866–1944) and Paul Klee (see nos. 141–150). The experience encouraged him to embark on a period of renewed experimentation, resulting in a synthesis of descriptive and abstract forms that dominated his output between 1927 and 1935. *Mountain Lake*, datable to about 1930, belongs to this second stage in the development of Kirchner's post-Expressionist style.

Broad bands of color, transforming the surface of the lake into a series of horizontal pictorial planes, arrest the spatial thrust engendered by the diminishing scale of the mountains. The mountains' silhouettes, in turn, have been accommodated to the design by means of parallel horizontal striations and near-identical stylized cloud formations that shroud their tops. Only the wavy pattern of pink and light green in the sky introduces a modicum of atmospheric depth. The delicate colors of the lake, ranging from light blue to light green and pink, contrast with the somber green of the primordial mountains, lending the setting an imaginary character that associates the watercolor with such lyrical abstractions of 1930 to 1932 as *Imaginary Nocturnal Landscape in Green and Black* and *Imaginary Meadow Flowers* (Gordon 1968, nos. 950–951). This reliance on fantasy recalls the subjectivity of Kirchner's work prior to 1920, as does the pictorial structure of the watercolor, which despite its predominantly decorative quality retains a markedly expressive dimension. The simplified forms give rise to a meditative mood that is intensified by the presence of the figure in the boat. The lonely boatman, held firmly in place by the pattern of the composition, allows the viewer to share empathically in his silent dialogue with nature.

Max Klinger

1857 Leipzig – Grossjena 1920

60.
Standing Female Nude, after 1910

Black chalk on tan wove paper; 698 x 388 mm

INSCRIPTION: Signed with black chalk at lower right, *M. Klinger*

ANNOTATION: With pencil on backing strip on verso at lower left, *Formasien*

CONDITION: Abrasions; strips of heavy paper adhered to edges of verso

PROVENANCE: Galerie Michael Pabst, Munich

EXHIBITION: Munich 1980

REFERENCE: Munich 1980, no. 6

Founders Society Purchase, John S. Newberry Fund (F1980.205)

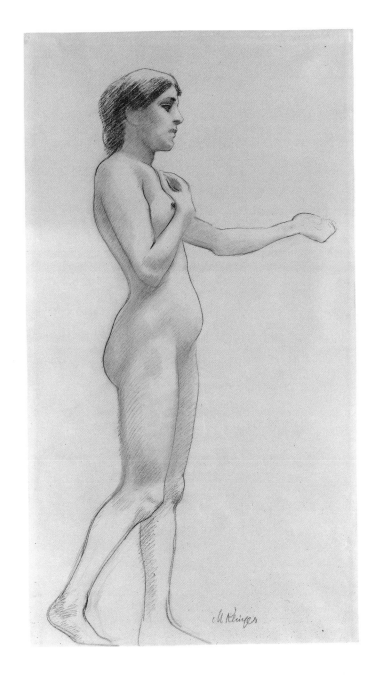

This drawing was done sometime after 1910, when Klinger abandoned the highly differentiated modeling that distinguishes his earlier graphic production in favor of a more simplified chiaroscuro achieved through the use of parallel hatchings. Both the posture and gesture of the model are reminiscent of the figure of Aphrodite offering the golden apple, a subject the artist had chosen for his own ex libris (Singer 1909, no. 310). Although the context of the drawing is not certain, there is a strong possibility that it originated in conjunction with one of two projects that preoccupied Klinger during the last ten years of his life: the figured tiles for two stoves manufactured to his specifications for his home in Grossjena (Leipzig 1970, p. 109, fig. 27), or Klinger's last print cycle, *Zelt* (Beyer 1930, nos. 332–377), a bizarre tale of his own invention dealing with the demonic power of woman over man.

Several preliminary figure studies for the tiles are preserved in the Museum der bildenden Künste, Leipzig. Each depicts a female nude, and most bear the date 1911 (Leipzig 1970, p. 110, no. 119). The forty-six etchings of *Zelt* were completed between 1912 and 1915. Dieter Gleisberg and Karl-Heinz Mehnert have verified the stylistic similarity between the drawings in Leipzig and the one in Detroit (letter to the author, February 23, 1983; Curatorial Files). They have also perceived a close relationship between the Detroit drawing and a group of drawings published as a portfolio in 1914. Although most of these drawings are not dated, all were executed just prior to publication.

Georg Kolbe

1877 Waldheim/Saxony – Berlin 1947

61.
Study of a Male Nude, early 1920s

Graphite pencil and brown and gray wash on cream wove paper; 474 x 374 mm

INSCRIPTION: Signed with pen and brown ink on recto at lower right, *GK*

ANNOTATIONS: With pencil on recto in upper left corner, *20.00*; with pencil on recto at lower left margin, *PX*

CONDITION: Loss at lower right; discoloration at lower edge

PROVENANCE: John S. Newberry, Grosse Pointe Farms, Michigan

Gift of John S. Newberry (1945.457)

The stylistic development evident in Kolbe's drawings corresponds closely to that manifested in his sculptural works. The manneristic figure of the male nude in this drawing recalls Kolbe's statues of the early 1920s, in which, under the influence of Expressionism, the naturalism of his earlier works gave way to a more austere conception, epitomized in attenuated proportions, simplified planes, and a marked interiorization of mood. Smoothly flowing patterns of light and shade accentuate the model's elongated limbs, easing the transitions between the individual parts of the body. While the posture of the figure is conventional, the gesture of the stylized hand contains a strong suggestion of the hieratic element which, in such statues as *Assunta* and *Lucino* (Ithaca 1972, nos. 5, 7), both executed in 1921, reinforces the enigmatic character of the subject.

62.
Kneeling Female Nude, ca. 1929–34

Black crayon on cream wove paper; 490 x 393 mm

INSCRIPTION: Signed with pencil on recto at lower right, *GK*

ANNOTATIONS: With pencil on verso at center of sheet, *275*; with pencil on verso in lower left corner, *KB 10*; blue customs stamp on verso in lower left corner, *Zollzweigstelle Bahnhof Freidrichstrasse Berlin*

CONDITION: Lightstruck; small tear at center upper edge

PROVENANCE: Robert H. Tannahill, Grosse Pointe Farms, Michigan

EXHIBITIONS: Detroit 1936; Detroit 1970a

REFERENCE: Detroit 1970a, pp. 75, 99, ill.

Bequest of Robert H. Tannahill (1970.305)

The emphatic posture of the figure in this drawing is reinforced by the vigorous modeling, as ripples of light and shade follow a line of action that rises from the legs into the torso, imparting its energy to the surrounding space. Three-dimensionally conceived, the drawing invites the viewer to envision the model in the round. Compared to Kolbe's earlier nudes from the years prior to 1919, whose slender bodies he portrayed in a variety of graceful, eurythmic arrangements, the posture of the model is explored in this drawing with greater dramatic force, a conception first evident in Kolbe's works from the late 1920s, and one to which he returned intermittently for the remainder of his career. The drawing may have originated in the context of such bronzes as *Small Pietà* (1929), *Crouching Woman* (1930), and *Small Annunciation* (1934) (Ithaca 1972, nos. 16, 18; Pinder 1937, p. 68), all of which are based on a similarly forceful interpretation of physical movement.

63.
Kneeling Female Nude, ca. 1930

Black crayon on cream wove paper; 489 x 393 mm

INSCRIPTION: Signed with black crayon on recto at lower right, *GK*

ANNOTATIONS: Red stamp on recto at lower right, *KB 11*; with pencil on verso at center of sheet, *247*; blue customs stamp on verso in lower right corner, *Zollzweigstelle Bahnhof Friedrichstrasse Berlin*

CONDITION: Mottled discoloration; lightstruck

EXHIBITION: Detroit 1935

Founders Society Purchase, Friends of Modern Art Fund (1935.57)

Kolbe's drawings are always sculpturally conceived, even those that did not serve as preliminary sketches for individual statues or sculptural groups but were executed for their own sake. Emphasis is usually on the contours and on a lively chiaroscuro that makes the image appear as if molded from the interaction of light and shade alone. As a rule, the model is shown either standing, kneeling, crouching, or striding. Yet from this limited number of postures Kolbe managed to develop an infinite number of gestural variations by making the figure seem as if in the process of rising, descending, or even floating.

In this drawing the kneeling model leans slightly backwards, her upraised hands clasped in a gesture of imploration. The absence of any physiognomic details strengthens the language of the body as the sole means of communication. The realistic conception of the nude is typical of Kolbe's work of the late 1920s and marks a departure from the accentuated proportions that dominated his figures in the early part of the decade (see *Study of a Male Nude*, no. 61). The drawing may have been done in conjunction with Kolbe's bronze of 1930, *Kneeling Woman* (Kolbe and Scheibe 1931, pls. 94a-c). Although in the statue the model's arms are lowered and the hands are placed upon the thighs, the posture is fundamentally the same, as is the wistful mood emanating from the figure.

Accessioned on June 13, 1935, the drawing was most likely included in the exhibition of drawings by modern German sculptors held at the Detroit Institute of Arts from March 5 to March 31 of that year. The Friends of Modern Art apparently acquired the drawing for the museum at the time of the exhibition.

Käthe Kollwitz

1867 Königsberg – Moritzburg 1945

64.
Burial, ca. 1903

Charcoal and pastel with touches of white chalk on light brown cardboard or composition board; 547 x 479 mm

ANNOTATIONS: With pencil on recto at lower left, *18206*; with pencil on recto at lower center, *gibt 6 cm breit*; with pencil on recto at lower left margin *3/- 4.- 3/4 flat chest*; with pencil on recto at lower right margin, *12* (in circle); with pencil on recto at lower center margin, *[2]206*; with pencil on recto near center of page, *No. 12*; matting notations around composition at top and bottom right, bottom left, and lower center; with pencil on verso at lower left, *30854*

CONDITION: Skinning; remnants of adhesive in margins

PROVENANCE: Stuttgarter Kunstkabinett, auction 8, 1950, no. 1527; Klipstein and Co., Bern, sales cat. 51, 1954, no. 84; Buchholz Gallery, New York; Robert H. Tannahill, Grosse Pointe Farms, Michigan

EXHIBITION: Detroit 1970a

REFERENCES: Detroit 1970a, pp. 74–75, ill. (as *Mother and Dead Child*); Nagel 1972, pp. 232–233, no. 253; Detroit 1979, p. 267, no. 218 (as *Mother and Dead Child*); Uhr 1982, pp. 138–139, ill.

Bequest of Robert H. Tannahill (1970.308)

Although the drawing is neither dated nor inscribed with any reference to its subject matter, it is identical with the drawing published in Nagel's catalogue where it is erroneously said to be dated 1905 and to bear the annotations *Bauernkrieg Begräbnis*. Most likely the drawing was done in 1903. This is suggested by two dated detail studies for the figure of the boy in the lower left, both of which presuppose the existence of the composition. Done from life, and probably showing the artist's son Peter asleep, one of these is in the collection of Walter Bareiss, Greenwich, Connecticut (Nagel 1972, no. 255), the other in the Staatliche Museen, Berlin (ibid., no. 257). In addition, three undated drawings related to the one in Detroit are known. A more sketchy and simplified version of the composition is recorded as having been in the Schocken collection (ibid., no. 252); a detail study for a woman preparing to dig the grave is in the collection of A. von der Becke in Munich (ibid., no. 254); and still another for the figure of the boy is in the Staatsgalerie, Stuttgart (ibid., no. 256).

All of these drawings are part of a series of variations on the theme of "Mother and Dead Child" that preoccupied Kollwitz throughout the year 1903 and culminated in such prototypical evocations of maternal grief as her lithograph *Pietà* (Klipstein 1955, no. 70) and the extraordinary etching *Mother with Her Dead Child* (Klipstein 1955, no. 72). According to Werner Timm (Nagel 1972, p. 232), the Detroit composition was at one point intended to serve as a preliminary study for one of the seven etchings of *The Peasants' War* (Klipstein 1955, nos. 66, 90, 94–98), a pictorial chronicle of the bloody peasant revolts in southern Germany during the early years of the Reformation, on which Kollwitz worked intermittently between 1903 and 1908. However, Kollwitz ultimately substituted for the theme of burial the image of a lonely mother searching the nocturnal battlefield for the body of her son (Klipstein 1955, no. 96).

Stylistically, the drawing anticipates Kollwitz's mature draftsmanship. In both the face and the hand of the child there is still evidence of that fascination with the particular which is characteristic of Kollwitz's early works. In the rest of the composition the specific has been subordinated to a more generalized conception of form and a reliance on simple, expressive gestures and postures.

Käthe Kollwitz, *Burial* (cat. no. 64)

65.
Death, Woman, and Child, ca. 1910

Charcoal on blue laid paper; 511 x 481 mm

INSCRIPTION: Signed with pencil on recto at lower right, *Kathe Kollwitz*

ANNOTATIONS: With pencil on recto at lower left, *Trittler. 18:VI928.–300.–*; with pencil on recto near lower left margin, *71–T–15*; pencil outlines on recto on all four sides; with pencil on verso at upper left, *20816–3*

WATERMARK: MBM

CONDITION: Sheet cut and torn irregularly; paper and adhesive residues at edges both recto and verso

PROVENANCE: Heinrich Stinnes, Cologne (red collector's mark [L. Suppl. 1376a] in lower left corner); Julius Carlebach Gallery, New York; Robert H. Tannahill, Grosse Pointe Farms, Michigan

EXHIBITION: Detroit 1970a

REFERENCE: Detroit 1970a, p. 75, ill. p. 100 (as *Mother and Child*)

Bequest of Robert H. Tannahill (1970.306)

One of the fundamental human experiences to which Kollwitz's imagination turned repeatedly throughout her career was death. She believed the subject to be inexhaustible and depicted it in many variations: allegorically, in the traditional form of the skeleton, and directly, in both the act of dying and the pain of bereavement. As the wife of a doctor in a poor working-class district in Berlin, she had become aware of death in its various manifestations and was herself to suffer the cruel loss of both her son Peter, who at eighteen died in battle on the second day of World War I, and subsequently his namesake, her beloved grandson, who was killed in action in 1942.

In the prophetic drawing in Detroit, the theme of a mother's farewell to her dead child achieves universal significance through the elimination of all ex-traneous details. Within the narrow confines of the composition, the faces of the woman and the child are poignantly juxtaposed, while death gently yet irrevocably pulls the child from the woman's embrace. Not included in Nagel's catalogue, the drawing is part of a series of compositional and detail sketches (Nagel 1972, nos. 593–607) in which Kollwitz developed and clarified the complicated interrelationship of the three figures in preparation for her 1910 etching *Death, Woman, and Child* (Klipstein 1955, no. 113). In terms of both conception and execution, the Detroit drawing is most closely related to the drawing in the collection of Mr. and Mrs. Edgar Stinton, San Mateo, California (Nagel 1972, no. 607), and directly anticipates the final composition of the etching.

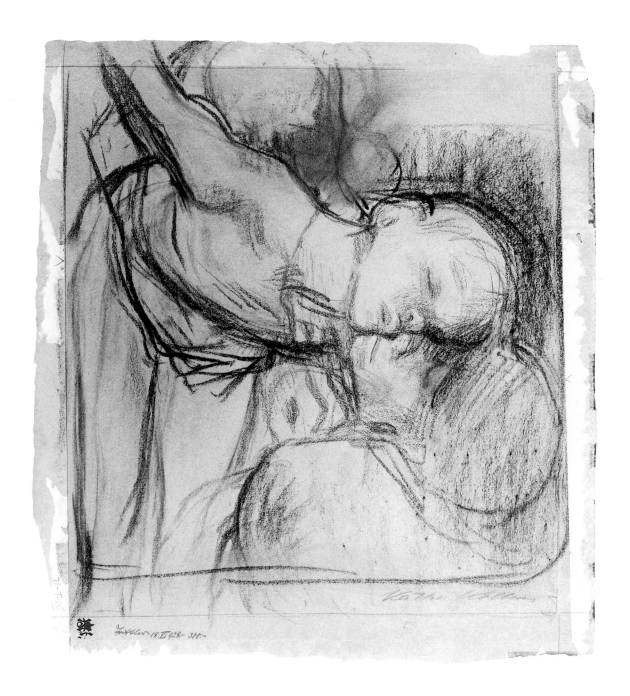

Käthe Kollwitz, *Death, Woman, and Child* (cat. no. 65)

66.
Two Studies for the Head of a Man, ca. 1921

Pen and brush and black ink heightened with white gouache on cream wove paper; 495 x 687 mm

INSCRIPTION: Signed with pencil on recto below the head on the right, *Kathe Kollwitz*

ANNOTATIONS: With pencil on recto at lower left corner, *7* (illegible annotation in pencil above 7 and partially erased [*131*] to right of 7); with pencil on recto at lower center, *44–14 CAN $275.–*; with pencil on verso at lower center, *1080*

CONDITION: Creases; surface grime; small tears

PROVENANCE: Ferdinand Roten, Baltimore (dealer)

REFERENCE: Nagel 1972, pp. 370–371, nos. 902–903, pl. 101

Founders Society Purchase, Hal H. Smith Fund (1954.246)

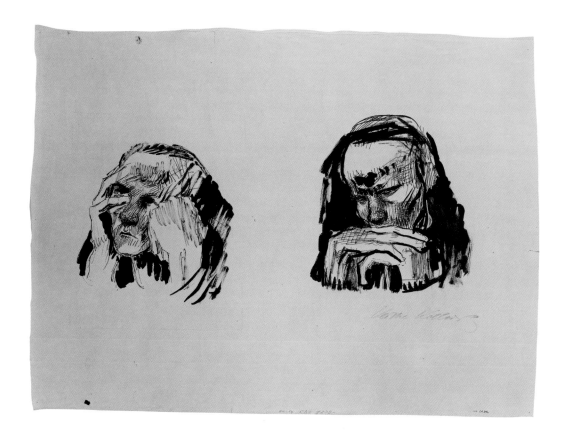

The drawing belongs to a series of studies done in preparation for Kollwitz's woodcut of 1922, *Small Male Head with Hands* (Klipstein 1955, nos. 161–162). One of these studies, now in the Baltimore Museum of Art, is dated 1921 (Nagel 1972, no. 901). More detailed than the Detroit drawing, it also shows two sketches of the head of a man, one of which directly anticipates the head on the left in the drawing in Detroit. The head on the right of the Detroit drawing, in turn, is the study that most closely foreshadows the woodcut. According to Werner Timm (ibid., p. 370) who mistakenly be-

lieved the Detroit sketches to occupy the recto and verso of the sheet, respectively, the contemplative man represented is probably the artist's brother, Dr. Konrad Schmidt. In keeping with Kollwitz's tendency to envision the individual as a type, the physiognomic peculiarities still evident in the Baltimore drawing have been subordinated in the subsequent studies to a generalized, universal conception. This is true for the Detroit drawing as well as for the three remaining drawings from this series (ibid., nos. 904–906).

67.
Empty Dishes, 1924

Black crayon on buff wove paper; 503 x 500 mm

INSCRIPTION: Signed and dated with pencil on recto at lower right, *Kathe Kollwitz/1924*

ANNOTATIONS: With pencil on recto in lower left corner, *13*; with pencil on recto at lower left margin, *Kein Brot*; with pencil on verso at lower left corner, *Aufnahme 18 x 24*; with pencil on verso in lower right corner, *40*; with pencil on verso near lower right corner *M.300.–*

CONDITION: Surface grime; creases; discoloration; trimmed on all sides

PROVENANCE: Unidentified collector (purple collector's mark on verso in lower right corner crossed out with pencil); Galerie St. Etienne, New York; Robert H. Tannahill, Grosse Pointe Farms, Michigan

EXHIBITION: Detroit 1970a

REFERENCES: Heilborn 1949, p. 55; Strauss 1950, p. 125; Detroit 1970a, p. 75, ill. p. 100; Nagel 1972, pp. 398–399, no. 1034

Bequest of Robert H. Tannahill (1970.307)

Kollwitz's drawing served as a preliminary study for her 1924 woodcut of the same title (Klipstein 1955, no. 197). A more sketchy and dramatically unresolved composition study for the same woodcut is in the Wallraf-Richartz-Museum, Cologne (Nagel 1972, no. 1035).

Stylistically, the drawing is a mature work and typical of Kollwitz's tendency after 1909 to divest a given subject of its larger anecdotal context in order to convey more succinctly the universally human dimensions of the story through simplified, yet eloquent, gestures, postures, and facial expressions. The subject belongs to the proletarian themes to which Kollwitz was drawn throughout her career, moved by a sincere social commitment and pro-found sympathy for the downtrodden and the poor. Specifically, the drawing is one of a series of works from the early 1920s that have as their common subject the suffering of Germany's children during the years of inflation and widespread famine that followed in the wake of World War I. At a time when the urban poor in particular were forced to rely on charity for their survival, Kollwitz repeatedly spoke out publicly on their behalf, through her broadsheet *Hunger* of 1923 and the two famous poster lithographs she contributed to the International Workers' Relief Fund in 1924, *Germany's Children are Hungry!* and *Bread!* (Klipstein 1955, nos. 259 and 268).

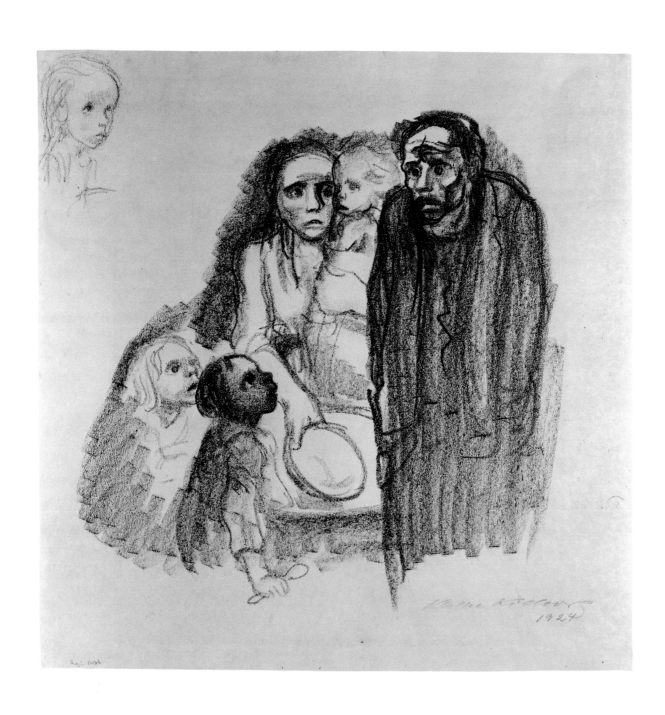

Hans Kuhn

1905 Baden-Baden

68.

Animal Market on the Beach, 1935

Watercolor on cream wove paper; 486 x 654 mm

INSCRIPTION: Signed and dated with pencil on recto at lower right, *h. Kuhn 35*

ANNOTATION: With pen and black ink on verso at upper left, *14.) Viehmarkt am Strand*

WATERMARK: P. M. FABRIANO

CONDITION: Good; slightly cockled

PROVENANCE: Curt Valentin, Berlin

EXHIBITION: Detroit 1936

REFERENCE: Newberry 1936, no. 3, pp. 37, 41

Founders Society Purchase, Friends of Modern Art Fund (1936.44)

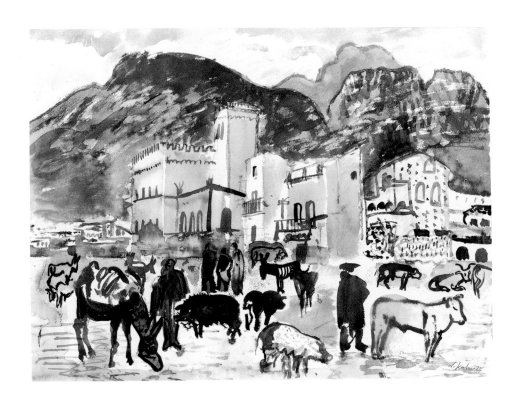

Kuhn's 1935 watercolor was painted toward the end of a five-year sojourn in Italy that brought him under the influence of the *pittura metafisica* of Giorgio de Chirico (1888–1978) and Carlo Carrà (1881–1966). While most of Kuhn's works from these years are conceived in a lyrical Surrealist idiom, conjuring up a mysterious view of an ideal Mediterranean world, this watercolor remains firmly rooted in visual experience. The unhurried pace of the small-town animal market has been captured with an almost-Impressionist fidelity to the ordinary and mundane. Contrasts of brilliant hues have been avoided. Instead, the colors have been applied loosely in delicate modulations of pink, yellow, green, and gray.

Previously believed to depict a town in northern Italy, the watercolor was most likely painted on the island of Ischia, near Naples, where Kuhn spent much of his time between 1930 and 1935. The annotation on the verso of the sheet, which identifies the scene as an animal market on the beach, confirms this suggestion. For only at a place like Ischia would donkeys, pigs, and assorted cattle, having been brought from the mainland by boat, be sold most conveniently right by the edge of the sea. Although the precise identity of the site remains to be verified, the mountains in the distance resemble the slopes of Monte Epomeo, Ischia's highest point of elevation, and the town in the middle ground possesses something of the character of Casamicciola, situated on the island's north coast.

126

Otto Lange

1879 Dresden 1944

69.
Boats in a Harbor, early 1930s

Watercolor, black ink, and gouache on cream jap-
anese paper with fibrous inclusions; 311 x 414 mm

INSCRIPTION: Signed with brush and black water-
color at lower right, *ottolange*

CONDITION: Good

PROVENANCE: Curt Valentin, Berlin

EXHIBITION: Detroit 1936

REFERENCES: Newberry 1936, pp. 37, 39, ill.;
Richardson 1936, p. 48

Founders Society Purchase, Friends of Modern Art
Fund (1936.46)

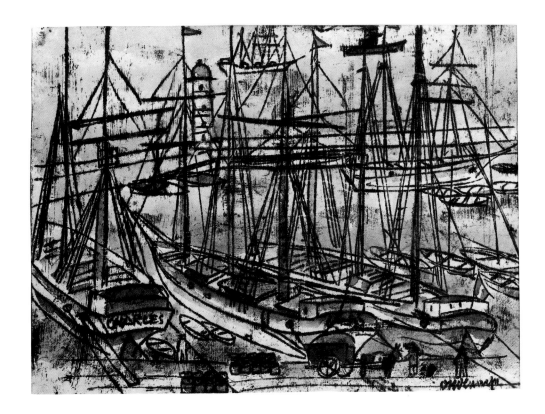

Throughout his development, which brought him into contact with Impressionism, Post-Impressionism, and Expressionism, Otto Lange's art retained a strong decorative component—the result both of his training and his professional activity. Having served an apprenticeship as a painter-decorator, Lange worked in this field for a number of years before he enrolled in the School of Arts and Crafts in his native Dresden. He subsequently attended the Dresden Academy, studying with Otto Gussmann, who was in charge of the master classes in decorative painting. Lange taught at the School of Arts and Crafts in Bromberg from 1915 until 1919, when he became a co-founder of the Dresden Secession and worked as an independent artist for several years. From 1925 to 1933 he taught textile design at the Academy in Plauen.

With its emphasis on simplified shapes and rhythmic patterns, Lange's watercolor in Detroit reflects this latter experience and was probably painted in the early 1930s. The lines of the masts and rigging of the ships have been drawn with a ruler and are joined by the structural lines of the vessels and the boundaries of the dock and pier to form an intricate web that unifies the spatial dimension of the setting. Additional elements, such as the arbitrary scale of the ships, the charming vignette of the toylike, mule-drawn cart, and the pale blue wash, which has been applied sparingly to the white paper throughout the composition, tend to strengthen the decorative character of the work.

Wilhelm Lehmbruck

1881 Meiderich/Duisburg – Berlin 1919

70.
Standing Female Nude, 1911

Blue crayon and graphite pencil on cream wove
paper; 432 x 323 mm

INSCRIPTION: Signed and dated with pencil on recto
at lower right, *W. Lehmbruck 1911*

ANNOTATIONS: With pencil on recto at lower left,
*Lehmbruck 17729/Weibl-Torso/mit erhobenem/
Arm*; with pencil on recto in lower left corner, *SOP*;
with pencil on recto near lower right margin, *Gr.
2564 eroox 18M*; with heavy pencil on verso at lower
left, *3 9.* (circled in red); with pencil on verso at
lower center, *Z.1522*; with pencil on verso in lower
right corner, *900.-*

CONDITION: Surface grime; faint horizontal creases

PROVENANCE: Robert H. Tannahill, Grosse Pointe
Farms, Michigan

EXHIBITION: Detroit 1970a

REFERENCE: Detroit 1970a, pp. 75, 101, ill.

Bequest of Robert H. Tannahill (1970.310)

Lehmbruck's *Standing Female Nude* is charac-
teristic of the many incidental sketches he made
throughout his career, usually with the purpose of
clarifying a particular gesture or pose. Dated 1911
(not, as was previously assumed, 1917), the drawing
illustrates Lehmbruck's quest for a synthesis of
French and German traditions. This same synthesis
defines the character of his first major sculptural
work of about the same time, the *Standing Female
Figure* of 1910 (Hoff 1969, pl. 59). While the con-
ception recalls the voluptuous nudes of Aristide
Maillol (1861–1944), the friezelike arrangement of
the limbs brings to mind the austere formal solu-
tions of Hans von Marées (1837–1887). The drawing
has close affinities to Lehmbruck's elegiac color
drawing of 1910 in the Wilhelm Lehmbruck Museum
der Stadt Duisburg, *Frieze of Women*, and his oil
painting, *Three Women* (formerly Kaiser-Friedrich-
Museum, Magdeburg), also of 1910 (Hoff 1969,
pls. 128–129).

71.
Two Wounded Men, ca. 1916/17

Black crayon and white gouache on cream wove paper; 432 x 320 mm

INSCRIPTION: Signed with black crayon on recto at lower center, *W. Lehmbruck*

ANNOTATIONS: With pencil on verso near upper left margin, *[Gray]*; with pencil on verso in lower right corner, *62* (torn away)

CONDITION: Yellowing at edges; small edge tears; losses in upper right corner and at lower left and bottom center

PROVENANCE: Curt Valentin, New York; Robert H. Tannahill, Grosse Pointe Farms, Michigan

EXHIBITIONS: Chicago 1939; Detroit 1970a

REFERENCES: Chicago 1939, no. 16; Detroit 1970a, pp. 75, 101, ill.; Uhr 1982, pp. 148–149, ill.

Bequest of Robert H. Tannahill (1970.309)

The Expressionism that from 1913 on began to manifest itself in Lehmbruck's sculpture and graphics is illustrated in the drawing *Two Wounded Men*. In contrast to his earlier sensuous conception, the simplified limbs of the two figures are defined in terms of an austere architectonic structure of horizontals, verticals, and diagonals so as to achieve an expressive interaction of volumes and voids. Emphasis is on rhythmic contrasts, exemplified in the juxtaposition of frontal and profile views and in the differentiation of the heads, one raised in defiance, the other inclined in surrender and grief. Numerous *pentimenti* testify to the progressive clarification of the composition and the strengthening of the expressiveness of the gestures and postures. They are visible even through the white wash that was applied to the sketch before the image was transferred to the stone for *Two Wounded Men I*, a lithograph published by Paul Cassirer in 1920 (Petermann 1964, L 1). (All of Lehmbruck's seventeen lithographs are transfer lithographs that were printed posthumously.)

The Detroit drawing is not dated but was most likely done sometime in 1916 or 1917. It is closely related both stylistically and iconographically to two pencil and crayon sketches of 1916 preserved in the collection of the artist's family, *The Young Regiments and the Last Cry* (inv. 782), and *Four Charging Wounded Warriors* (inv. 728; Washington et al. 1972, pls. 79, 83), and to Lehmbruck's etching of 1917, *Wounded Young Men* (Petermann 1964, no. 196). According to Petermann (L 1), an undated preliminary study for the Detroit composition is owned by the artist's family (inv. 729); a variation of the theme, the lithograph *Two Wounded Men II* (ibid., L 2), has been dated by Hoff to 1916/17 (Hoff 1969, pl. 109, p. 159).

The Detroit drawing thematically complements such major sculptures as Lehmbruck's *Fallen Man* of 1915–16 and *Seated Youth* of 1918 (ibid., pp. 111, 119), although it is unlikely that the subject was ever intended to be explored in bronze or stone. Dramatically conceived, the drawing belongs to the multi-figured arrangements that dominate Lehmbruck's paintings and prints and signifies, like so many of his works from this time, his response to the First World War. Like his depictions of the *Pietà*, a subject to which he turned repeatedly during these years (Petermann 1964, nos. 159–160; Washington et al. 1972, pls. 60, 84, 86–88), the drawing records in a prototypical theme the collective misery of mankind brought on by the armed conflict.

Peter Lipman-Wulf

1905 Berlin

72.
Circus, 1950

Pen and black ink, watercolor, and gouache on heavy tan wove paper; 609 x 461 mm

INSCRIPTION: Titled, signed, and dated with pen and black ink on recto at lower right, *Circus Peter Lipman-Wulf 1950*

ANNOTATION: With pencil on verso at upper right, *From J. Carlbach [sic] /937 3rd Ave*

CONDITION: Repaired tear top center; abrasion through center and lower left quadrant to which pigment has been applied, probably by the artist; right and bottom edges irregularly trimmed

PROVENANCE: Carlebach Gallery, New York; Mr. and Mrs. Stanley Marcus, Dallas, Texas

Gift of Mr. and Mrs. Stanley Marcus (1956.277)

The relationship of free-standing sculpture to architectural space first occupied Lipman-Wulf's imagination in the late 1930s, leading him to seek to reconcile the two by accommodating sculpture to the two-dimensional surface of the wall. Rejecting the traditional concept of the sculptured frieze, in the 1940s he developed a series of ceramic reliefs, in which the images are made up of either deeply incised, flat surfaces—rather than rounded forms—or of undulating, ribbon-like pieces of clay set off against a perforated or incised ground. Dated 1950, Lipman-Wulf's drawing was most likely conceived in conjunction with the latter approach, illustrated by the ceramic triptych *Life Cycle* of 1941, the composition of which is based on a series of small, flattened human figures on a background bearing large, incised human faces that are seen from close up (reproduced in *Leonardo* 4, no. 3 [1971]: 223). The implied volume of the two partial figures in the drawing notwithstanding, Lipman-Wulf adapted the image of the acrobats to the two-dimensional surface of the sheet. There is no modeling, and the figures appear as if traced upon a clay tablet, an effect that is reinforced by the pervasive brown of the watercolor wash, which is unmodulated and relieved only by a few touches of yellow and blue gouache.

Alfred Lörcher

1875 Stuttgart 1962

73.
Crowd of Standing Nudes, ca. 1959

Graphite pencil on cream wove paper; 294 x 210 mm

INSCRIPTION: Signed with pencil on recto at lower right, *AL* (in monogram)

ANNOTATION: With pencil on verso at lower right, *unverkäuflich*

CONDITION: Good; yellowing at edges

PROVENANCE: John S. Newberry, New York

Bequest of John S. Newberry (1967.137)

The representation of the individual as a member of a group was a pictorial problem to which Lörcher turned in the late 1950s. In addition to bronzes in which a small number of people are gathered around tables, engaged in conversation and debate, he made a series of multifigured sculptures and reliefs which subordinate the individual to the collective identity of the mass.

Although this drawing cannot be associated with a specific piece of sculpture, it too was undoubtedly conceived with a relief in mind. The oblique view from above implies a spatial dimension, but the figures have been flattened out and arranged in a vertical space. As if the anonymity of the individual were a measure of his dependence on others, the figures have been gathered in ranks of two, three, four, and more. All share the same body type, distinguished by a small head, broad shoulders, and bulging limbs. Each figure, moreover, possesses the same pictorial weight and could logically be multiplied in any direction, enlarging and changing the bounds of the composition as by a continuous ornamentalized script.

Stylistically as well as conceptually, the drawing is closely related to a group of studies depicting large crowds of men walking (Grüterich 1976, p. 146, figs. 208–209, pp. 269–271, Z 83.1–83.11). According to Grüterich, these drawings are datable to about 1959, between Lörcher's bronze relief *Panic I (Revolution)* (present whereabouts unknown; ibid., pp. 236–237, R 43), executed during that year, and his late rider reliefs of 1959–60.

74.
Horses and Riders, ca. 1959–60

Graphite pencil on cream wove paper; 294 x 210 mm

INSCRIPTION: Signed with pencil on recto at lower right, *AL* (in monogram)

ANNOTATION: With pencil on verso at lower right, *unverkäuflich*

CONDITION: Good; yellowing at edges

PROVENANCE: John S. Newberry, New York

EXHIBITION: Munich 1964

REFERENCE: Munich 1964, ill. on back cover

Bequest of John S. Newberry (1967.136)

This drawing is a composition study done in conjunction with a group of rider reliefs that Lörcher completed between 1959 and 1961 (Grüterich 1976, p. 238, R 48, 50, 52-55). Executed in terra cotta, each relief is governed by a different distribution of the figures, resulting in different tensions between empty and occupied space and in a variety of movements, positions, and directions. Although the ranks of the figures in the drawing are organized more loosely than in any of the reliefs, the static conception of the individual figures allies the sketch most closely to the terra cotta *Female Riders* of 1959–60 in the Staatsgalerie Stuttgart (ibid., p. 170, fig. 247, p. 238, R 48), in which the horses are also facing uniformly toward the left. In contrast to the relief, the fact that not all the horses are mounted is explainable on the basis of procedure. Lörcher always drew the horses first and added the riders afterward, using a method of schematization which approximates the figures to the pictorial laws of the two-dimensional composition. In subsequent stages of the working process, Lörcher usually heightened the figures with crayon (see *Eight Standing Female Nudes*, no. 75) so as to achieve a greater degree of plasticity, which allowed him to anticipate the effect of the relief in the preliminary drawing. Two closely related studies for the same relief are preserved in the Alfred Lörcher Archiv of the Staatsgalerie Stuttgart (ibid., p. 277, Z 100.10, 100.11).

75.

Eight Standing Female Nudes, ca. 1961

Graphite pencil and sienna crayon on cream wove paper; 294 x 210 mm

INSCRIPTION: With pencil on verso at lower right, *unverkäuflich*

CONDITION: Yellowing at edges; tear bottom center

PROVENANCE: John S. Newberry, New York

Bequest of John S. Newberry (1967.134)

This drawing most likely belongs to a group of studies of standing women that Grüterich dated to about 1961 (Grüterich 1976, pp. 274–275, Z 96.1–96.6). All are based on the same monumental conception and a similar compositional format, the figures being ranked in two and three rows, each row placed above the other. Some of the drawings, including the one in Detroit, have been heightened with crayon to give greater plasticity to the figures. No sculpture by Lörcher can be associated with these drawings. They may have been an outgrowth of such projects as his bronze *Three Seated Women* of 1961 (ibid., pp. 210–211, P 69), for which several closely related studies have been preserved (ibid., pp. 274–275, Z 95.1–95.5).

76.

Horses and Riders, ca. 1962

Graphite pencil on cream wove paper; 294 x 210 mm

INSCRIPTION: Signed with pencil on recto at lower right, *AL* (in monogram); with pencil on verso at lower right, *unverkäuflich*

CONDITION: Good; yellowing at edges

PROVENANCE: John S. Newberry, New York

Bequest of John S. Newberry (1967.135)

This drawing is a composition study for what may have been Lörcher's last rider relief, the terra cotta *Riders,* completed in January 1962 (Galerie der Stadt Stuttgart; Grüterich 1976, pp. 172–174, fig. 253, p. 238, R 57). Flattened out so as to approximate the two-dimensional effect of the relief, the figures are seen frontally and have been distributed along a central axis that rises on a slight diagonal from the lower left to the upper right. Despite the vertical perspective, the paper ground implies a modicum of space, an illusion that is all but denied by the flat surface of the terra cotta. In a preliminary drawing in the Staatsgalerie Stuttgart (ibid., pp. 278–279, Z 100.20), the riders are arranged in a similar way, except that the axis of the composition leans in the opposite direction and the sheet has been divided more or less into two halves, one occupied by the figures, the other left empty. A somewhat more finished study for the relief, preserved in the Galerie der Stadt Stuttgart, has been dated by Grüterich as early as 1960 (ibid., pp. 172–173, fig. 252, p. 278, Z 100.24).

August Macke

1887 Meschede/Westphalia – Perthes-les-Hurlus, France 1914

77.

Half-length Female Nude Standing before
a Mirror, ca. 1911

Watercolor over graphite pencil on off-white wove
paper; 119 x 134 mm

CONDITION: Good; right and bottom edges
irregularly cut

PROVENANCE: August Macke Estate, Bonn (purple
artist's estate stamp [L. Suppl. 1775b] on verso at
lower right); Leonard Hutton Galleries, New York,
1963; Robert H. Tannahill, Grosse Pointe Farms,
Michigan

EXHIBITIONS: Bielefeld 1957; New York 1963;
Detroit 1970a

REFERENCES: Bielefeld 1957, p. 21, no. 126, ill.;
New York 1963, no. 20; Detroit 1970a, pp. 75, 102, ill.;
Uhr 1982, pp. 152–153, color ill.

Bequest of Robert H. Tannahill (1970.311)

In a letter of April 26, 1910, to Bernhard Koehler, Macke explained that modern art without roots in tradition was little more than a haphazard experiment indicative of confusion (Vriesen 1957, p. 76). Macke had formed this opinion on the basis of his study of modern French painting and its logical development from Impressionism to Cézanne, Gauguin, Seurat, and Matisse. As is apparent from this watercolor, the example of Matisse, whose work he had seen in an exhibition in Munich in 1910, strengthened Macke's own sensitivity to luminous color and simplified form. Datable on the basis of style to about 1911, the watercolor is an essay in the contrast of warm and cool colors and curvilinear and straight lines. Shades of pale green give way to blue and darker green in the woman's hair and at the outer contours of the body, accentuating the delicate flesh tones as well as the rich brown of the edge of the mirror in the upper right. By subtly emphasizing the vertical elements of the composition, Macke held in check the rhythm of repeated elliptical shapes initiated in the model's upraised arms and echoed in the oval frame of the mirror. The composition not only demonstrates Macke's preference for simple, traditional themes, but also his ability to manipulate color and form so as to give pictorial expression to a serene and untroubled world.

78.
Crouching Girl, 1913

Black crayon on tracing paper; 270 x 320 mm

ANNOTATION: With pen and ink on verso along lower left margin, *Hockendes Mädchen 1913 KZ 2/13*

CONDITION: Smudging and uneven discoloration; losses at upper corners

PROVENANCE: August Macke Estate, Bonn (black artist's estate stamp [L. Suppl. 1775b] on verso at lower left); Robert H. Tannahill, Grosse Pointe Farms, Michigan

EXHIBITION: Detroit 1970a

REFERENCE: Detroit 1970a, pp. 75, 102, ill.

Bequest of Robert H. Tannahill (1970.312)

Macke's stylistic development was not entirely consistent. While his paintings show a steady progression toward a more abstract handling of color and form, most of his drawings and watercolors continued to be done from life. According to the Macke Estate number on the verso of the sheet, this drawing dates from 1913, a year when Macke's paintings were dominated by transparent Cubist planes and pure color inspired by the Orphism of Robert Delaunay (1885–1941). Far removed from any synchronist notions of time and space, the sketch betrays Macke's roots in the tradition of academic life drawing. Although there is no interior modeling, the emphatic contours accentuate the figure's line of action, which can be traced from the shoulder down through the back and upward again through the left leg. A few simplified patterns of shading, applied with no concern for technical precision, reinforce the model's dominant gestural line. Drawings such as this testify to what extent sensory perception remained for Macke a corrective to the metaphysical speculations about art that led his friends Wassily Kandinsky and Franz Marc (1880–1916) —with whom he had participated in the historical first exhibition of "Der Blaue Reiter" in Munich in the winter of 1911/12—to an ever greater departure from nature.

Gerhard Marcks

1889 Berlin – Burgbrohl/Eifel 1981

79.
Portrait of the Artist's Daughter Ute, 1929

Graphite pencil on cream laid paper; 316 x 272 mm

INSCRIPTION: Dated with pencil on recto at lower right, *30 XI 29*

ANNOTATIONS: With pencil on verso at lower right, *M 19*; at center of sheet, *12*

CONDITION: Good; lightstruck

PROVENANCE: Mrs. Russell A. Alger, Grosse Pointe Farms, Michigan

Gift of Mrs. Russell A. Alger (1940.37)

While most of Marcks's commissioned portraits date from the years after 1945, portraits of members of his family, close associates, and friends are known from all stages of his career. This drawing from November 30, 1929, is a study for a terra cotta head Marcks made that year of his eight-year-old daughter Ute (Gerhard-Marcks-Stiftung, Bremen; Rudloff 1977, no. 200). Closely approximating the sculpture in physiognomic detail and expression, the drawing has been executed in Marcks's usual cursory manner. There is little emphasis on conventional modeling, yet the few parallel hatchings and the smooth contours convincingly suggest the delicate texture of the young girl's face. Marcks's portrait etching of Ute also dates from 1929 and, according to Rudloff, was based on the terra cotta.

80.
*Design for a Plaquette for the
City of Erfurt*, ca. 1930

Graphite pencil on cream laid paper; 133 x 183 mm

ANNOTATIONS: With pencil on verso in lower left corner, *II 207*; blue export stamp on verso at lower right, *MADE IN GERMANY*

CONDITION: Good; pencil lines slightly smudged; portion of legend on left side has been erased. Shallow cut runs vertically through center of drawing, corresponding to crease on verso, which may indicate drawing was to be folded at this point

EXHIBITION: Detroit 1969

REFERENCE: Detroit 1969, p. 37

Gift of Robert H. Tannahill (1945.83)

This drawing is a design for the two sides of a commemorative or prize plaquette for the city of Erfurt. The wheel on the left side of the drawing, above the lettering "Die Stadt Erfurt," is the symbol of the city and derives from the coat of arms of the archbishopric of Mainz, to which Erfurt belonged in medieval times. The sketch on the right, for the other side of the plaquette, shows a standing female figure holding a laurel wreath.

According to Martina Rudloff (letter to the author, December 3, 1982; Curatorial Files), the drawing dates from about 1930. The plaquette itself was apparently never executed, and nothing is known about the purpose for which it was intended. Two, or possibly three, related designs, inscribed with the word *PAX*, are preserved in the collection of the Gerhard-Marcks-Stiftung in Bremen.

81.
Portrait of Trude Jalowetz, 1932

Graphite pencil on off-white wove paper;
400 x 278 mm

INSCRIPTION: Dated and signed with pencil on recto
above sitter's left shoulder, *2 XII 32/X/ Marcks*

ANNOTATIONS: With pencil on recto in lower right
corner, *KB 276*; blue customs stamp on verso in
lower right corner, *Zollzweigstelle Bahnhof
Friedrichstrasse Berlin*

CONDITION: Yellow staining; creases at top edge

EXHIBITION: Detroit 1935

Gift of Mrs. William Clay (1935.16)

This drawing depicts Trude Jalowetz, a student of
weaving at the School of Arts and Crafts in
Giebichenstein Castle, near Halle, where Marcks
taught from 1925 until his dismissal by the National
Socialists in 1933.

The modeling emphasizes the sitter's large, ex-
pressive eyes, surmounted by the peculiar shape of
the eyebrows, which meet at the center, spanning
the forehead in a continuous, gently curving arch.
Dated December 2, 1932, the drawing may have been
done in conjunction with the portrait head of Trude
Jalowetz (Rudloff 1977, no. 267) on which Marcks
was working at about the same time. The bronze is
the first portrait sculpture Marcks made of Jalowetz
in which her hair is tied together at the nape of the
neck. In three earlier portrait heads (ibid., nos.
238–240), done between 1931 and 1932, the sitter's
shorter hair is allowed to hang freely. Ernest
Rathenau, who published nearly seventy of Marcks's
drawings of Trude Jalowetz, included a portrait dated
January 16, 1933, that is similar in conception and
execution to the one in Detroit (Rathenau 1967, pl.
30). Accessioned on April 11, 1935, the Detroit draw-
ing was apparently purchased by Mrs. William Clay
for the Detroit Institute of Arts from the exhibition
of drawings by modern German sculptors held at the
museum from March 5 to March 31 of that year.

From 1931 to 1933, when she was forced to leave
Germany because of her Jewish background, Trude
Jalowetz was Marcks's favorite model. In addition to
the examples already cited, she posed for three more
portraits, including a lithograph and a woodcut of
1932 and a portrait bust of 1933 (Rudloff 1977, no.
271), as well as six statues (ibid., nos. 249, 255, 261,
262, 268, 280). Even after her departure from Ger-
many, Trude Jalowetz continued to haunt Marcks's
imagination. Between 1934 and 1935 he completed
five more portraits of her, including three sculptures
(ibid., nos. 286, 301, 302), a lithograph, and a wood-
cut, all of which were based on earlier drawings or
portrait heads. From the same two years date no less
than eleven statues (ibid., nos. 287–291a, 298, 299,
303, 318, 319) that either bear the features of Trude

Jalowetz or were developed from drawings for which
she previously posed. Her characteristic physiog-
nomy appears for the last time in *Mourning Woman*
(ibid., no. 543), a stone monument of 1949, erected
amid the ruins of Sankt Maria im Kapitol, Cologne,
to commemorate the dead of the Second World War.

82.
Girl Combing Her Hair, ca. 1932

Graphite pencil with stumping on cream wove paper; 388 x 250 mm

INSCRIPTION: Signed with pencil on recto at lower right, *Marcks*

ANNOTATION: With pencil on verso near lower center, *15*

CONDITION: Lightstruck; surface grime

PROVENANCE: Buchholz Gallery, New York; John S. Newberry, New York

EXHIBITIONS: Detroit 1946 (traveled to City Art Museum, St. Louis); Detroit 1947; Bloomfield Hills 1947; Ann Arbor 1948; New York 1948; Cambridge 1948; San Francisco 1948; Detroit 1949; Detroit 1965

REFERENCES: St. Louis 1946, p. 27, no. 202; New York 1948, no. 27; Cambridge 1948, p. 13; Detroit 1949, no. 31, p. 23; Detroit 1965, p. 64, ill.

Bequest of John S. Newberry (1965.175)

This drawing is a study of Marcks's bronze statuette of 1932, *Small Standing Woman in a Shirt* (Rudloff 1977, no. 261). Done quickly and without concern for three-dimensional effects, the sketch is typical of the laconic quality that is also the most characteristic formal element of Marcks's sculptures. The drawing agrees closely in the disposition of the drapery and the gestures of the figure with the corresponding bronze. The model for the drawing was Trude Jalowetz, who posed for Marcks during the same year for three additional statues and for four portraits (see nos. 81, 83, 86, 87).

83.
Standing Female Nude (Guerrera),
ca. 1933

Graphite pencil with stumping on discolored cream
wove paper; 425 x 240 mm

INSCRIPTIONS: With pencil on recto at lower left, *X*;
signed with pencil on recto at lower right, *G. Marcks*

ANNOTATION: With pencil on verso in lower left cor-
ner, *v40*

WATERMARK: E [·G· VOLKERSZ]

CONDITION: Lightstruck

PROVENANCE: Buchholz Gallery, New York;
Robert H. Tannahill, Grosse Pointe Farms, Michigan

EXHIBITION: Detroit 1969

REFERENCE: Detroit 1969, p. 37

Gift of Robert H. Tannahill (1958.41)

The physical appearance of the model suggests that
Trude Jalowetz (see no. 81) posed for this drawing,
which implies that it was executed not later than
1933. Marcks eventually used the drawing as a study
for his bronze statuette *Small Standing Guerrera* of
1934 (Rudloff 1977, no. 287). Observed from the left
rear, the model's pose is identical with that of the
bronze, although in the sculpture the figure is more
attenuated and less indebted to nature than in the
preliminary sketch. Marcks, whose admiration for
the sculptural tradition of classical antiquity is well
documented, apparently chose the title for the
bronze because the figure's posture resembled that
of the fifth-century B.C. *Wounded Amazon*
(Staatliche Museen, East Berlin; Rohde 1968, p. 101,
fig. 77), variously attributed to Polykleitos and
Kresilas. In a 1934 bronze, *Standing Trude* (Rudloff
1977, no. 288), for which *Small Standing Guerrera*
evidently served as a source of inspiration, the anal-
ogy to the ancient work is unmistakable, although
unacknowledged in the title.

84.
Standing Female Nude, ca. 1933

Graphite pencil on cream wove paper; 479 x 289 mm

INSCRIPTION: Signed with pencil at lower right,
X/G. Marcks

ANNOTATIONS: With pencil on recto near center of
upper margin, *2 1/4*; with pencil on recto near lower
right margin, *4 1/8*; with pencil on recto in lower
right corner, *(3)*; with pencil on verso in lower left
corner, *v40*

CONDITION: Slight yellowing; left edge torn rather
than trimmed

PROVENANCE: Robert H. Tannahill, Grosse Pointe
Farms, Michigan

EXHIBITION: Detroit 1969

REFERENCE: Detroit 1969, p. 37

Gift of Robert H. Tannahill (1958.43)

This drawing agrees stylistically with no. 83, the
shading having been indicated by the same cursory
vertical hatching. The model, too, is obviously the
same. Unlike the preceding drawing, however,
which anticipates Marcks's bronze *Small Standing
Guerrera* of 1934 (Rudloff 1977, no. 287), this study
was apparently executed for the purpose of addi-
tional observation and control. The model stands
similarly erect, but shields her face with upraised
arms, her head slightly inclined and turned toward
the right shoulder.

85.
Greek Flute Player, ca. 1933

Graphite pencil with stumping on cream wove paper; 379 x 242 mm

INSCRIPTION: Signed with pencil on recto at lower right, *Marcks*

ANNOTATIONS: With pencil on verso at upper left, *#1676*; with pencil on verso in lower left corner, *v40*; with pencil on verso near center of sheet, *77*

CONDITION: Good; lightstruck

PROVENANCE: Buchholz Gallery, New York, 1947 (gallery label on verso in lower left corner, *inv. no. 538*); John S. Newberry, New York

EXHIBITIONS: New York 1941; New York 1947; Detroit 1965

REFERENCES: New York 1941, no. 52; New York 1947, no. 51; Detroit 1965, p. 61, ill.

Bequest of John S. Newberry (1965.176)

Simplified in contour and form, this drawing is a preliminary study for *Greek Flute Player* (Rudloff 1977, no. 269), a small bronze of 1933, of which the Detroit museum owns a cast (1965.263). The shadows cast by the cloth draped over the youth's head have been indicated lightly by hatching and rubbing without developing a strong impression of plasticity. Lacking only the support for the seated figure, the drawing anticipates the sculpture in all details and conveys a true feeling of the boy's total absorption in his activity.

According to Rudloff, the figure of the flute player can be traced to a sketch Marcks made in 1928 while traveling in Greece. Marcks's stucco *Large Flute Player* (private collection; ibid., no. 273) is a variation on the subject. This sculpture resembles the *Greek Flute Player* in pose and gesture, except that the drapery has been arranged over the figure's upper left leg. Conceived around 1931 as the central piece of a multifigured pediment, the stucco model was apparently never cast.

The subject of the flute player is also found among the sketches Marcks made in 1932 and 1933 for his woodcut cycle Orpheus and was included in the print *Orpheus in the Underworld* when the cycle was finally executed in 1948 (Minneapolis 1953, no. 128, cover ill.).

86.
Standing Woman in Long Robe (Alcina I), ca. 1933

Graphite pencil on cream wove paper; 468 x 293 mm

INSCRIPTION: Signed with pencil on recto at lower right, *Marcks*

ANNOTATIONS: With pencil on recto in lower left corner, *N4/1486*; with pencil on verso in lower left corner, *v40*; with pencil on verso in lower right corner, *1517*

WATERMARK: E·G·VOLKERSZ

CONDITION: Diffuse yellow staining, probably from discolored fixative

PROVENANCE: Buchholz Gallery, New York; Robert H. Tannahill, Grosse Pointe Farms, Michigan

EXHIBITION: Detroit 1970a

REFERENCE: Detroit 1970a, p. 75

Bequest of Robert H. Tannahill (1970.313)

Except for the volume of the left leg protruding through the folds of the floor-length robe, this drawing betrays little of the plasticity of Marcks's bronze *Alcina I* of 1934 (Rudloff 1977, no. 290), for which it served as a preliminary study. The modeling is abbreviated, indicated by hatchings that only hint at the compact form of the sculpture. The posture and expression of the figure, on the other hand, are analogous to those in the finished bronze. The features of the model are those of Trude Jalowetz (see no. 81), which suggests that she posed for the drawing not later than 1933, although Rathenau published two other preliminary drawings for the statue modeled by Jalowetz, one of which is dated February 25, 1934 (Rathenau 1967, pls. 43, 44). According to Rudloff, earlier studies of 1932 show the model with short hair. Marcks made two other versions of the statue in 1934, both of which depict the figure with loosely flowing hair. *Alcina II* (Rudloff 1977, no. 291) was cast in bronze. *Alcina IIa* (ibid., no. 291a), equipped with a plinth, was cast in cement. For the title Marcks presumably chose the name of the beguiling sorceress in Boiardo's *Orlando innamorato* and Ariosto's *Orlando furioso* in recognition of the name's evocative association, rather than with a specific iconographic meaning in mind.

Gerhard Marcks, *Standing Woman in Long Robe*
(cat. no. 86)

87.
Seated Female Nude (Ino), ca. 1934

Graphite pencil on cream wove paper; 397 x 290 mm

INSCRIPTION: Signed with pencil on recto at lower
right, *Marcks*

ANNOTATIONS: With pencil on verso at lower left,
v40; with pencil on verso in lower left corner,
N 4599; with pencil on verso at lower center, *18*

CONDITION: Good

PROVENANCE: Robert H. Tannahill, Grosse Pointe
Farms, Michigan

EXHIBITION: Detroit 1969

REFERENCE: Detroit 1969, p. 37

Gift of Robert H. Tannahill (1945.76)

This drawing is a study for Marcks's bronze *Ino* of 1934 (Rudloff 1977, no. 289). The posture of the figure is more erect than in the sculpture, where the head is inclined in a mood of wistful reverie. That Marcks sought to explore this position in the preliminary sketch is indicated by the erasures and the hesitant draftsmanship of the head of the figure and in the upraised arms. Although the finished sculpture bears the features of Trude Jalowetz (see no. 81), who had left Germany in 1933, the hairstyle and full-bodied figure of the nude suggest that Marcks's

eldest daughter Brigitte served as the model for the Detroit drawing. That Trude Jalowetz had posed for the statue earlier is documented by an undated drawing published by Rathenau (1967, pl. 46).

The title of the sculpture bears no evident relationship to the iconography of the piece, unless the bronze is accepted as possibly depicting Ino, second wife of Athamas and aunt and nursemaid of Dionysus, in her later manifestation as the sea goddess Leucothea (Ovid, *Metamorphoses*, 4:416).

88.
Standing Female Nude (Barbara), ca. 1934

Graphite pencil with stumping on cream wove paper; 424 x 240 mm

INSCRIPTIONS: With pencil on recto at lower left, *X*; signed with pencil on recto at lower right, *Marcks*

ANNOTATION: With pencil on verso in lower left corner, *v40*

CONDITION: Lightstruck; loss upper right corner; right edge torn rather than trimmed

PROVENANCE: Buchholz Gallery, New York; Robert H. Tannahill, Grosse Pointe Farms, Michigan

EXHIBITION: Detroit 1970a

REFERENCE: Detroit 1970a

Bequest of Robert H. Tannahill (1970.314)

This drawing was done in conjunction with two bronzes of 1934, modeled after Marcks's eldest daughter Brigitte, who was seventeen at the time. One of the bronzes is a statuette, entitled *Small Barbara* (Rudloff 1977, no. 293), the other, *Large Barbara I* (ibid., no. 296), is life-size. The energetic conception of the nude relates the drawing more closely to *Large Barbara I* than to the slightly more attenuated forms and introspective mood of the statuette, although in the sculpture the legs of the figure stand farther apart, and the right arm is extended in a more rigid position. Marcks slightly reworked the bronze in 1939 and cast it anew as *Large Barbara II* (ibid., no. 367). Between 1930 and 1937 Brigitte Marcks was, next to Trude Jalowetz (see no. 81), her father's favorite model, posing for thirteen statues and two portraits (ibid., nos. 214, 215, 234, 236, 246, 258, 274, 277, 289, 293–296, 320, 341; see also no. 87).

89.
*Standing Woman in Open Dress
(Demeter)*, ca. 1935

Graphite pencil with stumping on cream wove paper; 379 x 263 mm

INSCRIPTION: Signed with pencil on recto at lower right, *G. Marcks*

ANNOTATION: With pencil on verso in lower left corner, *v40*

WATERMARK: SCHOELLERSHAMMER around figure of hammer

CONDITION: Good; slight yellowing

PROVENANCE: Robert H. Tannahill, Grosse Pointe Farms, Michigan

EXHIBITION: Detroit 1969

REFERENCE: Detroit 1969, p. 37

Gift of Robert H. Tannahill (1945.79)

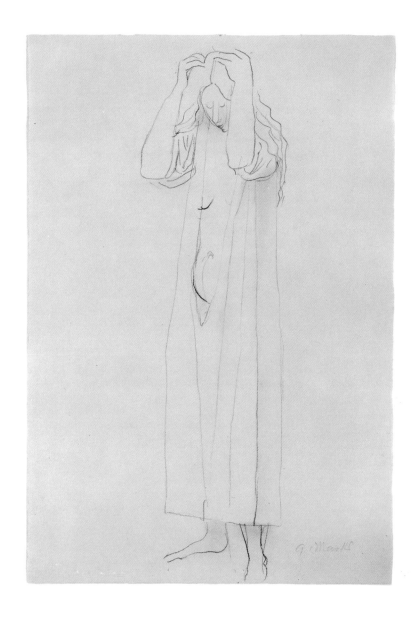

This drawing is a preliminary study for Marcks's 1935 bronze *Demeter* (Rudloff 1977, no. 305). Despite the lack of modeling, the stereometric folds of the garment anticipate the compact form of the statue closely. In the bronze the upraised hands of the woman are pulling a cloth over her head in allusion to the mourning goddess's sorrow over the loss of her daughter Persephone.

Color Plates XIII-XXXII

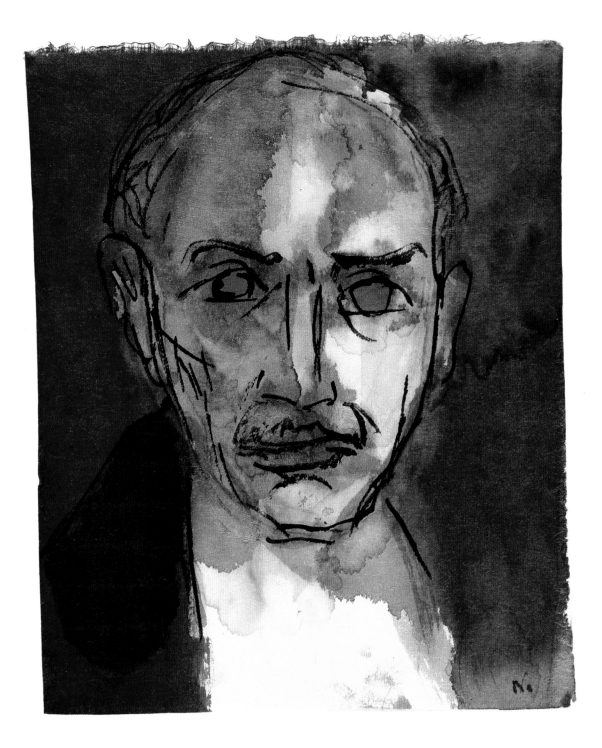

Plate XIII Emil Nolde, *Self-Portrait* (cat. no. 101)

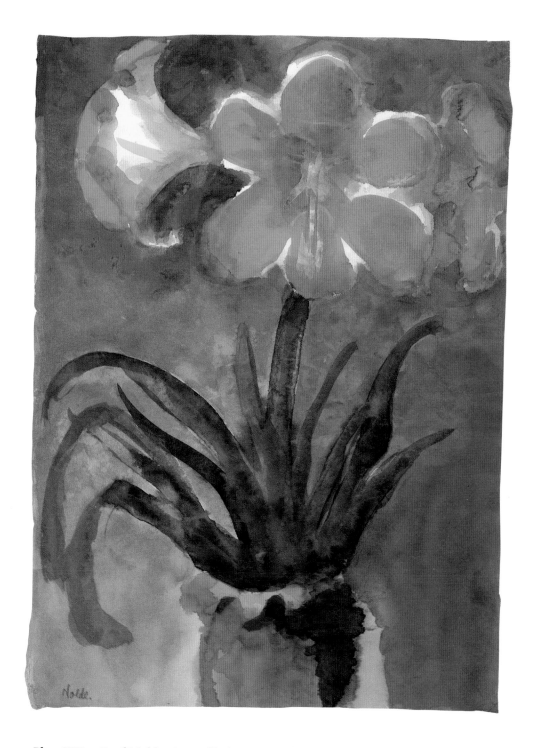

Plate XIV Emil Nolde, *Amaryllis* (cat. no. 102)

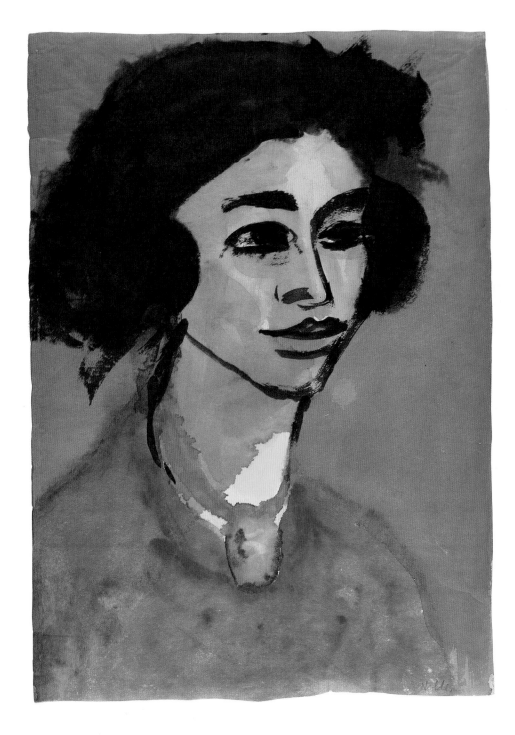

Plate XV Emil Nolde, *Portrait of Mary Wigman* (cat. no. 103)

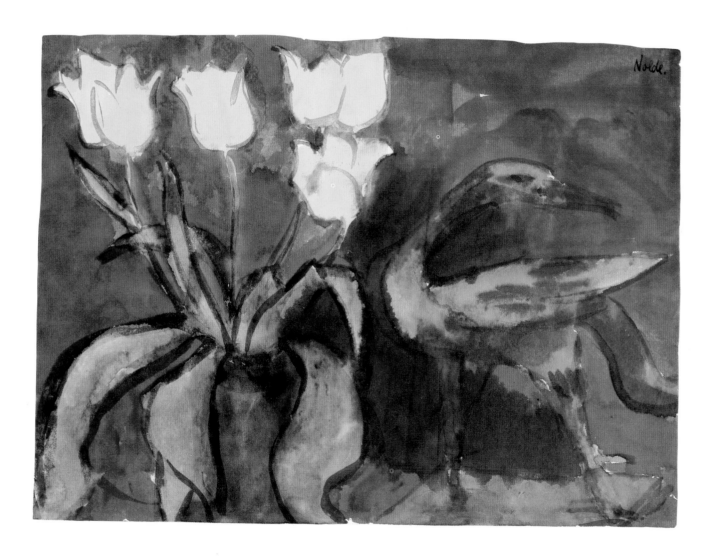

Plate XVI Emil Nolde, *Tulips and Bird* (cat. no. 104)

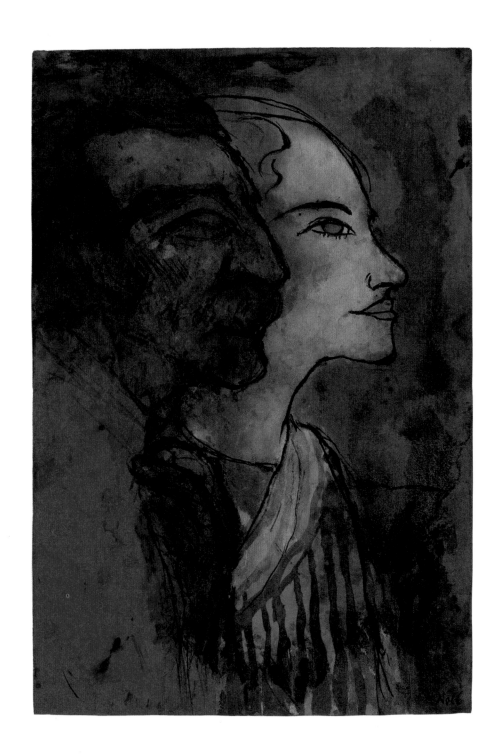

Plate XVII Emil Nolde, *Portrait of the Artist and His Wife* (cat. no. 107)

154

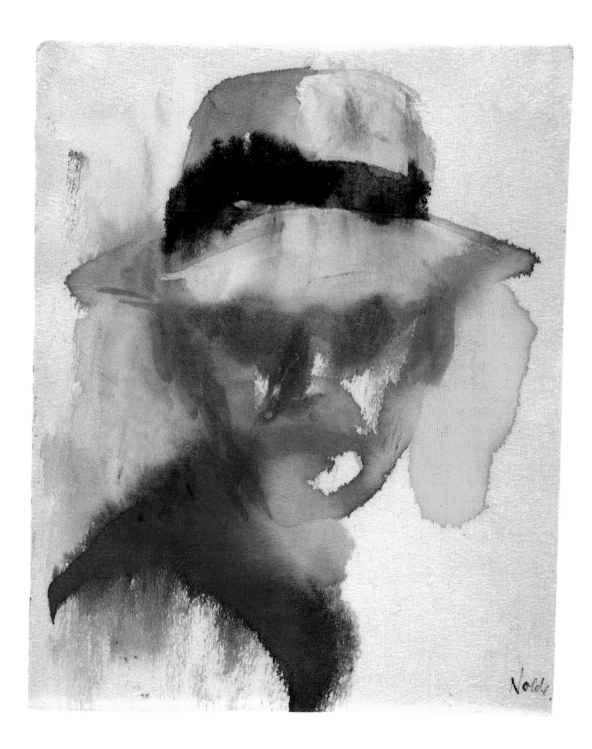

Plate XVIII Emil Nolde, *Self-Portrait* (cat. no. 109)

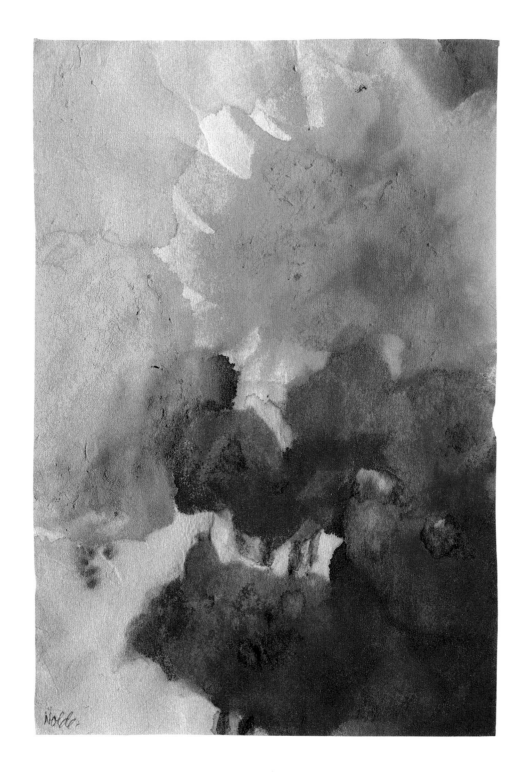

Plate XIX Emil Nolde, *Flowers* (cat. no. 110)

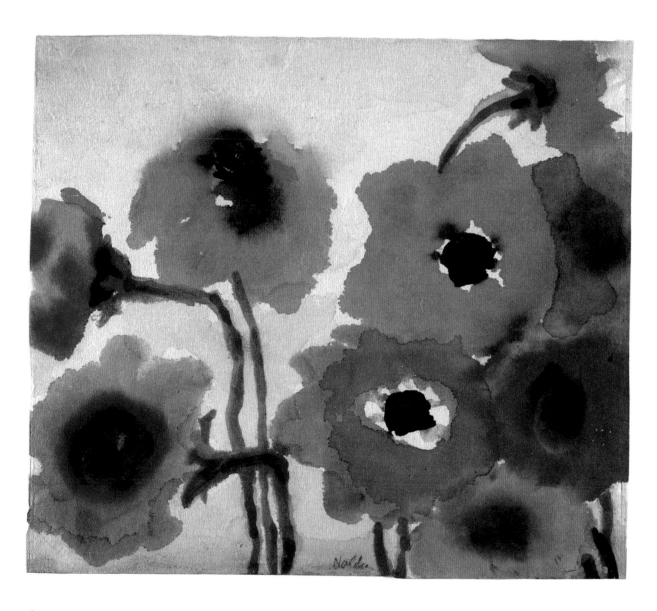

Plate XX Emil Nolde, *Nine Anemones* (cat. no. 111)

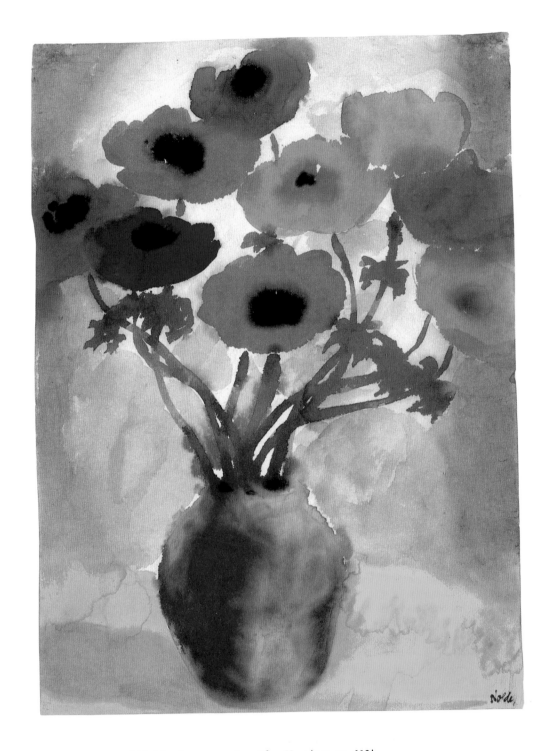

Plate XXI Emil Nolde, *Anemones in a Blue Vase* (cat. no. 112)

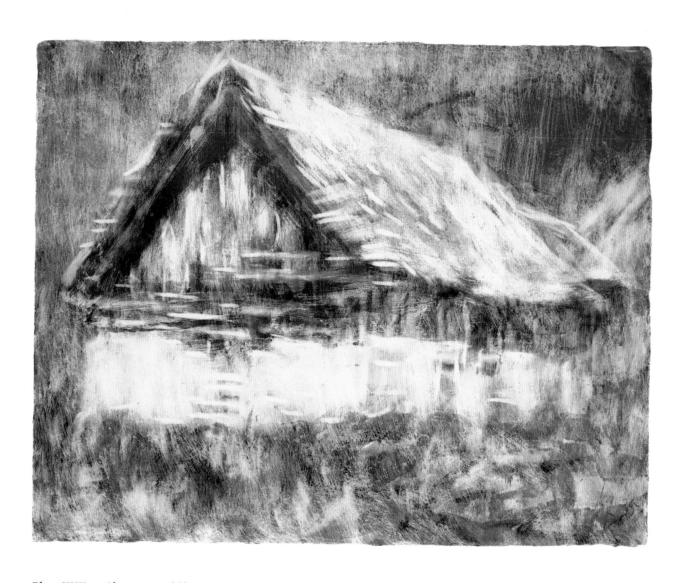

Plate XXII Christian Rohlfs, *House in the Mountains* (cat. no. 123)

Plate XXIII Karl Schmidt-Rottluff, *Tomatoes and Cucumber* (cat. no. 132)

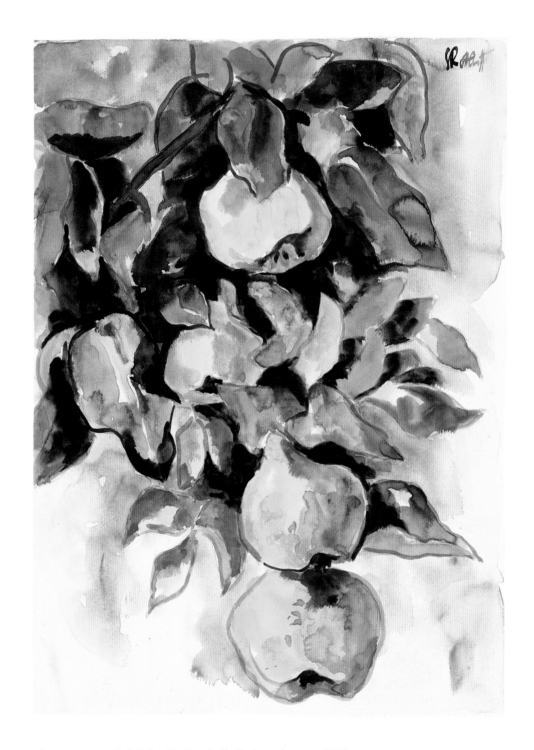

Plate XXIV Karl Schmidt-Rottluff, *Quinces* (cat. no. 133)

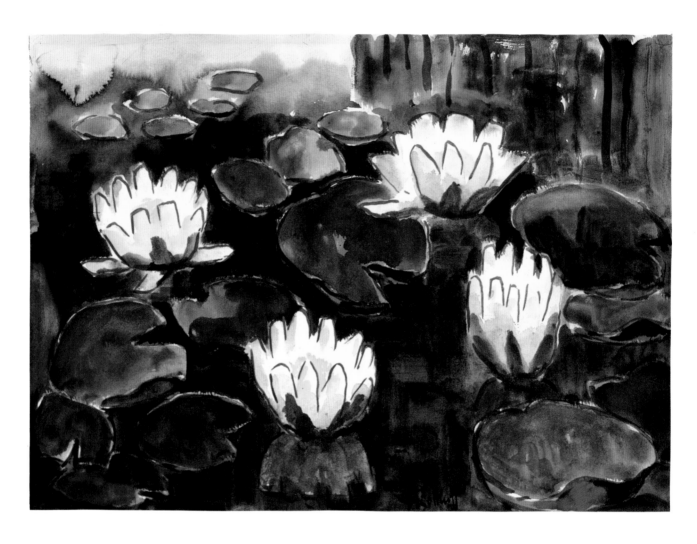

Plate XXV Karl Schmidt-Rottluff, *Water Lilies* (cat. no. 135)

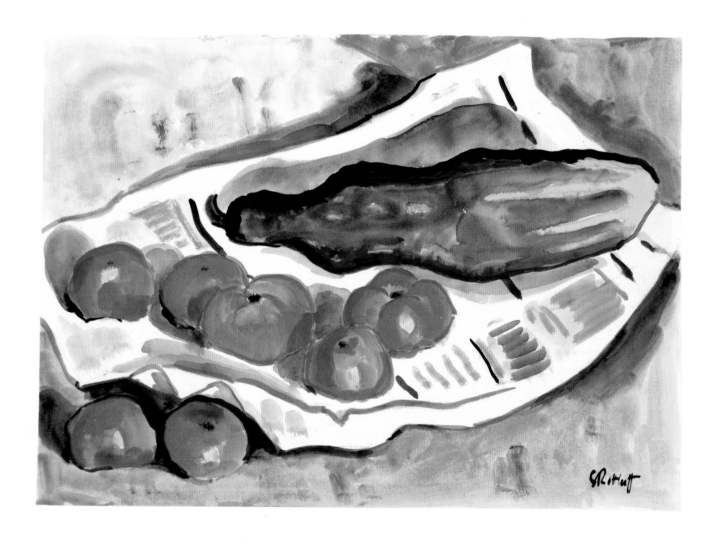

Plate XXVI Karl Schmidt-Rottluff, *Still Life with Cucumbers and Tomatoes* (cat. no. 136)

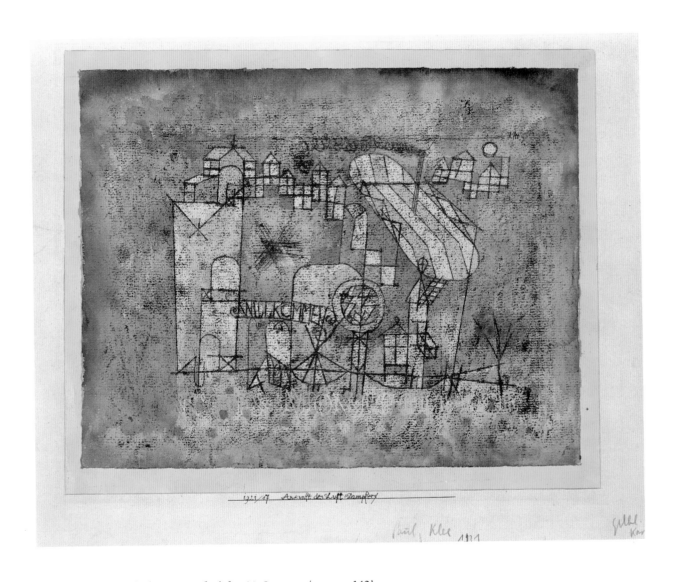

Plate XXVII Paul Klee, *Arrival of the Air Steamer* (cat. no. 142)

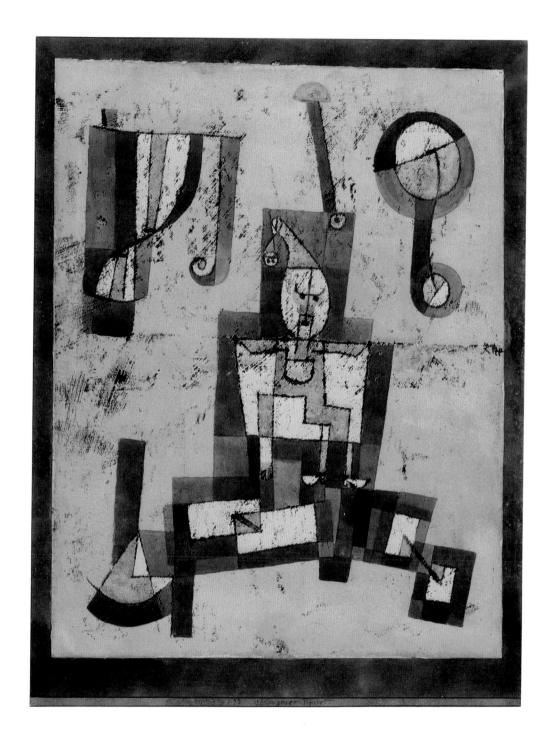

Plate XXVIII Paul Klee, *Captive Pierrot* (cat. no. 145)

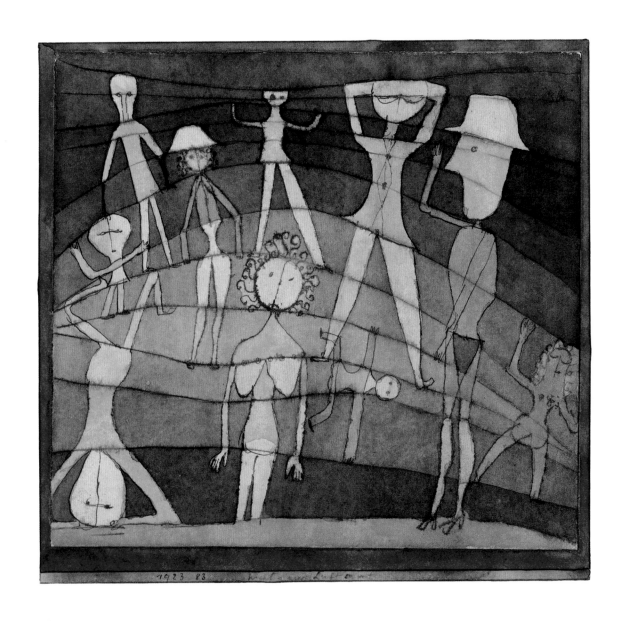

Plate XXIX Paul Klee, *Open-Air Sport* (cat. no. 146)

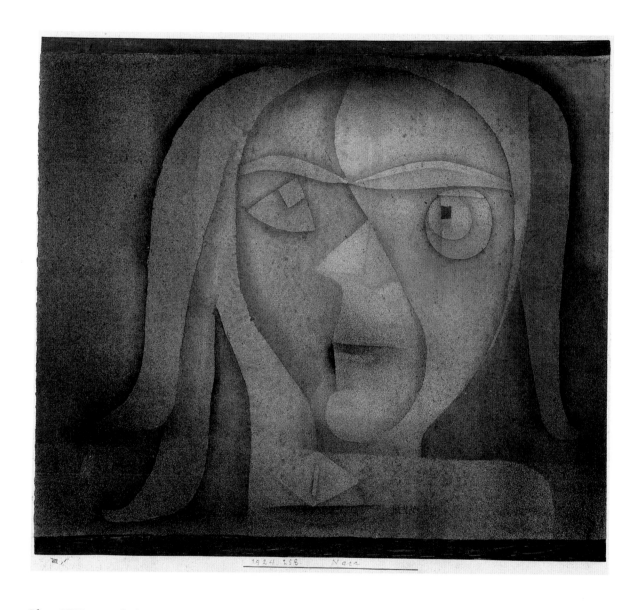

Plate XXX Paul Klee, *Jester* (cat. no. 147)

Plate XXXI Paul Klee, *Storm over the City* (cat. no. 149)

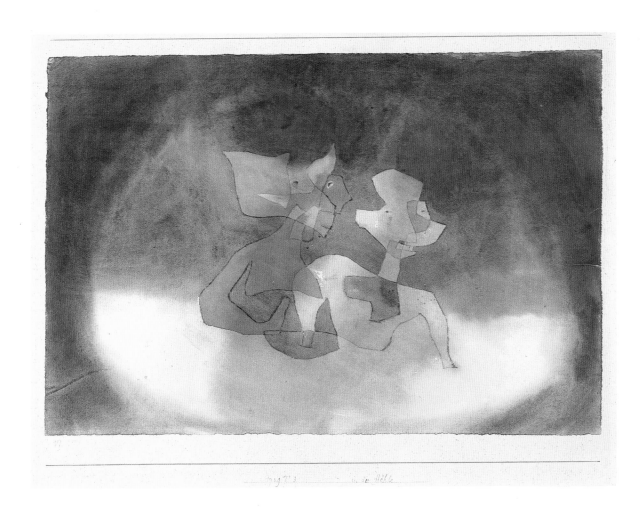

Plate XXXII Paul Klee, *Into the Cave* (cat. no. 150)

Gerhard Marcks

1889 Berlin – Burgbrohl/Eifel 1981

90.
Standing Female Nude, ca. 1936

Graphite pencil with stumping on discolored wove paper; 465 x 292 mm

INSCRIPTION: With pencil on recto at lower right, *X*

WATERMARK: E·G·VOLKERSZ

CONDITION: Lightstruck; dark lines forming a rectangle around the figure transferred from heavy pencil lines on the reverse of a previous window mat

PROVENANCE: Buchholz Gallery, New York; Robert H. Tannahill, Grosse Pointe Farms, Michigan

EXHIBITION: Detroit 1970a

REFERENCE: Detroit 1970a, p. 75

Bequest of Robert H. Tannahill (1970.315)

This is one of Marcks's rare, more fully developed drawings. The contours have been carefully reinforced, and there is sufficient modeling to bring out the lean figure of the young woman. Apparently intended as a representation of Eve, the drawing is a preliminary study for Marcks's bronze of 1936, less specifically titled *Girl with Apple* (Rudloff 1977, no. 328). In the drawing the contrapposto is more pronounced, the model bearing comparatively greater weight on the engaged leg. The position of the figure is otherwise identical to that of the bronze.

91a.
Standing Female Nude (Betula), frontal view, 1938

Graphite pencil on cream wove paper; 448 x 328 mm

INSCRIPTION: Dated and signed with pencil on recto at lower right, *X/14 1 38/G. Marcks*

ANNOTATIONS: Matting notations in pencil on recto at lower left, *M* and *up/here*; with pencil on verso in lower left corner, *v40*

CONDITION: Lightstruck; stain from cup or glass

PROVENANCE: Robert H. Tannahill, Grosse Pointe Farms, Michigan

EXHIBITION: Detroit 1969

REFERENCE: Detroit 1969, p. 37

Gift of Robert H. Tannahill (1945.75)

Before Marcks began work on a sculpture, he made numerous drawings, ranging from rapid sketches containing his first ideas for a given work to preliminary studies for the fully conceptualized project, in which the model is observed from many different points of view. In the sculptural process—with the drawings displayed on easels and shelves near his modeling stand—he relied less on nature than on the preliminary studies. His sculptures, as a result, not only retain strong linear elements, but are based on simplifications and abstractions already achieved in the preparatory sketches. In general, they agree remarkably in posture and expression with the drawings that directly preceded them.

Dated January 14, 1938, *Standing Female Nude* is one of five in the collection of the Detroit Institute of Arts (no. 91a-e), all of which were done in preparation for the bronze *Betula* (Rudloff 1977, no. 355) of 1938.

All are simple contour drawings, and each depicts the model from a different position. There is no modeling, and even such anatomical details as the joints of the knees and the young woman's breasts have been reduced to ornamentalized patterns. Marcks's daughter Gottliebe, born in 1922, posed for the subject, as she did for at least nine other sculptures executed between 1934 and 1942 (ibid., nos. 285, 324, 324a, 327, 338, 352, 368, 373, 409).

The name "*Betula*," Latin for birch tree, which Marcks chose as a title for the sculpture, probably had personal associations for him. The original plaster cast for *Betula* was heavily damaged when Marcks's studio in Berlin was destroyed by bombs in 1943. After the war, Marcks reworked the fragment, a torso without arms and head, for recasting.

91b.
Standing Female Nude (Betula), back view, 1938

Graphite pencil on cream wove paper; 446 x 326 mm

INSCRIPTION: Signed with pencil at lower right, *G. Marcks*

ANNOTATIONS: Indecipherable annotation with pencil on recto in lower right corner, [(M)] (inverted)?; with pencil on verso in lower left corner, *v40*

CONDITION: Good

PROVENANCE: Robert H. Tannahill, Grosse Pointe Farms, Michigan

EXHIBITION: Detroit 1969

REFERENCE: Detroit 1969, p. 37

Gift of Robert H. Tannahill (1945.77)

91c.
Standing Female Nude (Betula), right profile view, 1938

Graphite pencil on discolored wove paper; 448 x 328 mm

INSCRIPTION: Signed with pencil on recto at lower right, *G. Marcks*

ANNOTATIONS: With pencil on recto in lower left corner, *(M)*; with pencil on verso in lower left corner, *v40*

CONDITION: Lightstruck; pressure-sensitive tape in upper corners

PROVENANCE: Robert H. Tannahill, Grosse Pointe Farms, Michigan

EXHIBITION: Detroit 1969

REFERENCE: Detroit 1969, p. 37

Gift of Robert H. Tannahill (1945.78)

91d.
Standing Female Nude (Betula), three-quarter profile view from the left, 1938

Graphite pencil on cream wove paper; 448 x 330 mm

INSCRIPTION: Signed with pencil on recto at lower right, *X /G. Marcks*

ANNOTATION: With pencil on verso in lower left corner, *v40*

CONDITION: Lightstruck

PROVENANCE: Buchholz Gallery, New York; Robert H. Tannahill, Grosse Pointe Farms, Michigan

EXHIBITION: Detroit 1969

REFERENCE: Detroit 1969, p. 37

Gift of Robert H. Tannahill (1966.29)

91e.
Standing Female Nude (Betula), frontal view, 1938

Graphite pencil on cream wove paper; 448 x 330 mm

INSCRIPTION: Signed with pencil on recto at lower right, *X/G. Marcks*

ANNOTATION: With pencil on verso in lower left corner, *v40*

CONDITION: Lightstruck

PROVENANCE: Robert H. Tannahill, Grosse Pointe Farms, Michigan

EXHIBITION: Detroit 1969

REFERENCE: Detroit 1969, p. 37

Gift of Robert H. Tannahill (1966.30)

92.
Reclining Female Nude, ca. 1941

Graphite pencil on cream wove paper; 261 x 426 mm

INSCRIPTION: Signed with pencil on recto at lower right, *X/G. Marcks*

ANNOTATIONS: With pencil on recto near center left margin, *m*; with pencil on verso at lower left, *v40*

CONDITION: Slight cockling; residue from pressure-sensitive tape at upper edge

PROVENANCE: Robert H. Tannahill, Grosse Pointe Farms, Michigan

EXHIBITION: Detroit 1969

REFERENCE: Detroit 1969, p. 37

Gift of Robert H. Tannahill (1945.74)

Recumbent figures are relatively rare in Marcks's work. This drawing may have been executed in conjunction with a project that first occupied him in 1941, *Reclining Girl* (Rudloff 1977, no. 394), a small statue cast in both bronze and zinc. According to Rudloff, four pencil studies of 1941 showing the recumbent figure in various positions were done with Marcks's daughter Ute as the model. Ute Marcks seems to have modeled for the Detroit drawing as well. The emphasis is exclusively on contours, as Marcks sought to explore different postural pos-

sibilities. In the sculpture, the model's hair is pinned up, and the figure rests on her left side, propped up on her elbow, supporting her head with her hand, while placing the other hand on the right thigh. In 1942, Marcks translated the statue into a life-size plaster model (ibid., no. 421), which served as the basis for a still larger statue in marble (ibid., no. 438), completed in 1943. Both of these works were destroyed in World War II. In a terra cotta of 1948 (ibid., no. 529), Marcks returned to the subject in a slightly modified form.

93.
Standing Female Nude, ca. 1941

Graphite pencil on cream wove paper;
482 x 291 mm

INSCRIPTION: Signed with pencil on recto at lower
right, *X/G. Marcks*; with pencil on recto in lower
right corner, [2]

ANNOTATION: With pencil on verso in lower left
corner, *v40*

WATERMARK: E·G·VOLKERSZ

CONDITION: Lightstruck; masking tape in upper
corners

PROVENANCE: Robert H. Tannahill, Grosse Pointe
Farms, Michigan

EXHIBITION: Detroit 1969

REFERENCE: Detroit 1969, p. 37

Gift of Robert H. Tannahill (1958.42)

The model's hairstyle and physical appearance point
to *Standing Eve with Flowing Hair* (Gerhard
Marcks-Stiftung, Bremen; Rudloff 1977, no. 400), a
zinc cast of 1941, as the possible context for this
drawing. In the sculpture, the figure stands with
both legs engaged, and both arms are extended
alongside the body. The shading is somewhat more
pronounced than is usually the case in Marcks's
drawings, the vertical hatchings having been applied
more profusely. The model for this drawing appears
to have been Marcks's daughter Ute, who in 1941
posed for four other statues (ibid., nos. 384, 388, 389,
392–394, see nos. 79, 92). Ironically, Marcks's *Stand-
ing Eve with Flowing Hair* was much damaged when
the zinc cast lay buried underground for protection
during World War II. The sculpture anticipates two
additional versions of the subject, one completed in
1944, the other in 1947 (ibid., nos. 450, 488).

94.
Seated Female Nude, ca. 1944

Graphite pencil with stumping on cream wove
paper; 381 x 260 mm

INSCRIPTION: Signed with pencil on recto at lower
right, *X/G Marcks*

ANNOTATIONS: With pencil on recto in lower right
corner, *(1)*; with pencil on verso in lower left corner,
v40; with pencil on verso at lower right, *T*

CONDITION: Lightstruck; masking tape adhered to
upper corners

PROVENANCE: Robert H. Tannahill, Grosse Pointe
Farms, Michigan

EXHIBITION: Detroit 1969

REFERENCE: Detroit 1969, p. 37

Gift of Robert H. Tannahill (1958.44)

Depicting the model at rest, this incidental sketch was most likely done in 1944 while Marcks worked on the preliminary studies for the second in a group of three closely related sculptures of a seated female nude. In the bronze (Rudloff 1977, no. 454), the figure is shown in a less casual pose. Gazing upward, she is seated erectly, supporting her weight with her extended right arm. Her left hand rests lightly on the left thigh. In both the original version of the subject, a plaster model of 1942 (ibid., no. 414), and in the third version, a bronze completed in 1945 (ibid., no. 476), the figure is shown with the legs crossed. The plaster model, for which Marcks's niece Maria Reimers had posed, was destroyed by bombs in 1943 before the work could be cast in metal. Marcks's daughter Gottliebe served as the model for the sculpture of 1945.

95.

Portrait of Countess Helga Bernstorff (recto)
Preliminary Study for Portrait of Countess Helga Bernstorff (verso), ca. 1947

Graphite pencil with stumping on cream laid paper; 269 x 229 mm

INSCRIPTION: Signed with pencil on recto at lower right, + *X/G. Marcks*

ANNOTATIONS: With pencil on verso at lower center, *Buchholz* (upside down); at lower right, 2"*Laid-M B:3/1" Duveen/gold toned*

CONDITION: Faint mat burn; light yellowing, probably from discolored fixative; portrait on verso has been partially erased

PROVENANCE: Buchholz Gallery, New York, 1953; Robert H. Tannahill, Grosse Pointe Farms, Michigan

EXHIBITION: Detroit 1970a

REFERENCE: Detroit 1970a, pp. 75, 103, ill.

Bequest of Robert H. Tannahill (1970.316)

The woman in this drawing is identifiable as Countess Helga Bernstorff, a relative of Marcks's wife, Maria. The drawing is done swiftly, with just enough modeling, achieved by rubbing and smudging the pencil lines, to enhance the features with a delicate chiaroscuro. Supporting her head with her right hand, the sitter gazes toward the left, enveloped in a mood of introspection. The drawing most likely dates from 1947 and may have been executed as part of the preliminary studies for the portrait head of Countess Bernstorff (Rudloff 1977, no. 491) which Marcks made during that year. Cast in bronze, the portrait served as the basis for a terra cotta mask of the countess (ibid., no. 492), which Marcks also completed in 1947. The verso of the drawing bears traces of an erased portrait showing the sitter in a three-quarter profile view.

96.
Standing Male Nude (Orion) (recto)
Preliminary Study for Standing Male Nude (Orion) (verso), ca. 1948

Graphite pencil on discolored laid paper;
440 x 317 mm

INSCRIPTION: Signed with pencil on recto at lower left, *G Marcks X*

WATERMARK: Rooster (in circle)

CONDITION: Stain through center of sheet, probably from discolored fixative; tear in upper right corner; drawing on verso incomplete

PROVENANCE: Buchholz Gallery, New York, 1950; John S. Newberry, New York

EXHIBITIONS: New York 1950; Detroit 1951; Detroit 1965

REFERENCES: New York 1950, no. 53; Detroit 1951, no. 18; Detroit 1965, p. 63, ill.

Gift of John S. Newberry (1959.63)

This drawing is a preliminary study for Marcks's bronze *Orion* (Rudloff 1977, no. 528) of 1948. The attenuated limbs and their rhythmic disposition are characteristic of Marcks's work after 1945 and represent a further development in his simplified portrayal of the human figure. Marcks's assured grasp of the surface modulation of the figure is illustrated by the single contour line to the left of the model, which was apparently intended to help clarify the posture. Another pencil sketch of the lower torso and the legs is executed on the verso of the sheet.

As is often the case in Marcks's sculpture, the title has only a vague iconographic relationship to the piece and was chosen less for illustrative reasons than for the associations the statue conjured up in the sculptor's mind. According to one version of the legend, Orion, a skillful hunter of great beauty and enormous physical strength, was blinded by Oenopion of Chios for having violated his daughter Merope, but eventually had his sight restored by the rays of the rising sun (Hyginus, *Poetica astronomica*, 2:34; Parthenius, *Erotica*, 20). Reinforced by the enigmatic gesture of the upraised hands, there is an air of expectancy surrounding the figure that is shared, although in a more introspective manner, by several of Marcks's bronzes from these years (cf. Rudloff 1977, nos. 457, 485, 486, 499).

Otto Mueller

1874 Liebau/Silesia – Breslau 1930

97.
Two Bathers, ca. 1928–30

Plate XII

Crayon, pastel, watercolor, and brush and black ink on off-white wove paper; 520 x 685 mm

INSCRIPTION: Signed with brown crayon on recto at lower left, *Otto Mueller*

ANNOTATIONS: With pencil on recto at lower left, *K.38*; with pencil on verso at upper left, *180.–* and *60 FH*; with black ink on verso at lower right, *I.M. 29*; label glued on verso to lower left corner: *Nierendorf Köln/Neue Kunst/Gürzenischstr. 16/No. 38* (partially erased)

CONDITION: Abrasion; faint vertical creases through center of sheet indicate that drawing may once have been rolled; both recto and verso appear to have rubbed against other drawings, causing a transfer of pigments

PROVENANCE: Günther Franke, Munich, 1937; Robert H. Tannahill, Grosse Pointe Farms, Michigan

EXHIBITIONS: Detroit 1966; Detroit 1970a; Detroit 1976

REFERENCES: *BDIA* 45, nos. 3–4 (1966): 60–61, no. 46, ill.; Detroit 1970a, pp. 75, 103, ill.; Detroit 1976, p. 203, no. 273, ill.

Bequest of Robert H. Tannahill (1970.317)

Mueller's bathers evoke a typically Expressionist utopia, an idyllic world in which man achieves harmony through intimate contact with nature. Within the limited range of his themes, that of bathers was the one Mueller explored most often. His conception avoided the rapture and sensuality with which such artists as Kirchner and Pechstein invested the subject in favor of a gentle lyricism frequently tempered by a touch of melancholy.

There is something wistful about the two female nudes in the Detroit drawing. Their gestures are arrested as if by some indefinable lassitude and their simplified features suggest deep contemplation. The delicate colors accentuate the drawing's tender mood. They are restricted to a few tones of blue, yellow, green, and brown which have been rubbed and brushed across the abrasive texture of the paper. The contours that make the figures stand out against the chalky ground also determine the rhythm of the composition. The bather on the right, standing in a frontal position, reinforces the vertical element. The seated bather on the left emphasizes both the horizontal and diagonal axes of the pictorial structure. Since there is neither foreshortening nor a pronounced spatial dimension, the figures having been conceived without any concern for real volume, the composition resembles a low relief. Both the subdued colors and the friezelike arrangement of the figures recall the conventions of ancient Egyptian wall paintings and reliefs, the influence of which Mueller acknowledged in the preface to the catalogue of an exhibition of his work at Paul Cassirer's in Berlin in 1919 (Buchheim 1963, p. 86).

The chronology of Mueller's drawings is difficult to establish. He rarely dated his works, and after 1915 his art showed little stylistic change. The angular lines employed in the Detroit drawing are associated with his works from the 1920s, as opposed to the mellifluous lines characteristic of his earlier output. There is a possibility that the drawing dates from about the same time as Mueller's lithograph *Three Bathers* of ca. 1928–30, which repeats the composition in a modified and expanded form (see Karsch in Berlin 1974, p. 120, no. 99). In the print, the contemplative character of the two adolescent bathers has been subordinated to greater physical action, and there is a corresponding change in the gestures of the figures. The accessories of the setting, however, as well as the disposition of the two nudes on the left, remain fundamentally the same.

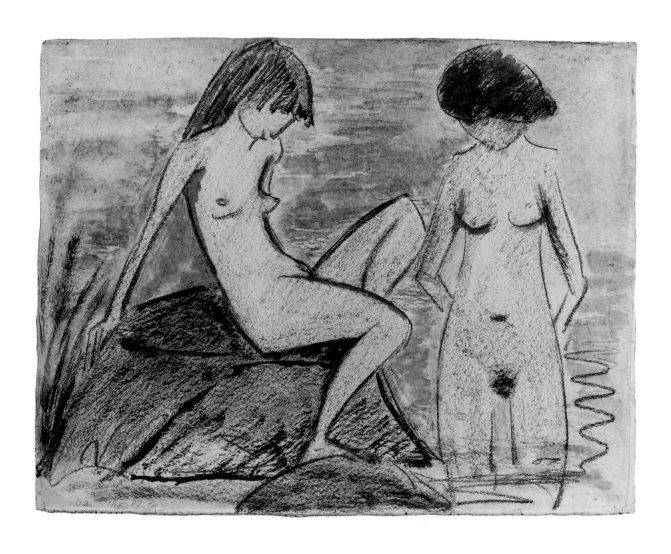

Ernst Wilhelm Nay

1902 Berlin – Cologne 1968

98.
Diana, 1949

Gouache over graphite pencil on cream wove paper
with an impressed laid texture; 260 x 282 mm

INSCRIPTION: Signed and dated with pen and black
ink on recto at lower right, *Nay 49*

CONDITION: Good

PROVENANCE: John S. Newberry, New York

EXHIBITION: Detroit 1965

REFERENCE: Detroit 1965, p. 70, ill.

Bequest of John S. Newberry (1965.226)

Nay's stylistic development follows a steady progression from representational forms to compositions in which color achieves a pictorial value independent of any thematic associations. Epitomizing Nay's efforts of the late 1940s, this gouache maintains a balance between figurative and abstract imagery. There is considerable emphasis on color relationships for their own sake, as is evident from the juxtaposition of the primaries red and yellow with such chromatically related shades as pink and brown and the neutrals black and white. Yet although the individual colors—applied in flat, unmodulated layers—assert their own values, they still find support in the graphic elements of the pictorial structure. Elliptical shapes, circles, dots, and segmented forms, unified by loops and splintered lines, not only add to the composition an independent expressive dimension, but also give rise to hieroglyphic signs that are vaguely representational, alluding to bows, arrows, and dimly perceived human forms that invest the colored shapes with objective meaning.

The 1949 gouache is similar in both form and expression to the ten color lithographs Nay executed in the summer of that year for the Bremen publisher and art dealer Michael Hertz. This commission encouraged Nay's tendency toward a more abstract handling of color and form, since the technical requirements of the lithographic process forced him to treat each color plane as an independent entity and to develop each composition—through juxtaposition and overprinting—from a limited number of hues. Although their thematic content is subordinated to the pictorial elements, Nay's color

lithographs, like the Detroit gouache, retain simplified figurative signs the definition of which is aided by the evocative titles of the individual prints. The influence of the color lithographs on his oil paintings of about the same time is seen in such works as *David and Bathsheba* (1949) and *Siren* (1950) (Haftmann 1960, pls. 39–40), to which the decorative surface quality of the gouache also bears a close relationship.

99.
Abstraction, 1957

Watercolor on white wove paper; 338 x 456 mm

INSCRIPTION: Signed and dated with blue ball-point pen on recto at lower right, *Nay 57/P.*

ANNOTATION: With pencil on verso in lower right corner, _10_.

CONDITION: Lined with white fabric resembling fine canvas

PROVENANCE: John S. Newberry, New York

EXHIBITION: Detroit 1965

REFERENCE: Detroit 1965, p. 70

Bequest of John S. Newberry (1965.225)

After 1955 Nay eliminated all graphic elements from his compositions, freeing himself from the figurative signs which until then had continued to invest even his most abstract works with emblematic meaning. Seeking to avoid all thematic allusions, he began to employ the color disk as his basic pictorial form, a shape in which all directions of movement are neutralized. In this watercolor of 1957, color alone sustains the composition. The circular color areas seemingly float at random in the picture space. Yet both movement and space are organized on the basis of the structural qualities of the colors. The rhythm of the composition is determined by the contrasts between the primaries red, yellow, and blue and their complementaries green, orange, and purple, as well as by the varying degrees of saturation of the individual hues. Having emphasized the structural value of color to the exclusion of all figurative and emotive associations, Nay transformed the composition into an autonomous pictorial organism that no longer expresses anything but itself.

Emil Nolde

1867 Nolde – Seebüll 1956

100.
The Steamer, ca. 1910

Watercolor on japanese paper; 195 x 140 mm

INSCRIPTION: Signed with pen and brown ink on recto in lower left corner, *Nolde.*

CONDITION: Repaired long vertical cut along right side

PROVENANCE: Günther Franke, Munich, 1937; Robert H. Tannahill, Grosse Pointe Farms, Michigan

EXHIBITION: Detroit 1970a

REFERENCES: Detroit 1970a, pp. 76, 106, ill.; Uhr 1982, pp. 174–175, color ill.

Bequest of Robert H. Tannahill (1970.322)

Nolde's watercolor was inspired by a brief stay in Hamburg in early 1910. The visit yielded not only many superb drawings, but an important group of etchings that communicate in a simplified and expressive form Nolde's subjective response to the seaport (Schiefler and Mosel 1966–67, 1: nos. 129–141, 144–147). In *The Steamer* Nolde conveyed his experience through color. Having saturated the paper with somber shades of green and blue, he allowed the colors to flow together and collect in random concentrations of varying hues, while controlling the flow and intensity of the colors in the upper half of the sheet with a wet brush or a tuft of cotton and re-applying washes in the lower half after the paper had begun to dry. He thus achieved a subtle distinction between sky and water, although light and texture are no longer the result of observation, but a function of color alone. Once the paper had dried, the image of the churning boat, emitting thick plumes of smoke, was rapidly executed by dragging a brush dipped in black wash across the colored ground. A final dab of reddish brown gives definition to the hull of the vessel.

The compositional structure of the watercolor is similarly expressive. By placing the boat close to the margin and permitting the bands of color to extend seemingly beyond the confines of the sheet, Nolde created the impression of an infinite expanse of sea. The slightly uneven edges of the watercolor suggest that the image was executed on a sheet that was cut by the artist to its present dimensions as part of the deliberate compositional process.

Whether the conception of the watercolor arose from the violent crossing of the Kattegat that Nolde experienced at about this time (Nolde 1934, p. 96), and which subsequently led him to paint series of pictures of the stormy sea, is difficult to say, for Nolde's imagination was receptive to the elemental forces in nature. Throughout his career, the sea remained for Nolde the embodiment of an ominous and primeval force. In addition to the Hamburg harbor etchings, the woodcut vignettes Nolde made in 1910 for the first edition of Gustav Schiefler's catalogue of the artist's early prints include several depictions of steamships that are conceptually close to

the Detroit watercolor (Schiefler and Mosel 1966–67, 2: nos. 72, 72a, 75). This is also true of the brush-and-ink drawing *Tug* (Urban 1970, p. 35) and the oil painting *Tugboat on the Elbe* (Haftmann 1959, pl. 2), both of which are preserved at the Nolde-Museum in Seebüll and are datable to 1910.

The watercolor technique employed in *The Steamer* had its origin in a chance discovery Nolde made in 1908 during a visit to Cospeda, a small town near Jena. Nolde recounted (Nolde 1934, pp. 88–89) how he was working out-of-doors on a cold winter day when snow fell on the watercolor sketches that lay scattered around him, altering the texture and saturation of the colors in an unexpected way. On another occasion the wet colors froze on the paper, forming random crystalline patterns. Nolde was fascinated by the autonomous behavior of the colors and welcomed the manner in which nature imposed her laws upon his work.

The Cospeda watercolors were painted on cardboard. Beginning in 1910, when Nolde first started to use highly absorbent japanese paper for his watercolors, he consciously strove to duplicate the accidental effects brought about two years earlier by the intervention of snow and frost. As the colors spread across the moistened paper, they merged with one another in arbitrary combinations, forming edges and color concentrations which gave rise to new and unexpected pictorial structures. These Nolde encouraged to emerge, alternately reinforcing the individual hues or lightening the saturations through admixtures of water. Once the evocative color base had dried sufficiently, Nolde consolidated the final image with a few deft brushstrokes.

Nolde continued to explore this technique, occasionally supplementing the watercolor medium with tempera, colored inks, and pastels. Since he rarely dated his watercolors, they are difficult to arrange in a chronological sequence, unless they can be grouped with works known to have been done at a specific time. After 1910 they show little stylistic development, except that the earlier ones tend to be more opaque and supported by heavier graphic elements than the transparent and fluid watercolors Nolde painted after 1935.

101.
Self-Portrait, ca. 1917

Plate XIII

Watercolor (applied to both recto and verso) and reed pen and black ink on japanese paper; 215 x 178 mm

INSCRIPTION: Signed with pen and green ink on recto in lower right corner, *N*.

CONDITION: Good; slight cockling; repaired cut lower right

PROVENANCE: John S. Newberry, New York

EXHIBITIONS: Bloomfield Hills 1947; Ann Arbor 1948; Cambridge 1948; New York 1948; San Francisco 1948; Detroit 1960; Detroit 1965; Detroit 1966

REFERENCES: Cambridge 1948, p. 23; New York 1948, no. 34; Detroit 1960, no. 6; Detroit 1965, pp. 70–71, ill.; *BDIA* 45, nos. 3–4 (1966): 62, ill., 73, no. 73

Bequest of John S. Newberry (1965.230)

Nolde apparently made few self-portraits. While their number among his drawings and watercolors is not known, only four are recorded among his paintings, and possibly no more than five are included among his prints. Of the four self-portraits in oil, each one was apparently intended to commemorate a particular stage in Nolde's life. The first was done in 1899, at the end of his apprenticeship, the next two date from 1917, when the painter turned fifty. In 1947 Nolde painted the fourth, in celebration of his eightieth birthday.

The watercolor from the Newberry collection may be contemporary with the oil painting of 1917 at the Nolde-Museum in Seebüll (Haftmann 1959,

frontispiece). Not only does the artist appear to be of the same age, but the two works are fundamentally similar in both conception and expression, with the face, dominated by the intense gaze of the blue eyes, shown against a background unified by one pervasive hue. In the watercolor this hue is a rich russet. It provides a foil for the cooler shades of green, yellow, purple, and blue, which have been used in the modeling and interact with the paper ground visible in the illuminated side of the face and the white shirt front. Prompted by the distribution of the colors, Nolde reinforced the physiognomic details with a few brushstrokes after the saturated paper had dried.

102.
Amaryllis, ca. 1918

Plate XIV

Watercolor (applied to both recto and verso) on japanese paper; 478 x 350 mm

INSCRIPTION: Signed with pencil on recto at lower left, *Nolde.*

CONDITION: Good

PROVENANCE: Heinz Schultz; Robert H. Tannahill, Grosse Pointe Farms, Michigan

EXHIBITION: Detroit 1970a

REFERENCE: Detroit 1970a, pp. 75, 104, ill.

Bequest of Robert H. Tannahill (1970.318)

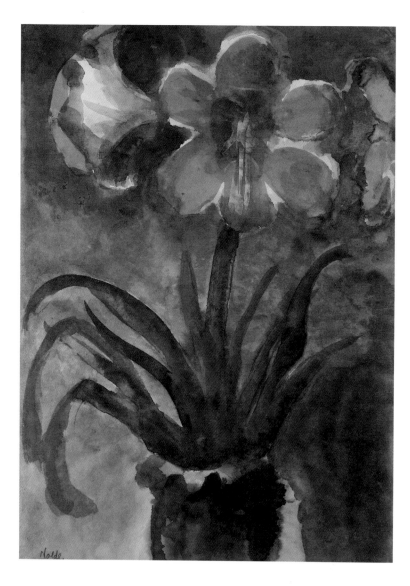

According to the donor's records (Curatorial Files), this watercolor was painted in 1918. There is no reason to doubt the accuracy of the date, since the work conforms technically to the procedure Nolde used in his watercolors of about this time. While there are no outlines to define the image, graphic elements are dominant. In the leaves and stem of the amaryllis, painting and drawing are fused in a single process, allowing the green color to stand out crisply against the blue of the paper ground. The complementary red of the blossoms, echoed by the less brilliant hue of the pot, has been applied somewhat more loosely. But here too, the placement of the color sufficiently approximates the technique of drawing to preserve the tangible character of the flowers.

103.

Portrait of Mary Wigman, ca. 1920

Plate XV

Watercolor on japanese paper; 486 x 346 mm

INSCRIPTION: Signed with pencil on recto near lower right margin, *Nolde.*

CONDITION: Adhesive residue on verso from previous mounting

PROVENANCE: J. B. Neumann, New York; Mrs. George Kamperman, Detroit

EXHIBITIONS: Chicago 1937; Detroit 1966

REFERENCES: Chicago 1937, no. 40; Woods 1965, p. 10; *BDIA* 45, nos. 3–4 (1966): 66, ill., 70, no. 65; Scheyer 1970, pp. 10, 11, ill.

Gift of Mrs. George Kamperman in memory of her husband, Dr. George Kamperman (1964.227)

To Nolde the dance was more than rhythmic motion or a form of artistic expression. It was an expression of life itself, a revelation of human feelings in movement and gesture (Nolde 1934, p. 138). He was fascinated by such Jugendstil dancers as Isadora Duncan and Loïe Fuller and keenly admired the primitive aspects of the dance as expressed in the ecstatic movements of the Australian dancer Saharet and the passionate dancing of the gypsies of Spain. Nolde's conviction that dancing was a profoundly personal experience also helped bond his friendship with Mary Wigman (1886–1973), the great German pioneer of modern dance.

Nolde first met Wigman in 1912, while she was studying eurythmics at the school of Emil Jacques-Dalcroze at Hellerau, near Dresden. As she wrote to Ernst Scheyer on August 7, 1967 (Scheyer 1970, p. 15), Nolde was in a sense responsible for her subsequent development, having called her attention to the work of Rudolf von Laban. In 1913 Wigman joined Laban at his mountain retreat near Ascona, Switzerland. His system of rhythmic exercises, stressing self-discovery and self-expression through movement, provided the foundation for her own method of dance gymnastics and freestyle dance. After Wigman's return from Switzerland in 1919, Nolde attended her revolutionary dance concerts whenever possible, usually reserving three seats, one for himself, one for his painting utensils, and one for his wife, who saw to it that he could make sketches of the dancer without being disturbed (Sorell 1975, p. 55).

The Detroit portrait of Wigman originated in a more conventional setting. Although the bust-length format allowed the fullest exploration of facial expression, the portrait is surprisingly detached,

possibly because the painter's well-known reticence—which did not interfere with his empathy when he painted the dancing figure—made an analysis of the sitter in the course of a direct encounter impossible. The life-size head is turned away from the viewer; the large eyes gaze dispassionately into the distance. The psychological reserve is reinforced by the generalized face, which bears only a typological resemblance to Wigman's strong and resolute features.

Technically, the watercolor takes up a pictorial problem which had occupied Nolde since 1914: how best to achieve an overall tonality in a painting without sacrificing the independence of the individual colors. In the Detroit watercolor this is accomplished through a carefully contrived alliance of the three primaries—red, yellow, and blue. Instead of being sharply contrasted, they have been applied in intermediate hues, which have been arranged so as to form transitions from blue to red, and from red and blue to yellow. Balancing each other in a subtle way, they unify the picture surface in a darkly glowing harmony of colors.

According to Scheyer, who confirmed the identity of the sitter during a visit to the dancer's home in the summer of 1969, the watercolor was done in Berlin in 1920 (letter to the author, May 31, 1982; Curatorial Files). In another watercolor portrait of Wigman (New York 1963a, pp. 32, 64–65, 84, no. 80), believed to have been painted at about the same time, the emphasis on purely pictorial values that underlies the conception of the portrait in Detroit has given way to a more expressive interpretation, which suggests that this other watercolor is either an idealized portrait of Wigman or that it was inspired by a dance performance.

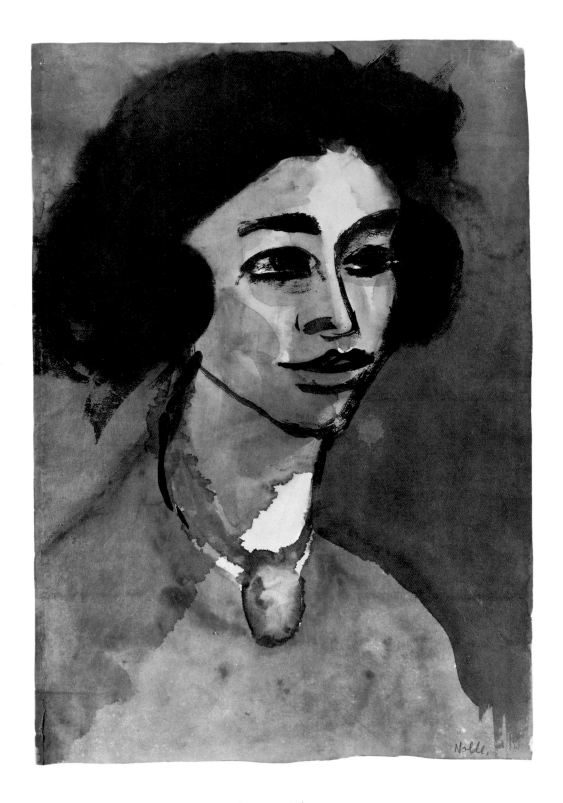

Emil Nolde, *Portrait of Mary Wigman* (cat. no. 103)

104.
Tulips and Bird, ca. 1920

Plate XVI

Watercolor on japanese paper; 350 x 485 mm

INSCRIPTION: Signed with pen and black ink on recto in upper right corner, *Nolde*.

CONDITION: Tipped onto mount with spots of adhesive at each corner

PROVENANCE: Paul M. Hirschland; The New Gallery, New York; Robert H. Tannahill, Grosse Pointe Farms, Michigan

EXHIBITION: Detroit 1970a

REFERENCE: Detroit 1970a, pp. 75, 105, ill.

Bequest of Robert H. Tannahill (1970.321)

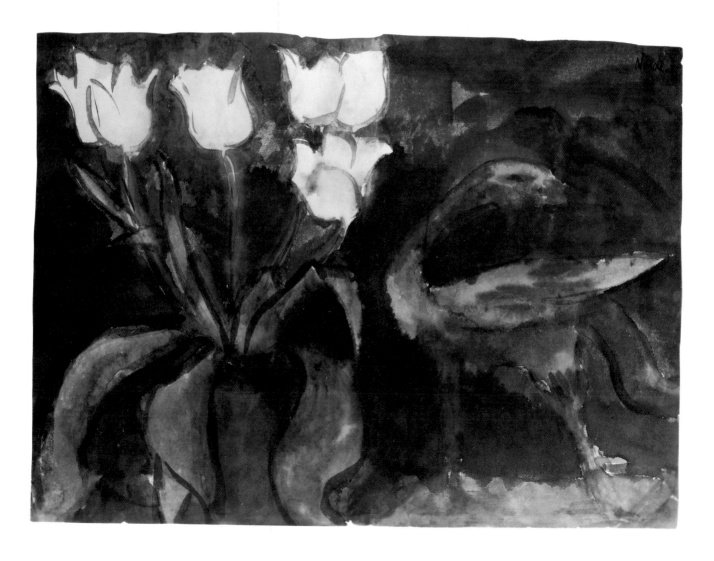

In his still lifes, Nolde frequently combined simple garden flowers with objects of a more exotic nature, such as masks and statuettes from the South Pacific, or assorted pieces of ceramics acquired in the course of his travels to Russia and the Far East. The juxtaposition usually heightens the viewer's perception of the individual objects, and even the most familiar flowers may take on a strange and unexpectedly mysterious air.

In the Detroit watercolor, an enigmatic bird, possibly a waterfowl made out of painted clay or wood, has been placed alongside a bouquet of yellow tulips. The distinction between art and nature is sufficiently blurred to suggest an anecdotal relationship between the bird and the flowers, transposing the still life from its homely context to a realm of fantasy. The ambivalence of the subject is reinforced by the luminous paper ground. Gravitating from bright red to russet, it functions less as a spatial setting than as a richly textured surface upon which the images appear. The darker shades of the red are complemented by the subdued yellow and green of the flowers and the amorphous area of dark blue which links the vase and the bird. The plumage of the bird is painted in variegated hues of yellow, blue, purple, and green, which alternately repeat and complement the colors of the bouquet and the ground.

According to a label that was attached to the frame of the still life when it was in the collection of The New Gallery, the watercolor dates from about 1920. The relatively opaque colors, as well as the graphic elements that have been employed to give shape and definition to the flowers and the bird, tend to confirm this date. In Nolde's watercolors they occur predominantly in this form before the mid-1930s. In his later watercolors the outlines have been either superimposed upon colors of greater transparency or have been omitted entirely. Conceptually, the watercolor has affinities to such paintings as *Flowers and Vayang Figures* and *Vayang Figures and Flowers* (Nolde-Museum, Seebüll; Haftmann 1959, pl. 31; Cologne 1973, no. 94, pl. 77), both of which date from 1928, the year during which Nolde painted still lifes almost exclusively.

105.
Panther, ca. 1923–24

Watercolor (applied to both recto and verso) on japanese paper; 339 x 470 mm

INSCRIPTION: Signed with pen and black ink on recto near lower left margin, *Nolde.*

CONDITION: Adhered to cardboard mount with spots of adhesive along all four edges

PROVENANCE: Wilhelm R. Valentiner, Raleigh, North Carolina

REFERENCE: *BDIA* 45, nos. 3–4 (1966): 78–79, ill.

Bequest of Wilhelm R. Valentiner (1963.132)

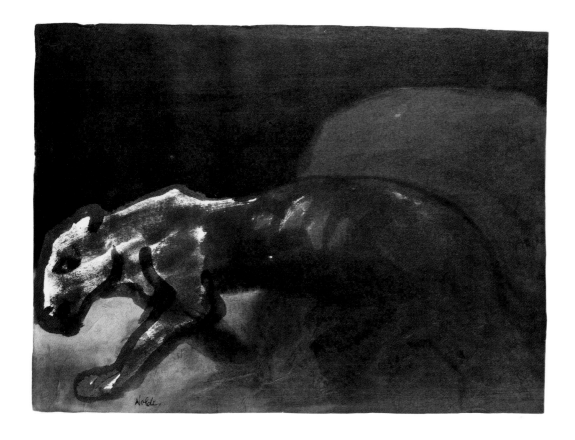

In general, Nolde painted animals only if he was fascinated by the particular beauty of their colors, or if they appealed to his own feeling for the animistic character of nature. *Panther* most likely belongs to the group of animal watercolors he painted at the Berlin Zoo in the winter of 1923/24, several of which are still in the collection of the Nolde-Museum at Seebüll (Urban 1966, pp. 51, 57, 63, 69, 75, 79, 85). The mood of the composition is solely determined by color, as shades of blue, brown, and black create a dark and mysterious ground that retains no vestige of illusionistic pictorial space. Except for the few spots where the sheet has been left untouched, the paper is thoroughly saturated with color. Upon this ground the image of the panther takes shape, only half premeditated, it seems, and half prompted by the suggestive power of the random distribution of the colors.

106.
Two Peasants, ca. 1930

Watercolor (applied to both recto and verso) and black ink on japanese paper; 193 x 145 mm

INSCRIPTION: Signed with pen and brown ink on recto at lower center, *Nolde.*

CONDITION: Good

PROVENANCE: John S. Newberry, Grosse Pointe Farms, Michigan

EXHIBITIONS: Minneapolis 1950; Seattle 1952; Detroit 1965; Detroit 1966

REFERENCES: Minneapolis 1950, no. 101; Myers 1957, p. 164, pl. 35; Detroit 1965, p. 70, ill.; *BDIA* 45, nos. 3–4 (1966): 69-70, ill., no. 66; Uhr 1982, pp. 182–183, color ill.

Gift of John S. Newberry (1945.461)

Bernard Myers's proposal to date this watercolor to about 1930 was presumably based on stylistic considerations, for the highly intricate texture and rich colorism are found among other watercolors Nolde painted at about the same time. The fibrous japanese paper has been completely saturated with color, the brilliant hues of red, yellow, and blue mingling freely with subdued earth colors that modulate from ocher to brown. Some of the colors were applied while the paper was wet. Others were added after the initial washes had dried, with the aim of strengthening a particular color or focus of interest. If the sheet is looked at from the verso, the variegated ground provides a vivid illustration of the free color arrangements from which Nolde subsequently developed the image. He virtually discovered the picture amid the blurred contours and color concentrations, consolidating the squat shapes and rough-hewn faces of the two peasants in an appropriately rugged configuration applied with a brush and black ink. The slightly uneven edges of the paper indicate that it was trimmed to suit the composition after the watercolor was completed.

As the watercolor illustrates, Nolde, in his search for expression, did not hesitate to explore the grotesque. His earlier scenes of country life, such as *Peasants (Viborg)* and *Market People*, both painted in 1908 and now preserved at the Nolde-Museum in Seebüll (Haftmann 1959, pl. 1; Cologne 1973, no. 11, pl. III), and the etchings of peasants and fishermen he made between 1899 and 1918 (Schiefler and Mosel 1966–67, 1: nos. 2, 32, 33, 38, 39, 159, 160, 202, 204), are similiar in conception. Utilizing caricature and intensified contrasts of light, shade, and color, Nolde subordinated the genre character commonly associated with these subjects to a mood of fantasy.

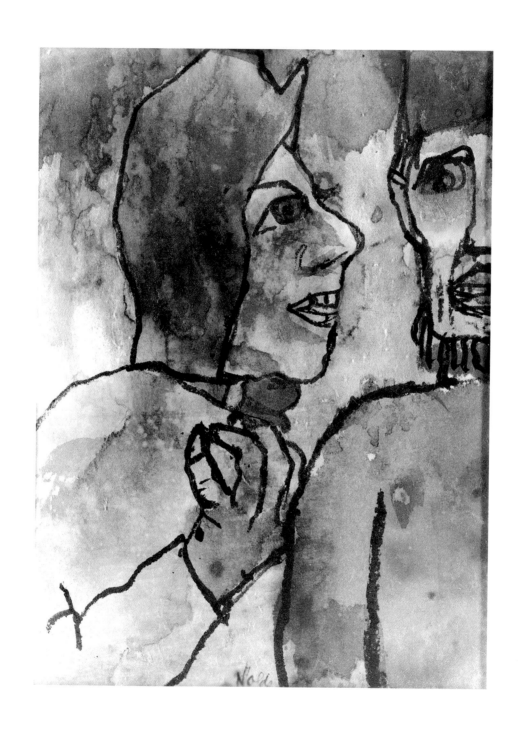

107.
Portrait of the Artist and His Wife,
ca. 1932

Plate XVII

Watercolor (applied to both recto and verso) and pen and black ink on japanese paper; 525 x 358 mm

INSCRIPTION: Signed with pen and black ink on recto in lower right corner, *Nolde*

CONDITION: Good; sheet creased as if crumpled after drawing was executed

PROVENANCE: Günther Franke, Munich, 1936; Robert H. Tannahill, Grosse Pointe Farms, Michigan

EXHIBITIONS: Detroit 1936a; Chicago 1937; Boston 1957; Detroit 1970a

REFERENCES: Nolde 1934, p. 260, ill.; Chicago 1937, no. 39; Boston 1957, no. 109, ill. p. 88; Detroit 1970a, pp. 56, ill., 59, 76; Detroit 1979, pl. XLXXX, pp. 215, 254; Detroit 1985, pp. 172–173, color ill.

Bequest of Robert H. Tannahill (1970.323)

The fundamental difference between man and woman was a theme that occupied Nolde's imagination throughout his career. He dealt with the subject not only within its fundamentally erotic context or in the guise of casual social encounters, but frequently projected it onto a legendary or symbolic plane, exploring the conflict inherent in this duality through compositional tensions and the juxtaposition of opposing colors.

In the Detroit double portrait, the pictorial means have been carefully contrived so as to bridge the elemental gulf between man and woman and to confirm the harmony of the relationship between husband and wife. The spiritual accord of the couple is implicit in the concordance of posture and expression and is symbolically underscored by the interrelationships of the colors. Both faces are illuminated by a greenish light, with the complexion of the artist in a barely perceptible tension with the lighter skin tone of his wife. Blue and red dominate the respective garments of the sitters. Instead of being contrasted, however, the two shades interpenetrate each other in innumerable transitions and repetitions. Having been applied in successive layers, they yield a rich and varied texture and a predominantly dark tonality that unifies the composition.

Ellen Sharp (Detroit 1970a, p. 59) suggested that the watercolor was done at about the same time as the slightly smaller double portrait (New York 1963a, no. 94, pp. 69, 84), since the age of the sitters appears to be the same in both works. While it is difficult to speak of actual resemblances, because the likenesses belong more to the realm of free invention than to the tradition of true portraiture, Sharp's suggestion is strengthened by the fact that the two watercolors are not only stylistically related, but that they were evidently conceived in the same spirit. According to a letter of July 15, 1957, from Iso Brante Schweide (New York 1963a, p. 69), this smaller portrait was created one night in early 1932, when Nolde arose from his bed to paint spontaneously what in a subsequent comment to his wife he called "the best portrait of our superior being." That Nolde may have attached a similar significance to the equally ideal double portrait in Detroit is suggested by his decision to include an illustration of the watercolor in *Jahre der Kämpfe* (Nolde 1934, p. 260), the second volume of his autobiography.

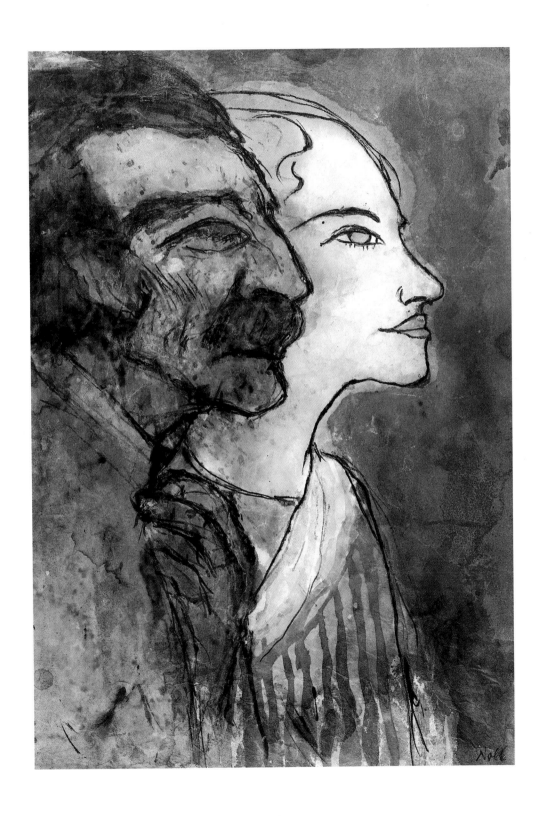

108.
Reflections, ca. 1935

Watercolor and brush and black ink on japanese paper; 342 x 470 mm

INSCRIPTION: Signed with pen and black ink on recto in lower right corner, *Nolde.*

CONDITION: Good

PROVENANCE: Günther Franke, Munich, 1937; Robert H. Tannahill, Grosse Pointe Farms, Michigan

EXHIBITIONS: Boston 1957; Detroit 1970a; Detroit 1976; Grosse Pointe Shores 1978

REFERENCES: Boston 1957, p. 110, no. 89, ill. p. 89; Detroit 1970a, pp. 59, 75, 105, ill.; Detroit 1976, p. 204, no. 274, ill.; Grosse Pointe Shores 1978, p. 24; Uhr 1982, 184–185, color ill.

Bequest of Robert H. Tannahill (1970.320)

Acquired by Robert H. Tannahill in 1937, this watercolor shares in the lyrical conception that from the mid-1930s onward dominated Nolde's work. Land, sea, and sky are enveloped in a radiant blue that is skillfully modulated so as to achieve the most delicate transitions between varying degrees of saturation. The yellow and greenish reflections of the distant lights hardly disturb the pervasive tonality of the blue ground. Neither does the graphic framework, which Nolde added after the original washes had dried, outlining the main features of the terrain, including a fence by the edge of the water, a dike crossing the lake to the opposite shore, and what may be an old windmill which has lost its vanes. Works of such concise construction are exceptional with Nolde and are found predominantly among his drawings and prints. Among his watercolors, only a few examples, such as *March Landscape in Winter* (Nolde-Museum, Seebüll; Urban 1970, pl. 8), to

which the Detroit watercolor bears a topographical resemblance, or Nolde's second landscape in Detroit (see *Landscape*, no. 113), employ graphic elements in the organization of the composition in a similar way.

The watercolor was inspired by the austere countryside of West Schleswig, the area between Tønder and Nolde, the artist's birthplace, which included the villages of Ruttebüll, Utenwarf, and Seebüll, where between 1918 and 1951 Nolde painted most of his important watercolor landscapes. According to Martin Urban (1970, p. 26), as late as the sixteenth century most of this region was still part of the North Sea and consisted of a few inhabited islands amid fens and mud flats that were flooded at high tide. Even during Nolde's lifetime, when dikes protected the land from the worst ravages of the sea, large areas of the countryside lay submerged from autumn to spring under water flowing from rivers and inland lakes.

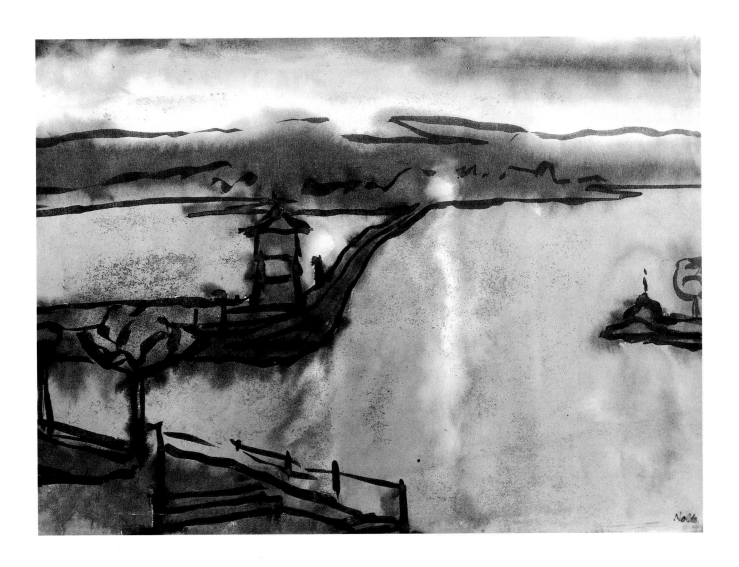

109.
Self-Portrait, ca. 1935–40

Plate XVIII

Watercolor (applied to both recto and verso) on japanese paper; 214 x 173 mm

INSCRIPTION: With pen and brown ink on recto in lower right corner, *Nolde.*

CONDITION: Good; edges trimmed after work was executed

PROVENANCE: Günther Franke, Munich; Robert H. Tannahill, Grosse Pointe Farms, Michigan

EXHIBITION: Detroit 1970a

REFERENCES: Detroit 1970a, pp. 75, 104, ill.; Uhr 1982, pp. 186-187, color ill.

Bequest of Robert H. Tannahill (1970.319)

In comparison with Nolde's earlier *Self-Portrait* (no. 101), in which the final definition of the image was achieved through graphic means, in this work the artist's features have been developed solely on the basis of color. The individual hues have been floated gently on the paper surface and distributed with the utmost economy, allowing much of the white paper ground to remain untouched and to contribute to the mood of the composition. A bright lemon yellow creates a cheerful ambiance, from which the greenish yellow panama hat with its contrasting black band and the bright blue of the artist's shoulder emerge as if of their own accord. Red accents emphasize mouth and ears; the eyes remain shrouded in pools of blue. The soft transitions between the hues and the transparency of the colors suggest that the *Self-Portrait* was done sometime after the mid-1930s, when a notably lyrical quality manifested itself in Nolde's work and the sonorous colorism of his earlier watercolors yielded to a more delicate tonality and subtler nuances.

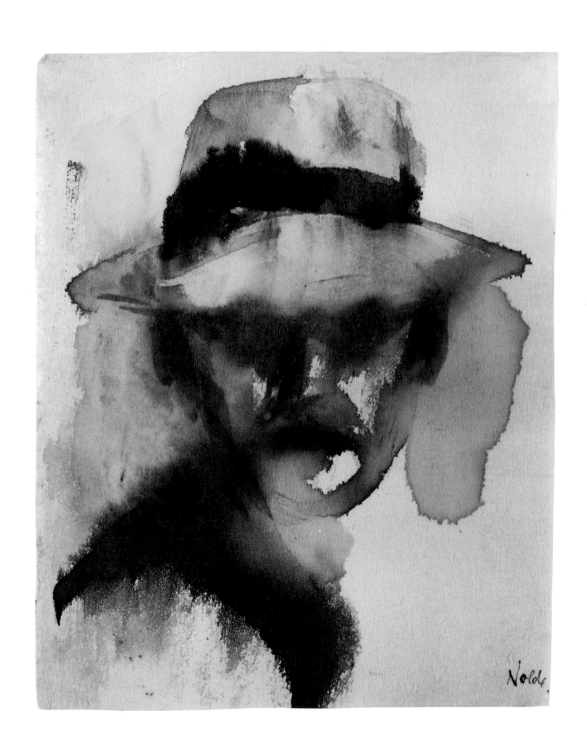

110.
Flowers (Zinnias and Asters), after 1935

Plate XIX

Watercolor (applied to both recto and verso) on japanese paper; 202 x 139 mm

INSCRIPTION: Signed with pen and brown ink on recto in lower left corner, *Nolde.*

CONDITION: Good; the surface of the drawing exhibits rubbed or lifted fibers resulting from working colors while sheet was wet; slight cockling

PROVENANCE: John S. Newberry, New York

EXHIBITIONS: Detroit 1960; Detroit 1965; Detroit 1966; Detroit 1970; Saginaw 1976

REFERENCES: Detroit 1960, no. 7; Detroit 1965, p. 70; *BDIA* 45, nos. 3–4 (1966): 70, no. 70, cover ill.; Detroit 1970, pp. 16–17, ill.

Bequest of John S. Newberry (1965.227)

The technique employed in this watercolor is similar to the one Nolde used in his so-called "Unpainted Pictures," on which he began work in 1938. Without any graphic elements to support the image, the composition has been developed entirely on the basis of color. Upon a ground of pink the complementaries blue and orange and yellow and green have been juxtaposed in fluid aggregates that suggest rather than describe the shapes of the flowers. Emphasis of form is achieved solely through the superimposition of additional layers of color. Most of the colors have been applied to both sides of the paper and allowed to soak through. As recto and verso reinforce each other, they yield a richly textured surface of colors that range from full opacity to highly transparent hues. The edges of the paper have been cut on all sides to condense and consolidate the composition.

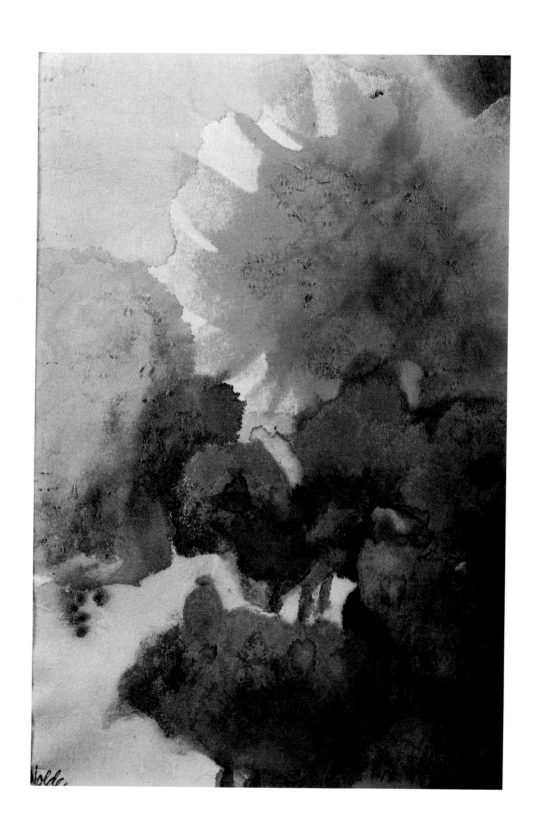

111.
Nine Anemones, after 1935

Plate XX

Watercolor (applied to both recto and verso) on japanese paper; 228 x 264 mm

INSCRIPTION: Signed with pencil on recto near lower center, *Nolde.*

CONDITION: Mounted to two-ply ragboard with spots of adhesive at each corner; slight cockling

PROVENANCE: John S. Newberry, New York

EXHIBITIONS: Detroit 1960; Boston 1962; Detroit 1965; Detroit 1966; Flint 1972

REFERENCES: Detroit 1960, no. 9; Boston 1962, no. 56; Detroit 1965, p. 70; *BDIA* 45, nos. 3–4 (1966): 48, ill., 70, no. 68

Bequest of John S. Newberry (1965.229)

The transparent colors and fluid execution suggest that this watercolor was painted after 1935. Form and texture of the flowers are based on color alone, the individual hues having been applied in successive layers and allowed to spread out freely until absorbed by the fibrous paper ground. Ranging from the intrinsic white of the paper to pale purple, the light-toned ground enhances the colors of the anemones, which have been distributed in random clusters of red, violet, and blue, with the green of the stems forming a linear accompaniment to the luminous circles of the petals. The compositional struc-

ture of the watercolor is common to many flower pictures by Nolde. Seen from up close and removed from all environmental allusions, the fragile anemones achieve a measure of monumentality that transcends the physical character of the species and dramatizes their effervescent glow. Nolde, who perceived in flowers a parallel to human existence and empathically identified with their growth and decay (Nolde 1934, p. 93), was fond of humanizing flowers and often made them the carriers of his own feelings and moods.

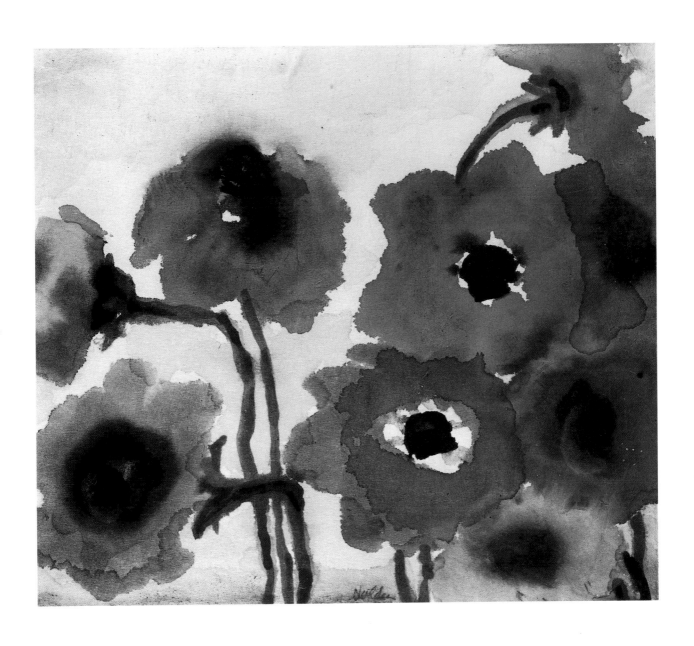

112.
Anemones in a Blue Vase, after 1935

Plate XXI

Watercolor on japanese paper; 470 x 350 mm

INSCRIPTION: Signed with pen and black ink on recto in lower right corner, *Nolde.*

CONDITION: Pigments faded, particularly the oranges; light creasing; upper right corner skinned

PROVENANCE: Robert H. Tannahill, Grosse Pointe Farms, Michigan

EXHIBITION: Detroit 1970a

REFERENCE: Detroit 1970a, pp. 58, ill., 76

Bequest of Robert H. Tannahill (1970.324)

In this flower still life, distinctions between line, form, and color have been all but eliminated. Without any contours to delimit the shapes of the anemones and the vase, the colors have been floated on in aggregates of red, salmon, blue, and purple, and set off against a ground of yellow and gray. The red is accentuated by the complementary green of the stems, which form a lively pattern linking the blossoms and the vase. Technically the watercolor is similar to *Nine Anemones* (no. 111). Both works share the transparency of color and fluid structure that are characteristic of Nolde's late style.

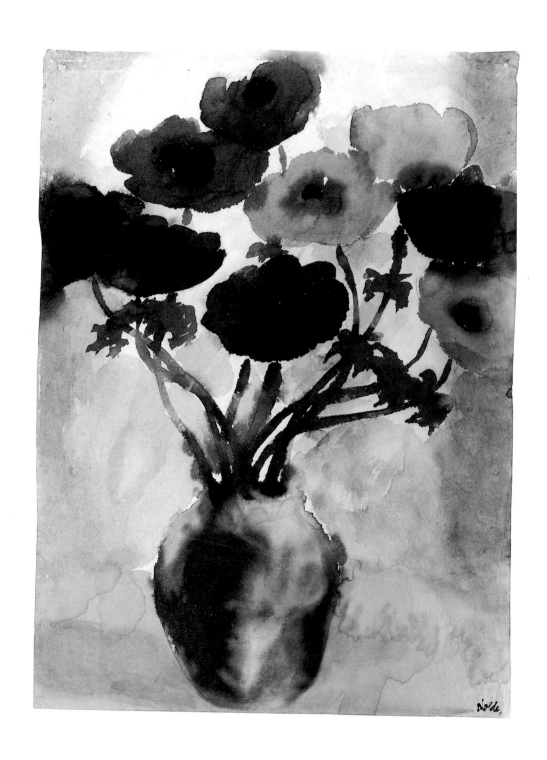

113.
Landscape, after 1935

Watercolor (applied to both recto and verso) over graphite pencil on japanese paper; 215 x 158 mm

INSCRIPTION: Signed with pen and black ink on recto in lower right corner, *Nolde.*

CONDITION: Good; slight cockling

PROVENANCE: John S. Newberry, New York

EXHIBITIONS: Detroit 1960; Detroit 1965; Detroit 1966

REFERENCES: Detroit 1960, no. 8; Detroit 1965, p. 70; *BDIA* 45, nos. 3–4 (1966): 70, no. 72

Bequest of John S. Newberry (1965.228)

Like the composition of *Reflections* (no. 108), the structural framework of this landscape is unusually simple, the repetitive pattern of the horizontal bands of color having been reinforced by outlines that separate the broad bands of land, sea, and sky. The ordering of the terrain is strengthened by the uniform tonality of the color planes. Ranging from blue to green and from purple to gray, with shades of red and green juxtaposed in the cluster of houses by the far shore, they unify the landscape in a predominantly somber mood. Some of the color patches have been applied to the reverse side of the paper and allowed to seep through to the recto, where their interaction with the texture of the fibrous japanese paper creates subtle atmospheric effects. As in other small water-

colors by Nolde, the slightly irregular edges of the sheet indicate that the bounds of the composition were established by trimming the paper to its present size.

The physical character of the site recalls the countryside near Seebüll, where Nolde settled in 1927, having left his farmhouse in the nearby village of Utenwarf when the construction of irrigation works threatened to destroy the wilderness and the peculiar beauty of the surrounding landscape. From his home and studio at Seebüll, erected on an ancient knoll protected from the encroachment of modern technology, the painter could see the north German plain for miles around.

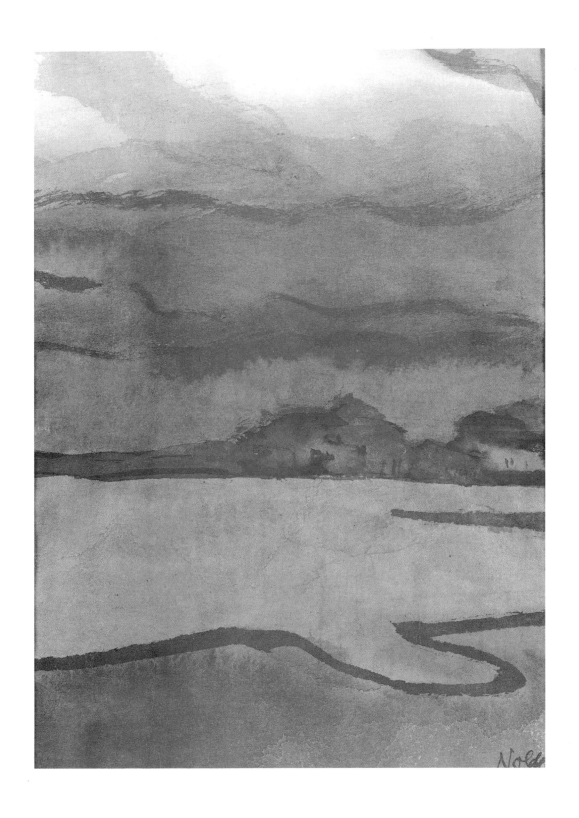

Max Pechstein

1881 Zwickau – Berlin 1955

114.
Standing Female Nude (recto)
The Circus (verso), ca. 1910

Pen and black ink and watercolor (recto), gouache
over graphite pencil (verso), on gray brown wove
paper with fibrous inclusions; 477 x 402 mm

INSCRIPTION: Signed with pencil on verso at lower
right *HMP* (in monogram)

ANNOTATION: With pencil on recto at upper left,
41/LX

CONDITION: Adhesive residue (recto); faint
mat burn (verso); old hinges cover portion of
design (verso)

PROVENANCE: Detroit Society of Arts and Crafts

EXHIBITIONS: Ann Arbor 1950; Detroit 1966;
Detroit 1970

REFERENCES: Ann Arbor 1950, no. 30; *BDIA* 45, nos.
3–4 (1966): 78; Detroit 1970, pp. 42–43, ill. of recto

Founders Society Purchase, Friends of Modern Art
Fund (1933.13)

Unlike Pechstein's earlier works, which combined Fauve color with a fundamentally Impressionist technique, this drawing is governed by the more simplified approach to color and form first evident in his output of 1910. In the figure of the female nude the modeling has been reduced to a few touches of red and black wash, while the emphatic lines circumscribing the stocky figure are as decorative as they are descriptive, accentuating the fleshy appearance of the model without denying the two-dimensional character of the image. In keeping with Pechstein's generally ebullient interpretation of the subject, the conception of the nude is robust and devoid of any concern for conventional notions of beauty.

The pictorial elements of the circus scene painted on the verso of the sheet are equally simplified. Broad patches of complementaries, orange and blue, are interspersed with touches of green and set off against bold patterns of black and white. Despite the ostensible movement of the figures of the animal trainer and the two galloping zebras, the composition is decorative and static rather than dynamic in effect. A watercolor postcard of 1910 in Los Angeles shows a more lively version of the subject (see Reed in Los Angeles 1977, p. 90, no. 141), as does a watercolor of 1911 in the Brücke-Museum, Berlin (Berlin 1975, no. 98, pl. 33).

Jack von Reppert-Bismarck

1908

115.
Boys Smoking, ca. 1930

Pen and black ink and watercolor on cream wove paper; 195 x 140 mm

INSCRIPTION: Signed with pen and black ink on recto at lower right, *Jack*

WATERMARK: Indecipherable

CONDITION: Solidly mounted to acidic cardboard; some yellowing from contact with mount

PROVENANCE: Balzac Galleries, New York

EXHIBITION: New York 1931

Gift of the Balzac Galleries (1931.57)

Jack von Reppert-Bismarck enjoyed a brief period of recognition between 1930 and 1932 when she exhibited at galleries in Berlin, New York, and London. Critics at the time were fascinated not only by the fact that "Jack" turned out to be a woman painter in her early twenties, but by her ability to invest her art with grace and charm as well as a subtle undercurrent of toughness. This quality is especially evident in Reppert-Bismarck's portrayal of adolescent boys and girls, her favorite theme, in which innocence goes hand in hand with a jaded sophistication that frequently lends the subject a disturbing air of worldliness.

In the Detroit watercolor showing three boys smoking, feigned adult demeanor takes the form of a relatively innocuous social act, in contrast to the barely disguised eroticism dominating Reppert-Bismarck's depiction of adolescent girls. Stylistically, the watercolor recalls the refined mannerism of Marie Laurencin (1885–1956). There is no emphasis on modeling, the figures having been executed by means of a few pen strokes and flat washes of pale blue, pink, and gray. The watercolor, which was donated to the museum in an effort to further the young artist's career, appears to date from about 1930 and was probably included in the February 1931 exhibition of Reppert-Bismarck's work held at the Balzac Galleries in New York. Some of the paintings and watercolors shown in New York were also featured in Reppert-Bismarck's first Berlin exhibition, organized by the F. P. Brandl Gallery in the fall of 1930, when the painter was only twenty-two.

Maria Reuter

1929 Flensburg

116.
Abstraction, 1962

Pen and black ink and brush and black wash on cream wove paper; 210 x 148 mm

INSCRIPTIONS: Signed with pen and black ink on recto at lower right, *MR*; with pencil on face mat in lower left corner, *62/C*

CONDITION: Good; adhered with spots of adhesive to cardboard mount

PROVENANCE: John S. Newberry, New York

Bequest of John S. Newberry (1967.45)

While in the following composition the interaction of the pictorial elements results in a dynamic equilibrium, the balance they achieve in this work is comparatively static. This is the result not only of symmetry, the composition having been divided horizontally, but of the greater homogeneity of the tonal values. The composition has been developed exclusively from modulations of black, applied in fairly uniform washes and enlivened by a few faltering pen strokes which move at random across the sheet. The ground is formed as if by two superimposed shades of black, the top layer vaguely resembling a piece of paper whose upper right corner has been torn away. The uneven outline contrasts with the smooth lower contour of the same layer of black, but is echoed in the sketchy form of the elliptical shape emphasizing the center of the composition. Divided, like the composition itself, into two nearly equal halves, the lower half more saturated than the other, this shape embodies the dual nature of the pictorial elements employed.

117.
Abstraction, 1962

Watercolor, pen and black ink, and brush and black ink wash on wove paper; 153 x 216 mm

INSCRIPTION: Signed with pencil on recto at lower right, *MR*

CONDITION: Good

PROVENANCE: John S. Newberry, New York

Bequest of John S. Newberry (1967.46)

Reuter's composition is an exercise in the dialectical process of pictorial forces. Guided by the principle of balance, she explored the comparative weight of saturation and mass by relying solely on modulations of black. The cross, traced slightly askew upon the monochromatic ground, provides a measure of the equilibrium of the pictorial elements. Its relationship to the line running parallel to the upper margin of the sheet is akin to that which exists between the two amorphous shapes resting upon the cross's horizontal axis. In both instances the pictorial elements are mutually corrective. What is achieved by directional means in one is accomplished in the other through color. For mass alone is insufficient to offset the weight of the darker shape in the upper left and requires reinforcement in proportion to the degree to which its opponent is itself lacking in saturation.

Reuter is heir to that generation of German painters who revived Expressionism on the abstract level in the 1950s. Attracted by the concept of self-expression, the meditative absorption with which she entered into the picture-making process is also a legacy of Paul Klee (see nos. 141–150), who perceived a similar dialectical relationship as the basis of both nature and art.

118.
Abstraction, 1963

Pen and black ink and brush and black ink wash on cream wove paper; 430 x 310 mm

INSCRIPTION: Signed with pen and black ink on recto at lower right, *Maria Reuter*

CONDITION: Good

PROVENANCE: John S. Newberry, New York

Bequest of John S. Newberry (1967.48)

This composition is closely related in conception and technique to the two preceding abstractions, although it most likely dates from 1963. The four color fields, each developed from modulations of black, are arranged around the axes of a cross so as to form reciprocal relationships determined by varying degrees of saturation. The greater the saturation is in one field, the weaker it is in the adjacent field. Thus the two upper fields relate to the two lower ones as each field relates to its diagonal opposite. The subtle gradations of the black wash make the relationships appear as if in a constant state of flux, translating the composition into a field of pictorial energy, while keeping the pictorial elements suspended in a dynamic balance.

119.
Abstraction, 1963

Black ink and black ink wash on coarse cotton fabric mounted on heavy black paper hinged to white backing mat; 496 x 350 mm

INSCRIPTIONS: With pencil on recto at lower left, *MR*; with pencil on verso of black paper mount at lower center, *Maria Reuter*

ANNOTATIONS: With pencil on verso of white backing mat at lower right, *MARIA REUTER/TUSCHE/LEIN-WAND, 1963*; with pencil on verso of white backing

mat at lower center, *15*; with pencil on verso of white backing mat in lower right corner, *500.-/TR 493.13*

WATERMARK: On white backing mat, ZERKALL BÜTTEN

CONDITION: Good

PROVENANCE: John S. Newberry, New York

Bequest of John S. Newberry (1967.47)

This *Abstraction* from 1963 is such a close variation of the preceding ink and wash drawing that it is reasonable to assume that both works were done at about the same time, except that Reuter here used a piece of rough-textured cotton as a ground. This tends to give the work the look of a small painting, and the artist further underscored this impression by affixing the cotton to a sheet of heavy black paper that is hinged to a white backing mat for contrast. The black and white sheets of paper, in turn, complement the shades of black and white employed in the four fields of the composition.

Emy Roeder

1890 Würzburg – Mainz 1971

120.
Two Sheep, 1933

Black crayon with smudging over graphite pencil on cream wove paper; 250 x 374 mm

INSCRIPTION: Signed and dated with pencil on recto at lower left, *E.R./33*.

ANNOTATIONS: With pencil on recto in lower left corner, *KB 195*; with pencil on verso in lower left corner, *KB 195*

CONDITION: Lightstruck; edges unevenly trimmed

EXHIBITION: Detroit 1935

Founders Society Purchase, Friends of Modern Art Fund (1935.59)

This drawing is one of several studies of sheep Roeder made in Bavaria between 1932 and 1936. Dated 1933, the drawing is not included among the seven drawings of sheep listed in Gerke's catalogue as having been executed during these years (Gerke 1963, nos. 470, 472-477). Two of the drawings (nos. 470, 477) are similar in conception to the example in Detroit, while the five remaining ones—depicting the sheep singly, as well as in groups of two and three—show the animals at rest.

Although there is no interior modeling, Roeder's drawing is a sculptor's drawing in the strictest sense of the word. Emphasis is, above all, on the characteristic form of the animals. All environmental details have been omitted, and the contours have been modified only slightly by touches of charcoal so as to render a textural illusion appropriate to the species.

Between 1937 and 1957 Roeder made fewer than twenty-five additional drawings of sheep (ibid., nos. 478–502) and twice developed the subject in a sculptural group. One bronze dates from 1937, the other from 1942–43 (ibid., nos. 107, 108). Roeder's drawing was most likely included in the exhibition of drawings by modern German sculptors held at the Detroit Institute of Arts from March 5 to March 31, 1935. The Friends of Modern Art apparently acquired the drawing for the museum at the time of the exhibition.

Christian Rohlfs

1849 Niendorf – Hagen 1938

121.
Two Heads, 1926

Water-based pigments on discolored wove paper;
501 x 368 mm

INSCRIPTION: Signed and dated with brush and
black ink on recto at lower right, *CR 26*

ANNOTATIONS: With pen and brown ink on verso on
paper glued to lower center of sheet, *Chr. Rohlfs,
Hagen, Hochstr. 73 / Germany / or: Ascona, Casa
Margot / Switzerland*; with pencil on paper label, *22*

CONDITION: Cockling, probably from the heavy
application of pigments; mended upper and lower
corners; surface abrasion, producing burnished
appearance on high points; small losses; squares of
paper adhered to verso

PROVENANCE: Lillian Henkel Haass and
Walter F. Haass, Detroit

EXHIBITIONS: Detroit 1936; Detroit 1936c;
Omaha 1971

REFERENCES: Newberry 1936, pp. 40, 41, ill.;
Richardson, 1936, p. 24, fig. 13; Myers 1955, p. 421,
ill.; Omaha 1971, p. 69, no. 164

Gift of Lillian Henkel Haass and Walter F. Haass in
memory of Reverend Charles W. F. Haass (1936.16)

For Rohlfs, people were never the subject of realistic psychological scrutiny or social comment. He invented faces the way he made up stories and fairy tales and in his search for expression invested them with an element of fantasy that frequently borders on the grotesque. Protagonists such as those depicted in *Two Heads* inhabit a realm that lies somewhere between genre and legend, defying a more precise definition.

Two Heads, dated 1926, recalls similar works by Nolde (see no. 106), whom Rohlfs first met in Soest in the summer of 1905, and who encouraged him in his quest for a more expressive use of color and form. The Detroit work is a fully developed statement of Rohlfs's Expressionism. Color is no longer used descriptively, but has become an independent force, deep blue glowing amidst shades of brown and black with an intensity reminiscent of stained glass. Having heavily applied the pigments with a wide, flat brush, Rohlfs used the narrow edge of the brush to wash out the colors in order to reinforce the linear definition of the image. In the process he exposed the paper ground, creating an emphatic linear network that not only helps circumscribe the two figures, but, in alliance with the darker lines, determines the structure of the composition.

The work is close in conception to two of Rohlfs's woodcuts of 1921, *Man with a Pointed Nose* and *Large Heads* (Vogt 1960, nos. 117, 119), and to two of his paintings from the same year, *Grotesque Conversation* (present whereabouts unknown) and *Conversation* (Märkisches Museum, Witten; Köcke 1978, nos. 663, 665).

Two Heads is one of six works that were most likely included in the exhibition of watercolors by Rohlfs held at the Detroit Institute of Arts from January 15 to February 12, 1936, and that may have been featured again in the exhibition of modern German watercolors shown at the museum between March 24 and April 26 of the same year. Along with three other works by Rohlfs now in Detroit (*House in the Mountains*, no. 123, *Men in Silk Hats*, no. 124, and *Sunflowers*, no. 126), the composition was apparently purchased from one of these exhibitions by Lillian Henkel Haass and Walter F. Haass for the museum's permanent collection. Documents dated April 13 and April 15, 1936 (Curatorial Files), indicate that payment for all six works was made to Dr. Wilhelm Abegg, Switzerland. Abegg, a close friend of Rohlfs, seems to have acted on behalf of the painter, providing Rohlfs with funds at his retreat in Ascona at a time when the opportunity for transferring currency out of Germany was increasingly threatened by the policies of the National Socialist regime.

122.
Bridge in the Ticino, 1935

Water-based pigments and gray purple crayon on cream wove paper; 362 x 509 mm

INSCRIPTION: Signed and dated with red crayon on recto at lower right, *CR 35*

ANNOTATIONS: With pencil on verso at lower left, *Nr. 13*; on verso near lower center, *Rohlfs*; with black crayon on verso near upper center, *Top*

CONDITION: Good

PROVENANCE: C. Edmund Delbos, Grosse Pointe, Michigan

EXHIBITIONS: Detroit 1936; Detroit 1936a; Detroit 1936c; Detroit 1970

REFERENCE: Detroit 1970, p. 18, ill.

Gift of C. Edmund Delbos (1947.360)

The dematerialization of form evident in all of Rohlfs late works is most apparent in his frequent depictions of the ancient stone bridges of the Centovalli and the Onsernone Valley northwest of Ascona. Without abandoning topographical fact completely, in these works Rohlfs came closest to translating his experience of the landscape of the Ticino into pure color.

In this work the terrain is all but dissolved in color, while the arch of the bridge appears as if formed by a stream of light. The composition has been developed from shades of blue, green, yellow, and brown, which were lightened by brushing the colored surface extensively with a bristle or fine wire brush after the pigments had dried. In the course of this process the paper ground was gently abraded, resulting in a dense network of parallel and intersecting lines that extends throughout the composition, unifying the colors and causing the entire picture surface to vibrate. The manipulation of the watercolor to produce the "brushy" effect combined with the minimal or lack of abrasion to portions of the paper ground indicate that a resist may also have been used.

C. Edmund Delbos, who donated the tempera to the museum in 1947, most likely acquired it directly from one of two exhibitions held at the Detroit Institute of Arts in early 1936. (For a brief discussion of the early exhibition record of this work and its probable provenance, see *Two Heads*, no. 121.)

123.
House in the Mountains, 1935

Plate XXII

Water-based pigments on cream wove paper;
515 x 653 mm

INSCRIPTION: Signed and dated with brown crayon
on recto at lower right, *CR 35*

ANNOTATIONS: With pencil on verso at lower right,
Rohlfs; on verso at lower left, *Nr. 9*; with pen and
black ink on verso on paper glued to lower center of
sheet, *Chr. Rohlfs, Hagen, Hochstr. / 73 / Germany /
or: Ascona, Casa Margot / Switzerland*

WATERMARK: Indecipherable

CONDITION: Good

PROVENANCE: Lillian Henkel Haass and
Walter F. Haass, Detroit

EXHIBITIONS: Detroit 1936; Detroit 1936c

REFERENCES: Newberry 1936, pp. 38, 41, ill.;
Richardson 1936, p. 24; Myers 1957, p. 77

Gift of Lillian Henkel Haass and Walter F. Haass in
memory of Reverend Charles W. F. Haass (1936.17)

Mountain houses in the Ticino are a recurrent motif in Rohlfs's late works. Built from rough, gray stones and weathered wood, the houses stimulated the painter's imagination, preoccupied as he was during the last years of his career with the pictorial problem of wresting the widest possible range of color modulations from a limited number of color chords. In the Detroit work, Rohlfs restricted his palette to the triad blue, yellow, and brown, making the cream-colored paper ground an integral part of the composition by washing out the colors with the narrow side of a wide, flat brush and gently abrading the colored surface with a bristle or wire brush. The mesh of the fine lines causes the colors to vibrate, resulting in effects that might be called impressionistic were it not for the lyrical mood that pervades the work, testifying to the artist's fundamentally subjective conception. (For a discussion of the early exhibition record of this work and its provenance, see *Two Heads*, no. 121.)

124.
Men in Silk Hats, 1935

Water-based pigments on heavy wove paper; 790 x 563 mm

INSCRIPTION: Signed and dated with brown crayon on recto at lower right, *CR 35*

ANNOTATIONS: With pencil on verso at upper left, *Nr. 3 Männer im Zylinder*; with pencil on verso in lower left corner, *2* (in circle) and *A*; with pencil on verso at lower right, *Rohlfs*; with pen and black ink on verso on paper glued to lower center, *Chr. Rohlfs, Hagen, Hochstr. 73 / or: Ascona, Casa Margot / Switzerland*; label bears purple customs stamp, *ZOLL/II–29* (in circle)

WATERMARK: P. M. FABRIANO

CONDITION: Paper fibers rubbed up and skinned; thin spots visible in transmitted light, especially in hat of smaller figure; paper and adhesive residues from previous mounting adhered to recto near top

PROVENANCE: Lillian Henkel Haass and Walter F. Haass, Detroit

EXHIBITIONS: Detroit 1936; Detroit 1936c

REFERENCES: Newberry 1946, p. 41; Richardson 1936, p. 24; Myers 1957, pp. 77, 102, pl. 20; Uhr 1982, pp. 198–199, color ill.

Gift of Lillian Henkel Haass and Walter F. Haass in memory of Reverend Charles W. F. Haass (1936.18)

As in *Two Heads* (no. 121), the figures depicted in *Men in Silk Hats* belong to a world in which fantasy and reality meet. Dressed in formal attire, they might well have been observed from life. Yet it is evident that their appearance served the painter first and foremost as a pretext for developing an expressive composition. Filling the pictorial space to the exclusion of all extraneous details, the figures have been translated into hulking abstractions. The effect of the simplified, masklike faces is sinister. The colors—somber shades of brown, blue, and green—reinforce the ominous mood.

Technically, the work illustrates a method of painting Rohlfs explored during the years 1930 to 1937. Having applied the pigments to the heavy paper, he held the sheet under a jet of running water, manipulating the surface with a brush so as to guide the flow of the colors as they merged with one another. After the paper had dried, Rohlfs applied new pigments and repeated the entire process until the colors had reached the desired blend and degree of saturation. Highlights as well as linear definition of the image were obtained by washing out the colors still further with the narrow side of a wide, flat brush. (For a discussion of the early exhibition record of this work and its provenance, see *Two Heads*.)

125.
Sunflowers, 1935

Water-based pigments on textured, white wove paper; 481 x 670 mm

INSCRIPTION: Signed and dated with red crayon on recto at lower right, *CR 35*

ANNOTATIONS: With pencil at lower right, *Rohlfs, Hagen, Hochstr. 73 / Germany / or: Ascona - Switzerland*; with pencil on verso at lower center, *Nr. 8*

WATERMARK: P. M. FABRIANO

CONDITION: Good; slightly cockled; thinner in the abraded highlights

PROVENANCE: Lillian Henkel Haass and Walter F. Haass, Detroit

EXHIBITIONS: Detroit 1936; Detroit 1936c

REFERENCES: Newberry 1936, p. 41; Richardson 1936, p. 24

Gift of Lillian Henkel Haass and Walter F. Haass in memory of Reverend Charles W. F. Haass (1936.19)

The light, which in Rohlfs's late works contributes to the dissolution of form, so dominates this composition that the image of the sunflowers may be said to have been developed from light alone. The colors—shades of yellow, green, and blue—were applied in successive stages, each application followed by a careful brushing of the colored surface under running water until the desired texture and tonal gradation were achieved. The image of the flowers was obtained by abrading the paper with a bristle or wire brush after the colors had dried. Light pervades the composition in the form of many fine lines that were torn into the paper in the course of this process, exposing the color and texture of the paper ground. Covering the entire surface of the sheet, the lines coalesce in dense aggregates circumscribing the blossoms. A few touches of yellow have been added to the abraded surface to reinforce the local color of the flowers. (For a discussion of the early exhibition record of the work and its provenance, see *Two Heads*, p. 121.)

126.
Sunflowers, 1935

Watercolor and blue crayon on cream wove paper;
335 x 583 mm

INSCRIPTION: Signed and dated with red crayon on
recto at lower right, *CR 35*

ANNOTATIONS: With pencil on verso at lower right,
Nr–14 Rohlfs; with pen and black ink on paper glued
to verso at lower right, *Chr. Rohlfs, Hagen, Hochstr.
73 / Germany / or: Ascona, Casa Margot /
Switzerland*

WATERMARK: P. M. FABRIANO

CONDITION: Good

PROVENANCE: Robert H. Tannahill, Grosse Pointe
Farms, Michigan

EXHIBITIONS: Detroit 1936; Detroit 1936c; Detroit
1970a; Detroit 1976

REFERENCES: Detroit 1970a, pp. 76, 106, ill.; Detroit
1976, no. 280, p. 208

Bequest of Robert H. Tannahill (1970.325)

The serene detachment of the sort emanating from
Violet Moonlight II (no. 127) has been subordinated
in this work to a more forceful conception. Soft tran-
sitions have given way to sudden flashes of color and
light sweeping across the surface of the sheet. As
form and movement penetrate one another, the
composition is transformed into a near-abstract de-
sign of considerable energy.

Painted in shades of blue, green, and brown, the
colored ground has been enlivened by random
patches of light, an effect Rohlfs achieved by vig-
orously brushing the colored surface while holding
the paper under running water. The blossoms of the
sunflowers were given slight definition by adding a
few touches of yellow to the transparent ground.
The slashing lights, which help unify the surging
rhythm of the composition, were obtained by wash-
ing out the pigments with the narrow side of a wide,
flat brush.

According to the donor's records (Curatorial
Files), Robert H. Tannahill purchased the work in
1936 from an exhibition at the Detroit Institute
of Arts. This was either the exhibition of water-
colors by Rohlfs held at the museum from January
15 to February 12 or the exhibition of modern Ger-
man watercolors shown between March 24 and
April 26. (For the work's earlier provenance, see *Two
Heads*, no. 121.)

127.
Violet Moonlight II, 1935

Water-based pigments, pastel, and crayon on heavy wove paper; 781 x 562 mm

INSCRIPTION: Signed and dated with black crayon on recto at lower right, *CR 35*

ANNOTATIONS: With red crayon on verso at upper left, *N° 13 Mondschein II / W*; with pencil on verso at upper left, *Violetter* and *1935* and *Nr. 1*; with blue crayon on verso *F LIX 9*; with pencil on verso near center of sheet, *NEWBERRY / str Page /* [indecipherable]; with pencil on verso at lower left center, *Violetter Mondschein*; with pencil on verso at lower right, *2500.–*; indecipherable red stamp at edge of paper at center right

WATERMARK: P. M. FABRIANO

CONDITION: Small losses in upper corners; vigorous working of pigments has lifted fibers and removed a layer of paper in the white highlights

PROVENANCE: Günther Franke, Munich, 1955; John S. Newberry, New York

REFERENCES: Vogt 1958, p. 200, no. 20; Uhr 1982, pp. 200–201, color ill.

Gift of John S. Newberry in memory of Dr. Wilhelm R. Valentiner (1959.12)

Violet Moonlight II was painted in Ascona, where from 1927 until shortly before his death in 1938 Rohlfs spent nine months out of each year. The view is toward the southeast, as seen from the terrace of the artist's vacation home, "Casa Margot," across the northern end of Lago Maggiore, to the wooded slopes of Monte Tamaro rising above the far shore. The landscape is one of several nocturnes Rohlfs painted in 1935. Closely related to the Detroit work, in terms of both conception and technique, is *Brown Moonlight*, an undated composition from the same year now in the Museum Folkwang, Essen (Scheidig 1965, pl. 137). The composition of the landscape is anticipated in a blue pencil drawing of 1931, also in Essen (Vogt 1958, p. 110).

Modulations of red and blue provide the unifying tonality of the landscape. As in all of Rohlfs's works after 1930, texture and coloristic scale were obtained by applying the colors in successive stages and by brushing the paper after each application under a jet of water so as to encourage the colors to blend. After the paper had dried, Rohlfs worked the sheet with a bristle or fine wire brush, gently abrading the colored surface. The many lines that were torn into the paper in the course of this process form an integral part of the image. They pervade the composition like the mesh of a net, enveloping lake, mountain, and sky in a transparent veil congealing in areas of greater concentration into pools of evanescent light. The dematerialization of color and form achieved in this manner gives rise to a lyrical mood that characterizes most of Rohlfs's late works.

Josef Scharl

1896 Munich – New York 1954

128.
*Sketches of Trees and Plants at Cape Cod
(Truro)*, 1950

Graphite pencil on off-white wove paper;
302 x 478 mm

INSCRIPTIONS: Signed and dated with pencil on
recto at lower right, *Jos. Scharl* over *1950*; with pen-
cil on recto at lower left, *Sketches of Trees / and
Plants / at Cape Cod / (Truro)*

ANNOTATION: With pencil on verso in lower right
corner, *360.–*

CONDITION: Tear at upper left

PROVENANCE: John S. Newberry, New York

Bequest of John S. Newberry (1967.49)

Although they were ostensibly observed from
nature, the trees and plants in this drawing have
little to do with botanical fact. Having been de-
veloped from calligraphic lines that subordinate pe-
culiarities of texture and structure to generalized
patterns and shapes, they are plantlike in ap-
pearance, rather than strictly imitative, and possess
a strong decorative appeal.

The effort to achieve a synthesis of description
and design is characteristic of Scharl's entire output.
In his German works from the 1920s and 1930s the
decorative elements inherent in his simplified forms
are generally overshadowed by the emotive strength
of the subject matter. In his American works the
decorative elements are more pronounced. Scharl
settled permanently in the United States in 1938
and, as was the case with George Grosz, the pessi-
mistic attitude dominating his earlier social themes
gradually gave way to a greater appreciation of
nature. Turning his attention increasingly to still life
and landscape, Scharl gave free rein to decorative
forms which in some compositions almost reach the
point of abstraction. Illustrating this later stage in
his development, the Detroit drawing belongs to a
group of plant and landscape studies, including sev-
eral seascapes, which Scharl executed on Cape Cod
at Truro in the summer of 1950 (Berlin 1973, nos.
138–144, 146–151, 166, 171).

Richard Scheibe

1879 Chemnitz – Berlin 1964

129.
Seated Female Nude, 1934

Graphite pencil on cream wove paper; 339 x 304 mm

INSCRIPTION: Signed and dated with pencil on recto at lower right, *Scheibe. 1934.*

CONDITION: Yellowing, probably from discolored fixative; adhered in spots to cardboard mount; top and sides perforated as if torn from a larger sheet

PROVENANCE: Weyhe Gallery, New York, 1935(?); Robert H. Tannahill, Grosse Pointe Farms, Michigan

EXHIBITIONS: Detroit 1935; Detroit 1970a

REFERENCE: Detroit 1970a, pp. 76, 107, ill.

Bequest of Robert H. Tannahill (1970.326)

This drawing was done in conjunction with the following figure studies of a crouching female nude and represents a subsequent, possibly even the final, stage in a series of studies for the same subject. Emphasis is on smooth contours and modeling, but the drawing is much more finished, and the posture of the model has been simplified. Instead of bending emphatically forward, clutching her arm and leg, the figure is seated in a more relaxed position. As a result, the mood of introspection, which in the other drawing is intensified by the model's gesture, takes on a gentler character of wistful reverie. Scheibe utilized this posture in a somewhat modified form in at least two sculptures, a marble statue of 1943, and a bronze of 1952 (Redslob 1955, pp. 56, 61).

The drawing may have been lent to the exhibition of drawings by modern German sculptors sponsored by the museum in March of 1935. Robert H. Tannahill acquired the drawing that year through the Detroit Society of Arts and Crafts, which had been empowered to act on behalf of the Weyhe Gallery, New York.

233

130.
Studies of a Crouching Female Nude (recto)
Study of a Seated Female Nude (verso), 1934

Graphite pencil with stumping (recto), pencil (verso), on cream wove paper; 303 x 419 mm

INSCRIPTION: Signed and dated with pencil on recto below left of center, *Sch. 1934.*

ANNOTATIONS: With pencil on verso in upper left corner, *W*; on verso at lower left margin, *KB 178*; on verso at lower right margin, *Scheibe, R*; purple customs stamp on verso in lower left corner, *Zollzweigstelle Bahnhof Friedrichstrasse Berlin*

CONDITION: Yellowed on recto, probably from discolored fixative; top, right and bottom edges perforated as if torn from a larger sheet

PROVENANCE: Weyhe Gallery, New York(?)

EXHIBITION: Detroit 1935

Founders Society Purchase, Friends of Modern Art Fund (1935.58)

The flowing contours and smooth modeling evident in this drawing are also characteristic of Scheibe's sculpture, as is the introspective mood enveloping the figure of the crouching female nude occupying the upper center of the sheet. That the drawing was intended to serve as a preliminary study for a piece of sculpture is suggested by the quick sketches surrounding the more finished rendering of the figure, which explore the posture of the model from six different points of view. The rapid sketch of a crouching nude on the verso was probably done at the same time, although there the model is shown in a far less expressive posture. This sketch virtually repeats, in mirror image, the posture of a bronze of 1932 (Kroll 1939, p. 19), of which the Detroit museum owns a cast (1970.223).

Despite the fact that the theme of the crouching, and seated, female nude is encountered frequently among Scheibe's sculptures (Kroll 1939, pp. 19, 21, 40, 50, 53, 56–57; Redslob 1955, pp. 56–57, 61), the

context of the Detroit drawing still remains to be identified. This task is made difficult by the loss of many of Scheibe's sculptures as well as by the obscurity to which his work was consigned after World War II. Even today Scheibe's accomplishments are overshadowed by the memory of the heroizing public monuments he created during the years of the National Socialist regime.

The drawing was probably included—and most likely through the courtesy of the Weyhe Gallery, New York—in the exhibition of drawings by modern German sculptors held at the Detroit Institute of Arts in March 1935. The Friends of Modern Art apparently purchased the drawing for the museum at the time of the exhibition.

Karl Schmidt-Rottluff

1884 Rottluff – Berlin 1976

131.
Blossoming Trees, early 1930s

Watercolor and brush and black ink over black crayon on white wove paper; 500 x 700 mm

INSCRIPTION: Signed with brush and black ink on recto at lower left, *SRottluff*

ANNOTATION: With pencil on verso in lower right corner, *32.*

CONDITION: Slight cockling

PROVENANCE: Günther Franke, Munich; Robert H. Tannahill, Grosse Pointe Farms, Michigan

EXHIBITIONS: Detroit 1936a; Detroit 1937; Detroit 1970a; Detroit 1976

REFERENCES: *The Detroit News*, November 28, 1937, p. 17, ill.; Detroit 1970a, pp. 76, 107, ill.; Detroit 1976, p. 210, no. 283, ill.; Uhr 1982, pp. 214–215, color ill.

Bequest of Robert H. Tannahill (1970.327)

The conception of this watercolor is dominated by a commitment to nature that first began to manifest itself in Schmidt-Rottluff's work in the mid-1920s. The pure colors of his earlier compositions have given way to subtly balanced modulations of the three primaries, red, yellow, and blue. Instead of being juxtaposed in broad planes of unified hues, the colors have been applied loosely over a summary sketch in black and interspersed with delicate shades of the complementaries purple and green. Light and atmosphere are not only a function of color, but also of the white paper ground, which has been made an integral part of the landscape, substituting for both color and form. Schmidt-Rottluff's characteristic emphasis on the structural logic of the composition is evident in the contrast between the rhythmic ascent of the houses in the distance and the random disposition of the blossoming trees, whose diaphanous forms are echoed in the billowing shape of the large cloud. Schmidt-Rottluff painted this watercolor in Hofheim, a small resort town just west of Frankfort on the southern slope of the Taunus mountains, where, as a guest of the collector and art dealer Hanna Bekker vom Rath, he spent every spring between 1932 and 1943 and after 1950. The immediate surroundings of Bekker vom Rath's villa, set amidst a large garden filled with magnificent trees, form the subject of several of the painter's watercolors and oils (Grohmann 1956, pp. 274–275; Hamburg 1976, pp. 153–154, nos. 110, 113). The Detroit landscape was painted there sometime in the early 1930s, possibly already in the course of Schmidt-Rottluff's first visit to Hofheim, as the annotation *32.* on the verso of the sheet may suggest.

132.
Tomatoes and Cucumber, early 1930s

Plate XXIII

Watercolor and brush and black ink over faint traces of black crayon on white wove paper; 500 x 698 mm

INSCRIPTION: Signed with brush and black ink at lower right, *SRottluff*

WATERMARK: P. M. FABRIANO

CONDITION: Good

PROVENANCE: Curt Valentin, Berlin

EXHIBITIONS: Detroit 1936; Detroit 1936b; New York 1936; Detroit 1966

REFERENCES: Newberry 1936, pp. 37, 40, ill.; Richardson 1936, p. 20; *BDIA* 45, nos. 3–4 (1966): 49, 77, no. 97, ill.

Founders Society Purchase, Friends of Modern Art Fund (1936.43)

Schmidt-Rottluff's still lifes illustrate most fully the approximation to nature that in the mid-1920s gave his stylistic development a new direction. It is especially in the still lifes he painted during the 1930s and 1940s that one finds a marked increase in the emphasis on the physical tangibility of objects. Round and bulbous shapes tend to predominate, encouraging extensive exploration of volume and mass (see *Quinces*, no. 133). In this watercolor, the definition of the objects is strengthened through contours applied with a brush and black ink. Set off from the lighter colors of the paper ground, the complementaries red and green, juxtaposed in the local colors of the tomatoes and the cucumbers, attain a level of saturation that contributes to the tactile quality of the still life.

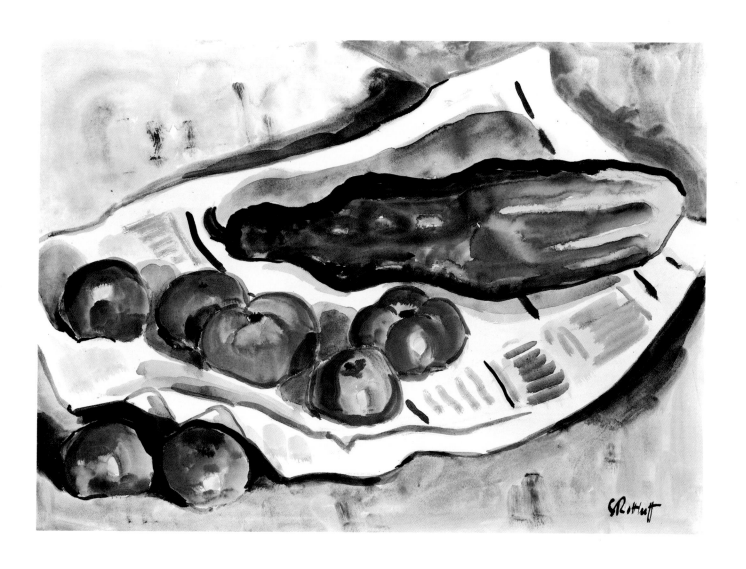

133.
Quinces, early 1930s

Plate XXIV

Watercolor on cream wove paper; 695 x 502 mm

INSCRIPTION: Signed with brush and black ink on recto at upper right, *SRottluff*

ANNOTATION: With pencil on verso at lower right, *68/48*

WATERMARK: P. M. FABRIANO

CONDITION: Good; a crackle has developed where the watercolor was applied thickly

PROVENANCE: Günther Franke, Munich; John S. Newberry, New York

EXHIBITIONS: Bloomfield Hills 1947; Ann Arbor 1948; Cambridge 1948; New York 1948; San Francisco 1948; Detroit 1960; Detroit 1965; Detroit 1966

REFERENCES: Cambridge 1948, p. 24; New York 1948, no. 46; Detroit 1960, no. 13, ill.; Detroit 1965, p. 76, ill.; *BDIA* 45, nos. 3–4 (1966): 77, 78, no. 100, ill.

Bequest of John S. Newberry (1965.231)

By juxtaposing advancing warm colors with receding cooler tones Schmidt-Rottluff here relied on the capacity of color to modify the spatial effects of lines and planes. This method allowed him to construct the composition largely on the basis of color without having to sacrifice volume and depth. Linear elements still serve a shape-defining function, but, within the boundaries of the contours, color creates the impression of weight and mass. Against a ground of pink and rose the image of the branch with four quinces has been developed from shades of yellow and green, with blue occupying the most distant spatial zone of the foliage. The form of the fruits is fullest wherever the color is the most intense. This exploration of the structural behavior of color is unusual with Schmidt-Rottluff and suggests an interest in the work of Cézanne (1839–1906). The close-up view, which separates the subject from its environmental context and allows for a careful analysis of form, allies this watercolor with the still lifes Schmidt-Rottluff painted at about the same time (see no. 132).

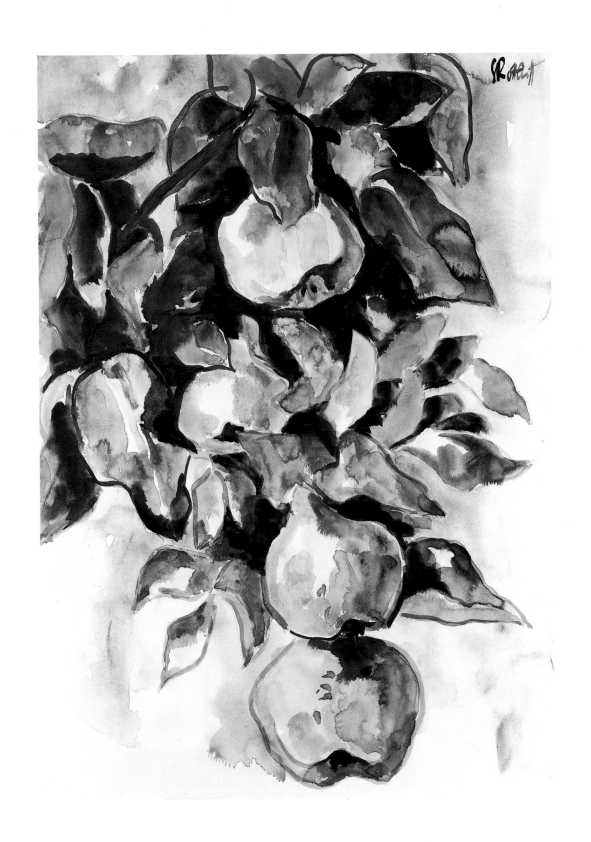

134.
View of Lake Leba with the Revekol, early 1930s

Watercolor and brush and black ink on cream wove paper with laid texture; 678 x 499 mm

INSCRIPTION: Signed with pen and black ink on recto at lower left, *SRottluff*

ANNOTATION: With pencil on verso at lower left, *66/48*

CONDITION: Good; slight cockling; spots of thickly applied black ink near base of tree have become friable and are flaking

PROVENANCE: John S. Newberry, New York

EXHIBITIONS: Detroit 1936a; Detroit 1960; Detroit 1965; Detroit 1966

REFERENCES: Detroit 1960, no. 14; Detroit 1965, pp. 76–77, ill.; *BDIA* 45, nos. 3–4 (1966): 77, no. 99, ill.

Gift of John S. Newberry (1961.17)

Schmidt-Rottluff's *View of Lake Leba with the Revekol* was painted during one of the annual summer trips he undertook between 1932 and 1943 to the fishing village of Rumbke in eastern Pomerania. Separated from the Baltic by a narrow strip of shifting dunes, Lake Leba is the remnant of a bay that silted up long ago. Only the Leba River, which feeds the lake, still manages to find its way to the open sea. The surrounding countryside, the monotony of which is relieved only by an occasional group of trees and small inlets of water rimmed with reeds, offered Schmidt-Rottluff the experience of a landscape that satisfied both his love of solitude and his growing interest in the spatial dimensions of his compositions, a pictorial problem that was to occupy him until 1945. Most of Schmidt-Rottluff's landscapes from Rumbke are dominated by the vast expanse of the lake, with the smooth silhouette of the Revekol visible beyond the southern shore. In his watercolors of Lake Leba, which have been compared to watercolors from East Asia (Grohmann 1956, p. 127), a mood of serenity is achieved through a marked reduction of the pictorial means. A few lines with the brush usually suffice to circumscribe the terrain. A few touches of color fill the landscape with light and atmosphere.

In the Detroit watercolor, the composition is determined by the calligraphic pattern of black ink. The vertical thrust of the bushes and trees is reinforced by the steep perspective of the foreground. The undulating lines of the fishing nets by the shore are echoed in the slopes of the Revekol in the distance. Contrasts of complementary colors have been all but avoided. The light orange yellow of the sky harmonizes with the pale purple of the lake. The strength of the purple in the water near the boat is offset by the presence of the adjacent hues of blue and green.

The watercolor dates most likely from the early 1930s and may have been done at about the same time as Schmidt-Rottluff's painting *Trees by the Bay* (private collection; Hamburg 1976, pp. 98–99, no. 29), which repeats the motif in a somewhat expanded horizontal format.

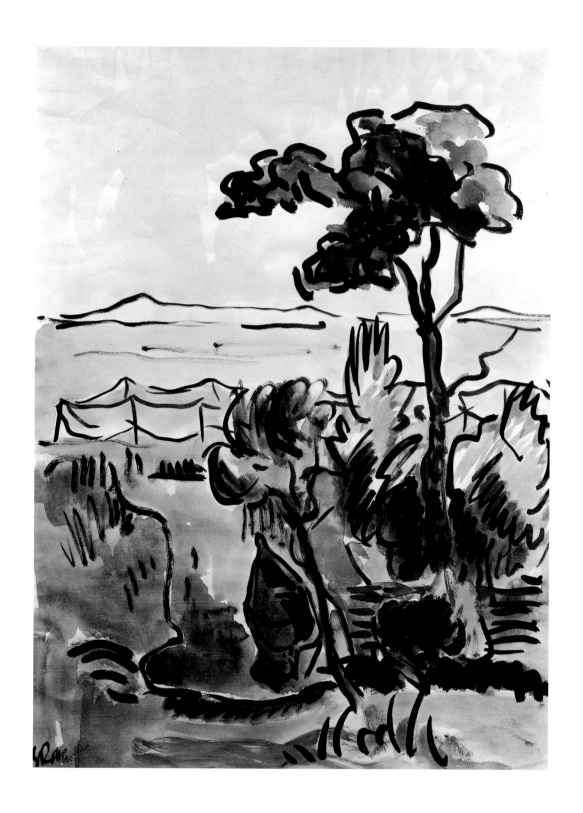

135.
Water Lilies, ca. 1934

Plate XXV

Watercolor over black crayon on cream wove paper;
499 x 697 mm

INSCRIPTION: Signed with brush and black ink on
recto near lower center, *SRottluff*

ANNOTATION: With black crayon on verso near
center of sheet, *68 x 98*

CONDITION: Good; spots of paper and adhesive
adhered to upper and lower left corners

PROVENANCE: Curt Valentin, Berlin, 1936; Robert
H. Tannahill, Grosse Pointe Farms, Michigan

EXHIBITIONS: Detroit 1936; Detroit 1936a; New
York 1936; Detroit 1970a; Grosse Pointe Shores 1978

REFERENCES: Detroit 1970a, pp. 76, 108, ill.;
Grosse Pointe Shores 1978, p. 24

Bequest of Robert H. Tannahill (1970.328)

This work was probably painted at about the same time as the watercolor *Water Lilies* of 1934 (Grohmann 1956, p. 278). Both paintings are similar in composition and conception, except that the colors in the Detroit version are generally more opaque. This is especially true of the blue and green of the pond and the water lily pads, which provide a dark foil for the white and yellow of the blossoms.

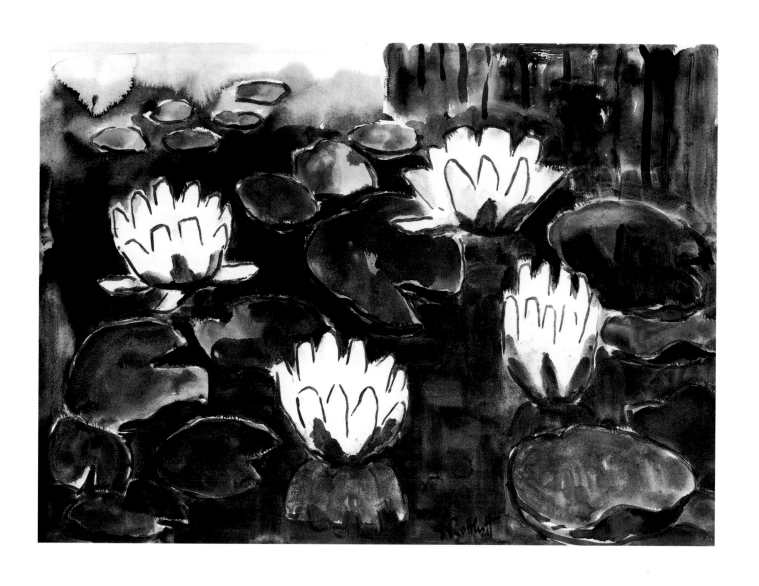

136.
Still Life with Cucumbers and Tomatoes, 1943

Plate XXVI

Watercolor and brush and black ink over faint traces of black crayon on cream wove paper; 493 x 657 mm

INSCRIPTIONS: Signed with brush and black ink on recto at lower left, *SRottluff*; with pencil on recto at lower center, *4312*; titled with pencil on verso at lower left, *Stilleben mit / Gurken u. Tomaten*

ANNOTATIONS: With pencil on verso at lower left corner, *64/48*; at lower center, *14, 2 x 9, 9*; at lower right, *VII*; at lower right corner, *10*; near the center of the sheet, *NEWBERRY / Louis 16th*

CONDITION: Good

PROVENANCE: Günther Franke, Munich, 1955; John S. Newberry, New York

EXHIBITIONS: Detroit 1965; Detroit 1966; Detroit 1970

REFERENCES: Detroit 1965, p. 76; *BDIA* 45, nos. 3–4 (1966): 77, no. 98; Detroit 1970, p. 10, ill.

Bequest of John S. Newberry (1965.232)

Painted in 1943, this watercolor bears the date and a work number at the lower margin. It is one of only a few watercolors by Schmidt-Rottluff from the early 1940s to have been inscribed. During these years he usually avoided giving any specific information that might reveal his evasion of the prohibition to paint that the National Socialists had imposed upon him in 1941. The same prohibition forced him to curtail his work in oil and to concentrate instead almost exclusively on watercolors, as did Nolde at the same time in his "Unpainted Pictures."

Schmidt-Rottluff's emphasis on the watercolor medium during this period resulted in works that tend to be more lavish in conception than his earlier watercolors and to approximate in color the texture and tonality of oil painting. In the Detroit still life—an arrangement of tomatoes, cucumbers, carrots, and a turnip—the bulbous shapes twist and turn and project into the viewer's space. The tactile quality of the individual forms is reinforced by strong contrasts of light and shade and emphatic black contours. The opaque colors contribute to the impression of solidity and weight. They are dominated by juxtapositions of the complementaries red and green. In the variegated ground the brilliance of the red is modified by the adjacent hues of purple and blue and by random hatchings applied with a brush and black ink.

137.
Still Life with Plaster Models, ca. 1945–48

Watercolor and brush and black ink over black crayon on off-white wove paper; 498 x 655 mm

INSCRIPTIONS: Signed with brush and black ink on recto at upper left, *S. Rottluff*; with pencil on recto at upper right, *für Mrs. I. Levin / Weihnacht 1948 SR*

ANNOTATION: Illegible embossed stamp on recto in lower right corner

CONDITION: Solidly mounted to cardboard support; paper and adhesive residues adhered to right edge

PROVENANCE: Mr. and Mrs. Isadore Levin, Detroit

EXHIBITION: Detroit 1966

REFERENCE: *BDIA* 45, nos. 3–4 (1966): 78

Gift of Mrs. Isadore Levin (1953.370)

The tactile quality of this still life, underscored by the spatial distribution of the statuettes and the vase, is characteristic of Schmidt-Rottluff's watercolors from the early 1940s. So are the opaque colors, which have been applied in complex modulations, juxtaposing gradations of blue with pink and combinations of russet and green with orange, yellow, and blue. That the watercolor should not be dated much earlier than 1945, however, is suggested by the distinct zones into which the areas of light and shade have been divided. The abstraction resulting from this simplification has progressed farthest in the vase, where the highlights form an independent band of color surrounding the object. The funda-mentally decorative conception was to provide the basis for the development of Schmidt-Rottluff's sur-face-oriented style after 1945. The two statuettes, plaster models of female nudes in conventional poses, are at variance with the painter's own earlier primitivizing sculpture, though entirely in keeping with the relaxed view of nature that dominated Schmidt-Rottluff's post-Expressionist work after about 1930.

The watercolor bears a dedicatory inscription to Mrs. Isadore Levin and was intended as a token of gratitude for the assistance that Mr. and Mrs. Levin showed Schmidt-Rottluff during the years of eco-nomic hardship following the end of World War II.

Wilhelm R. Valentiner

1880 Karlsruhe – New York 1958

138.
*View of the Bell Tower of the Church of the
Holy Spirit, Heidelberg,* ca. 1904/05

Graphite pencil and white gouache on gray wove
paper; 327 x 239 mm

ANNOTATION: With pencil on verso in lower right
corner, *Altstadt Heidelberg / Jugendzeichnung von /
W R Valentiner*

CONDITION: Slight cockling; corners dog-eared

PROVENANCE: Elisabeth Paatz, Heidelberg, 1975;
Mr. and Mrs. Bernhard Sterne, Detroit

Gift of Mr. and Mrs. Bernhard Sterne (F1975.16)

Dominating the Heidelberg market square, the
Church of the Holy Spirit, a hall church in the late
Gothic style, was built over a three-hundred-year
period. The nave and choir date from the early fif-
teenth century. The narthex and octagonal bell
tower were completed in 1544, although it was not
until 1709 that the tower was finally capped with a
welsche Haube, a bulbous dome, especially charac-
teristic of the churches in the Swabian countryside
and the Bavarian foothills of the Alps.

To Valentiner, who spent part of his childhood in
Heidelberg, the tower was a familiar sight and a re-
minder of the hours he spent at the window of his
attic room in his father's house high on the slopes of
the Königsstuhl, gazing down at the lofty spire
through an opening in the trees. The drawing most
likely dates from 1904 or 1905, when Valentiner was
back in Heidelberg, completing his studies at the
university. Only a year or two earlier, while attend-
ing the University of Leipzig, he had begun to paint
and draw, still unsure of his professional goals, until
he discovered in art history a discipline that satis-
fied his intellectual curiosity as well as his interest
in literature, history, and the arts. The drawing is by
no means unaccomplished. The houses and trees
possess little tactile substance, but the tower has
been carefully observed, its structural features made
palpable by the sensitive rendering of the effects of
light and shade on the architectural details. The
drawing is curiously truncated at the bottom edge.
By omitting the lower stories of the houses and the
church itself, Valentiner deprived the tower of its
larger architectural context.

Austrian Drawings

Gustav Klimt

1862 Baumgarten/Vienna – Vienna 1918

139.
Sleeping Boy, ca. 1905–07

Graphite pencil on cream wove paper; 550 x 350 mm

ANNOTATION: With pencil on recto at lower right, *Gustav Klimt Nachlass*

CONDITION: Good; three tabs of brown paper tape adhered to recto along upper edge

PROVENANCE: Gustav Klimt Estate, Vienna; (blue artist's estate stamp [L. 1575] at lower right); Christian M. Nebehay, Vienna

EXHIBITION: Vienna 1967

REFERENCES: Novotny and Dobai 1967, p. 374, no. 221; Vienna 1967, no. 35, ill.; Strobl 1982, pp. 52–53, no. 1306, ill.

Founders Society Purchase, John S. Newberry Fund (1967.96)

Fritz Novotny and Johannes Dobai believed that this drawing was executed in conjunction with Klimt's late and unfinished painting *Baby (Cradle)* of 1917–18, now in the National Gallery of Art, Washington, D.C. Although they acknowledged that the postures of the two children are different, they failed to point out the equally marked discrepancy in the age of the models. The painting depicts an infant, gazing at the viewer from beneath a random array of colorful blankets, while the nude sleeping boy in the drawing is possibly between one and two years old. Stylistically, too, the drawing is incompatible with Klimt's graphic production of 1917 to 1918. In contrast to the continuous lines, which in Klimt's late drawings circumscribe the individual forms in a freely meandering flow, the contours in the Detroit drawing are broken and have been partly reinforced to accentuate the plasticity of the boy's body.

The same approach to line and form is found in Klimt's drawings from the period 1905 to 1907. This was recognized by Alice Strobl, who associates the Detroit sheet with the painting *Three Ages of Women* of 1905 (Galleria Nazionale d'Arte Moderna, Rome; Novotny and Dobai, no. 141); she groups the drawing with several other studies of children made for the painting, all now in the Albertina (inv. 23653, 23656, 23658, 23659, 23666, 23671). Whether this association is as close as Strobl assumes remains open to question, however, since the sleeping boy differs not only in gender but in posture and physiognomy from the curly haired girl depicted in the painting and in the preliminary studies in Vienna.

Koloman Moser

1868 Vienna 1918

140.
Dancer III, ca. 1904

Graphite pencil on blue-lined graph paper;
398 x 339 mm

INSCRIPTION: With pencil on recto below composition at lower right, *III*

ANNOTATION: With pencil on verso at upper right, *202*

CONDITION: Loss at upper right; repaired tears along left side; two-piece paper support joined horizontally at center

PROVENANCE: Galerie Michael Pabst, Munich

EXHIBITIONS: Vienna 1979; Munich 1980

REFERENCES: Vienna 1979, pp. 123, ill., 291, no. 129; Munich 1980, no. 78, ill.

Founders Society Purchase, Lee and Tina Hills Graphic Arts Fund (F1980.204)

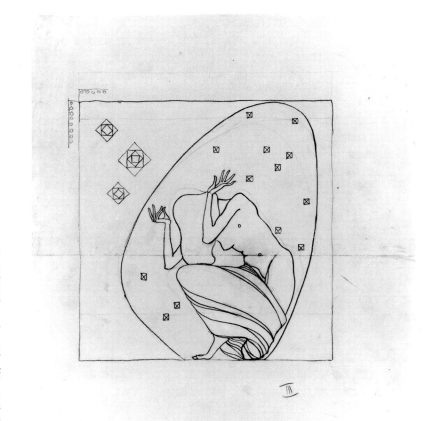

Moser's drawing is the third in a group of five designs for repoussé metal reliefs executed in 1904 by the Wiener Werkstätte, the influential arts and crafts studios, which Moser—together with Josef Hoffman (1870–1956) and Fritz Wärndorfer—had founded in 1903 (Vienna 1979, nos. 126–131).

Conceived so as to harmonize with the carefully controlled linearity of the typical Jugendstil interior, a style the Viennese preferred to call *"Sezessionstil,"* the drawing shares in the decorative idiom typical of such Wiener Werkstätte products as wallpapers, stained glass, mosaics, inlaid woods, and textiles. In the drawing, both the shadowless, flat figure of the dancer and the curvilinear flow of the drapery reinforce the two-dimensional surface of the design.

In contrast to the linear profusion dominating Moser's designs from the 1890s, the simple composition reflects the inspiration of the Scottish architect Charles Rennie Mackintosh (1868–1928) and his associates of the Glasgow School, Margaret Macdonald (1865–1933) and Frances and Herbert MacNair (1874–1921 and 1868–1955, respectively), whose lucid interiors, decorated with enigmatic figures swathed in flowing draperies, had made a profound impression on Viennese artists and the Viennese public at the time of the eighth exhibition of the Vienna Secession in 1900.

Swiss Drawings and Watercolors

Paul Klee

1879 Münchenbuchsee/Bern – Muralto/Locarno 1940

141.
Garden, 1915

Watercolor over graphite pencil on paper mounted on thin cardboard; sheet (including border), 130 x 242 mm, mount, 235 x 305 mm

INSCRIPTIONS: Signed with pen and brown ink on recto in lower right corner, *Klee*; with pen and brown ink on mount below lower left corner of composition, *1915 162*

ANNOTATIONS: With red pencil on verso at upper left, *No 830* (in rectangle); with pencil on verso near lower center, *2554/Paul Klee/Garten 1915/162/ Berliner Katalog "Der Sturm" 7 (Febr. 1917.)*

CONDITION: Good; cardboard mount skinned, probably during removal of previous mat

PROVENANCE: Dr. Dürr, Mannheim, 1929; Städtische Kunsthalle Mannheim, 1937 (brown collector's mark [L. Suppl. 1781e] on verso near left center); Nierendorf Gallery, New York, 1945; Robert H. Tannahill, Grosse Pointe Farms, Michigan

EXHIBITIONS: Berlin 1917; Detroit 1970a

REFERENCES: Berlin 1917; Detroit 1970a, pp. 65, 78, 114, ill.; Uhr 1982, pp. 112–113, color ill.

Bequest of Robert H. Tannahill (1970.342)

Garden belongs to a group of abstract watercolors from 1914 to 1915 (Glaesemer 1976, nos. 52–55) in which Klee first explored the expressive possibilities of pure color and pure form. The rhythmically organized composition, painted entirely in modulations of black and white, recalls the disciplined structure of early Cubist works by Picasso and Braque with which Klee became familiar in 1912. Unlike the orthodox Cubists, however, who shattered nature into fragments of form, Klee constructed the composition by joining together pictorial elements that are inherently abstract. Two-dimensional planes commingle with forms that define not only the inner surfaces of taut, ribbon-like structures, but—in a play of optical illusion—also describe the outer surfaces of vertical rectangular blocks distributed throughout the picture space.

Spatially ambiguous elements such as these first appeared in Klee's watercolors in 1915 (Glaesemer 1976, nos. 55, 56) and continued to form the basis of many of his compositions until 1923. According to Marianne Teuber (in Munich 1979, pp. 268–272), they have their origin in the theories of visual and psychological perception formulated by Ernst Mach (1838–1916) and can be traced to diagrams in Mach's book *Die Analyse der Empfindungen und das Verhältnis des Physischen zum Psychischen* (Jena, 1886; Klee probably knew the fourth, enlarged edition of 1903, published in Jena). Mach's notion of the ability of abstract elements of form to conjure up configurations and to elicit psychological reaction from the viewer confirmed Klee in his own belief in the correspondence between the laws of nature and the pictorial process. The Detroit watercolor, for instance, is still pervaded by the memory of a landscape. But the structural elements have been modified so as to transform the compositions into a pictorial metaphor of growth.

The watercolor, formerly in the collection of the Kunsthalle Mannheim, was confiscated by the National Socialists in 1937 and was subsequently sold abroad.

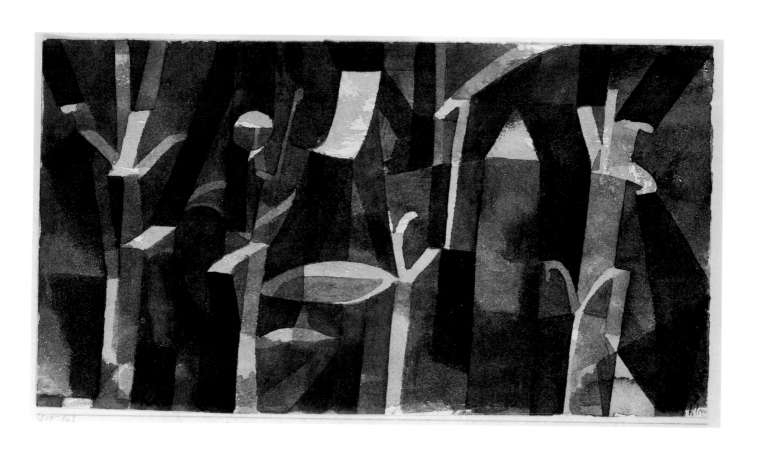

142.
Arrival of the Air Steamer, 1921

Plate XXVII

Oil transfer and watercolor on paper with laid texture mounted on thin cardboard. Decorative border of watercolor surrounds mounted sheet; sheet (including border), 269 x 334 mm, mount, 323 x 460 mm

INSCRIPTIONS: Signed with pen and black ink on recto at upper right, *Klee*; with pen and black ink on mount below center of composition, *1921/17 Ankunft des Luft-Dampfers*

ANNOTATIONS: With pencil near right lower margin, *Paul Klee/1921*; in lower right corner, *gelbl. Passep./Kartongr. 55*; with pencil on verso at center of mount, *10*

WATERMARK: [VIDACON-LES-ANNONAY B CRAYON ANCnf MANUFac] CANSON & MONTGOLFIER

CONDITION: Not completely laid down, therefore upper and lower edges have cockled and lifted; mount is acidic and has yellowed

PROVENANCE: Buchholz Gallery, New York; Robert H. Tannahill, Grosse Pointe Farms, Michigan

EXHIBITION: Detroit 1970a

REFERENCES: Detroit 1970a, pp. 65, 78, 114, ill.; Detroit 1979, p. 213, color pl. XLI

Bequest of Robert H. Tannahill (1970.345)

To Klee the pictorial process was more important than fidelity to nature. It was for this reason that he subordinated nature to formal elements that are not based on visual perception but create an imaginary world parallel to human experience. In this composition the entire structural ensemble has been invented. Squares, rectangles, triangles, segmented shapes, and circles combine to conjure up the whimsical image of the landing pier and toylike town welcoming the arrival of an equally quixotic ship. The star-shaped configuration hovering above the banner, inscribed with the word "WILLKOMMEN," functions somewhat like a psychological exclamation point, emphasizing the cheerful character of the scene represented.

The composition derives from a pen-and-ink drawing of 1919, titled *Joyous Arrival of the New Ship* (*Frohe Ankunft des neuen Schiffes*, 1919/134, present whereabouts unknown; Grohmann 1960, p. 79), which Klee transferred to this sheet by inserting a piece of japanese paper covered with black oil paint behind the original drawing and tracing the image with a metal stylus. The process of transfer explains not only the velvety texture of the lines, but also the random black smudges visible throughout the composition, an effect caused accidentally by the pressure of the artist's hand. Klee, who first developed this method of transfer in early 1919, apparently while exploring the lithographic process, occasionally transferred the same composition more than once, in which case the various works differ from each other in their color base (Glaesemer 1976, p. 190, no. 80, figs. a, b).

In the Detroit work the graphic structure has been traced upon a ground painted in delicate shades of tan, blue, and rose. Touches of yellow, blue, and white, added after the transfer was completed, accentuate the ship and the roofs of the houses. As was his custom, Klee glued the color sheet to a board in order to enhance the luminosity of the pigments by juxtaposition with the surrounding ground of white. He also "framed" the composition on all sides with a narrow strip of yellow watercolor. Until about 1925, Klee enclosed many of his watercolors in such colored borders, either on all sides or only at the top and bottom of the sheet. After 1925 he followed this practice only rarely.

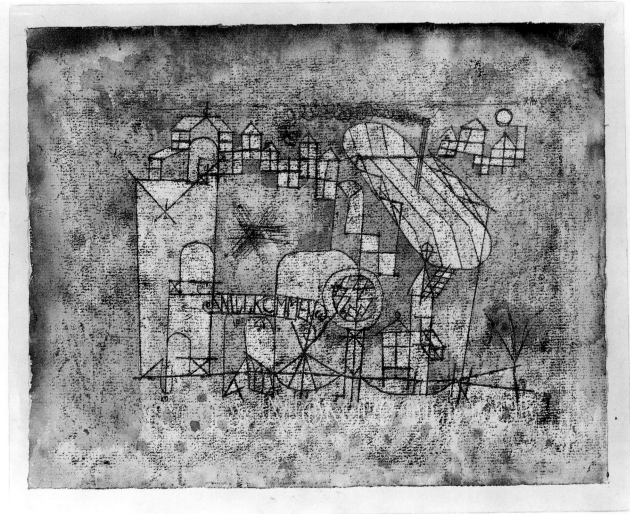

1921/17 Ankunft des Luft=Dampfers

143.
Female Jumping Jack, 1922

Graphite pencil on cream wove paper mounted on thin cardboard. Decorative lines of black ink on mount above and below image; sheet (including border), 290 x 222 mm, mount, 500 x 320 mm

INSCRIPTIONS: Signed with pen and black ink on recto in upper left corner, *Klee*; with pen and black ink on mount below center of composition, *1922 218 Hampelfrau*; with pencil in upper right corner, *1922/ 1/2*

CONDITION: Surface grime; yellowing

PROVENANCE: Galerie Rosengart, Lucerne, 1964; John S. Newberry, New York

EXHIBITION: Detroit 1965

REFERENCES: Grohmann 1934, p. 19, no. 79; Detroit 1965, p. 50, ill.

Bequest of John S. Newberry (1965.188)

Female Jumping Jack belongs to a series of drawings and prints from the early 1920s in which Klee developed puppet-like figures from geometric elements and ornamental arabesques that fold and unfold and wind and unwind in a constant process of metamorphosis, engendering ever-new formal inventions (Grohmann 1960, pp. 81, 84–85, 89–93; Kornfeld 1963, nos. 84-86; Cologne 1979, nos. 50, 81, 82). Although it approximates human proportions, the figure has been given a purely imaginary definition. Spirals ending in circles and dots interlock with fanlike shapes to suggest physiognomic patterns and anatomical relationships without denying the mechanical character of the pictorial structure as a whole. Having intellectualized the forms of the human figure by divesting them of their illusionistic function, Klee nonetheless accepted the associative power of the pictorial signs as a bridge between abstract form and the objective world when he added the illusionistically rendered pull, thereby transforming the toylike figure into a real toy.

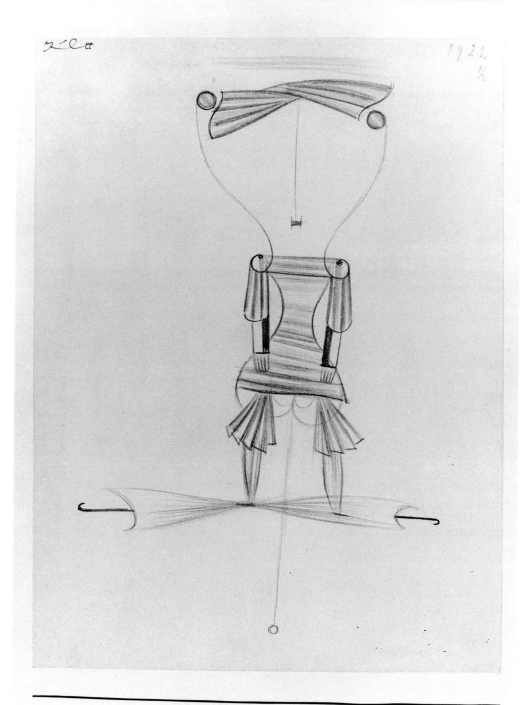

1922 218 Hampel frau

144.
Plants in the Moonlight, 1922

Pen and black ink, watercolor, and gouache on laid paper solidly mounted on thin cardboard. Decorative border of gouache on support above and below mounted sheet; sheet (including border), 246 x 160 mm, mount, 355 x 269 mm

INSCRIPTIONS: Signed with pen and black ink on recto at lower left margin, *Klee*; with pen and black ink on mount below center of composition, *1922/149 Pflanzen im Mondschein*

ANNOTATIONS: With pencil on recto in lower left corner, *S. Cl*; with pencil on verso near center of lower margin, *2*

CONDITION: Light foxing; corners of mount fractured

PROVENANCE: Galerie Rosengart, Lucerne, 1964; John S. Newberry, New York

EXHIBITIONS: Munich 1925; Detroit 1965

REFERENCES: Munich 1925, no. 72; Detroit 1965, p. 51, ill.

Bequest of John S. Newberry (1965.237)

Klee shared with the nineteenth-century German Romantics the wish to penetrate into the secret life of nature, seeking, as he wrote in his diary in 1916, "a distant point at the origins of creation," where he sensed "a kind of formula for man, animal, plant, earth, fire, water, air, and all circling forces at once" (Klee 1964, p. 232). Searching for the prototypical rather than the specific, in his many representations of flowers and plants he was not concerned with botanical fact but evolved a pictorial language of his own invention, stripped of all the peculiarities of a given species or class. As this watercolor illustrates, Klee's efforts to find a pictorial equivalent for the primordial laws of nature led him to develop not only schematic plant forms, such as the one shown at the lower right, but also hybrid configurations that hover somewhere between botanical and human forms. The larger figure is typical of the hu-morous confusions between human figures, plants, and animals that occur frequently in Klee's work from the years 1921 to 1923 (Grohmann 1954, p. 185; Geelhaar 1972, nos. 26–28, 30–33; Glaesemer 1976, no. 79). Here the pictorial structure has taken on a human physiognomic character, the eye being represented by a small simplified flower. Emphasizing the empathic response of this "human plant" to the moon above, two variations on the shape of the moon have been incorporated into the "anatomy" of the figure, as if to signify some fundamental cosmic accord. The configurations appear to float in mid-air, their simplified structures contrasting sharply with the subtle modulations of the colored ground, where shades of blue and gray give way to pink at the lower margin. Narrow strips of blue gray gouache, added to the top and bottom of the sheet, harmonize with the delicate tones of the watercolor.

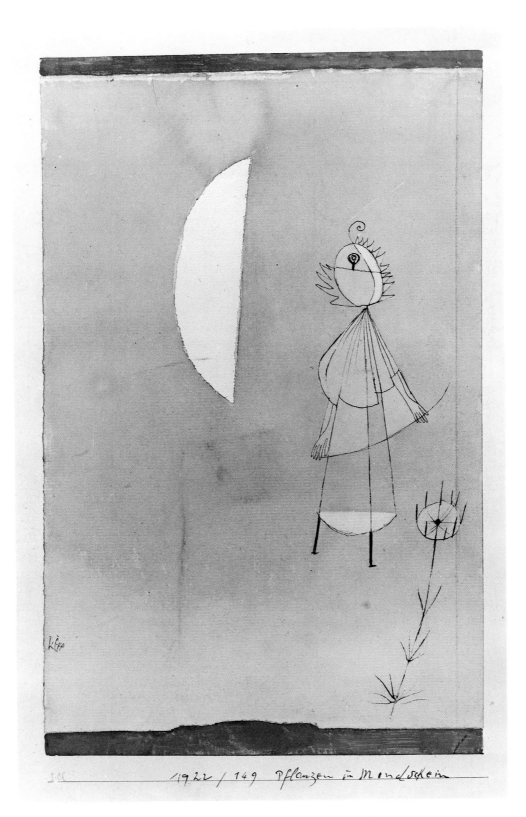

1922 / 149 Pflanzen in Mondschein

145.
Captive Pierrot, 1923

Plate XXVIII

Oil transfer, watercolor, and black ink on heavy paper mounted on gray cardboard. Decorative border of watercolor and black ink surrounds mounted sheet; sheet (including border), 397 x 302 mm, mount, 478 x 367 mm

INSCRIPTIONS: Signed with pen and black ink on recto near center of right margin, *Klee*; with pen and black ink at center of gray border at bottom of sheet, *1923///37 Gefangener Pierrot*; with pencil on mount at left center, *VIII*

ANNOTATIONS: With pencil in lower right corner, *19*; with pen and brown ink on verso at upper right, *Inv. No.*; with pen and black ink at upper right, *ERV*; with pencil at upper left, + (in circle); with red

crayon in lower left corner, *13* (in circle); with pencil at lower left, *NY 10883*; near right of center, *13 x 16 3/4*

CONDITION: Lower left corner of drawing has lifted from mount; edges of mount have been cut down

PROVENANCE: Buchholz Gallery, New York, 1950; Robert H. Tannahill, Grosse Pointe Farms, Michigan

EXHIBITION: Detroit 1970a

REFERENCES: Grohmann 1954, pp. 174, 189, no. 181, ill.; Detroit 1970a, p. 78; Ponente 1972, pp. 76, 78, ill.

Bequest of Robert H. Tannahill (1970.341)

Klee's tendency to discover objective meaning in even the most abstract formal elements is well illustrated by this watercolor. Here the hapless protagonist finds himself trapped within the confines of a structure of colored forms that acquires objective significance only in association with the clown's eloquent facial expression. The configurations in the upper half of the composition have greater affinity with recognizable forms and apparently allude to theatrical props.

During 1923 Klee frequently turned to theatrical subjects that combine purely abstract and figurative forms in a similar way (Grohmann 1934, p. 20, nos. 9, 21, 23, p. 21, nos. 34, 46, 66; Grohmann 1954, nos. 178, 179, 190, 198; Grohmann 1960, p. 97). In the Detroit work, Klee used a sheet of paper covered with black oil paint to trace the linear structure of the composition upon a watercolor ground of pale orange. All the other colors were added after the graphic design was in place. The costume of Pierrot has been painted in shades of ocher and yellow, rather than the traditional white. Echoed in the colors of the painted "frame" with which Klee surrounded the composition, the gray tones of the structure holding the figure imprisoned have been applied in successive layers and differ in opacity depending on the number of coats of watercolor employed. The tension resulting from the differences in both the mass and tonal weight of the blocklike shapes invests the architectonic structure with a vital and seemingly growing dimension.

The Roman numeral *VIII* inscribed at the lower left of the mount indicates a qualitative ranking that allowed Klee to determine, at a glance, the approximate monetary value of the work. Klee, who at times noted the ranking of a given work on the back of the frame, used ten such classifications, culminating in the category "Sonderklasse." Although Jürgen Glaesemer has indicated that Klee's classifications frequently appear to have been arbitrary (Glaesemer 1976, p. 9), the relatively high ranking that this watercolor shares with the Detroit *Jester* (no. 147) seems to reflect, at least in part, a recognition of the complexity of the pictorial process involved in both works. Other Detroit watercolors, such as *Woman Reading* (no. 148), *Storm over the City* (no. 149), and *Into the Cave* (no. 150), which are simpler in technique, bear lower marks of classification.

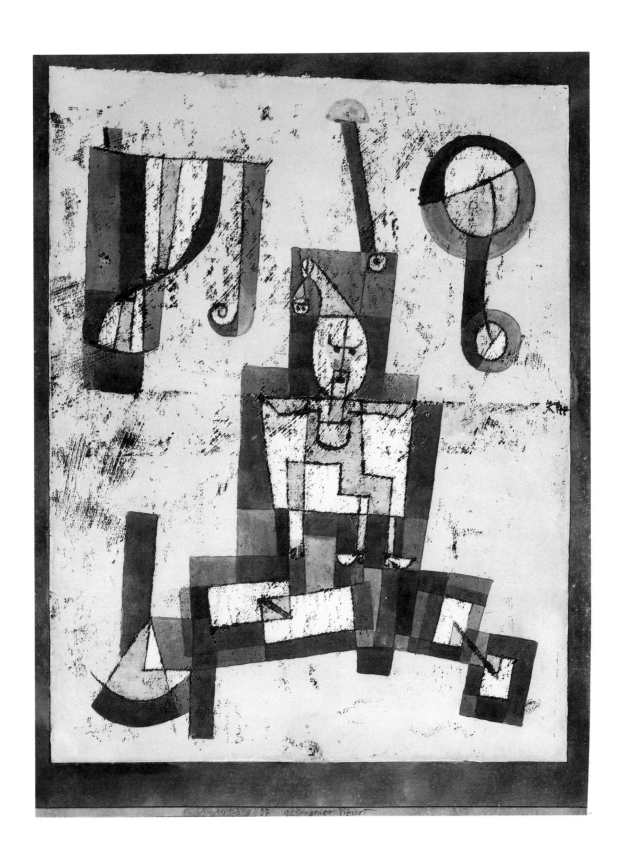

146.
Open-Air Sport, 1923

Plate XXIX

Pen and black ink and watercolor on paper mounted on thin cardboard. Decorative border of watercolor surrounds mounted sheet; sheet (including border), 228 x 240 mm, mount, 242 x 254 mm

INSCRIPTIONS: Signed with pen and black ink on recto at upper right, *Klee*; with pen and black ink on gray border at bottom of composition, *1923 83 Licht- und Luftsport*

ANNOTATIONS: With pencil on verso at lower left, [indecipherable] *Grosse/Birk*; partial label glued to lower right corner bearing partial stamp, *RIE NIERENDOR* [Galerie Nierendorf] and annotation in pen and blue ink, *C217* over *1088*.

CONDITION: Good; thumbprint has lifted pigment in blue border at lower left; edges of mount have been cut down

PROVENANCE: J. B. Neumann, New York, 1940; Robert H. Tannahill, Grosse Pointe Farms, Michigan

EXHIBITIONS: New York 1938; Detroit 1940; Detroit 1976; Grosse Pointe Shores 1978

REFERENCES: New York 1938, p. 180, ill.; Detroit 1976, p. 197, no. 260, ill.; Grosse Pointe Shores 1978, p. 27

Bequest of Robert H. Tannahill (1970.343)

This watercolor is one in a series of compositions from the early 1920s, developed from either straight parallel or undulating horizontal bands of color, upon which Klee recorded the narrative action in a kind of figurative script (Grohmann 1954, nos. 47, 48, 187; Grohmann 1960, p. 78; Kornfeld 1963, no. 87; Glaesemer 1976, nos. 75, 84, 87, 88). The origins of this conception can be traced to the year 1916, when Klee first explored the expressive possibilities of written symbols in a group of watercolors composed of the hand-lettered text of excerpts from several Chinese poems (Glaesemer 1976, pp. 4–42, no. 62). Seeking to achieve, like the traditional Chinese poet, a unity between the content of the text and the purely formal properties of the script, Klee used color, size, and proportion to differentiate the pictorial character of the individual letters, words, and phrases in accordance with their meaning, providing the text with an evocative underpinning of color and form.

In the Detroit watercolor, form and content have been similarly unified, except that the abstract written symbols have given way to easily recognizable figural forms. The pictorial structure has been developed from undulating horizontal bands of blues and greens. Presenting space as in a state of continuous change, the individual bands of color fluctuate in width as they span the composition, setting in motion a rhythmic framework to which the ten human figures, painted in shades of orange and green, have been subordinated. There is irony in the fact that despite their implied agility and calisthenic posturing, the figures cannot escape their confining ambiance. They are both prisoners and products of their environment, for even their anatomical proportions and physiognomic peculiarities are entirely a function of the pictorial structure and vary with the position each figure occupies in relation to the alternating width of the horizontal bands of the composition. It is this subjection of individualized forms to a shared structural framework rather than the influence of the arbitrary forms of the art of children or of the insane, as was previously asserted (Detroit 1976, p. 197), which explains the schematic rendering of the figures. The same conception underlies Klee's perspective interiors of 1921 to 1925 (Glaesemer 1976, p. 190, no. 80, figs. a, b), in which the shapes of the human figures have been accommodated to the rapidly converging orthogonals of the rooms they inhabit. A particularly close parallel to the Detroit work, in terms of both form and content, is provided by Klee's watercolor of 1923, *In the Meadow* (*Auf der Wiese*, 1923/93; Grohmann 1954, no. 187; in 1967 in the collection of Marian Willard Johnson, New York; cf. Basel 1967, no. 68).

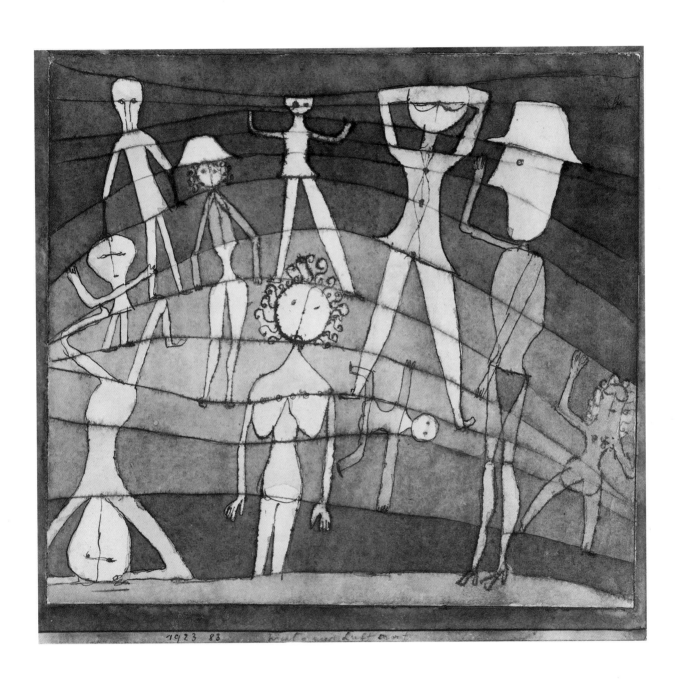

147.
Jester, 1924

Plate XXX

Watercolor, gouache, and graphite pencil on paper with laid texture solidly mounted on thin cardboard. Decorative border of gouache on support above and below mounted sheet; sheet (including border), 311 x 357 mm, mount, 412 x 437 mm

INSCRIPTIONS: Signed with pen and black ink on recto at lower center, *Klee*; with pen and black ink on mount below center of composition, *1924.258. Narr*; with pen and black ink on mount below left corner of composition, *VIII*

ANNOTATIONS: With pencil on recto at lower right margin, *20 3/4 x 27*; with pencil on recto in lower right corner, *126*; with pen and black ink on verso near upper center, *14* (in circle); with pencil on verso at lower center, *Klee "Fool"*; with blue crayon on verso at lower right, *14*; red customs stamp in upper right corner, *Zollamt Güterbahnhof Düsseldorf*;

Buchholz Gallery label glued to upper left, annotated with pen and black ink, *FOOL / PAUL KLEE / COLL. MISS G. SCHEYER / 2245*

CONDITION: Good; mount is acidic and shows deterioration and yellowing with small breaks and tears

PROVENANCE: Unidentified collector (indecipherable purple collector's mark on verso in upper left corner); Galka Scheyer, Hollywood; Buchholz Gallery, New York, 1945; Robert H. Tannahill, Grosse Pointe Farms, Michigan

EXHIBITIONS: New York 1943; Detroit 1970a

REFERENCES: New York 1943, no. 5; Detroit 1970a, pp. 65, 78, 116, ill.

Bequest of Robert H. Tannahill (1970.344)

The spray technique that Klee employed in this watercolor is related to several formal experiments that occupied him in 1924. In some works from that year he developed the individual forms from short, colored striations (Glaesemer 1976, no. 106). In others he explored the pictorial possibilities of woven textiles by painting on a ground covered with cheesecloth (Glaesemer 1976, no. 107). Klee first used the spray technique about 1916, primarily for the purpose of obtaining unifying, atmospheric effects, as in *Christmas Work for the Men at the Front* (*Weihnachtsarbeit für die Feldgrauen*), a pen-and-ink drawing in the Kunstmuseum in Bern (Glaesemer 1976, no. 40). This was still his aim in the Detroit composition *Storm over the City* (no. 149), a watercolor of 1925 in which the graphic image appears as if enveloped in an atmospheric haze.

In the Detroit *Jester*, by comparison, the spray technique served as the sole form-defining agent. The physiognomic pattern and the shape of the jester's head and cap were achieved by using an atomizer and spraying the watercolor paint over stencils. Cubist influences are evident in the simultaneous depiction of frontal and profile views, which in this particular case has the effect of dividing the face not only spatially but psychologically as well. The frontal view is mysterious and distant. The profile view, being closer to nature, appears more human and approachable. The difference in mood generated by the two views is a direct expression of the tension between the different shapes of the eyes—one triangular, one circular—and between the rhomboid pupil in one eye and the square-shaped pupil in the other. Klee made a similar distinction between the two eyes in *Monsieur Pearl-Pig* (*Monsieur Perlenschwein*, Kunstsammlung Nordrhein-Westfalen, Düsseldorf; Cologne 1979, no. 171), a watercolor of 1925 also painted in the spray technique.

In her discussion of the Düsseldorf watercolor, Teuber (in Munich 1979, pp. 261–262) related this convention to theories of visual and psychological perception that Klee knew through Ernst Mach's book *Die Analyse der Empfindungen und das Verhältnis des Physischen zum Psychischen* (see also *Garden*, no. 141). As Teuber explained, Mach distinguished between the psychological properties of rhomboid and square-shaped forms. He considered the rhombus dynamic on account of its diagonal sides, and the square, resting on one of its horizontal sides, static in character. In his teaching at the Bauhaus, Klee not only emphasized the correlation of form and psychological perception, but also discussed the emotive difference between the dynamic rhombus and the static square (Spiller 1971, pp. 44, 55, 57, 111.).

In the Detroit watercolor, as if to emphasize the jester's traditionally ambiguous relationship to the world around him, Klee identified two fundamentally different methods of perception with the actual shape of the jester's eyes. The enigmatic mood of the watercolor is underscored by the predominantly somber colors, a combination of shades of brown interspersed with touches of purple and orange.

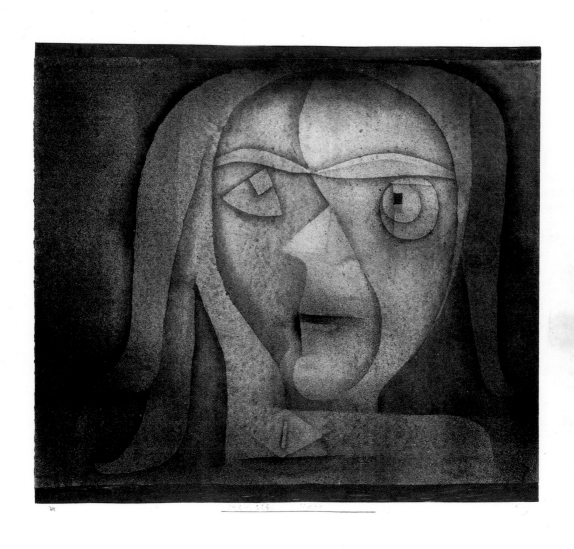

148.
Woman Reading, 1925

Oil transfer and watercolor on paper with laid texture solidly mounted on thin cardboard; sheet (including border), 316 x 479 mm, mount 418 x 579 mm

INSCRIPTIONS: Signed with pencil and black ink on recto at center right, *Klee*; with pen and black ink on mount below center of composition, *1925 E. Sieben. Lesende II.*; on recto near lower left corner of composition, *IV.*

ANNOTATION: With pencil at lower margin, *42 88* [indecipherable]-*naturel*

CONDITION: Surface grime; mount has skinned areas and adhesive residue; bottom of mount has been trimmed

PROVENANCE: Galérie Mettler, Paris

EXHIBITIONS: Grand Rapids 1950; Denver 1963

REFERENCES: Scheyer 1936, no. 137; Denver 1963, no. 14

City of Detroit Purchase (1930.283)

A closer approximation to nature distinguishes this work from much of Klee's output of the mid-1920s. Although the description of the recumbent figure has been achieved by the most economical means, the simplified lines amply define both the posture and the expression of the woman. The closest analogies to the formal and expressive properties of *Woman Reading* are found in transfer drawings from 1919 (Grohmann 1960, p. 77; Glaesemer 1973, no. 646) in which Klee achieved a similar union of observation and characterization in a comparably abbreviated form. Contrary to his usual practice, Klee did not add color to the drawing after he transferred the graphic elements to the colored ground. As a result, the muted shades of yellow and ocher watercolor that unify the composition endow the drawing with a pictorial dimension without interfering with the fundamentally graphic character of the work.

149.
Storm over the City, 1925

Plate XXXI

Oil transfer and watercolor on wove paper solidly mounted on thin cardboard. Decorative lines in black ink on support above and below mounted sheet; sheet (including border), 384 x 419 mm, mount, 501 x 537 mm

INSCRIPTIONS: Signed with pen and black ink on recto at left center, *Klee*; with pen and black ink on mount below center of composition, *1925 "V-null" Sturm über der Stadt*; with pen and black ink on mount near lower left, *IV*.

CONDITION: In raking light the surface of the drawing shows burnished streaks, some quite regular, sweeping vertically from top to bottom, which may be components of the design or a result of the mounting process; mount is acidic and has adhesive residue in upper margin

PROVENANCE: Buchholz Gallery, New York, 1944; Robert H. Tannahill, Grosse Pointe Farms, Michigan

EXHIBITIONS: New York 1943; Detroit 1970a

REFERENCES: New York 1943, no. 7; Detroit 1970a, pp. 65, 78, 116, ill.

Bequest of Robert H. Tannahill (1970.346)

This watercolor is part of a small group of works from the mid- and late 1920s in which Klee used the spray technique to produce mood-enhancing, atmospheric effects that make the graphic elements, over which the pigments were applied, appear as if suspended in air (Glaesemer 1976, nos. 114–116, 122, 123, 126; Cologne 1979, nos. 151, 155, 200). The simplified silhouette of the town, which Klee traced upon the sheet by means of a piece of paper covered with black oil paint, emerges like a mirage from a mist of blues, purples, yellow, and pink that were applied with an atomizer. A storm cloud floating above the towers of the town is preceded by an arrow, painted in brown watercolor and pointing toward the left.

The arrow played a major part in Klee's theoretical discussions at the Bauhaus (Spiller 1961, pp. 403–430) and occurs with particular frequency in his paintings and watercolors from 1919 to the mid-1930s. Its meaning differs according to the role of the arrow in the context of the composition. On its most lofty metaphoric level, Klee associated the arrow with human spirituality and used it to symbolize mankind's futile yearning to transcend earthbound nature (Spiller 1961, p. 67). The arrow is found with this meaning in *Nightflutterer's Dance* (*Nachtfaltertanz*, 1923/124, present whereabouts unknown; Grohmann 1954, no. 191), where it signifies the fatalistic forces that counteract the upward straining of the figure. In other works the arrow is simpler in meaning, representing physical rather than spiritual movement (Glaesemer 1976, no. 90). If directed against a particular object, as in the watercolor *Stricken Place* (*Betroffener Ort*, 1922/109, Kunstmuseum, Bern; Glaesemer 1976, no. 88), the arrow intensifies the movement and takes on an expression of threatening energy. In the Detroit watercolor there is no implication of such a conflict of forces. Here the arrow functions somewhat like a road sign, signaling the direction of the storm cloud that is passing over the town.

1925 V.nds" Sturm über der Stadt

150.
Into the Cave, 1929

Plate XXXII

Pen and brown ink, watercolor, and pastel on paper with laid texture solidly mounted on thin cardboard. Decorative lines in brown ink on support above and below mounted sheet; sheet (including border), 300 x 457 mm, mount, 411 x 524 mm

INSCRIPTIONS: Signed with pen and black ink on mount near upper right margin, *Klee*; with pencil on mount in lower left corner of composition, *VI*; with pen and brown ink on mount below center of composition, *1929 T. 3. in die Höhle*

ANNOTATIONS: With pencil on recto in lower left corner, *9.043*; with pencil on verso in upper left corner, *B 10602*; shipper's stamp glued on verso to upper left corner; purple customs stamp on verso in upper left corner, *Douane Centrale Exportation Paris*

CONDITION: Good; several creases at sides; the mount is discolored in the form of small brown spots, either a type of foxing or darkened inclusions in the board, and has been cut down

PROVENANCE: Buchholz Gallery, New York, 1948; Robert H. Tannahill, Grosse Pointe Farms, Michigan

EXHIBITION: Detroit 1970a

REFERENCES: Detroit 1970a, pp. 65, 78, 117, ill.; Detroit 1971, p. 203, ill.

Bequest of Robert H. Tannahill (1970.340)

This watercolor is related to several formulations of pictorial space that Klee explored in 1929 and 1930. All are based on the principle of pictorial energy in motion. While in some compositions the spatial effects are determined by progressive color modulations (Geelhaar 1972, nos. 109, 111; Glaesemer 1976, nos. 147, 148), in others intersecting lines form planes, which in turn give rise to three-dimensional structures (Geelhaar 1972, nos. 125, 126, 129; Glaesemer 1976, nos. 131, 146, 150, 151). A spatially active structural pattern also accounts for the odd shape of the two creatures that are the focus of the Detroit watercolor. The two figures have been developed from one continuous line, which bends, turns back upon itself, and crosses over, following a rhythmically accented movement that gradually transmutes the linear pattern into a three-dimensional configuration. Engendered by the moving line, the planes congeal into forms that appear to be still in the process of evolution. Their potentially mobile and changeable character is enhanced by the transparent colors—shades of pink, orange, yellow, and blue—which form a patchwork of amorphous, yet firmly bounded planes.

It is difficult to say to what extent the "anatomy" of the two enigmatic figures was premeditated or prompted by accidental associations encroaching upon the pictorial structure in the course of the working process. For it is the very discrepancy between the associative and purely abstract pictorial elements that accounts for the humorous character of the figures. Klee intensified the associative aspects of the pictorial structure by placing the two figures in front of the opening of a cave they are about to enter. As they gaze into the darkness of the cave, painted in shades of deep rose and gray, the physiognomic patterns assume an almost human character. The previous assumption, that the figures are situated inside the cave and are looking out (Detroit 1970a; Detroit 1971), is based on a mistranslation of Klee's title of the work and is not supported by the pictorial facts.

Hugo Weber

1918 Basel – New York 1971

151.
Abstraction, 1953

Gouache and pastel on thin cardboard;
510 x 662 mm

INSCRIPTION: Signed and dated with pencil at lower right, *Hugo Weber 53 / Ann Arbor 7/15/53*

CONDITION: Surface grime; edges yellowed

PROVENANCE: Dr. and Mrs. Ernst Scheyer, Detroit

Gift of Dr. and Mrs. Ernst Scheyer (F1977.33)

This abstraction epitomizes the free color dynamics that dominated Weber's output in the early 1950s. The pictorial structure is fluid and based on the linear energies of forms that surge through the composition like figures written in space. Accompanied by secondary lines of orange and pink pastel, the key figure of the composition, painted in black gouache, traverses the pictorial space as if in search of a directional focus, altering its speed, scale, and texture until its energies are spent in the expanse of the white paper ground. Working in a semi-automatic manner, but retaining control of the dimensions of the canvas or paper at all times, Weber referred to these spontaneous color drawings as "vision in flux" (Weber 1952, p. 32). They are evocative projections of movement, conceived with the idea of separating the picture from the confines of the wall and allowing it to merge with the surrounding space.

Bibliography

Andrews 1977
Andrews, Keith. *Adam Elsheimer*. New York, 1977.

Ann Arbor 1948
Ann Arbor, The University of Michigan, Museum of Art. "Drawings and Watercolors from the Collection of John S. Newberry." 1948.

Ann Arbor 1950
Ann Arbor, The University of Michigan, Museum of Art. *Sport and Circus*. Exh. cat., 1950.

Ann Arbor 1954
Ann Arbor, The University of Michigan, Museum of Art. "Beckmann and Rouault." 1954.

Anzelewsky 1971
Anzelewsky, Fedja. *Albrecht Dürer: Das malerische Werk*. Berlin, 1971.

Arndt 1968
Arndt, Marianne. "Die Zeichnungen Anselm Feuerbachs: Studien zur Bildentwicklung." Ph.D. diss., Rheinische Friedrich-Wilhelm Universität, Bonn, 1968.

Bartsch
Bartsch, Adam. *Le Peintre-Graveur*. 21 vols. Leipzig, 1854–76.

Basel 1967
Basel, Kunsthalle. *Paul Klee 1879–1940: Gesamtausstellung*. Exh. cat., 1967.

Baumeister 1947
Baumeister, Willi. *Das Unbekannte in der Kunst*. Stuttgart, 1947.

BDIA 20
"Accessions." *Bulletin of the Detroit Institute of Arts* (Annual Report) 20, no. 5 (1940–41): 47.

BDIA 45
"German Expressionist Prints, Drawings, and Watercolors: *Die Brücke*." Foreword by Ernst Scheyer and introduction by Ellen Sharp. *Bulletin of the Detroit Institute of Arts* 45, nos. 3–4 (1966) (served as catalogue for Detroit 1966).

Berend-Corinth 1958
Berend-Corinth, Charlotte. *Die Gemälde von Lovis Corinth*. Munich, 1958.

Berend-Corinth 1958a
Berend-Corinth, Charlotte. *Mein Leben mit Lovis Corinth*. Munich, 1958.

Bergsträsser 1959
Bergsträsser, Gisela. *Johann Heinrich Schilbach, ein Darmstädter Maler der Romantik*. Darmstadt, 1959.

Berlin 1917
Berlin, Der Sturm Galerie. *Paul Klee*. Exh. cat., 1917.

Berlin 1924
Berlin, Amsler and Ruthardt. *Künstler vom Ende des XIX. bis Anfang des XX. Jahrhunderts*. Auct. cat. 105, Oct. 28–29, 1924.

Berlin 1962
Berlin, Akademie der Künste. *George Grosz 1893–1959*. Exh. cat., 1962.

Berlin 1973
Berlin, Galerie Nierendorf. *Josef Scharl*. Kunstblätter 29. 1973.

Berlin 1974
Berlin, Galerie Nierendorf. *Otto Mueller zum hundertsten Geburtstag: Das graphische Gesamtwerk*. Exh. cat. edited by Florian Karsch, 1974.

Berlin 1975
Berlin, Die Brücke-Museum. *Das Aquarell der Brücke*. Exh. cat. compiled by Leopold Reidemeister, 1975.

Berlin 1977
Berlin, Nationalgalerie, Staatliche Museen Preussischer Kulturbesitz. *Verzeichnis der Gemälde und Skulpturen des 19. Jahrhunderts*. Coll. cat. by Barbara Dieterich, Peter Krieger, and Elisabeth Krimmel-Decker, 1977.

Berlin 1979
Berlin, Nationalgalerie Berlin, Staatliche Museen Preussischer Kulturbesitz. *Ernst Ludwig Kirchner 1880–1938*. Exh. cat. compiled by Lucius Grisebach and Annette Meyer zu Eissen, 1979–80.

Berliner 1955
Berliner, Rudolf. "Arma Christi." *Münchner Jahrbuch der Bildenden Kunst* 3rd ser., 6 (1955): 35–152.

Bern 1954
Bern, Klipstein and Company (formerly Gutekunst and Klipstein). *Lagerkatalog 51. Zur Feier des Neunzigjährigen Jubiläums der Gründung des Hauses H. G. Gutekunst*. Sales cat., 1954.

Bern 1967
Bern, Kornfeld and Klipstein. *Auktionskatalog 123*. Auct. cat., 1967.

Beyer 1930
Beyer, Carl. "Max Klingers graphisches Werk von 1909–1919, eine vorläufige Zusammenstellung im Anschluss an den Oeuvre-Katalog von Hans W. Singer." Leipzig, 1930. Typescript inserted at back of Singer 1909.

Bielefeld 1957
Bielefeld, Städtisches Kunsthaus. *Macke.* Exh. cat., 1957.

Bjurström 1972
Bjurström, Per. *German Drawings.* Vol. 1 of *Drawings in Swedish Public Collections.* Stockholm, 1972.

Bloomfield Hills 1947
Bloomfield Hills, Michigan, Cranbrook Academy of Art. "Collection of John S. Newberry." 1947.

Bock 1921
Bock, Elfried. *Die deutschen Meister.* Vol. 1 of *Die Zeichnungen alter Meister im Kupferstichkabinett.* Berlin, 1921.

Bock 1929
Bock, Elfried, ed. *Die Zeichnungen in der Universitätsbibliothek Erlangen.* 2 vols. Frankfort on the Main, 1929.

Bodenstein 1974
Bodenstein, J. F., ed. *Arno Breker: Skulpturen-Aquarelle-Zeichnungen-Lithographien-Radierungen.* Bonn, 1974.

Boetticher 1891–1901
Boetticher, Friedrich von. *Malerwerke des neunzehnten Jahrhunderts: Beiträge zur Kunstgeschichte.* 2 vols. 1891–1901. Reprint (2 vols. in 4). Hofheim/Taunus, 1969.

Boston 1957
Boston, Museum of Fine Arts. *European Masters of Our Time.* Exh. cat., 1957.

Boston 1962
Boston, Museum of Fine Arts. *Fifty-one Watercolors and Drawings – The John S. Newberry Collection.* Exh. cat., 1962.

Boston 1964
Boston, Institute of Contemporary Art. *Julius Bissier.* Exh. cat. with foreword by Sue M. Thurmann, 1964.

Boston et al. 1968
Boston, Museum of Fine Arts. *Ernst Ludwig Kirchner: A Retrospective Exhibition* (circulated to Seattle and Pasadena). Exh. cat. by Donald E. Gordon, 1968.

Bremen 1972
Bremen, Kunsthalle. *Ernst Ludwig Kirchner: Aquarelle und Handzeichnungen.* Exh. cat., 1972.

Briquet
Briquet, Charles Moïse. *Les Filigranes: dictionnaire historique des marques du papier, dès leur apparition vers 1282 jûsqu'en 1600....* 4 vols. 2nd ed. Leipzig, 1923. Reprint. Hildesheim and New York, 1977.

Buchheim 1963
Buchheim, Lothar-Günther. *Otto Mueller: Leben und Werk.* Feldafing, Germany, 1963.

Cambridge 1948
Cambridge, Mass., Harvard University, Fogg Museum of Art. *Drawings and Watercolors XIX–XX Centuries from the Collection of John S. Newberry, Jr.* Exh. cat., 1948.

Cambridge 1950
Cambridge, Mass., Harvard University, Busch-Reisinger Museum. *Kirchner.* Exh. cat., 1950.

Campione 1964
Campione/Lugano, Switzerland, Galerie Roman Norbert Ketterer. *E. L. Kirchner.* Sales cat., 1964.

Campione 1971
Campione/Lugano, Switzerland, Galerie Roman Norbert Ketterer. *Ausstellung Ernst Ludwig Kirchner: Gemälde, Aquarelle, Zeichnungen, Graphik.* Exh. cat., 1971.

Chicago 1937
The Art Institute of Chicago. *Sixteenth International Exhibition: Watercolors, Pastels, Drawings, and Monotypes.* Exh. cat., 1937.

Chicago 1939
The Art Institute of Chicago. *Eighteenth International Exhibition: Watercolors, Pastels, Drawings, and Monotypes.* Exh. cat., 1939.

Chicago 1939a
Chicago, The Arts Club. *Sculpture by Lehmbruck.* Exh. cat., 1939.

Cleveland 1934
Cleveland Museum of Art. "Eleventh Annual
Exhibition of Watercolors and Pastels." 1934.

Cologne 1973
Cologne, Kunsthalle. *Emil Nolde: Gemälde, Aqua-
relle, Zeichnungen und Druckgraphik. Ausstellung
des Wallraf-Richartz-Museums und der Stiftung
Seebüll Ada und Emil Nolde in der Kunsthalle
Köln.* Exh. cat., 1973.

Cologne 1979
Cologne, Kunsthalle. *Paul Klee: Das Werk der Jahre
1919–1933; Gemälde, Handzeichnungen, Druck-
graphik.* Exh. cat., 1979.

Conzelmann 1969
Conzelmann, Otto, ed. *Otto Dix: Handzeich-
nungen.* Hanover, 1969.

Copenhagen 1961
Copenhagen, Thorvaldsen's Museum. *Thorvaldsen's
Museum.* 1961.

Davis 1937
Davis, Florence. "A Varied Art Menu." *The Detroit
News,* November 28, 1937, 17.

Deecke 1973
Deecke, Thomas. "Die Zeichnungen von Lovis
Corinth: Studien zur Stilentwicklung." Ph.D diss.,
Freie Universität, Berlin, 1973.

Denver 1963
The Denver Art Museum. *Paul Klee in Review.*
Exh. cat., 1963.

Detroit 1935
The Detroit Institute of Arts. "Drawings by Modern
German Sculptors." 1935.

Detroit 1936
The Detroit Institute of Arts. "Modern German
Watercolors." 1936.

Detroit 1936a
The Detroit Institute of Arts (Russell A. Alger
House). "Modern Watercolors, Drawings, and Prints
from The Museum of Modern Art and Private
Collections." 1936.

Detroit 1936b
Detroit Society of Arts and Crafts. "Paintings and
Watercolors by Karl Schmidt-Rottluff." 1936.

Detroit 1936c
The Detroit Institute of Arts. "Watercolors by
Christian Rohlfs." 1936.

Detroit 1937
Detroit Society of Arts and Crafts. "Contemporary
German Paintings." 1937.

Detroit 1938
Detroit, Wayne State University, Art Department.
"Watercolors and Drawings by John Gutmann." 1938.

Detroit 1940
Detroit Society of Arts and Crafts. "Paintings and
Watercolors by Paul Klee." 1940.

Detroit 1946
The Detroit Institute of Arts. *Origins of Modern
Sculpture.* Exh. cat., 1946.

Detroit 1947
The Detroit Institute of Arts. "Modern Drawings
from Detroit Collections." 1947.

Detroit 1949
The Detroit Institute of Arts. *Fifty Drawings from
the Collection of John S. Newberry.* Exh. cat., 1949.

Detroit 1949a
The Detroit Institute of Arts. *German Paintings and
Drawings from the Time of Goethe in American
Collections.* Exh. cat., 1949.

Detroit 1951
The Detroit Institute of Arts. *Exhibition of 25
Recent Additions to the Collection of John S.
Newberry, Jr.* Exh. cat., 1951.

Detroit 1960
The Detroit Institute of Arts. *European and Amer-
ican Watercolors from the John S. Newberry Collec-
tion.* Exh. cat., 1960.

Detroit 1960a
The Detroit Institute of Arts. *Master Drawings of
the Italian Renaissance.* Exh. cat., 1960.

Detroit 1965
The Detroit Institute of Arts. *The John S. Newberry
Collection.* Exh.cat., 1965.

Detroit 1966
The Detroit Institute of Arts. "German Expressionist
Prints, Drawings, and Watercolors: *Die Brücke.*"
1966–67. (See *BDIA* 45; entire issue served as cata-
logue for this exhibition).

Detroit 1967
The Detroit Institute of Arts. *Paintings in the
Detroit Institute of Arts: Checklist of Paintings
Acquired Before January, 1967.* 2nd ed. 1967.

Detroit 1969
The Detroit Institute of Arts. *The Robert Hudson Tannahill Gifts to the Detroit Institute of Arts: A Catalogue Issued on the Occasion of the Opening of the Robert Hudson Tannahill Wing of American Art, June 1, 1969.* Exh. cat. edited by Graham Hood, 1969.

Detroit 1970
The Detroit Institute of Arts. *Museum Director's Choice: A Personal Selection from the Collection of the Detroit Institute of Arts.* Exh. cat. by Willis F. Woods, 1970.

Detroit 1970a
The Detroit Institute of Arts. *The Robert Hudson Tannahill Bequest to the Detroit Institute of Arts: A Catalogue Issued on the Occasion of the Exhibition "A Collector's Treasure: The Tannahill Bequest." May 13–August 13, 1970.* Exh. cat., 1970.

Detroit 1971
The Detroit Institute of Arts. *The Detroit Institute of Arts Illustrated Handbook.* Edited by Frederick J. Cummings and Charles H. Elam, 1971.

Detroit 1976
The Detroit Institute of Arts. *Arts and Crafts in Detroit, 1906–1976: The Movement, the Society, the School.* Exh. cat., 1976–77.

Detroit 1979
The Detroit Institute of Arts. *Selected Works from the Detroit Institute of Arts.* 1979.

Detroit 1985
The Detroit Institute of Arts. *100 Masterworks from the Detroit Institute of Arts.* Edited by Julia P. Henshaw with an introduction by William H. Peck, 1985.

Dijon 1953
Musée de Dijon. *Saint Bernard et l'art des Cisterciens.* Exh.cat., 1953.

Düsseldorf 1960
Düsseldorf, Städtische Kunsthalle. *Ernst Ludwig Kirchner.* Exh. cat., 1960.

Ebertshäuser 1976
Ebertshäuser, Heidi, ed. *Adolph von Menzel: Das graphische Werk.* 2 vols. Munich, 1976.

Elam 1965
Elam, Charles H. "John S. Newberry." *Bulletin of the Detroit Institute of Arts* 44, no. 4 (1965): 67–69.

Essen 1971
Essen, Museum Folkwang. *Otto Dix: Aquarelle, Handzeichnungen, Radierfolge "Der Krieg."* Exh. cat., 1971–72.

Flint 1972
Flint, Michigan, Flint Institute of Arts. *Flowers in Art.* Exh. cat., 1972.

Frankfort and Hamburg 1965
Frankfort on the Main, Kunstverein, and Hamburg, Kunstverein. *Max Beckmann: Gemälde-Aquarelle-Zeichnungen.* Exh. cat., 1965.

Frankfort 1968
Frankfort on the Main, Städelsches Kunstinstitut. *Karl Philipp Fohr 1795–1818.* Exh. cat. compiled by Hans Joachim Ziemke, 1968.

Geelhaar 1972
Geelhaar, Christian. *Paul Klee und das Bauhaus.* Cologne, 1972.

Gerke 1963
Gerke, Friedrich. *Emy Roeder: Eine Werkbiographie mit einem Gesamtkatalog der Bildwerke und Zeichnungen.* Wiesbaden, 1963.

Glaesemer 1973
Glaesemer, Jürgen. *Paul Klee.* Vol. 2, *Handzeichnungen I. Kindheit bis 1920.* Sammlungskataloge des Berner Kunstmuseums. Bern, 1973.

Glaesemer 1976
Glaesemer, Jürgen. *Paul Klee.* Vol. 1, *Die farbigen Werke im Kunstmuseum Bern.* Sammlungskataloge des Berner Kunstmuseums. Bern, 1976.

Göpel and Göpel 1976
Göpel, Erhard, and Barbara Göpel. *Max Beckmann: Katalog der Gemälde.* 2 vols. Bern, 1976.

Gordon 1968
Gordon, Donald E. *Ernst Ludwig Kirchner.* Cambridge, Mass., 1968.

Grand Rapids 1950
Grand Rapids, Michigan, Grand Rapids Art Gallery. "Paintings and Prints by Paul Klee." 1950.

Grohmann 1934
Grohmann, Will. *Paul Klee: Handzeichnungen 1921–1930.* Berlin, 1934.

Grohmann 1954
Grohmann, Will. *Paul Klee.* New York, [1954].

Grohmann 1956
Grohmann, Will. *Karl Schmidt-Rottluff*. Stuttgart, 1956.

Grohmann 1960
Grohmann, Will. *Paul Klee: Drawings*. Translated by Norbert Guterman. New York, 1960.

Grohmann 1965
Grohmann, Will. *Willi Baumeister: Life and Work*. Translated by Robert Allen. New York, [1965].

Grosse Pointe Shores 1978
Grosse Pointe Shores, Michigan, Grosse Pointe War Memorial. *Robert Hudson Tannahill Memorial Exhibition*. Exh. cat., 1978.

Grosz 1930
Grosz, George. *Über alles die Liebe*. Berlin, 1930.

Grote 1944
Grote, Ludwig. *Das Antlitz eines Jugendbundes: Zeichnungen von Carl Philipp Fohr*. Der Kunstbrief 15. Berlin, 1944.

Grüterich 1976
Grüterich, Marlis. *Alfred Lörcher: Skulptur, Relief, Zeichnungen*. Stuttgart, 1976.

Haftmann 1959
Haftmann, Werner. *Emil Nolde*. Translated by Norbert Guterman. New York, 1959.

Haftmann 1960
Haftmann, Werner. *E. W. Nay*. Cologne, 1960.

Hamburg 1976
Hamburg, Altonaer Museum and B. A. T. Cigaretten-Fabriken GmbH. *Schmidt-Rottluff*. Exh. cat., 1976.

Heawood 1976
Heawood, Edward. *Watermarks, Mainly of the 17th and 18th Centuries*. Vol. 1 of *Monumenta Chartae Papyraceae Historiam Illustrantia: or Collection of Works and Documents Illustrating the History of Paper*, edited by E. J. Labarre. Hilversum, Holland, 1950.

Heilborn 1949
Heilborn, Adolf. *Käthe Kollwitz*. Die Zeichner des Volkes, vol. 1. 4th ed. Berlin, 1949.

Hess 1974
Hess, Hans. *George Grosz*. New York, 1974.

Hind 1938–48
Hind, Arthur M. *Early Italian Engravings*. 2 vols. London, 1938–48.

Hoff 1969
Hoff, August. *Wilhelm Lehmbruck: Life and Work*. New York, 1969.

Ithaca 1972
Ithaca, New York, Cornell University, Andrew Dickson White Museum of Art. *Georg Kolbe 1877–1947: Sculpture from the Collection of B. Gerald Cantor. Drawings from the Georg Kolbe Museum, Berlin*. Exh. cat., 1972.

Jedding 1955
Jedding, Hermann. *Der Tiermaler Joh. Heinr. Roos (1631–1685)*. Studien zur deutschen Kunstgeschichte, no. 311. Strasbourg-Kehl, 1955.

Jensen 1961
Jensen, Jens Christian. "Die beiden Zeichnungen aus Fohrs Heidelberger Freundeskreis." *Heidelberger Fremdenblatt* (March 1961): 10.

Jensen 1968
Jensen, Jens Christian. *Carl Philipp Fohr in Heidelberg und im Neckartal: Landschaften und Bildnisse*. Edited and with an introduction by Georg Poensgen. Karlsruhe, 1968.

Kansas City 1964
Kansas City, Missouri, Kansas City Art Institute and School of Design, Charlotte Crosby Kemper Gallery. *Lovis Corinth 1858–1925*. Exh. cat., 1964.

Karlsruhe 1971
Karlsruhe, Staatliche Kunsthalle. *Katalog Neuere Meister: 19. und 20. Jahrhundert*. 2 vols. Compiled by Jan Lauts and Werner Zimmermann. Karlsruhe, 1971–72.

Karlsruhe 1976
Karlsruhe, Staatliche Kunsthalle. *Anselm Feuerbach 1829–1880: Gemälde und Zeichnungen*. Exh. cat., 1976.

Klee 1964
Klee, Felix, ed. *The Diaries of Paul Klee, 1898–1918*. Berkeley, Los Angeles, and London, 1964.

Klipstein 1955
Klipstein, August. *Käthe Kollwitz: Verzeichnis des graphischen Werkes*. Bern, 1955.

Koch 1941
Koch, Carl. *Die Zeichnungen Hans Baldung Griens*. Berlin, 1941.

Köcke 1978
Köcke, Ulrike. *Christian Rohlfs: Oeuvre-Katalog der Gemälde*. Edited by Paul Vogt. Recklinghausen, 1978.

Kolbe and Scheibe 1931
Kolbe, Georg, and Richard Scheibe. *Georg Kolbe: 100 Lichtdrucktafeln mit einem Begleitwort von Georg Kolbe und einer Einführung von Richard Scheibe*. Marburg, [1931].

Kornfeld 1963
Kornfeld, Eberhard W. *Verzeichnis des graphischen Werkes von Paul Klee*. Bern, 1963.

Kroll 1939
Kroll, Bruno. *Richard Scheibe: Ein deutscher Bildhauer*. Die Kunstbücher des Volkes, edited by Konrad Lemmer, vol. 1. Berlin, 1939.

Leipzig 1891
Leipzig, Städtisches Museum. *Verzeichnis der Kunstwerke im Städtischen Museum zu Leipzig*. 18th ed. Leipzig, 1891.

Leipzig 1970
Leipzig, Museum der Bildenden Künste. *Max Klinger 1857–1920*. Exh.cat., 1970.

Lima 1968
Lima, Ohio, Allen County Museum. "Freedom and Order." 1968.

Lincoln et al. 1955
Lincoln, University of Nebraska, Art Galleries. *Ernst Barlach* (circulated to Seattle, Dayton, Cambridge, and Washington, D.C.). Exh. cat., 1955.

Lipman-Wulf 1971
Lipman-Wulf, Peter. "Wall, Space, and Sculpture: A Memoir." *Leonardo* 4, no. 3 (1971): 221–226.

Löffler 1981
Löffler, Fritz. *Otto Dix: Werkverzeichnis der Gemälde*. Recklinghausen, 1981.

Lohmeyer 1935
Lohmeyer, Karl. *Heidelberger Maler der Romantik*. Heidelberg, 1935.

London 1936
London, Christie, Manson, and Woods. *Catalogue of the Famous Collection of Old Master Drawings Formed by the Late Henry Oppenheimer, Esq., F.S.A.* Sales cat., 1936.

London 1950
London, P. and D. Colnaghi and Co., Ltd. *Exhibition of Old Master Drawings*. Exh. cat., 1950.

London 1965
London, The Arts Council of Great Britain, Tate Gallery. *Max Beckmann 1884–1950: Paintings, Drawings, and Graphic Work*. Exh. cat., 1965.

Los Angeles 1977
Los Angeles, University of California, Frederick S. Wight Gallery. *German Expressionist Art: The Robert Gore Rifkind Collection*. Exh. cat. by Orrel P. Reed, Jr., 1977.

Lübeck 1965
Lübeck, Overbeck-Gesellschaft. *Lovis Corinth 1858–1925: Handzeichnungen und Aquarelle*. Exh. cat., 1965.

Lugt
Lugt, Frits. *Les Marques de collections de dessins & d' estampes. . . .* Amsterdam, 1921. *Supplément*. La Haye, 1956.

Marsalle 1920
Marsalle, L. de [E. L. Kirchner]. "Zeichnungen von E. L. Kirchner." *Genius* 2, no. 2 (1920): 216–234.

Meder 1922
Meder, Joseph. *Handzeichnungen alter Meister aus der Albertina und aus Privatbesitz*. Vienna, 1922.

Minneapolis 1950
Minneapolis, University of Minnesota, University Gallery. *German Expressionism in Art: Painting, Sculpture, Prints, 1905–1935*. Exh. cat., 1950.

Minneapolis 1953
Minneapolis, Walker Art Center. *Gerhard Marcks*. Exh. cat., 1953.

Möhle 1966
Möhle, Hans. *Die Zeichnungen Adam Elsheimers*. Berlin, 1966.

Montreal 1953
Montreal, Museum of Fine Arts. *Five Centuries of Drawings*. Exh. cat., 1953.

Müller 1960
Müller, Heinrich. *Die späte Graphik von Lovis Corinth*. Hamburg, 1960.

Munich 1925
Munich, Galerie Hans Goltz. *Gesamtausstellung 1920/25*. Vol. 2 of *Paul Klee*. Exh. cat., 1925.

Munich 1963
Munich, Bayerische Staatsgemäldesammlungen. *Alte Pinakothek München Katalog II: Altdeutsche Malerei*. Coll. cat. by Christian A. zu Salm and Gisela Goldberg, 1963.

Munich 1964
Munich, Galerie Günther Franke. *Alfred Lörcher zum Gedächtnis*. Exh. cat., 1964.

Munich 1968
Munich, Haus der Kunst. *Carl Spitzweg und sein Freundeskreis*. Exh. cat., 1968.

Munich 1969
Munich, Bayerische Staatsgemäldesammlungen, Schack-Galerie. *Vollständiger Katalog*. 2 vols. Catalogue by Eberhard Ruhmer, Rosel Gollek, Christoph Heilmann, Hermann Kühn, and Regina Löwe, 1969.

Munich 1979
Munich, Städtische Galerie im Lenbachhaus. *Paul Klee: Das Frühwerk 1883–1922*. Exh. cat. compiled by Armin Zweite, 1979.

Munich 1980
Munich, Galerie Michael Pabst. *Graphik der Secession*. Catalogue 10. Exh. cat., 1980.

Munich 1980a
Munich, Galerie Michael Pabst. *Max Klinger (1857–1920)*. Exh. cat., 1980.

Myers 1955
Myers, Bernard S., ed. *Encyclopedia of Painting*. New York, 1955.

Myers 1957
Myers, Bernard S. *The German Expressionists: A Generation in Revolt*. New York, 1957.

Nagel 1972
Nagel, Otto, ed. *Käthe Kollwitz: Die Handzeichnungen*. Berlin, 1972.

Nagler 1835–52
Nagler, Georg Kaspar. *Neues Allgemeines Künstler-Lexikon: oder, Nachrichten von dem Leben und den Werken der Maler, Bildhauer, Baumeister, Kupferstecher, Lithographen, Formschneider, Zeichner Medailleure, Elfenbeinarbeiter, etc.* 25 vols. Leipzig, 1835–52. Reprint. Linz, 1904.

Newberry 1936
Newberry, John S., Jr. "Modern German Watercolors." *Bulletin of the Detroit Institute of Arts* 16, no. 3 (1936): 37–41.

Newberry 1950–51
Newberry, John S., Jr. "A Drawing by Hans Baldung Grien." *Bulletin of the Detroit Institute of Arts* 30, nos. 3–4 (1950–51): 59–60.

New York 1894
New York, American Art Galleries. *Catalogue of Peoli Sale*. Sales cat., [1894].

New York 1931
New York, Balzac Galleries. "Exhibition of Jack von Reppert Bismarck." 1931.

New York 1936
New York, The Westermann Gallery. *Karl Schmidt-Rottluff: Oil Paintings and Watercolors*. 1936.

New York 1937
New York, The Westermann Gallery. *Watercolors by German Painters*. Exh. cat., 1937.

New York 1938
New York, The Museum of Modern Art. *Bauhaus: 1919–1928*. Exh. cat. edited by Herbert Bayer, Walter Gropius, and Ise Gropius, 1938.

New York 1941
New York, Buchholz Gallery (Curt Valentin Gallery). *From Rodin to Brancusi: European Sculpture of the Twentieth Century*. Exh. cat., 1941.

New York 1943
New York, Buchholz Gallery (Curt Valentin Gallery). *Paul Klee, André Masson and Some Aspects of Ancient and Primitive Sculpture*. Exh. cat., 1943.

New York 1947
New York, Buchholz Gallery (Curt Valentin Gallery). *Drawings by Contemporary Painters and Sculptors*. Exh. cat., 1947.

New York 1948
New York, Buchholz Gallery (Curt Valentin Gallery). *Drawings and Watercolors from the Collection of John S. Newberry, Jr.* Exh. cat., 1948.

New York 1950
New York, Buchholz Gallery (Curt Valentin Gallery). *Contemporary Drawings*. Exh. cat., 1950.

New York 1963
New York, Leonard Hutton Galleries. *Der Blaue Reiter*. Exh. cat., 1963.

New York 1963a
New York, The Museum of Modern Art. *Emil Nolde*. Exh. cat. by Peter Selz, 1963.

New York 1963b
New York, Leonard Hutton Galleries. *Jaenisch: His Fuguettes and Formations*. Exh. cat., 1963.

New York 1964
New York, The Museum of Modern Art. *Max Beckmann*. Exh. cat. with essay by Peter Selz and contributions by Harold Joachim and Perry T. Rathbone,1964.

Nolde 1934
Nolde, Emil. *Jahre der Kämpfe*. Berlin, 1934.

Novotny and Dobai 1967
Novotny, Fritz, and Johannes Dobai. *Gustav Klimt*. Salzburg, 1967.

Omaha 1971
Omaha, Nebraska, Joslyn Art Museum. *The Thirties Decade: American Artists and their European Contemporaries*. Exh. cat., 1971.

Oshkosh 1972
Oshkosh, Wisconsin, Paine Art Center and Arboretum, Nathan Paine Collection. *Adolf Schreyer*. Exh. cat., 1972.

Panofsky 1948
Panofsky, Erwin. *Albrecht Dürer*. 3rd ed. 2 vols. Princeton, 1948.

Panofsky 1955
Panofsky, Erwin. *The Life and Art of Albrecht Dürer*. 4th ed. Princeton, 1955.

Petermann 1964
Petermann, Erwin. *Die Druckgraphik von Wilhelm Lehmbruck*. Stuttgart, 1964.

Pinder 1937
Pinder, Wilhelm. *Georg Kolbe: Werke der letzten Jahre*. Berlin, 1937.

Ponente 1972
Ponente, Nello. *Klee: Biographical and Critical Study*. Translated by James Emmons. Geneva, 1972.

Princeton et al. 1982
Princeton, New Jersey, Princeton University, The Art Museum. *Drawings from the Holy Roman Empire 1540–1680: A Selection from North American Collections* (circulated to Washington, D.C. and Pittsburgh). Exh. cat. by Thomas Da Costa Kaufmann, 1982.

Raleigh 1958
Raleigh, The North Carolina Museum of Art. *E. L. Kirchner, German Expressionist*. Exh. cat. by W. R. Valentiner, 1958.

Rathenau 1967
Rathenau, Ernest, ed. *Gerhard Marcks: Seraphita*. Foreword by Edwin Redslob. New York, 1967.

Redslob 1955
Redslob, Erwin. *Richard Scheibe*. Die Kunst unserer Zeit 9, edited by Konrad Lemmer. Berlin, 1955.

Richardson 1936
Richardson, E. P. *Twentieth-Century Painting*. Detroit, 1936.

Roennefahrt 1960
Roennefahrt, Günther. *Carl Spitzweg: Beschreibendes Verzeichnis seiner Gemälde, Ölstudien und Aquarelle*. Munich, 1960.

Rohde 1968
Rohde, Elisabeth. *Griechische und römische Kunst in den Staatlichen Museen zu Berlin*. Berlin, 1968.

Rudloff 1977
Rudloff, Martina. *Gerhard Marcks: Das Plastische Werk*. Edited and with a biographical introduction by Günter Busch. Frankfort on the Main, 1977.

Rupprich 1956–69
Rupprich, Hans, ed. *Dürer: Schriftlicher Nachlass*. 3 vols. Berlin, 1956–69.

Saginaw 1976
Saginaw, Michigan, The Saginaw Art Museum. "Flowers in Art." 1976.

St. Louis 1946
St. Louis, City Art Museum. *Origins of Modern Sculpture*. Exh. cat., 1946.

St. Louis 1948
St. Louis, City Art Museum. *Max Beckmann*. Exh. cat., 1948.

San Franciso 1948
San Francisco, California Palace of the Legion of Honor. "Newberry Collection." 1948.

Scheidig 1965
Scheidig, Walther. *Christian Rohlfs*. Dresden, 1965.

Scheyer 1932
Scheyer, Ernst. "Aus Carl Fohrs künstlerischer Hinterlassenschaft." *Neue Heidelberger Jahrbücher* n.s. (1932): 82–90.

Scheyer 1936
Scheyer, Ernst. *Drawings and Miniatures from the XII. to the XX. Century.* [Detroit, 1936].

Scheyer 1949
Scheyer, Ernst. "German Paintings and Drawings from the Time of Goethe in American Collections." *The Art Quarterly* 12, no. 3 (Summer 1949): 231–256 (served as catalogue for Detroit 1949a).

Scheyer 1970
Scheyer, Ernst. "The Shapes of Space: The Art of Mary Wigman and Oskar Schlemmer." *Dance Perspectives* 41 (Spring 1970).

Schiefler and Mosel 1966–67
Schiefler, Gustav, and Christel Mosel, eds. *Emil Nolde: Das graphische Werk.* 2 vols. Cologne, 1966–67.

Schilling and Schwarzweller 1973
Schilling, Edmund, and Kurt Schwarzweller, eds. *Städelsches Kunstinstitut Frankfurt am Main. Katalog der deutschen Zeichnungen: Alte Meister.* 3 vols. Munich, 1973.

Schult 1958
Schult, Friedrich, ed. *Ernst Barlach: Das graphische Werk.* Berlin, 1958.

Schult 1971
Schult, Friedrich, ed. *Ernst Barlach: Werkkatalog der Zeichnungen.* Hamburg, 1971.

Seattle 1952
Seattle Art Museum. "Expressionism." 1952.

Singer 1909
Singer, Hans Wolfgang. *Max Klingers Radierungen, Stiche und Steindrucke.* Berlin, 1909.

Sommer 1942
Sommer, Johannes. *Arno Breker.* Vol. 11 of *Rheinische Meisterwerke,* edited by A. Stange. Bonn, [1942].

Sorell 1975
Sorell, Walter, ed. and trans. *The Mary Wigman Book.* Middletown, 1975.

Spiller 1961
Spiller, Jürg, ed. *The Thinking Eye.* The Notebooks of Paul Klee, translated by Ralph Mannheim, vol. 1. New York and London, 1961.

Spiller 1971
Spiller, Jürg, ed. *Paul Klee: Das bildnerische Denken.* Form – und Gestaltungslehre, 3rd ed., vol. 1. Basel, 1971.

Stange 1934–61
Stange, Alfred. *Deutsche Malerei der Gotik.* 11 vols. 1934–61. Reprint. Nendeln, Liechtenstein, 1952–69.

Strauss 1950
Strauss, Gerhard. *Käthe Kollwitz.* Dresden, 1950.

Strauss 1974
Strauss, Walter L. *The Complete Drawings of Albrecht Dürer.* 6 vols. New York, 1974.

Strobl 1982
Strobl, Alice. *Die Zeichnungen 1904–1912.* Vol. 2 of *Gustav Klimt: Die Zeichnungen.* Salzburg, 1982.

Stuttgart 1950
Stuttgarter Kunstkabinett. *8. Auktion.* Auct. cat., 1950.

Stuttgart 1981
Stuttgart, Galerie der Stadt. *Otto Dix: Menschenbilder. Gemälde, Aquarelle, Gouachen und Zeichnungen.* Exh. cat. by Otto Conzelmann, 1981–82.

Sutton 1979
Sutton, Denys. "Robert Langton Douglas: Part IV." *Apollo* (July 1979): 2–56.

Thieme and Becker
Thieme, Ulrich, and Friedrich Becker. *Allgemeines Lexikon der bildenden Künstler.* 37 vols. Leipzig, 1907–50.

Thienemann 1856
Thienemann, Georg Aug. Wilh. *Leben und Wirken des unvergleichlichen Thiermalers und Kupferstechers Johannes Elias Ridinger.* Leipzig, 1856. Reprint. Amsterdam, 1962.

Tietze and Tietze-Conrat 1928–36
Tietze, Hans, and Erika Tietze-Conrat. *Kritisches Verzeichnis der Werke Albrecht Dürers.* 3 vols. Augsburg, Basel, and Leipzig, 1928–36.

Uhr 1977
Uhr, Horst. "*Pink Clouds, Walchensee*: The 'Apotheosis' of a Mountain Landscape." *Bulletin of the Detroit Institute of Arts* 55, no. 4 (1977): 209–215.

Uhr 1982
Uhr, Horst. *Masterpieces of German Expressionism at the Detroit Institute of Arts.* New York, 1982.

Urban 1966
Urban, Martin. *Emil Nolde. Flowers and Animals: Watercolors and Drawings.* Translated by Barbara Berg. New York, 1966.

Urban 1970
Urban, Martin. *Emil Nolde: Landscapes, Watercolors, and Drawings.* Translated by Paul Stevenson. New York, 1970.

Vienna 1926–41
Vienna, Sammlung Albertina. *Beschreibender Katalog der Handzeichnungen in der graphischen Sammlung Albertina.* 6 vols. Coll. cat. edited by Alfred Stix, 1926–41.

Vienna 1967
Vienna, Galerie Christian M. Nebehay. *Gustav Klimt: 56 Zeichnungen.* Catalogue 11. Exh. cat., 1967.

Vienna 1979
Vienna, Hochschule für angewandte Kunst and Österreichisches Museum für angewandte Kunst. *Kolomon Moser 1868–1918.* Exh. cat., 1979.

Vogt 1958
Vogt, Paul. *Christian Rohlfs: Aquarelle und Zeichnungen.* Recklinghausen, 1958.

Vogt 1960
Vogt, Paul. *Christian Rohlfs: Das graphische Werk.* Recklinghausen, 1960.

Vriesen 1957
Vriesen, Gustav. *August Macke.* Stuttgart, 1957.

Washington et al. 1972
Washington, D.C., The National Gallery of Art. *The Art of Wilhelm Lehmbruck* (circulated to Los Angeles, San Francisco, and Boston). Exh. cat. by Reinhold Heller, 1972.

Weadock 1928
Weadock, Isabel. "A Dürer Drawing." *Bulletin of the Detroit Institute of Arts* 9, no. 7 (1928): 85.

Weber 1952
Weber, Hugo. "Vision in Flux – Painting about Space in Space." *Arts and Architecture* 69, no. 3 (March 1952): 32–33.

Wescher 1936
Wescher, Paul. "Hans Baldung, called Grien (1484/5–1545)." *Old Master Drawings* 10, no. 40 (March 1936): 70.

Wescher 1950
Wescher, Paul. "An Unnoticed Dürer Drawing in the Detroit Institute of Arts." *The Art Quarterly* 13, no. 2 (Spring 1950): 156–160.

Wethey 1969–75
Wethey, Harold E. *The Paintings of Titian.* 3 vols. London, [1969–75].

Winkler 1957
Winkler, Friedrich. *Albrecht Dürer: Leben und Werk.* Berlin, 1957.

Winkler 1965
Winkler, Friedrich. "Verzeichnis der seit 1939 aufgefundenen Zeichnungen Dürers." In *Festschrift Dr. h. c. Eduard Trautscholt zum Siebzigsten Geburtstag.* Hamburg, 1965.

Woods 1965
Woods, Willis F. "The Kamperman Collection." *Bulletin of the Detroit Institute of Arts* 44, no. 1 (1965): 7–15.

Index

Note: All numbers refer to pages and not to catalogue numbers. Those in boldface refer to pages on which color plates are to be found, and those in italics refer to black and white illustrations.